All The Best!

Mike Shula

June, 2018

Regards!

"Bobs"

THE HOMETOWN TEAM

Sports Publishing books may be purchased in bulk at special discounts for sales promotion, corporate gifts, fund-raising, or educational purposes. Special editions can also be created to specifications. For details, contact the Special Sales Department, Sports Publishing, 307 West 36th Street, 11th Floor, New York, NY 10018 or sportspubbooks@skyhorsepublishing.com.

Sports Publishing® is a registered trademark of Skyhorse Publishing, Inc.®, a Delaware corporation.

Visit our website at www.sportspubbooks.com.

10 9 8 7 6 5 4 3 2 1

Library of Congress Cataloging-in-Publication Data is available on file.

Cover design by Tom Lau
Cover photo credit Steve Babineau

ISBN: 978-1-68358-093-5
Ebook ISBN: 978-1-68358-094-2

Printed in China

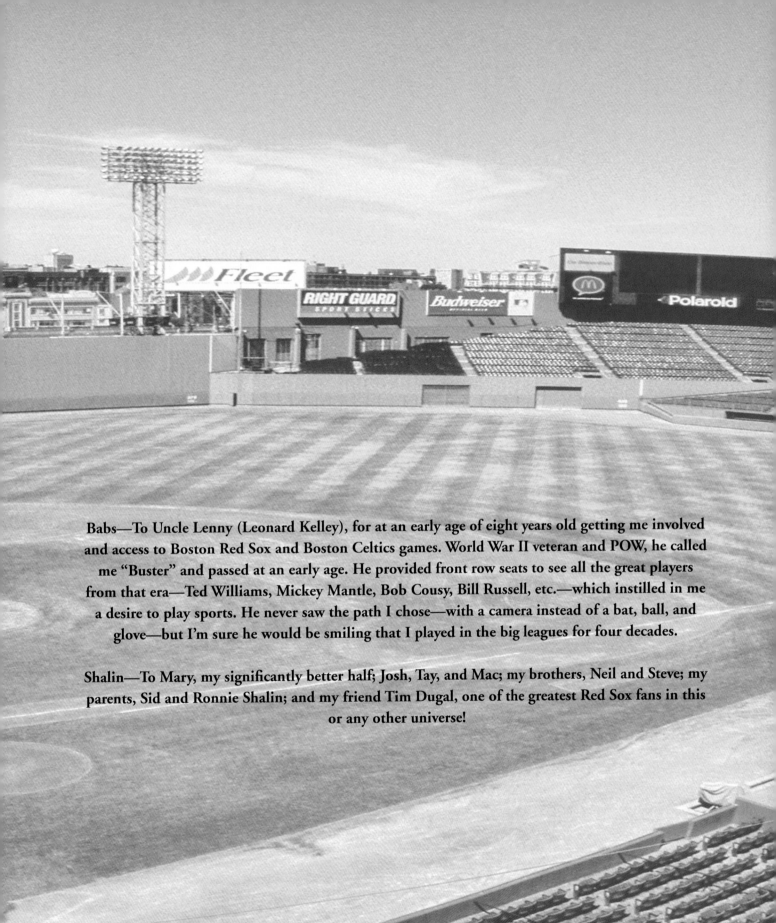

Babs—To Uncle Lenny (Leonard Kelley), for at an early age of eight years old getting me involved and access to Boston Red Sox and Boston Celtics games. World War II veteran and POW, he called me "Buster" and passed at an early age. He provided front row seats to see all the great players from that era—Ted Williams, Mickey Mantle, Bob Cousy, Bill Russell, etc.—which instilled in me a desire to play sports. He never saw the path I chose—with a camera instead of a bat, ball, and glove—but I'm sure he would be smiling that I played in the big leagues for four decades.

Shalin—To Mary, my significantly better half; Josh, Tay, and Mac; my brothers, Neil and Steve; my parents, Sid and Ronnie Shalin; and my friend Tim Dugal, one of the greatest Red Sox fans in this or any other universe!

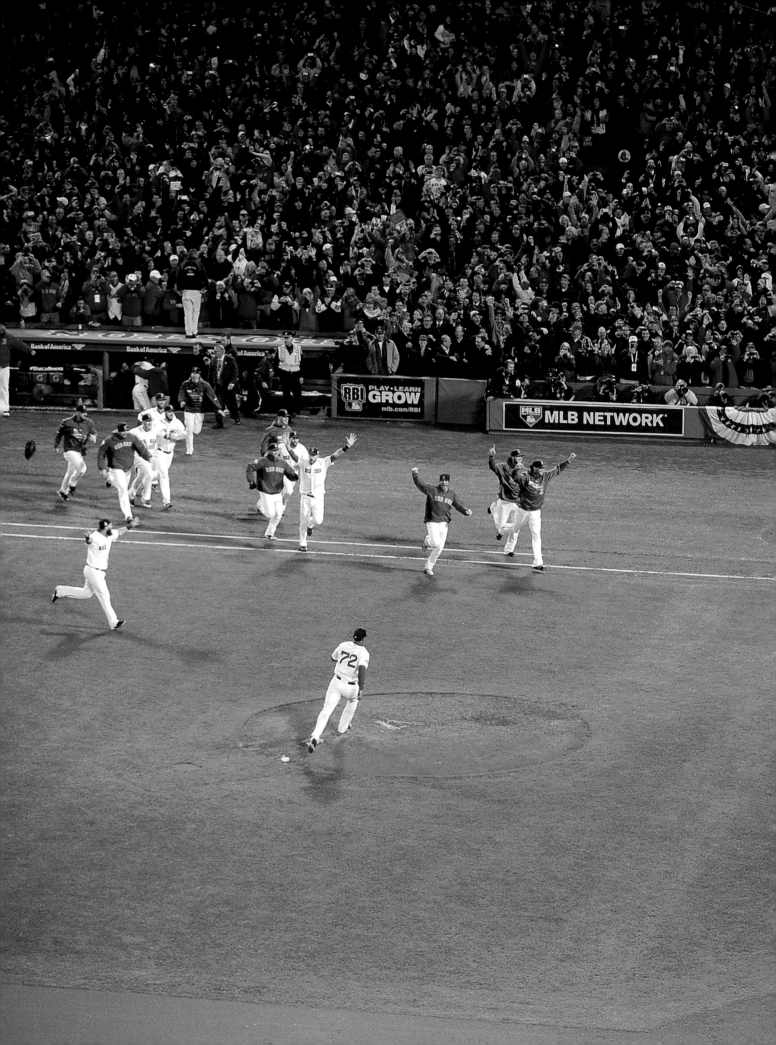

THE HOMETOWN TEAM

Four Decades of Boston Red Sox Photography

STEVE BABINEAU

WRITTEN BY MIKE SHALIN

FOREWORDS BY

DENNIS ECKERSLEY AND DWIGHT EVANS

SPORTS
PUBLISHING

Contents

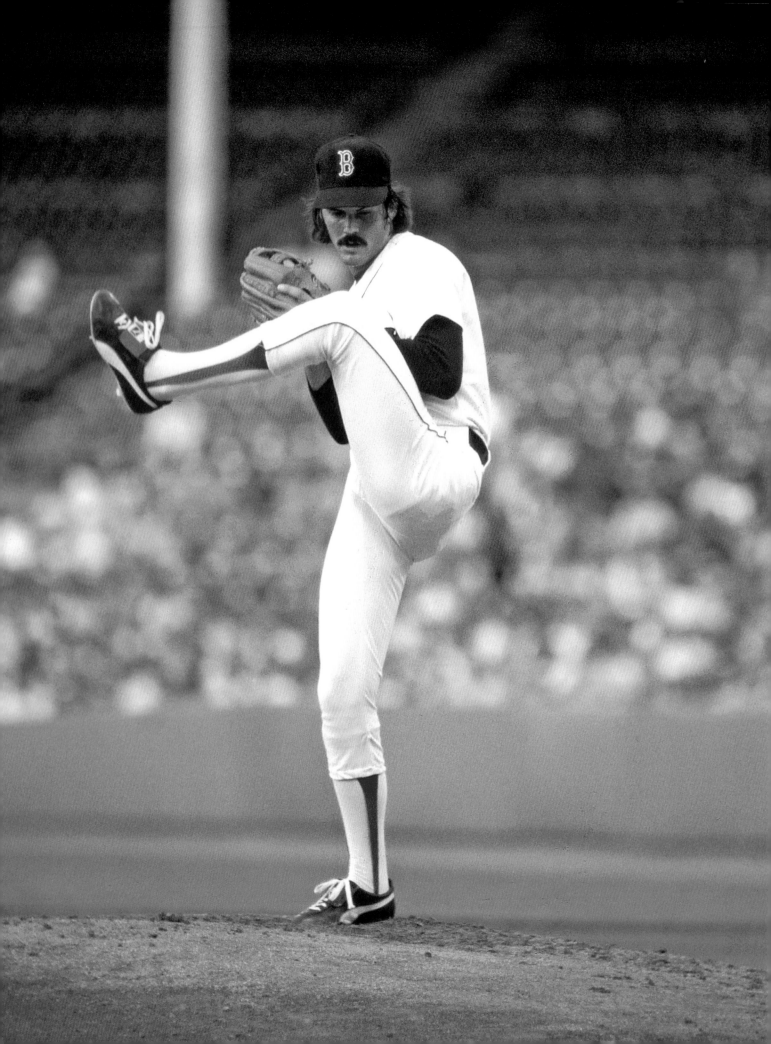

FOREWORD

I was born in Oakland, California, and was lucky enough to win a World Series for my hometown team after the tragedy of the 1989 earthquake.

I also pitched in Boston, Cleveland, Chicago, and St. Louis and have a plaque in Cooperstown.

All great places.

But Boston is my home.

Fenway Park is my home.

I first met Steve Babineau when he was taking pictures for the Fleer Baseball Card Company. That was a long time ago, but I was excited when Steve, working with Mike Shalin, someone who goes back to my first stay with the Red Sox, asked me to write a foreword for Steve's book.

I have to admit it was a strange feeling when Steve tracked me down outside of the NESN booth to take my picture for the book. So much time had passed and here I was again, posing for a picture for Steve Babineau.

Steve's love for sports and his longevity in this market is something he can truly be proud of. He can also be more than proud of all the work he has done with his cameras for all these years.

I hope you enjoy this book. I'm thrilled to be a part of it.

—Eck

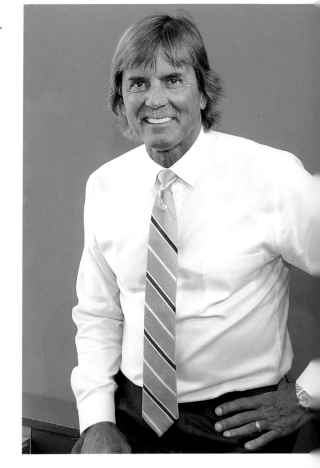

FOREWORD

My first time seeing Fenway? Gosh, it was 1972. We had just come from Yankee Stadium, and walking in here was pretty special. I was always early to the park, anyway, so coming out here, with nobody in the stands, was a lot of fun. Being twenty years old, it was the highlight of my life at the time.

Fenway Park is very special.

People always ask, "What's your favorite ballpark?" It's Fenway.

The wall hurt me more than it helped me, but I love the uneven dimensions here—you don't see that in every ballpark. Other ballparks are more evenly dimensioned and kind of cookie cutters, especially back then. This place was very special.

But the wall hurt me because I was a line drive hitter—my first hit I hit a line drive off the top of the wall and I'm rounding first base and the ball's coming back in and I had to get back to first base because I'd have been an easy out.

I hit a lot of line drives off that thing. Jimmy Rice was the same way.

I can remember Steve [Babineau] becoming part of the Fenway scene when he came out to shoot baseball cards, and when I saw him last year and he said he was doing this book with Mike, I was more than happy to be a part of it. It will be great fun looking back.

—Dwight Evans

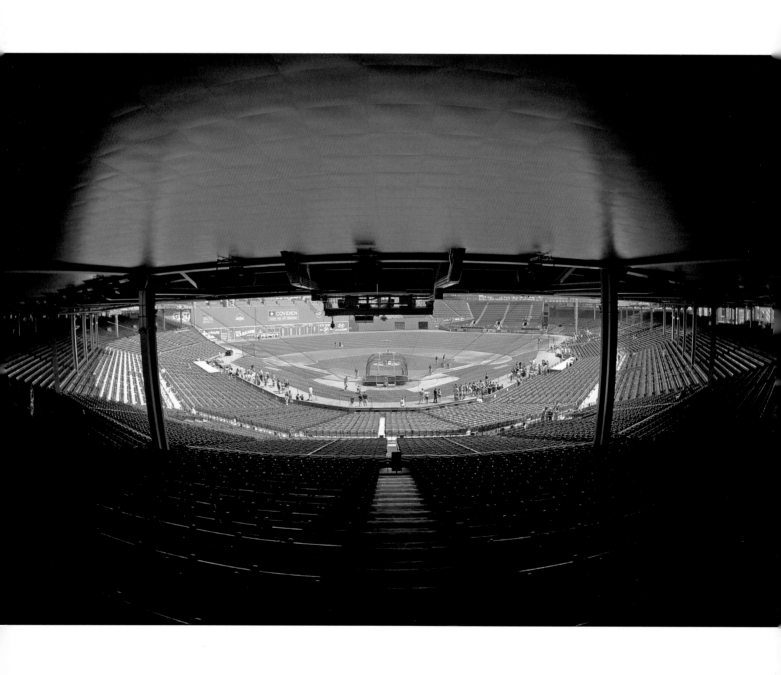

Acknowledgments

Thank you to my soul mate and wife, Anita (to whom, incidentally, I've been married for four decades), for putting up with the schedules associated with being a sports photographer for the Boston Bruins, Boston Red Sox, Boston Celtics, Manchester Monarchs, Portland Pirates, Worcester Ice Cats, Worcester Sharks, Fleer Corporation, Topps Company, and UMASS Lowell, as well as the Boston Garden/TD Garden. To John Kuenster, editor of *Baseball Digest* out of Chicago, who back in 1976 opened the door for me to photograph Major League Baseball for *Baseball Digest*, which led to shooting baseball cards for Fleer Corporation for 14 years and also for MLB for some time. To Dick Bresciani, Vice President of Public Affairs for the Red Sox; Debbie Matson, Director of Publications for the Red Sox; and Julie Cordeiro, former Red Sox chief photographer, for adding my son Brian and me to the staff in 1999. To Rick Dunfey and Anne Gram of Dunfey Publications, who produce the Red Sox Yearbook, for utilizing my action photography beginning in the early '80s and for adding Brian's creative talents in studio work so he could continue to be involved with the publication to this day. Over the four decades, many contacts/friendships have been made, so many thanks to: the NESN staff at the office and game day crews over the years, as well as many fellow photographers—Jim Davis, Matt Stone, Matt West, Matt Lee, Barry Chin, Winslow Townson, Charlie Krupa. Jerry Buckley, Dennis Brearley, Mike Ivins, Billy Weiss, Jack Maley, Julie Cordeiro, Brita Meng Outzen, Cindy Loo, Elsa, Damian Strohmeyer, Stuart Cahill, Elise Amendola, Ken Babbitt, Rich Pilling, and Pete Travers. To my many supporters in many different fields: Roger Coyle, Jim Christopher, Tom Grassi, Jean McDonough Abate, Joe Crowley, Steve Malloy, Dorian Color Lab, Bud Rowdy, Adam Fredericks, Peter Flaherty, and, most important, Ray "Fenway Park Green" Gerst.

—"Babs"

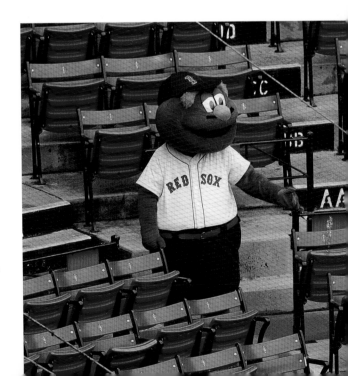

The author in this effort wishes to thank photographer Steve Babineau, for allowing me to go along for this ride, as well as Gethin Coolbaugh, Jonny Miller, Gordon Edes, Pam Kenn, Dave Laurila, and all the baseball writers, broadcasters, and players I've met along this long journey.

—Mike Shalin

Introduction

Yes, I must admit, I grew up a fan of the New York Yankees.

The Yankees are all I heard about living in Cambridge, Massachusetts. I was born in 1952 and attended my first Red Sox game probably in 1959 at the age of seven with Uncle Lenny (Leonard Kelley). The Yankees dominated the American League, winning thirteen American League titles from 1950 through 1964, and eight World Series titles by the time I was twelve.

Mantle, Maris, Ford, Berra, Kubek, Richardson, Boyer, Howard, Skowron—I "knew" them all. It seemed that was all I saw on TV growing up—the Yankees playing somebody on weekend national broadcasts.

I remember my favorite show was "Home Run Derby," first broadcast in 1960 by ZIV Television and featuring stars from other teams I had never seen. Hank Aaron seemed like he was always on the show (seven appearances), and this made sense since he became the player to break Babe Ruth's home run record. But, to see other future HOFs—Ernie Banks, Al Kaline, Harmon Killebrew, Mickey Mantle, Willie Mays, Eddie Matthews, Duke Snider, and Frank Robinson—in subsequent years, when Uncle Lenny took me to games at Fenway Park, was quite impressive.

I wanted to be a ballplayer.

Uncle Lenny had a connection with a sportswriter named Larry Claflin, who wrote for the Boston Herald American. All I remember is that we had great seats at Fenway for the Red Sox, who were cellar dwellers in my early years, and also to see the Boston Celtics at the Boston Garden. I was lucky to see first-hand those incredible Celtics teams of the sixties.

I vividly remember September 28, 1960, when Uncle Lenny elbowed me as I was eating popcorn when Ted Williams hit his last home run—in his last at bat, and Lenny kept saying "there it goes" as I look to an empty bleacher area in right field and watched the ball bounce around. Uncle Lenny kept saying, "Will he wave to the crowd?" as he rounded the bases, and Williams did not.

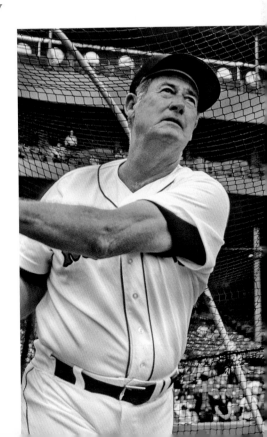

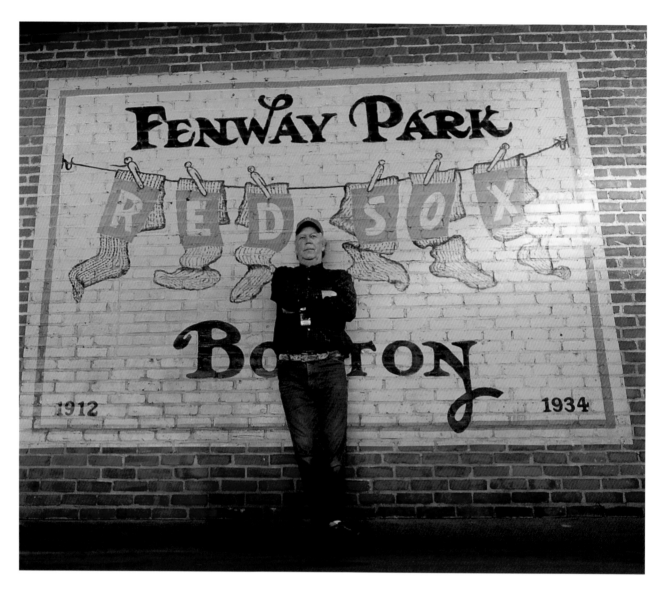

Later in life and having carved out a career in sports, I realized what a historical moment I had witnessed. My sister, Phyliss, older by eighteen years, was a huge Ted Williams fan, and I remember her scrapbook under the piano seat at our house that she had kept on Williams's career. Many times I fanned through that scrapbook growing up.

So I played ball every day, making the minor league team (JD Lynch Ins.) at seven and getting bumped up to the majors at eight (Wise Potato Chips), as an infielder. I had a strong arm and could cover a lot of ground at shortstop, being at that time almost six feet tall. The gang from Porter Square Cambridge met every morning in the summer at 8:30. We would walk about two miles to St. Peter's Field and play a pickup game, head home at noon, and then my buddy, Rick Marshall, would play Wiffle ball in my backyard until 4 p.m.

Then, after supper, the gang would meet around 5 p.m. and head back to St Peter's Field to play home run derby out in right field while the city softball league played under the lights.

I went on to play Babe Ruth ball (three years), then high school (Rindge Technical) ball and was captain in 1970. But before I started my high school career, a bunch of my baseball friends from West Cambridge kept bugging me because I wasn't playing hockey. I loved to play street hockey with these guys but never skated until

the eighth grade and simply didn't have funding for gear—and my dad and Uncle Lenny didn't follow the game. Because I was tall, I think basketball was in their plan.

Well, I made the freshman hockey team and played both JV and Varsity for three years, getting 32 games a year and all the practice ice times allocated to each program. Needless to say, I became a pretty good player by the end of my senior year. However, it cost me in the long run—I blew out my right knee as a junior playing in a practice, and they did ligament surgery.

This set me back for the remainder of the junior year for hockey, but I was able to play baseball with a brace. At the same time, I now had become a Bruins fan with the second coming of the savior Bobby Orr to town. The Bruins often practiced at Harvard about a mile from my high school, so I could watch practices and take a camera along with me. Our high school team also practiced at Watson rink, and I ended up working at the rink part-time. So there began the Bruins connection.

The Bruins were in the headlines while I was in high school, winning Stanley Cups in '69-70 and '71-72. The Red Sox, other than the '67 "Impossible Dream Team," were not winners and didn't really matter. I now was in my teenage years. I remember senior year playing Brookline, and my baseball coach Mr. Gibson saying to me after a game that Frank Malzone (Sox scout) was at the game to watch a player from the Brookline team—but he came up to Coach Gibson and asked, "Who is your shortstop?" and he wanted info and stats on my career.

I thought that was pretty cool. I graduated from Rindge Tech and spent six months at Boston State College, majoring in Physical Education. I decided, having worked the previous two summers for a computer company in Waltham and having been offered a full-time job, that it made sense to play baseball in Sudbury, Massachusetts, for the Sudbury Thunderbirds and work a regular job at eighteen years old. The plan was to try to hitch on with a Cape Cod baseball team at some point.

The plans all changed when, with my passion to play hockey still there, I experienced my second right knee injury, this one putting me in a full-length cast for three months. Then, my fastball as a pitcher went from 90 to 82 miles an hour because my right leg was my drive leg off the rubber. I was now throwing batting practice velocity, and my range at shortstop also suffered.

At the same time now, at twenty, I met my wife, from Canada, and the rest is history.

Being a fan of sports, I became a fan of taking pictures of sports. Having played baseball and hockey, I felt I had an advantage in anticipating situations in a manual focus lens format—this was key. I got married at twenty, with a full-time job, and I got a break getting access to shoot the World Hockey Association and the NHL for the Hockey News in Montreal. That led to the Topps Hockey Card Company and other magazine publishers taking interest in my work.

My baseball connection was Century Publishing Company, which produced *Baseball Digest*. The editor, John Kuenster, was also the editor for *Hockey Digest*. I asked Mr. Kuenster,

since I was already established in supplying them with hockey material, if I could also shoot baseball. To his credit, I owe him my entry into Major League Baseball. He called the PR director of the Red Sox, Dick Bresciani, and requested credentials for the 1976 season.

So here I was shooting in Fenway Park, looking up to the sky saying, "Uncle Lenny, I made it to the big leagues."

This inside track to MLB, along with now being the team color photographer for the Boston Bruins, had put me on a path of staying involved with the two sports I loved to play. Keeping my regular job and moving up the ladder of responsibility with work and family, I was somewhat content.

However, my career went to the next level when one of my supervisors and good friend, Steve Malloy, came into my office and said, "Did you hear that Fleer Corporation had won their lawsuit against the Topps Company for the rights to produce baseball cards?"

Up to that time, Topps had the monopoly on the trading card industry. It took me about five minutes to find the phone number and make a call to Fleer Corporation and speak with a Mr. Tom Teagan and introduce myself. Unbelievably, he was at my house the next day, up from Philadelphia, and offering me a contract to shoot baseball cards over the last three months of the 1980 season.

I worked for Fleer as a staff photographer for fourteen years, until the end of the 1994 season, as well as working my regular job. I had the opportunity to shoot games out

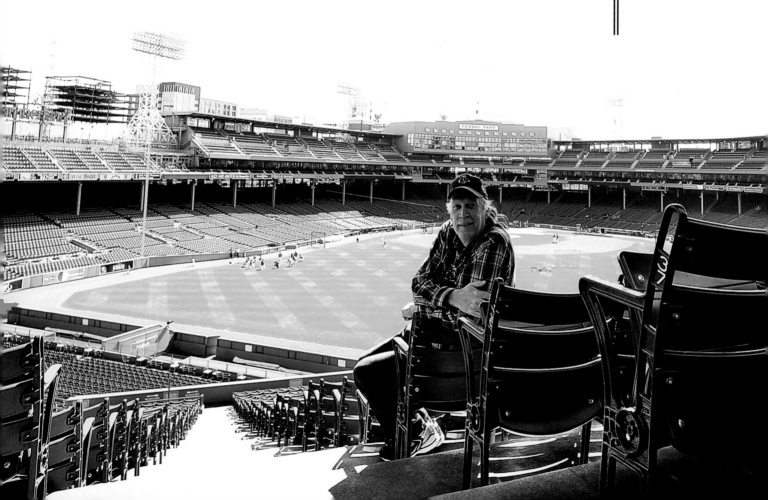

of Fenway Park, Olympic Stadium (Montreal), CNE Stadium (Toronto), Tiger Stadium (Detroit), and two weeks of spring training every year in Central Florida.

From 1995 through 2000, I contributed to Major League Baseball archives, shooting games out of Fenway Park. Keeping my foot in the door led me to being a major supplier to the Red Sox Yearbook Publication, produced by Dunfey Publications, early on, as I supplied game action images and portrait setup images with the help of my son Brian Babineau. This connection led Dick Bresciani to ask me and Brian to join the Red Sox staff as team photographers in 2000.

I'd like to think that the "Bambino Curse" was lifted when the Babineaus were added. After all, the Red Sox have won three World Series since we came on board.

—SB

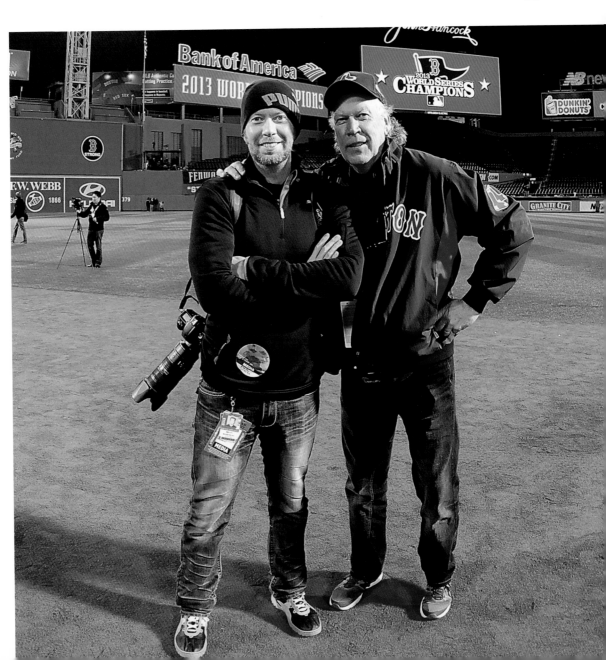

I can't honestly tell you how long I've known Steve Babineau.

We didn't grow up together. We didn't go to college together. We didn't stand up at each other's wedding. We're not godfather to each other's kids.

I moved to Boston thirty-five years ago, and Babineau didn't help me move my stuff.

I also can't even honestly tell you when we met.

None of the above pertains to our relationship, if we can call it that.

What I DO know is that Steve Babineau is a fixture in Boston.

Not a building, like Fenway Park or TD Garden. Not a tourist attraction.

Just a damn good photographer—one who has been in the middle of it all in the Boston sports scene for four decades.

Always arriving early at Bruins and Celtics games, I got to know Steve as he and his kids, Brian, Jamie, and Keith (in charge of the visitors' locker room), did their thing at the Garden. I would talk to Steve about his passions—photography, old westerns, and Neil Young.

He told me he spent fourteen years shooting for the Fleer Baseball Card Co., in addition to his work on Upper Deck, Topps, and Pinnacle hockey cards. We would kick around ideas for a book, and he came up with the idea for what you're reading right now.

I came to Boston to cover the Red Sox for the *Boston Herald* in 1983 and have done various things through the years, working as a freelancer since leaving the *Herald* in 2005.

Among my endeavors is working as an official scorer at Fenway, something I've done since 2003. But it's at the Garden where Steve and I talked most, and where our friendship developed. Thus, I'm thrilled to lend my words to this labor of love from Steve—his forty-plus years of shooting the Hometown Team.

—MS

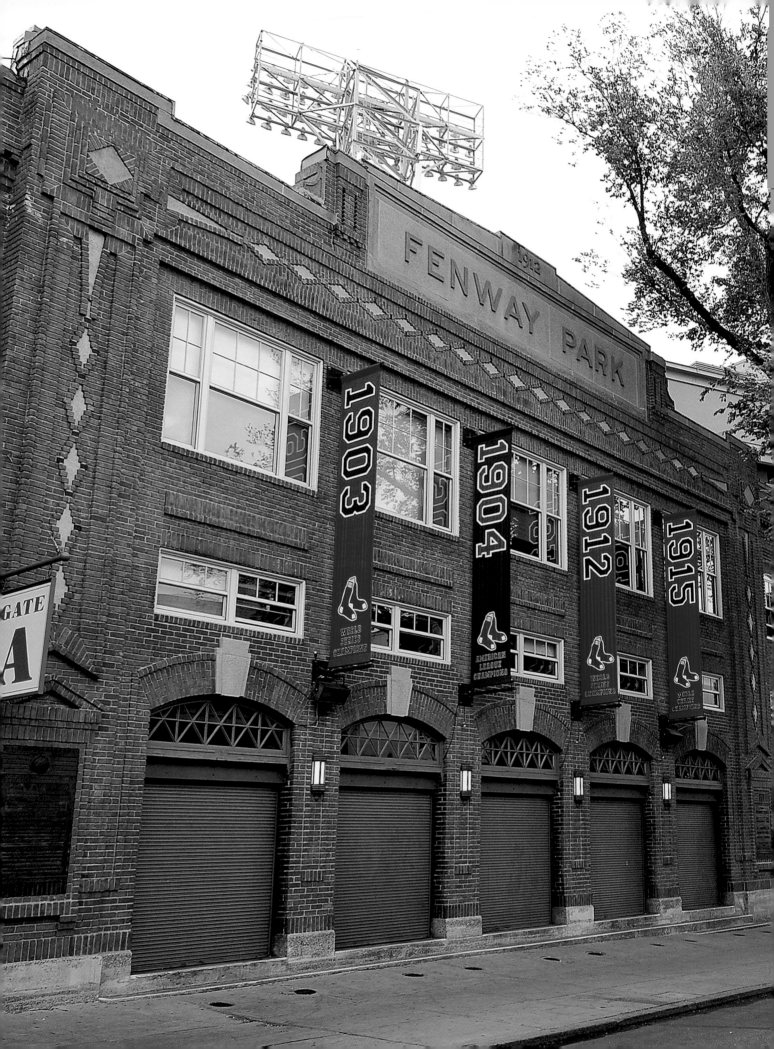

FENWAY PARK

As a young baseball writer making the move from New York to Boston in 1983, I walked into a rapidly aging ballpark that appeared to be on its way to riding into the baseball sunset.

There was no way to project 3 ½ decades into the future and think the place, renovated over and over, would not only still be standing but would also be the home of the Red Sox for a long time to come.

There have been changes in ownership, changes in management, and all kinds of managerial changes.

There has been more suffering, with the painful 1986 World Series the latest chapter in the Curse of the Bambino. Pain had become a serious part of being a Red Sox fan.

There was Morgan's Magic in 1988, but nothing in the playoffs. There was another division title in '90 and again nothing—eight postseason games in the two seasons and nary a victory.

There was more pain in the rest of the '90s. Then Grady Little left Pedro Martinez on the mound too long (matter of opinion) in the 2003 playoffs against the Yankees, and Trot Nixon's failing to catch Derek Jeter's drive to key that comeback.

More pain.

But there have also been the highlights. There was that special moment at the 1999 All-Star Game, where the All-Stars gathered around Ted Williams in the infield—and Pedro Martinez, who started the game and pitched two perfect innings with five strikeouts.

Then, of course, came 2004, when the Sox came back, at home, from being down 0–3 in the ALCS to the dreaded Yankees and doing it against Mariano Rivera. The comeback started, of course, when Dave Roberts, a short-timer in terms of service to the franchise, stole the biggest base in club history.

1

The Red Sox won the World Series in 2004. They did it again in 2007. Then, after a rather uncomfortable split with Terry Francona, there was Bobby Valentine, but then another title under first-year manager John Farrell—three championships in ten years.

The old place was supposed to have been replaced a long time ago. It was coming down, with a new place on the Boston waterfront, they said. On another occasion, it was coming down with a new place directly behind the old place. But none of it happened. They saved it—with the group Save Fenway Park taking the lead.

"There is something magical about each game at Fenway Park that is irreplaceable and it cannot be crafted someplace else; it is its own unique experience and it's a special experience," president of Save Fenway Park said in *Why Fenway: Exploring the Red Sox Mystique.*

They put seats on the Monster. They added other seating, other things to make the place "newer." The concourses were made wider, even though you don't want to make your way through said concourses before or after a playoff game. Food choices and the restrooms were improved. Parking is still a nightmare, but that is somehow also part of the experience.

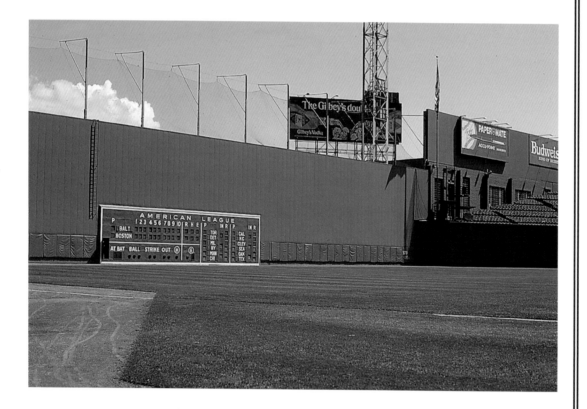

There have been championships. There have been reunions. In 2017, they celebrated the 10th anniversary of the '07 title and the 50th of the Impossible Dream. They retired the No. 34 jersey worn by David Ortiz.

There was more. There was Fenway turning into a concert venue—and an outdoor hockey rink, where Marco Sturm scored in overtime to give the Bruins a win over the Flyers in a Winter Classic. And football? Boston College played Notre Dame as Fenway turned back the clock to when the then-Boston Patriots used Fenway as a home.

To put it simply, there is something special about a stadium that's survived over a hundred years. Joe Maddon complained about the size of the visitors' clubhouse, but ask any player coming in for a first visit and he tells you how special it is to be there.

In the foreword for *Why Fenway*, Bill Lee wrote:

"I didn't want to come to Boston from sunny California—I wanted to be a Dodger. But once I got to Boston, I fell in love."

Hope you are enjoying Steve's pictures of the place!

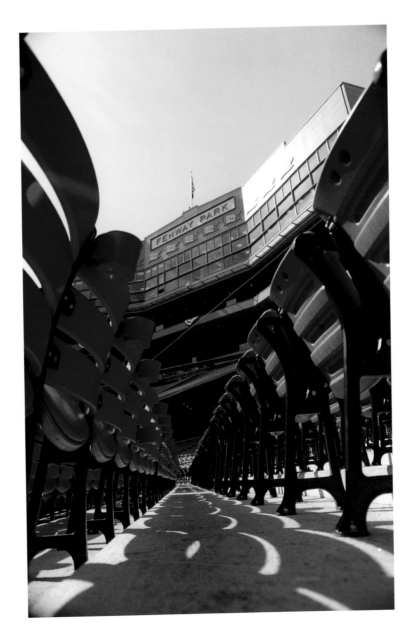

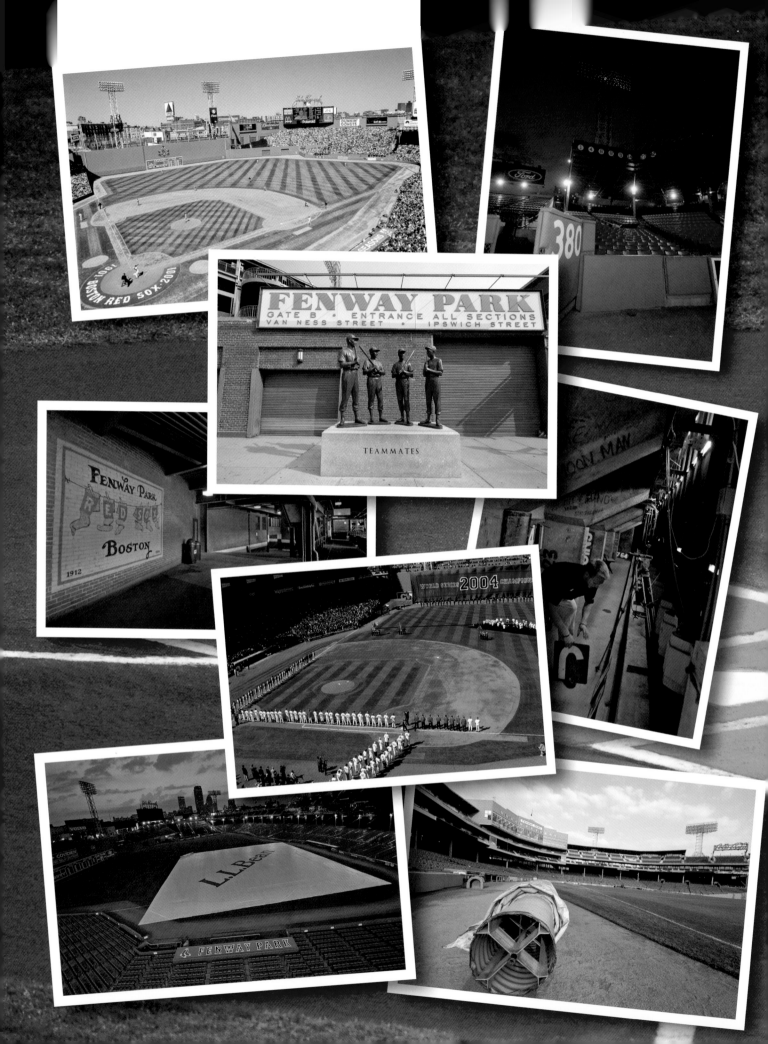

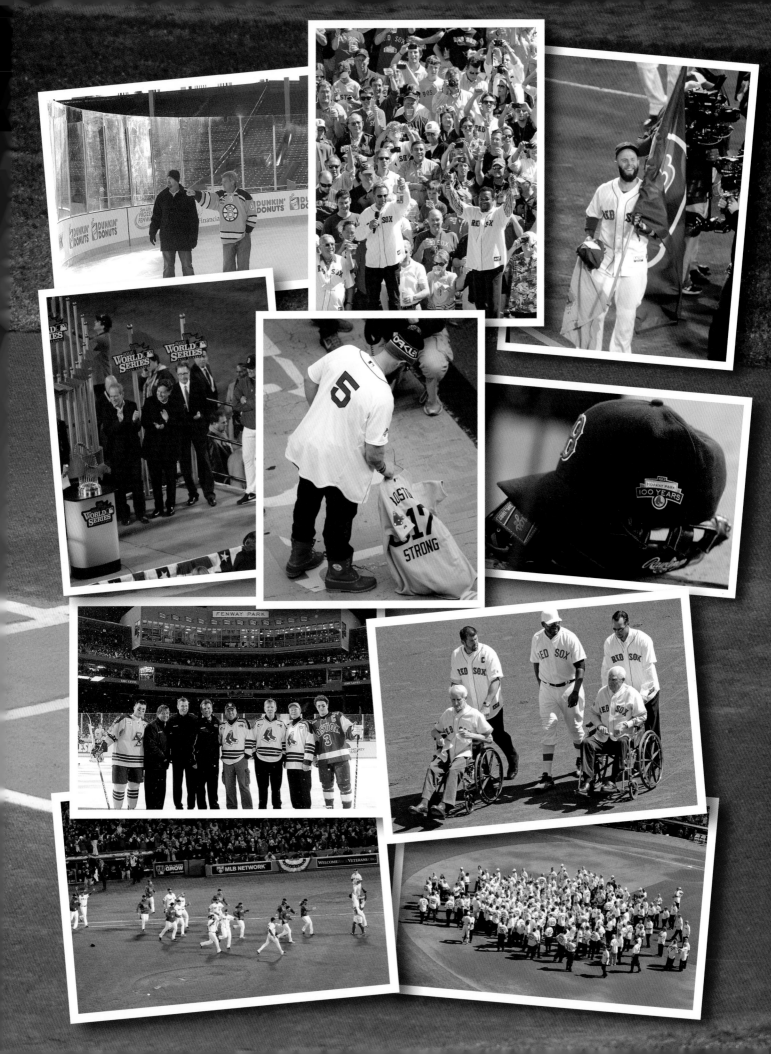

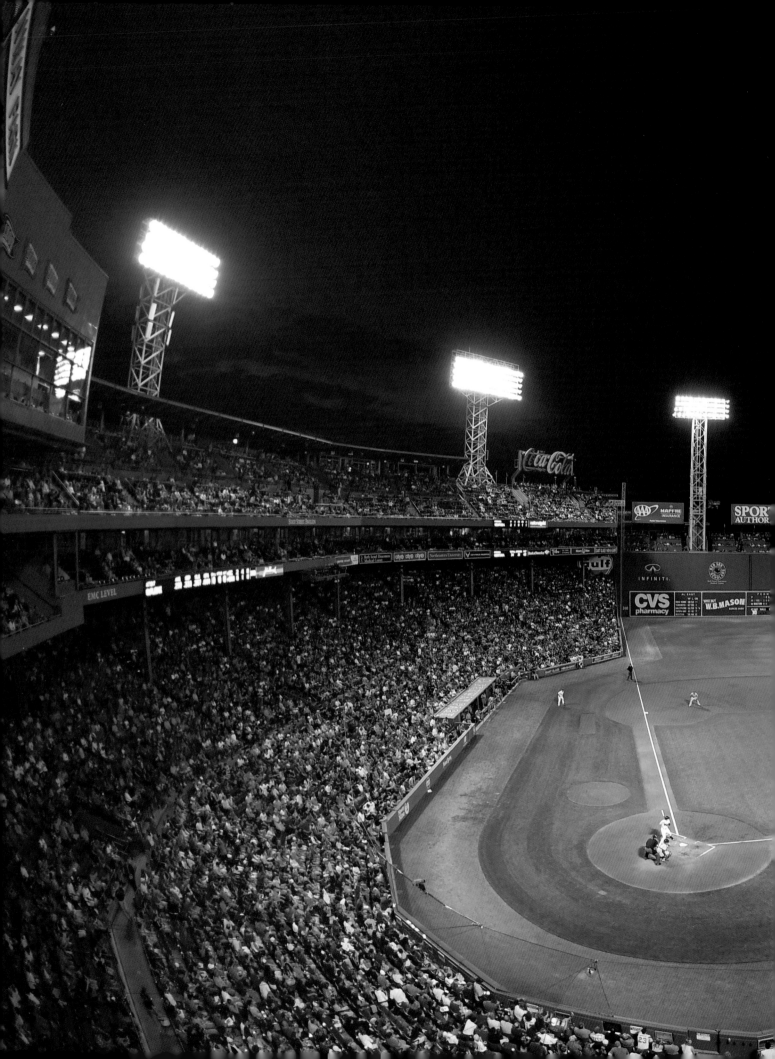

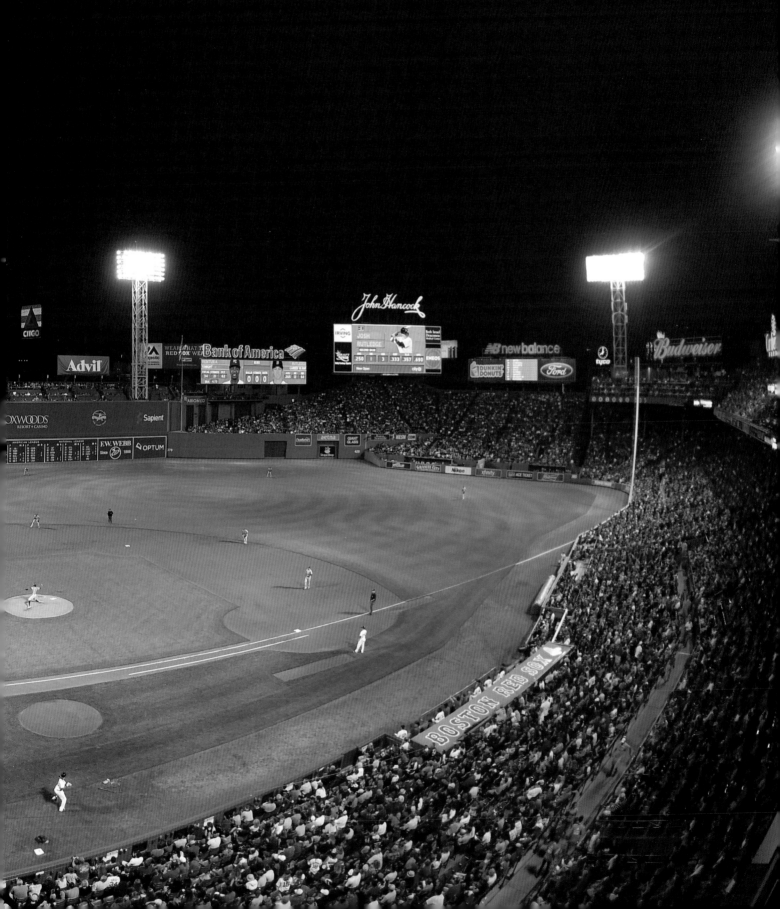

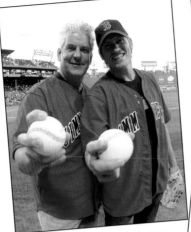

Lenny Clarke, Denis Leary

Joe Mooney, Head Groundskeeper 1971-2000

Steven Tyler

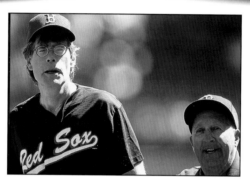

Stephen King, Al Forester (groundskeeper)

Lou Gossett Jr.

David Cassidy

Kevin Garnett

Senator John Kerry

John Henry, Tom Werner, Larry Lucchino, and Mayor Menino

Neil Diamond

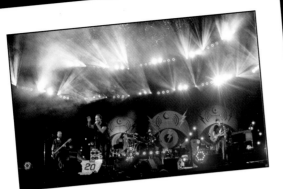

Pearl Jam

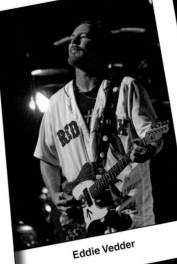

Eddie Vedder

Bill Lee

Bill Monbouquette

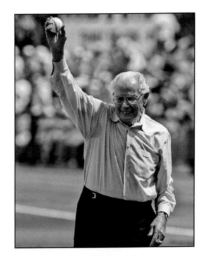

Dom DiMaggio

Jim Lonborg

Patriots' Bill Belichick, Jonathan Kraft, Robert Kraft,
& Tom Brady

John Travolta

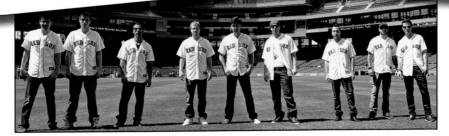

New Kids on the Block & Backstreet Boys

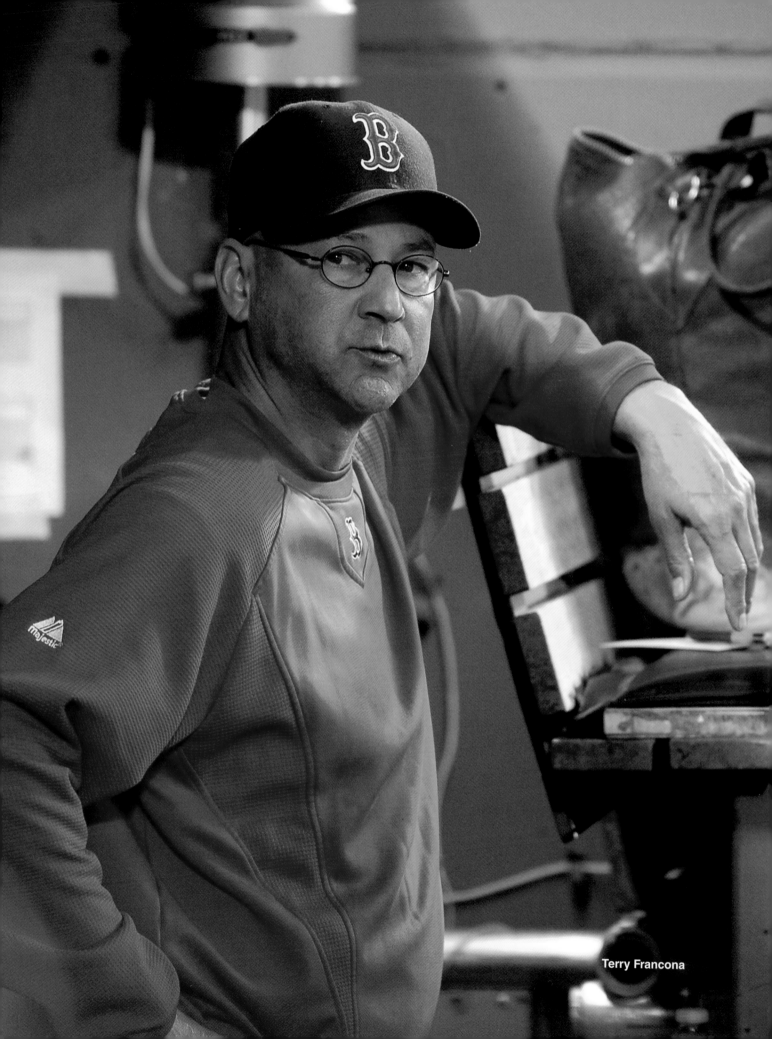

Terry Francona

SKIPPERS & BRAIN TRUST

2

John Farrell picked up his 400th victory as Red Sox manager in a game in early August, 2017. But by October, following a Boston loss in the ALDS, Farrell was out of the job.

After all, it wasn't that big a stretch to say the man had been fired by the public.

Such is the life of a Red Sox manager.

Farrell had been through so much. He had lived in first place, lived in last place. He had lived through cancer, and even through a bit of an off-field miniscandal. Not to mention a change in general managers.

He did things right. He did things wrong, as well.

But perhaps the guy deserves some credit?

Farrell was fired after winning his second straight AL East title—and losing in the ALDS for the second straight season—and was replaced by Alex Cora, who was on the '07 championship team and had just won a World Series as the Houston Astros' bench coach.

In January, 2017, I asked Farrell about his ups and downs (both of which certainly continued into the 2017 season), about how his cancer battle may well have changed his viewpoint, and about what it's like to manage in Boston.

John Farrell

"I don't know, maybe when it's all said and done I'll have a better answer for you," he said. "There's no question my own health situation plays into this. It's made me, I think, look at this position a little bit more objectively. I love what I do. I still give it everything I have and yet I realize you're not going to please everyone, which is part of what's so great about Boston.

"If they didn't care, they wouldn't pay attention or say things. But you go through it now, four times as a pitching coach, four times as a manager, and because of the wide swings that we've experienced on the field, you're probably

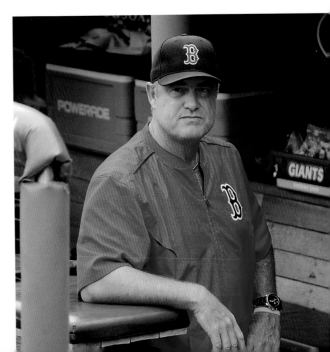

first-hand experiencing the reaction on the full spectrum of things. I'm not going to say I've experienced it all by any means—because this year is going to be a different year in and of itself. But there's been a lot of situations I found myself in that you continue to try to be the same person that you are and be as genuine as you can be."

What it is about Boston—is it that they care so much?

"Without a doubt. That's the root of it," Farrell said. "And then you combine that with the traditional history of a charter member in major league baseball. There's such, at least for our country, there's such history wrapped up in this city in and of itself. What's different here from some of the other cities is that this isn't a transient city so people grow up with the Red Sox ingrained in them. It's part of the fabric of who they are and that's something that you can't replicate—and that's one of the things that you love about this region and certainly this city."

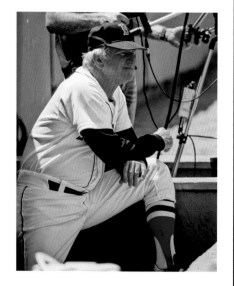

John McNamara

He was the latest in a line of managers who have felt the heat of the fans through the years (with the exception of Terry Francona, won two World Series, one ending the 86-year drought). John McNamara didn't put Dave Stapleton in for defense in the 10th inning of Game 6 of the 1986 World Series—after the controversy of a Roger Clemens blister or no blister— and lived with it forever. Grady Little didn't pull Pedro Martinez in 2003 and lost his job. Bobby Valentine was . . . well, Bobby Valentine. Don Zimmer didn't win the 1978 playoff game after his team blew a huge race lead but then rallied back to force the one-game play-off with the Yankees.

Grady Little

Don Zimmer (R)

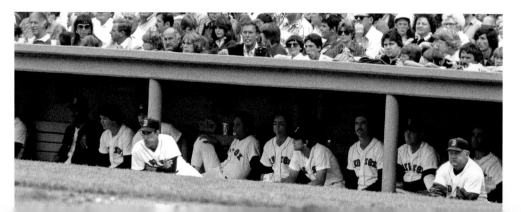

They all came up short, until Francona, and even he left under lousy circumstances.

"That's the nature of managing," McNamara told Gordon Edes, then of the *Boston Globe*, in 2004, after Little was fired. "Upstairs, they're the ones who dictate the course of a manager's future. It was the same way for me in 1988. We were at the All-Star Game just a few games out of first place, but there was such a cloud over that ball club on us every day. There was a cloud over whether I was going to be here today or not. A Mac watch."

Francona won two World Series but was then dumped in a sour divorce and went on to manage Cleveland. Many think he's headed for the Hall of Fame.

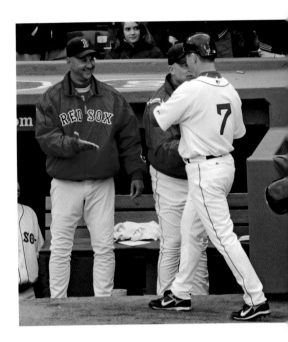

Terry Francona

"I made more than my share of mistakes but still show up. I try my ass off and do everything I can for our team to win," Francona said when he came back for the Boston Baseball Writers Dinner in 2017. "I think in this town, especially, people know you're trying, they appreciate that.

"Mikey Lowell fell in the seats on a popup, remember that? It seemed like from that day on—it couldn't hurt he was the MVP of the World Series—but it seemed like that day to me, the switch went on—that's the kind of town this is."

Zimmer, whose teams won 97 games in 1977, 99 in '78, and 91 in '79—before there was a wild card—remembers what it was like after Graig Nettles caught Carl Yastrzemski's popup to send the Yankees to the ALCS and the Red Sox home.

"For the first time in my baseball life, I was crying, right along with [the team]," Zimmer said in his autobiography, written with Bill Madden. "Then I gained my composure and let them know what I'd been thinking and feeling all through that eight-game winning streak at the end of the season."

Zimmer said he told his players, "There is not one man in this clubhouse who should even think about dropping his head. I couldn't be more proud of this ballclub and the way you guys played those last 20 games of the season. Everyone in this town gave up on you but yourselves and me and I just want you to [know] it. This is something we just have to live with. It's baseball."

Especially in places like Boston.

Looking back at '86, McNamara told Edes, "I can be second-guessed for Buckner, I guess, but I had a Gold Glove fielder. I would take the criticism if the ball had been hit to his right and he couldn't get to it, but the ball was hit directly at him. The ball went through his legs. So be it. If I remember right, a ball went through the legs of the Mets' second baseman, [Tim] Teufel, in Game 2, and we won, 1–0."

JOE MORGAN

It's thirty years later, and even Joe Morgan is still amazed by what happened back in 1988.

Morgan Magic!

"It was unbelievable the way it went—12 straight wins was a record for an interim manager," Morgan said in the summer of '17. "Fred Haney had the record at 11 and I played for him in Milwaukee in 1959.

"It was crazy because there were cars going by my house by the numbers, all day long, saying, 'there's where he lives.' I went to the hardware store one time and the guy wouldn't take any money for a hammer I got.

"It was crazy. Head downtown and shopping took quite a while because everyone was talking to you, let's put it that way."

The Red Sox had hit the All-Star break with a 43-42 record, thanks to eight losses in their last 12 games. They were in a virtual tie for fifth place in the then-seven-team AL East, nine games out of first.

They turned to their veteran coach and minor league manager and then, after a rainout, they reeled off 12 straight wins.

"I had given up hope of managing," Morgan said. "But the biggest break I got, really, was when [Rene] Lachemann left the third base coaching box to go back to California. I became the third base coach and therefore the man on the spot when the guy [John McNamara] got fired. That was the break I got."

Morgan remembered what happened on THAT DAY.

"I was sitting in there waiting to go out on the field and I saw Hayward Sullivan come in the back door of McNamara's office," he said. "Then I looked up and I see (Lou) Gorman coming in the other door walking right toward me and he said, 'We're gonna make a managerial change, Joe—you're gonna run the club until we find a manager.' I said, 'You've already got one—don't look too far.'"

Morgan said he had no way of even imagining what would come next, the magic taking the Red Sox all the way to the playoffs.

"Nobody could [imagine it], could they?" he said. "In the first place, a manager gets fired, they have a lousy team, and how they went 12 in a row . . . and in the second place, how many teams ever win 12 in a row, ANY time?

"You never know why it happens that way, but it did."

He said brass came to him later about his future: "They never used the word 'interim,' but they just came in and said we're gonna extend your contract including the following year and that was that."

Magical, indeed.

But that's not what people remember.

Torey Lovullo, who managed for Farrell during Farrell's cancer treatments in 2015, became the manager of the Arizona Diamondbacks in 2017. Lovullo said he quickly noticed the difference between the two locales.

"Things are more magnified in Boston," Lovullo told Dave Laurila of Fangraphs. "We brought a lot of the same concepts to Arizona that we had there, and we're still working through some of those things. We're still trying to get to those final pieces of the puzzle that will lead us to a championship, and that's going to take some time.

"I think the media here is a little bit more patient with understanding that it's going to take a little bit of time—there might be a little more wiggle room. In Boston, it's always a win-now mentality. We expect to win here, but we also want to sustain winning. We don't want to have a highlight year, and then not be able do it the next year. We believe we're going to get to that level pretty soon, because we've seen this formula work."

The last-place finish under Valentine included everything going wrong that could go wrong.

"It's obviously disappointing," Nomar Garciaparra told Gethin Coolbaugh, then of *Bleacher Report*, late in that season. "The mentality [in Boston] is if you're not going to the postseason, it's a disappointing season. If you don't win it all, it's a disappointing season."

Looking back, in 2004, McNamara said, "Let me clarify this: My time in Boston was very good. The fans were good to me. Hell, I still get letters from people up there, 'Why don't you come back?'"

Francona, who may well have been slighted when the Red Sox held their tenth anniversary of the 2007 team a day before his Indians came to town, talked about how special it was to come to Boston during the winter to receive an award.

"You can't spend eight years in a place and not have a lot of great memories and a lot of friends that . . . if you see them once a year it's better than none," he said.

Bobby Valentine

Asked if it was hard to believe it had been over a dozen years since he and his team ended the curse in 2004, Francona said, laughing, in January 2017, "Not when I try to exercise, or walk. No, it seems like it's been more than that."

DAN DUQUETTE

Dan Duquette wasn't the Red Sox general manager when the team finally won the World Series, but that doesn't mean it wasn't as special for him as it was for so many others in Red Sox Nation.

Even if he had been fired from his dream job.

"I watched the first five innings of the 2004 World Series with Lou Gorman in the 600 Club," Duquette said from his general manager's office in Baltimore in 2017. "We had a terrific visit. We reminisced about the opportunity and the missed opportunities of our tenures there and then we went out and we watched the Red Sox win the first game of the '04 World Series.

"I had worked pretty much my entire adult life for the opportunity to help the Red Sox and see them win the World Series. So I went on to St. Louis and saw Pedro pitch Game 3 and I saw Derek Lowe pitch Game 4 and celebrated with my friends and my family."

After all, many members of that '04 team were put there by Duquette, who fulfilled a lifetime dream for a kid from Dalton, Massachusetts, when he became the club's GM in 1994 at the age of thirty-six.

"I had always aspired to work with the Red Sox since I was a kid," Duquette said. "When I found out pretty early on that it wasn't going to be as a player, I set out to learn the skills that I needed to make a contribution to the team.

"It was my intent, from a very early age, to help the Red Sox overcome the drought of the championship. A lot of people say it was a curse—I always wanted to help the team win a championship—that's something that was important to my grandmothers, my grandfathers, my father, and a lot of people in New England, a lot of people who grew up in New England and being around baseball I wanted to be a part of that."

He didn't quite get there. His players did, but . . .

He laughed, saying, "You know what? Timing in life is everything, right?

"When I joined the Red Sox, I pretty much told the fans when we started out it's going to take five to seven years for us to get into a position for us to compete for

a championship. That was in 1994, before the strike. We really set out in earnest to build up the talent and have a competitive team by embarking on international recruiting, hiring international scouts, by building up the talent base for the whole organization, foregoing signing major league free agents that would cost us draft picks. That was all part of a plan to build up a talent base and putting the club in a position so that they contend for a championship year in and year out."

But then, the Red Sox were sold and Duquette was gone.

"On a personal level, the team was sold and my time there ended," he said. "But that didn't take away from the talent base that we built and the team being in contention. We left with a good team and a good farm system and the new ownership leveraged that to win a championship."

He would be gone nine years. He started the Dan Duquette Sports Academy for kids ages eight to eighteen. He was the owner of the Pittsfield Dukes of the New England Collegiate Baseball League. He helped start Israel Baseball and even had a part in a production of *Damn Yankees*.

Then he came back with the Orioles.

Why so long?

"My kids were in school and they weren't interested in moving," he said. "I spent a lot of time on the road away from my children. This pro sports is 24/7/365—I was ready to do something else when the Red Sox ended and I did get an opportunity to coach my boys' teams and to see my daughter go to college and see the kids grow up. And then after our younger son, Dana, went to college that's when I really tried to get back into it. Part of that was opportunity and it was also a personal choice that I made."

When he was in Boston, he came across as cold and aloof, making it clear he was there just to get the job done. He rubbed a lot of people the wrong way.

"Obviously, being away from it I had to reflect on things that I could do better if I got another opportunity to be able to work with a major league club," he said. "I don't think I take things quite as seriously now as I did when I was younger—given the experience that I've had, so all that was good. I had a chance to reflect on how I could improve and help other people around a major league base team so when I got another opportunity I applied those skills and made some specific changes that actually made it easier to do the job."

Part of his problem in Boston was with the media—we were used to having the ever-chatty Gorman to talk to during the offseason. Duquette cut that *way* down, another thing he learned from.

"Lou was a great storyteller, that was his style," Duquette said. "I was more of a builder and the job that I was hired to do in Boston was build up the infrastructure and build a competitive team.

"I had to make choices with my time as to where I was going to spend it. A lot of that went into scouting and development with the big league club, but the demands that you have for people to talk to you as the chief executive of the Red Sox are immense. I could have done a better job in terms of being accessible to the media, but I was more focused on the job of building up the talent base and building up the system and scouting and player development—and changing the culture around the major league team. That took a lot of time and energy. That was a specific choice that I made and in retrospect I should have spent more time with the media because it's such a demanding market."

Despite the demands, Duquette managed to make a lot of monumental moves. His tenure brought Pedro Martinez and Manny Ramirez to Boston. He swung a trade that sent Heathcliff Slocumb to Seattle for Lowe and Jason Varitek. He made many that helped end the drought.

"I was happy to see the club win," he said. "The club fulfilled the promise that we envisioned for it when we brought a lot of those players in—and I was happy for the players; a lot of them who it was their last shot."

Duquette cited a number of players from the 2002-04 teams who contributed to the team's success.

"I was happy for the players. They got an opportunity. That was THEIR time, that was THEIR moment to shine and they did."

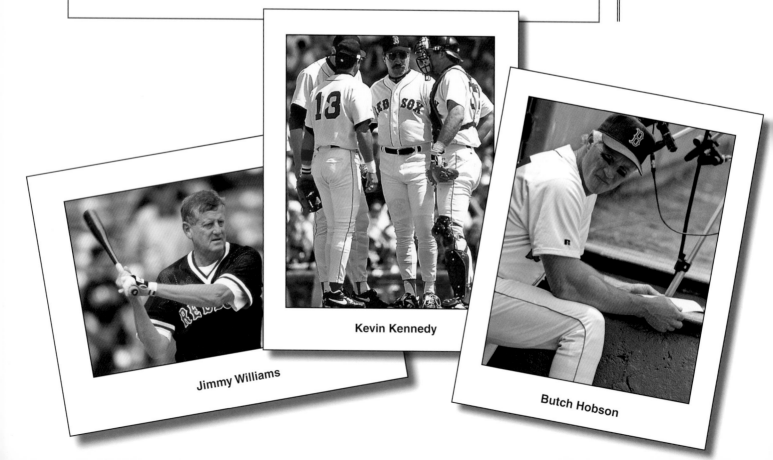

Kevin Kennedy

Jimmy Williams

Butch Hobson

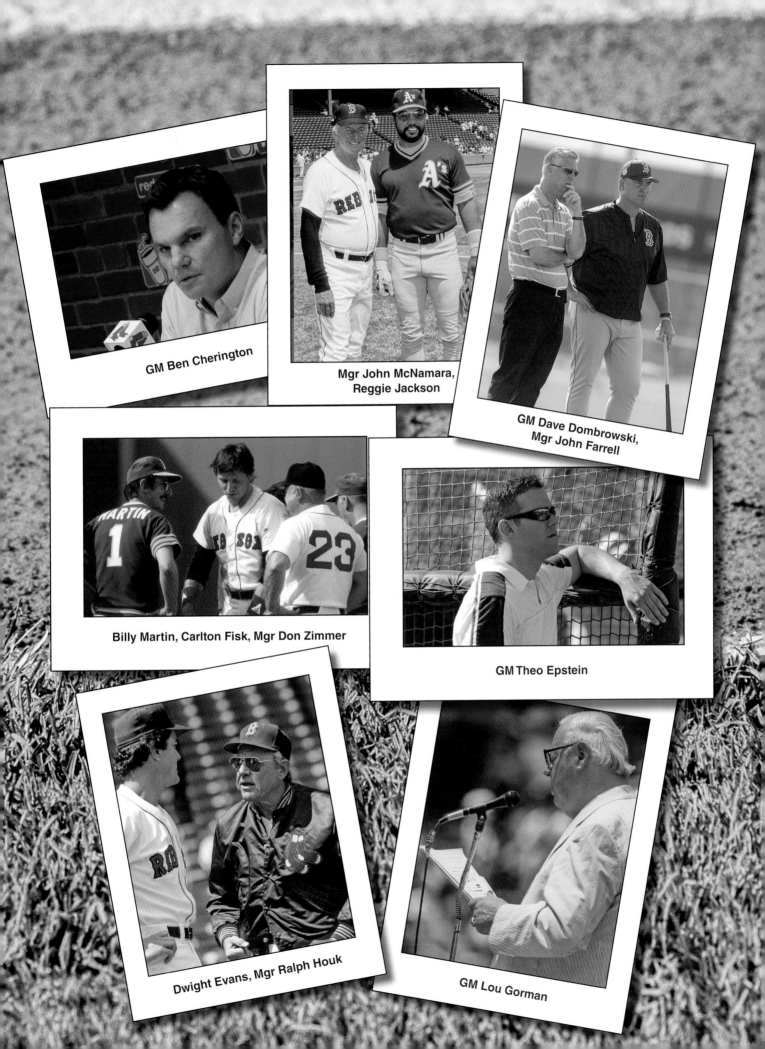

GM Ben Cherington

Mgr John McNamara, Reggie Jackson

GM Dave Dombrowski, Mgr John Farrell

Billy Martin, Carlton Fisk, Mgr Don Zimmer

GM Theo Epstein

Dwight Evans, Mgr Ralph Houk

GM Lou Gorman

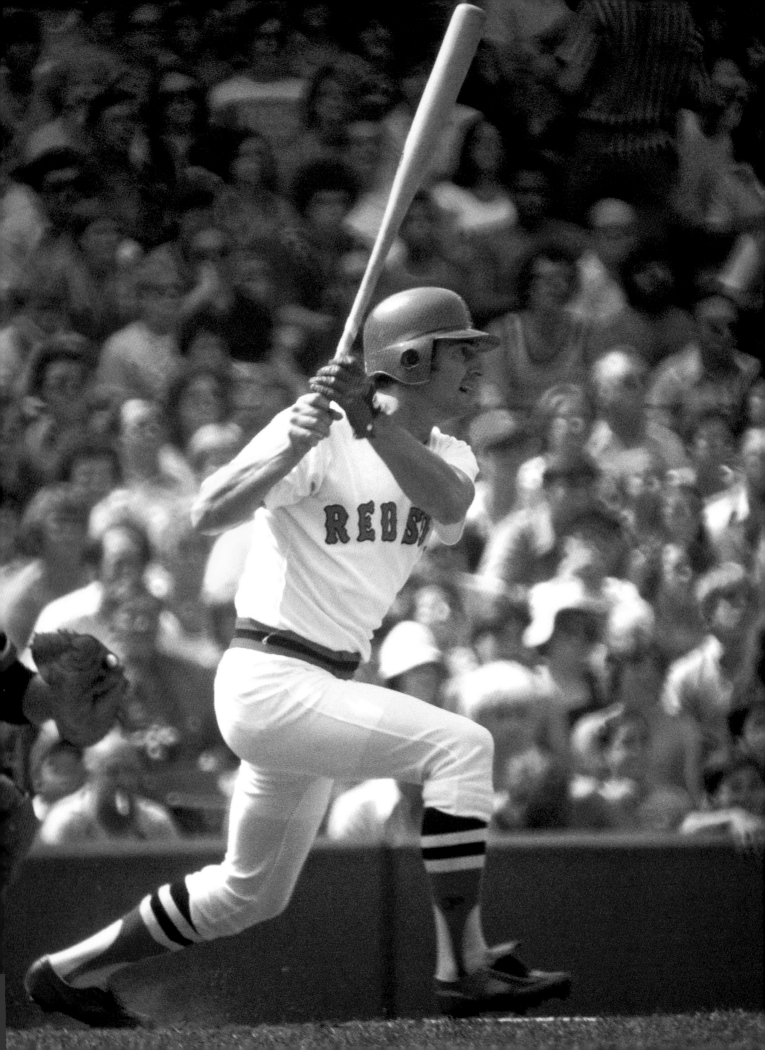

FRANCHISE PLAYERS

Carl Yastrzemski

Yaz.

It's one of those names in sports that doesn't need to be carried past that one name.

Yaz.

You can make the more-than-solid argument Ted Williams is the greatest hitter ever to play for the Red Sox.

You can make the argument David Ortiz was the guy who carried the team to world championships.

But when it comes to Carl Yastrzemski, you're talking about the guy who made the Red Sox relevant in the modern city of Boston.

His career started in 1961, but it was 1967 that saw Yaz win the Triple Crown, playing his best to help his team survive a tight pennant race in the closing days of the season. Remember, there were no play-offs in 1967—a team either won the pennant or went home, which, of course, happened when the Red Sox lost to the Yankees in the 1978 one-game playoff.

Yaz was there when it mattered. He hit .326 with 44 homers, 121 RBIs, and 1.040 OPS. But it was that final weekend, where the Red Sox had to win or go home, that the MVP came through, setting up that dramatic seven-game World Series loss to the St. Louis Cardinals.

The Impossible Dream.

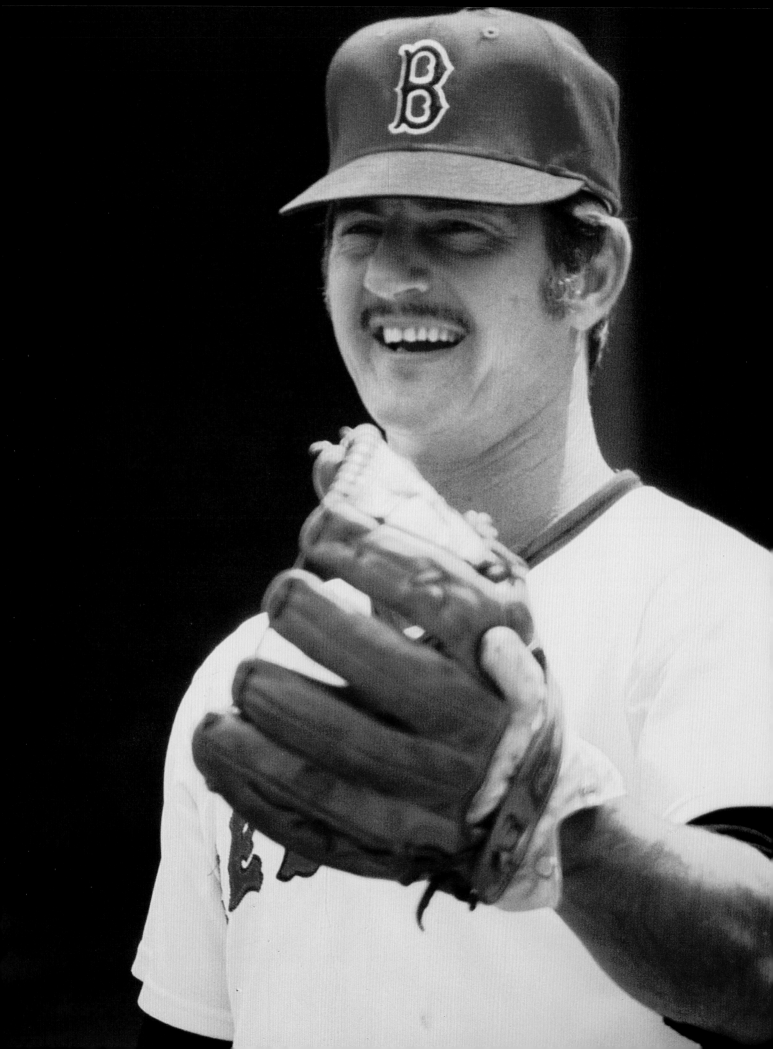

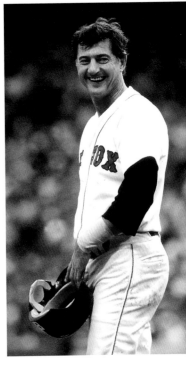

Yastrzemski finished the season on a 10-game hitting streak (20-for-37, .541) and went 7-for-8 in the final two games against the Minnesota Twins. He also had a 56-game on-base streak during that special season—the year the fans showed up at Fenway, the year the Red Sox, for so long lowly finishers as the Yankees ran up pennants and World Series, mattered in Boston.

"Over the final 10 games of the season, Carl Yastrzemski played like a dervish," Rico Petrocelli said in his *Tales from the 1967 Boston Red Sox Dugout*, which he wrote with Chaz Scoggins. "Even if he hadn't done a thing all season to help us win, Yaz would have deserved the Most Valuable Player Award based on those last 10 games alone."

Speaking at the reunion of the 1967 Impossible Dream, Yaz said, "You know everything fell into place for me personally the last few weeks of the season, because every time I came up, there were men on base. Pitchers couldn't pitch around me, so I had the chance to focus in and hit. If you didn't have men on base, then pitchers could pitch around me.

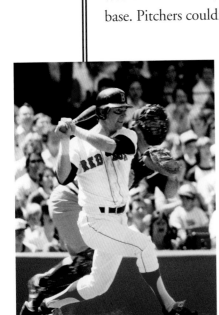

"Everyone down the stretch on that team contributed. It was like somebody different every day. And that's what it takes to win a pennant. And we were very fortunate that we had 25 guys and all of them contributed."

Said '67 teammate Ken Harrelson: "Ted Williams was a good friend of mine, a great hitter. He and [Stan] Musial were arguably the two best hitters that ever lived. Neither one of those ever had a year like Yastrzemski had in '67. Never had a year like that. Yaz had the most impactful year on a franchise in the history of the game."

Yaz was also a central figure in the 1975 charge to the World Series and hit a home run off Ron Guidry in the '78 playoff game. He played all the way through the 1983 season before heading for Cooperstown.

"I think my toughness put me in the Hall of Fame," Yastrzemski told Peter Gammons in April 2017.

"When I came to the plate, even though I knew I was going to get thrown at, it never bothered me. I never was hit in the head, which was fortunate. I used to think, *This pitcher is not going to bother me.* I tried to raise myself to another level."

Said Gammons: "In the 46 years I have regularly covered Major League Baseball, I can unequivocally say he was the toughest man I have ever known. And I say that with the greatest of respect."

Yaz's competitive nature was never more evident than in a 1978 game at Toronto, when Blue Jays lefty Balor Moore threw a pitch behind him. Determined to make the pitcher pay, Yastrzemski drilled a slider off the centerfield fence for one of his all-too-frequent clutch hits, and the Red Sox won the game.

Furthermore, Red Sox fans will forever recall what Carl Yastrzemski did for baseball in Boston, following the great Ted Williams to lead the franchise into being something truly special.

In his later years on the field, Yaz also made an impression on the young guys coming through.

"I had deep, deep respect for Yaz," says Rich Gedman, a young catcher as Yastrzemski's career wound down. "I was just a puppy dog and he was really good to a young player and I think he was much different than people thought that he was—at least to me.

"He was great to me. I adored him as a little boy [growing up in Worcester, Massachussetts] and to get a chance to play with him for three years . . . one of my favorite people in the whole wide world. And not that we talked a lot—it's just that I adored him."

So did the game.

A check of the 2017 Red Sox media guide shows Yaz at No. 1 on the club all-time in games (3,308), hits (3,419), at-bats (11,988), doubles (646), RBIs (1,844), runs (1,816), extra-base hits (1,157), and total bases (5,539).

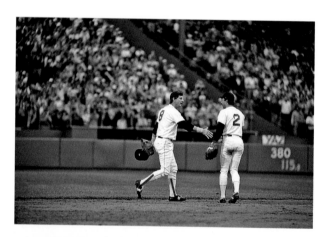

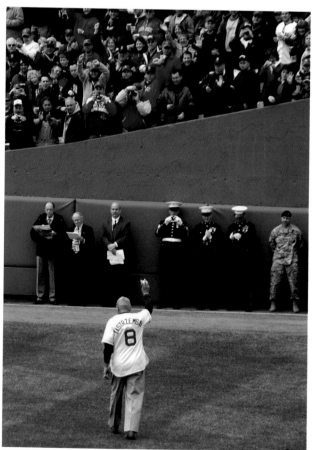

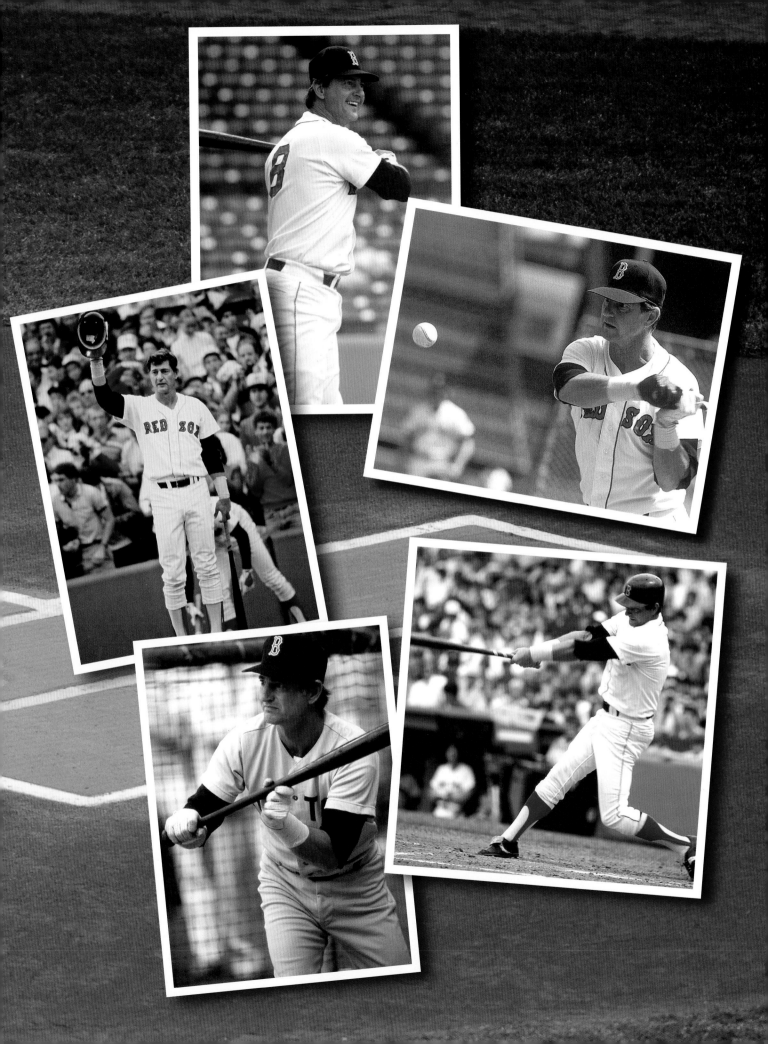

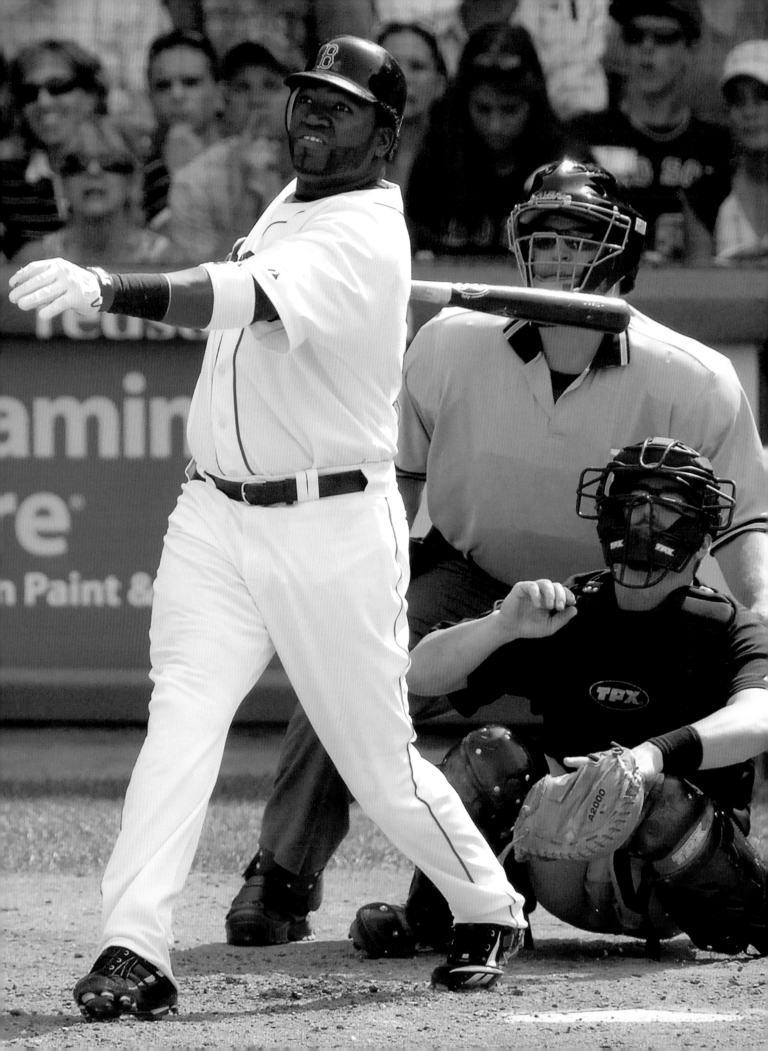

David Ortiz

Fans didn't want to believe it. His teammates didn't want to believe it.

But it was true—David Ortiz retired at the end of the 2016 baseball season.

He was ready to leave the long days of getting his body ready to hit four or more times a game as a still-potent DH. He was ready to leave it behind to spend time with his family.

And officially take his place among the team's all-time greats.

Not that he wasn't there before—but retirement meant a time to reflect, a time for everyone to truly appreciate what this man had done for the Boston Red Sox.

After all, Ortiz, despite not playing in the field, was more important than anyone in the team's history.

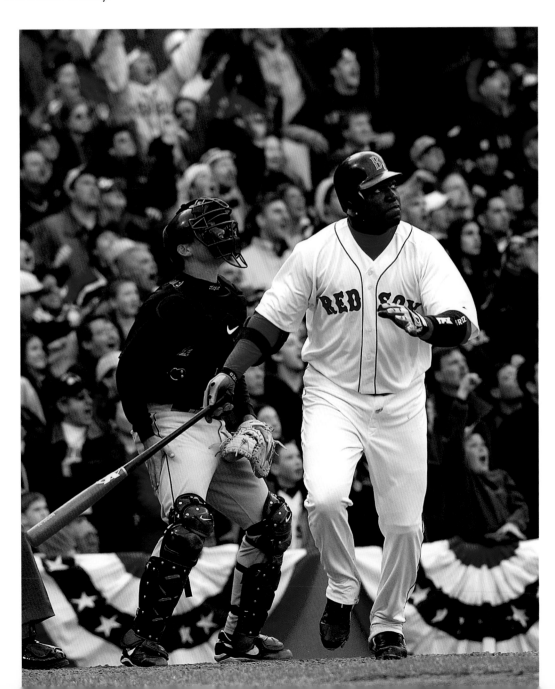

Big Papi would forever be known as the man who told the stunned citizens of Boston "This is our fucking city" after the Boston Marathon attack. He's the friendly face who was more than unfriendly to opposing pitchers as he led the way through *three* World Series titles.

Think about that. It was 86 years between titles, and Ortiz, both on and off the field, was a maestro of three within 10 years.

In 2016, he hit .315, the third-highest batting average of his career. While collecting gifts in every city he visited for the final time, he hit 38 homers and drove in 127 runs—his 10th 100-RBI season. His 1.021 OPS marked the fifth time in his career he had cleared 1.0.

Then he retired.

Would he return for the 2017 World Baseball Classic? There were rumors he was staying ready to join the Dominican team. That passed. So did Pedro Martinez saying—probably tongue-in-cheek—that Papi was coming back.

He was done with baseball.

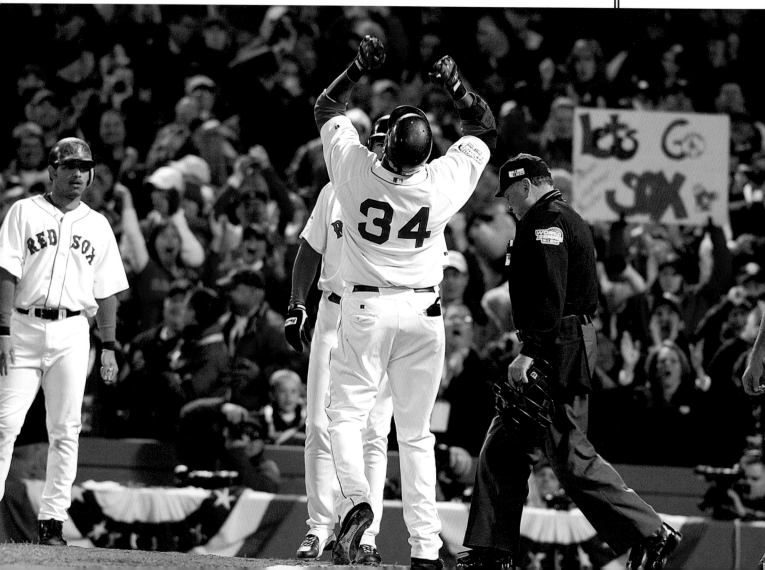

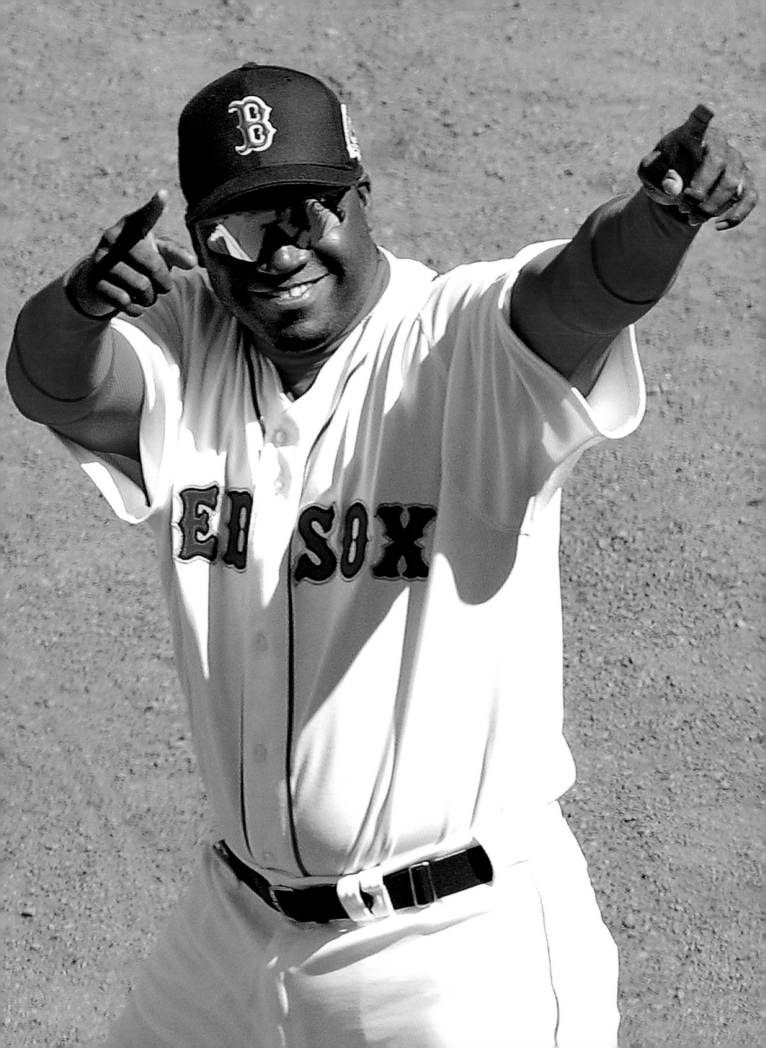

In June, 2017, the Red Sox officially made Ortiz's No. 34 the 11th retired number to go up on the right field façade at Fenway.

"That happening to me today, it's a super honor to be out there hanging with those guys," Ortiz said. "Those guys, those numbers have a lot of good baseball in it," Ortiz said.

Remember, the Ortiz story was kind of an accident. The Twins, who played in the Metrodome back then, didn't realize what kind of damage this big guy could do. Then, thanks to the urging of Martinez, the Red Sox signed him, and suddenly Ortiz was second on the DH depth chart—behind Jeremy Giambi—when the 2003 season started.

Ultimately, Ortiz, of course, teamed with Manny Ramirez to form what may well have been the most potent 1–2 power punch of their generation. But even after Manny was gone, Ortiz forged on and made opposing pitchers pay—dearly.

"He is incredibly important to the Red Sox, the city, and Major League Baseball, for that matter," said John Farrell, his final manager. "I am fortunate to have worn the same uniform as him."

"You are not our teammate, you are our family, and it will be like that until the day we die," Pedroia said at the retirement ceremony, introducing Big Papi.

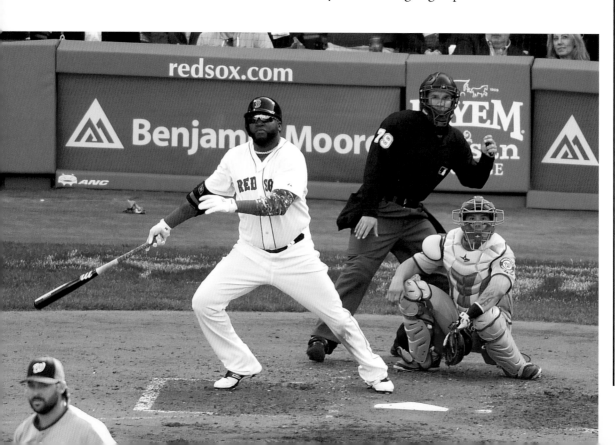

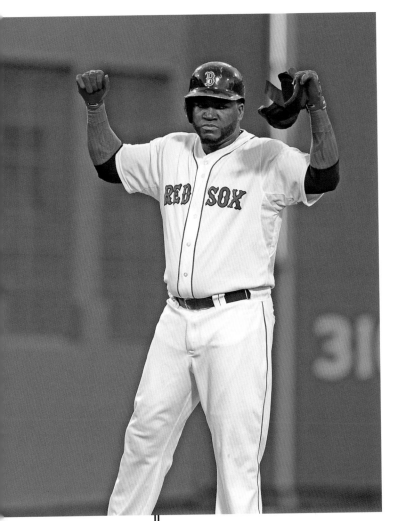
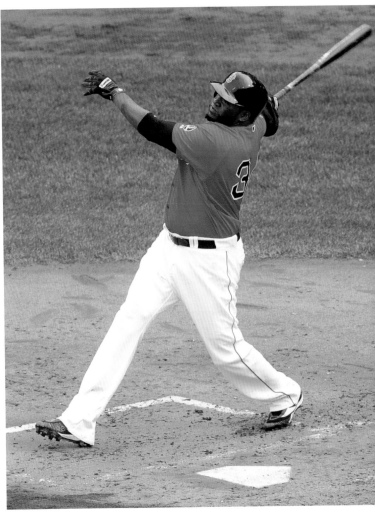

"It was very touching, very emotional," a tearful Ortiz said. "I was trying to hold my ground until I saw Pedroia. Me and [Pedroia] go way back. [Pedroia] is like my baby brother. I know what he said comes from the bottom of his heart. I couldn't hold it anymore."

Dave Dombrowski, the Red Sox boss, may have summed it all up in one long thought.

"He's an icon," he said. "You don't say that very often about individuals in a community. But to me, he's an icon in the city of Boston. He deserved that. That's how he's treated by the community. He's well respected, and it's a special night for everybody."

If you check the 2017 records section of the Red Sox media guide, you'd find that No. 34 was second all-time in home runs (483); third in RBIs (1,530), doubles (524), and extra-base hits (1,023); fourth in slugging percentage (.570) and walks (1,133); fifth in games (1,953), at-bats (7,163), runs (1,204), and total bases (4,084); sixth in hits (2,079); and 14th in on-base percentage (.386).

For his career, counting his days with the Twins, Ortiz finished at .286, with 541 homers (17th on baseball's all-time list), 1,768 RBIs (22nd), a .931 OPS, 1,419 runs, and a .380 on-base percentage.

And when it ended, fittingly, there was an Ortiz roast at the House of Blues behind Fenway.

Rob Gronkowski: "Did you know a DH spends an average of 4.3 minutes a game actually doing something athletic? My mom's Fitbit has more steps from a brisk mall walk than David notched in a fucking doubleheader. Oh, Papi, you're an inspiration to overweight beer league soft-ball players everywhere."

Comedian Bill Burr: "Where the fuck do you get off being honored when you only have three championships? Last I checked, Brady had five and he's still playing. Imagine if you just ate a salad every once in a while."

And comedian Lenny Clarke: "You're an author of a best-selling book, and the biggest word in that book was 'baseball.' Now you've actually written one more book than you've read."

All in great fun for a great name in Boston sports—a name and face we will be seeing in television ads for years to come.

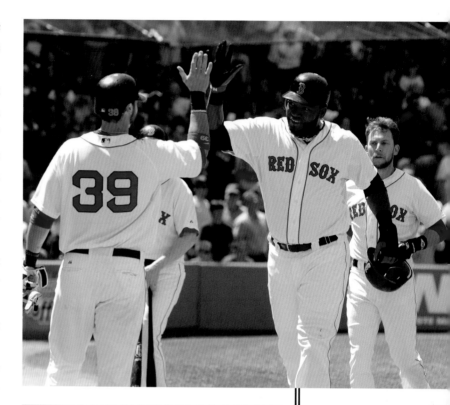

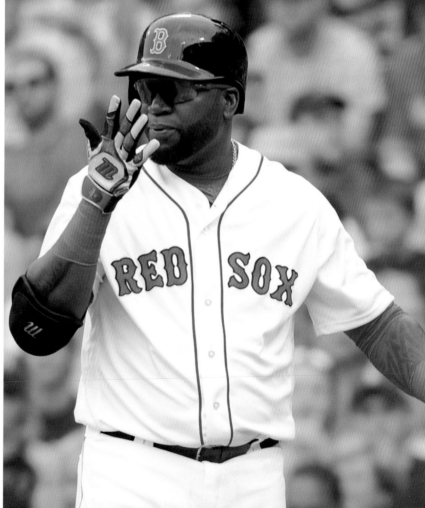

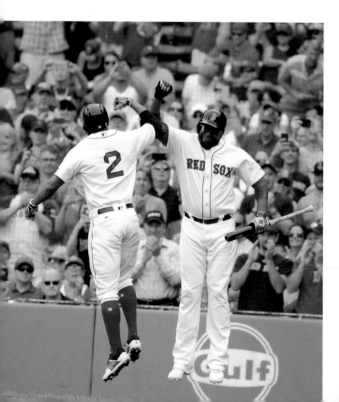

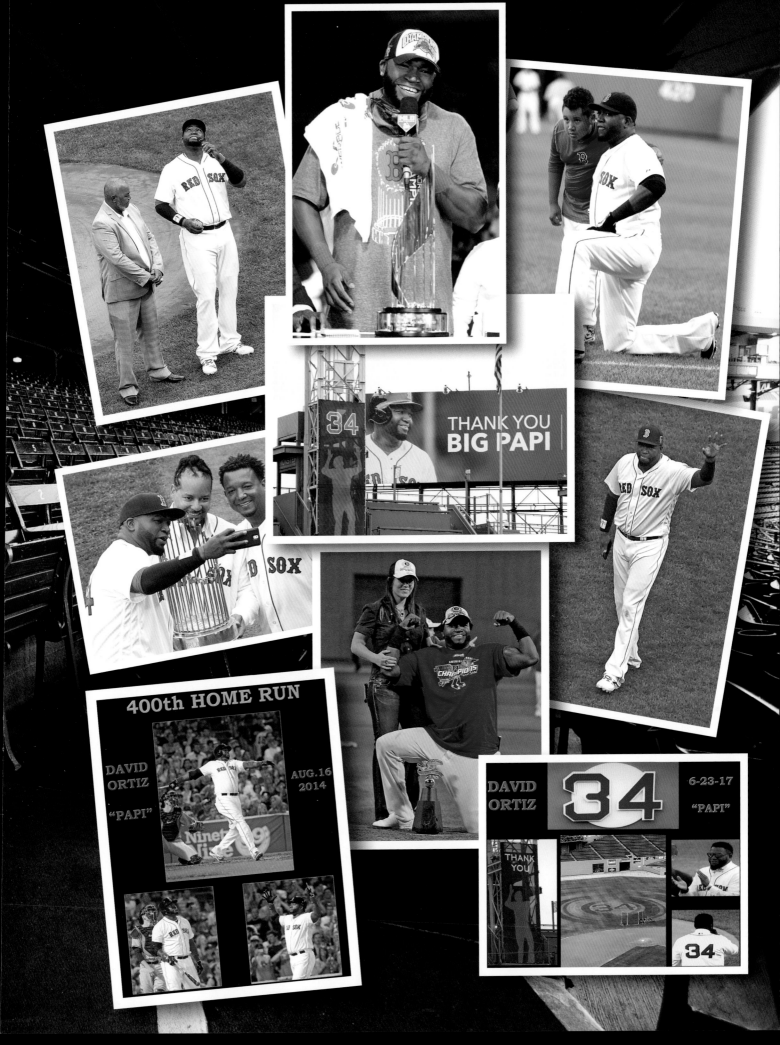

THANK YOU
BIG PAPI

400th HOME RUN

DAVID
ORTIZ

"PAPI"

AUG.16
2014

DAVID
ORTIZ

34

6-23-17

"PAPI"

THANK
YOU

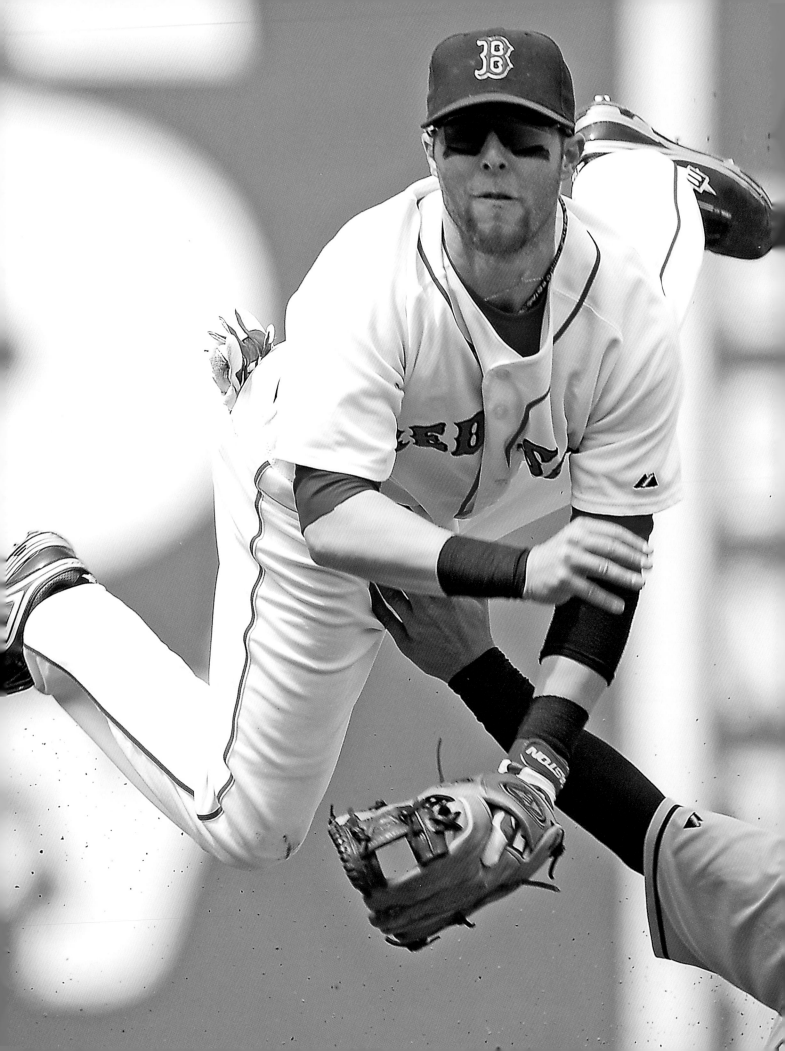

DUSTIN PEDROIA

Hanley Ramirez had just hit a walkoff home run in the 15th to win a game for the Red Sox in the summer of 2017.

Afterward, the subject of Dustin Pedroia—and what the little second baseman had done that night—was brought up to Ramirez.

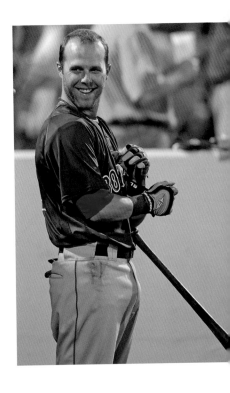

Laughing, he said, "Why we gotta talk about Pedey? Everybody knows Pedey. Pedey can do it all—that's why he is who he is.

"It's unbelievable. But the biggest thing is heart. He's a great, great teammate, a great person, a great guy."

Pedroia is one of the heart and soul guys of the Red Sox since his arrival in 2007, when he won the American League Rookie of the Year Award, followed by the MVP the following season.

That night, he pulled off a heady double play and tied the game with a late two-out double—and he then had a late two-out double the next night. Pedroia stuff.

His career has been hampered by a series of injuries and then quick comebacks. Terry Francona, his former manager, used to talk about what a pain Pedroia was when forced to spend time on the bench.

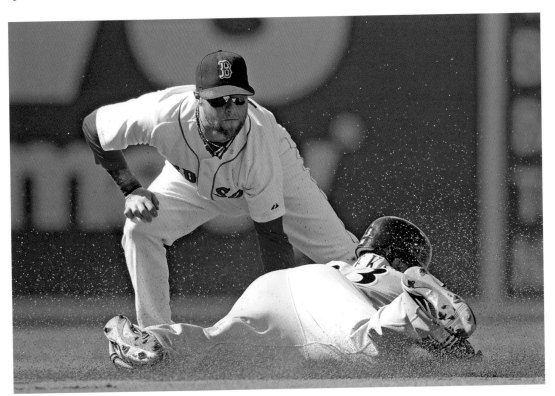

And through it all, if you listen to Pedroia tell it, he was being called by the wrong name by team leader David Ortiz.

Speaking at a roast for Ortiz the night before his number was retired in 2017, Pedroia said, "It was in 2015, so I'd already played with David for, I don't know, nine years. I hit right in front of him—for nine years. I was kind of struggling at the plate, we go on deck and we're playing the Indians at home."

He said there was a ball in the dirt, "and the ball kind of rolled over to me. Catcher comes over to me and goes, 'What's up, Dustin?' I go, 'Hey, what's up man?'

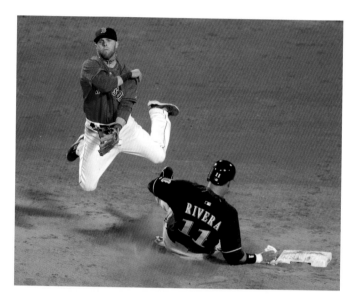

"David walks over and goes, 'What the fuck'd he call you? I go, 'What?' He goes, 'What'd he call you?' I said, 'Dustin.' He goes, 'Why'd he call you that?' I go, 'That's my fuckin' name.' He goes, 'Oh, is that right?' I'm like, 'Yeah, bro. I've played 1,600 games with you. They've actually said it 5,000 fuckin' times. 'Now batting, number 15, DUSTIN Pedroia.'

"And he goes, 'I thought it was Peewee.' So now the umpire's—this is dead serious—so now the umpire comes back, and I go, I'm standing there, I haven't got a hit in a week, and I'm looking at him, I'm like, 'You thought my parents would name me fuckin' Peewee?' And he's just looking at me. And we're having a conversation, the umpire's yelling at me, the catcher's laughing because he can hear kind of what he's [saying] . . . which is I don't know. That's my favorite [Ortiz story]."

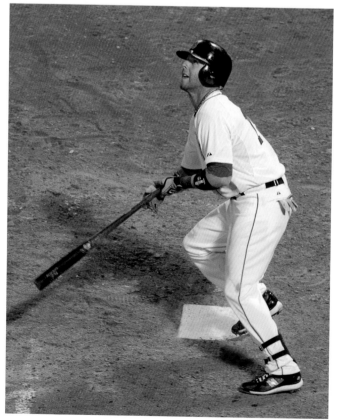

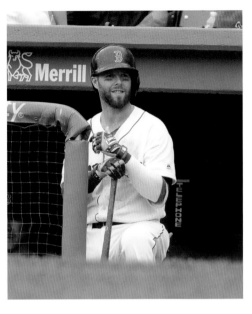

Pedroia, who always plays the game like he's playing his last, has suffered from hand, knee, and other injuries. The disabled list was not foreign to him, but neither was playing the game hard.

Call him a throwback. Call him a dirt dog. Call him whatever you want—it always comes out hustle.

During a radio interview with WEEI back when they were together, Francona, asked about his second baseman being underrated, said, "I'm supposed to be biased with all our guys, and I am. But, no, I think I might disagree. I think if you asked the players around the league—especially the players—I think you're gonna find how much respect they have for him, the way he plays the game and how good he actually is.

"I know, a couple of years ago when he played on that [World Baseball Classic] team, I was telling Jeter before he met him—I said, 'you're gonna love this guy.' I said, 'you guys are gonna be inseparable.' And when it was over, he was like, 'You're right, I couldn't get enough of him.' And that's how guys feel when they're around him."

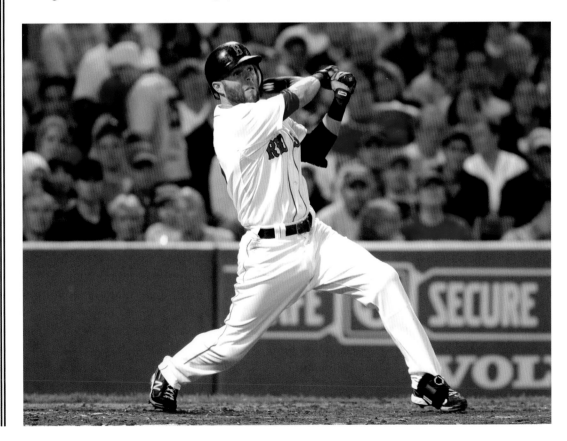

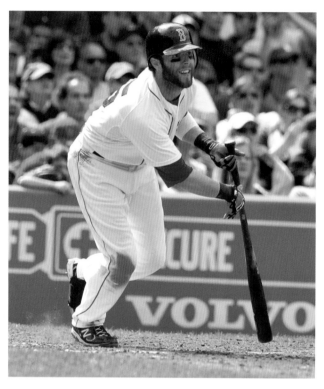

By the end of the 2017 season, Pedroia was sixth all-time in doubles (394); eighth in hits (1,802), extra base hits (549), and total bases (2,646); ninth in at-bats (6,000); 10th in runs (920); 11th in games (1,503); 13th in walks (621); 15th in RBIs (724); 18th in home runs (140); and tied for 21st in batting average (.300).

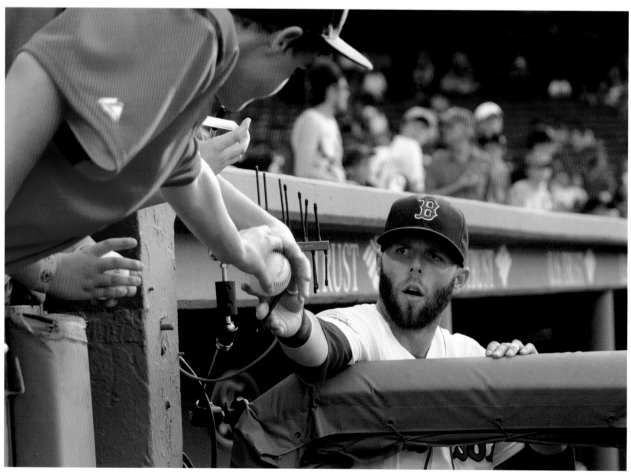

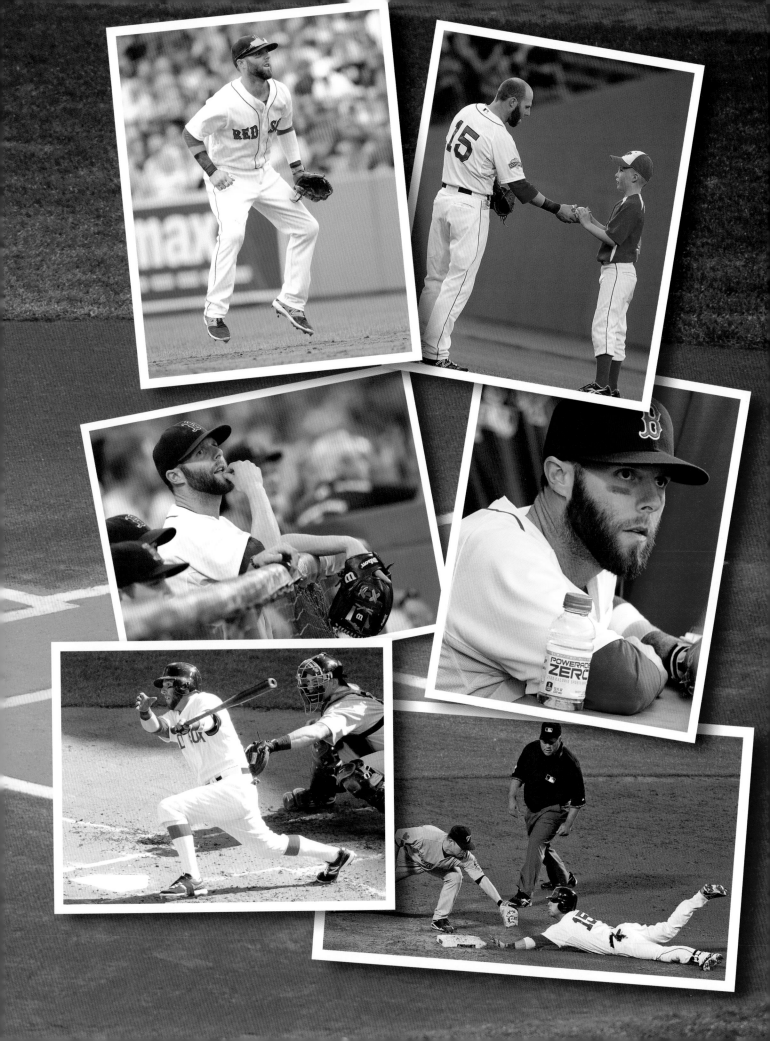

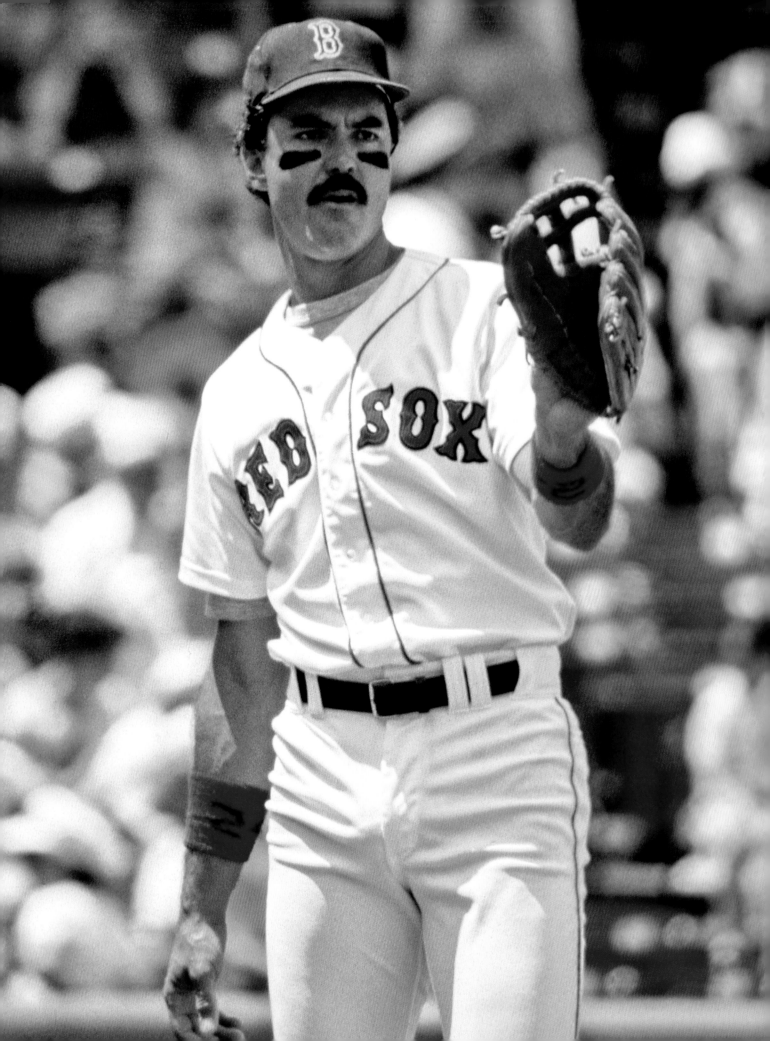

DWIGHT EVANS

Ever wonder how Dwight Evans got the name Dewey?

Well, it came from Don Lock.

But we really don't know why.

"He was my manager in Winston-Salem—he played in the major leagues with Philly and a few other teams—but he was pretty special for me, in many ways," Evans said during a 2017 chat at Fenway. "He taught me a lot about the outfield. He was really my mentor in the outfield.

"We had a guy named Don Neuhauser and another guy, Louie—I can't remember Louie's last name, but he called Don Neuhauser 'Newy' and he called Louie 'Louie' and he named me 'Dewey.'"

But here's where it gets interesting—we can't find anyone who knows who Louie was—or even if there WAS a Louie.

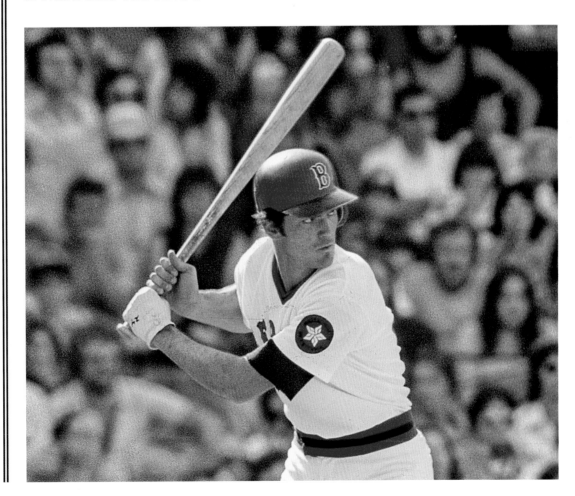

We checked the 1971 Winston-Salem roster. No first name Louis, no last name Lewis. Could it have been a coach? A trainer? An equipment guy? A batboy?

Even Lock himself can't seem to remember a Louie, or how he gave Dewey the name Dewey.

"It was probably just one of those things," Lock said. "I don't remember how it happened, but I do remember it having something to do with [the] Donald Duck cartoon.

"I don't remember how Evans became Dewey, but what's amazed me is the darn thing stuck."

The story is even on Wikipedia.

Rick Burleson was a teammate on that Winston-Salem team—and he had no idea where the name came from, either.

But it gets better.

"When I got to the big leagues, in 1972, Game of the Week, and there was some kind of special report, they didn't even announce the lineups [on TV]," Evans said. "So my father's watching, out on the west coast, and it was Curt Gowdy, Game of the Week, Saturday Game of the Week, he didn't know I was playing. All of sudden, 'fly ball to Dewey Evans in left field,'—I started in left field. And I lost the ball in that autumn sun and it never came out and it dropped 15 feet behind me.

"Of course, the next ball's hit to left-center and Tommy Harper calls for it and *he* lost it in the sun, as well. We lost the game 2–1 to Detroit. I called my father after the game and I said, 'I lost that ball in the sun. I couldn't get it out and it cost us the game,' and he goes, 'I don't care about that, what's

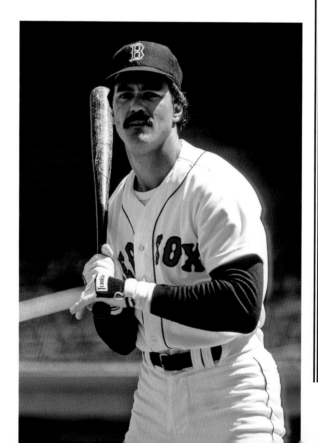

this Dewey stuff?' I said, 'If you heard what they called me in the stands, Dad, Dewey is a pretty good name.'"

Lock said Evans "was always sitting in the back of the bus doing something kinda goofy," and also remembers his young player was "a natural to the outfield," adding, "he turned out to be a little better hitter than I thought he'd be."

Said Evans: "I do remember something about the Donald Duck cartoon. Oh well—we are talking about 1971?"

Evans wore No. 40 when he got to the Red Sox but always wanted 24—he was a Willie Mays fan growing up—and eventually got his wish.

Reminded people in Los Angeles are supposed to hate the Giants, Evans said, "How can you hate Willie Mays? I just thought that he was the greatest athlete, the greatest player to ever play the game, with all the tools that he had."

Evans lived through the disappointment of 1975, '78, and '86, leaving him short of winning a World Series.

The most disappointing? "Eighty-six," he said.

"We had the game," he said of that fateful Game 6. "We're in Shea Stadium in the 10th inning, we're two runs up. I was looking at John McNamara, he was going to let Calvin Schiraldi go out for the third inning and I almost said to him . . . Steamer [Bob Stanley] at that time was our hottest reliever, he was really dealing, and he was a fresh guy to go on out there. I almost said something—I had that rapport with John that I could have said something. It might not have changed his mind, but it would have made me feel better inside."

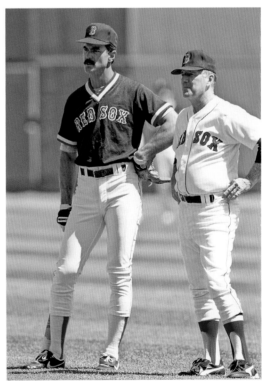

"He got two strikes, we're up two runs, two strikes, two outs, bloop single. And then, next hitter: two strikes, another single. I'm still out there thinking, 'this is great, it's been 80-something years.' Then another single. Then that play . . . then he brings Steamer in. Then Mookie Wilson—this thing happened and it just happened and unfolded.

"Then the ground ball hit to Buck. And everyone says Stapleton . . . but I'm looking at the whole thing in right field materialize. I see this little grounder, and if you knew Shea Stadium at the time, when they drew the lines, there was actually dug out—there was like edges to the white chalk line. It wasn't just flat. Like a little groove.

"I don't know if it hit that but I see Buck see the ball hit, he knows who's running and he sees Steamer going to cover first base. And he kinda goes, 'what I do I do?' Mookie's beating him to the bag so I gotta beat *him* to the bag . . . and the ball, as sure as I'm looking at you right now, was bounding, and it stopped. It just hit, maybe a dirt clod, I don't know what it hit, but it just went flat and under his glove.

"I stay in touch with Buck and he's a great guy. And we wouldn't have been there without him. He had 200-something hits and 102 RBIs, just a great gamer, great guy. Good guy."

When they welcomed Buckner back to Fenway, "They brought me up from Florida to catch him [on the first pitch]," Evans says. "I was nothing that day but he threw that pitch and it was great."

There are many who feel Evans should be in the Hall of Fame. He hit more home runs than any other player in the American League during the '80s. Eight Gold Gloves. Three All-Star teams. He finished with 385 homers and 1,384 RBIs.

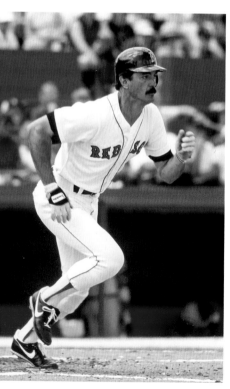
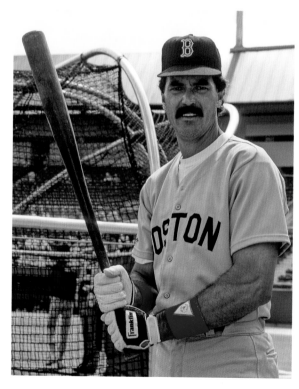
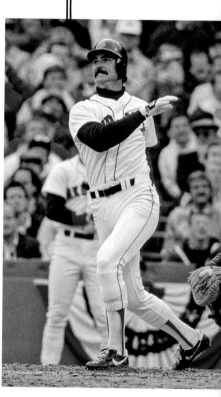

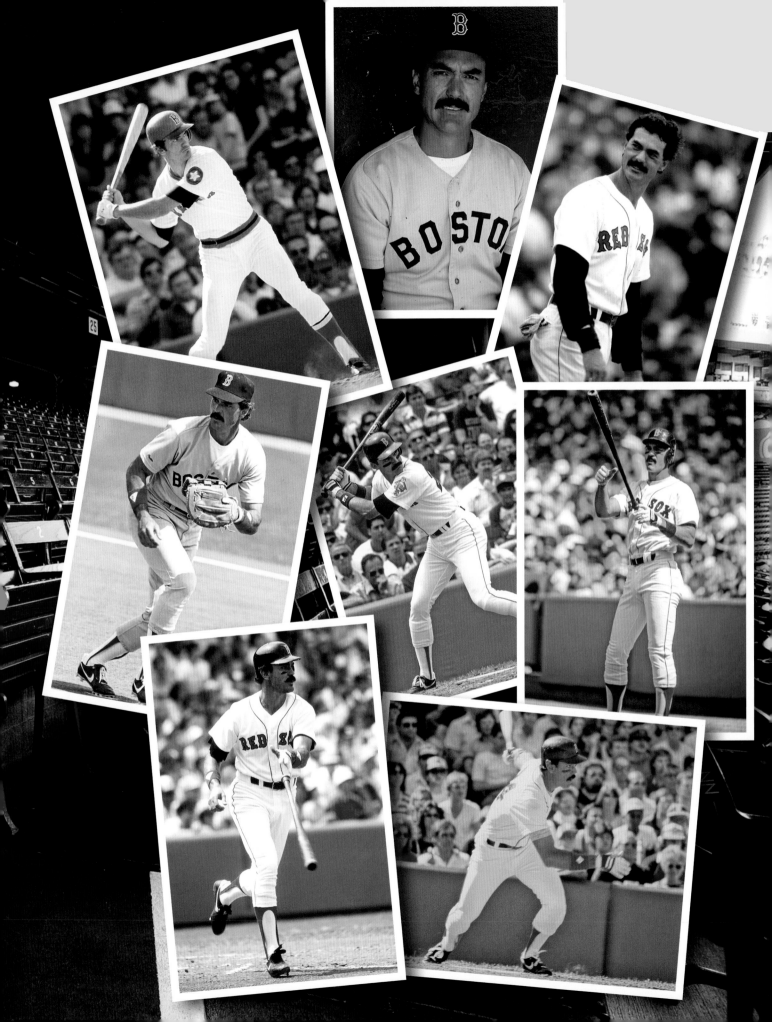

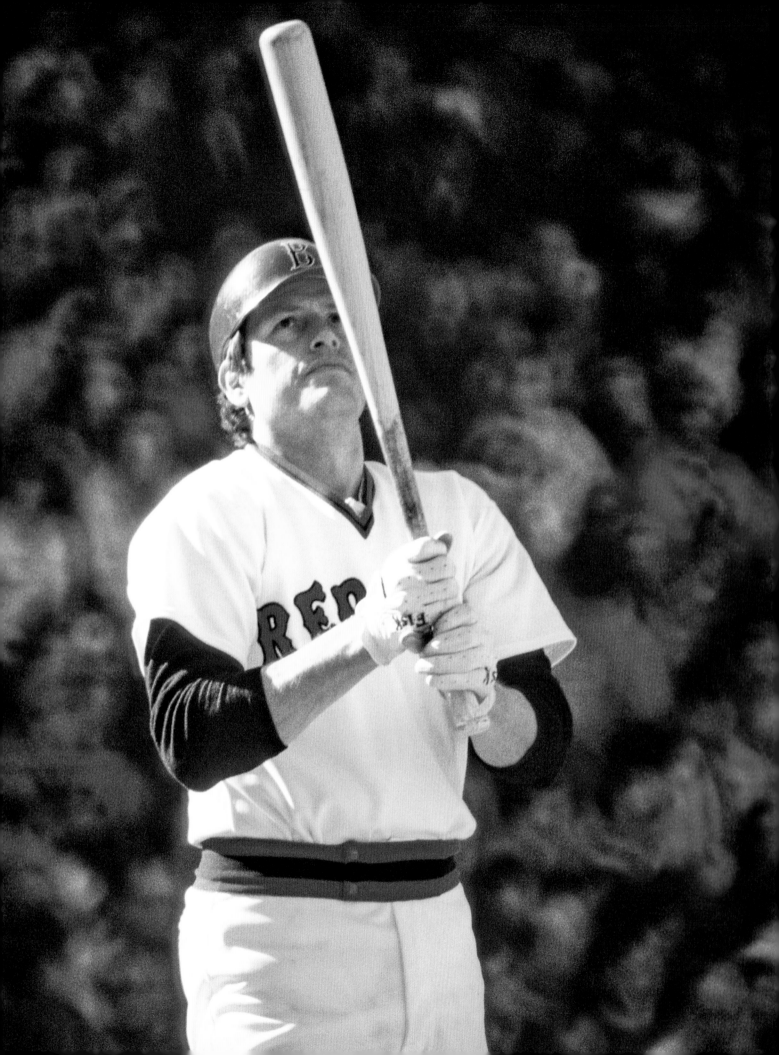

Carlton Fisk

It's almost hard to believe when you consider his importance to the Hometown Team, but Carlton Fisk played more games with the White Sox than with the Red Sox.

The greatest catcher in Red Sox history, allowed to walk out of town when Haywood Sullivan mailed his contract out two days too late, something many have thought was done on purpose, left for Chicago and played the rest of his Hall of Fame career with the wrong Sox.

He played 11 years in Boston, batting .284 with 162 homers and 568 RBIs in 1,078 games. He then played 13 years in Chicago, batting .257 but with 214 homers and 762 RBIs in 1,421 games.

He was No. 27, one of the numbers hanging on the right field façade at Fenway, in Boston. He was No. 72 for the White Sox—a number that will never be worn by another player in that organization.

Naturally, with a script only Hollywood could write, the White Sox started the 1981 season with a game in Boston. With his new team trailing his old team 2–0 in the eighth inning, Fisk hit a three-run homer. He was 4-for-8 in the two-game series and then, the following week, hit two homers and drove in four runs in a three-game series in Chicago. The Red Sox did go 3–2 in the three games.

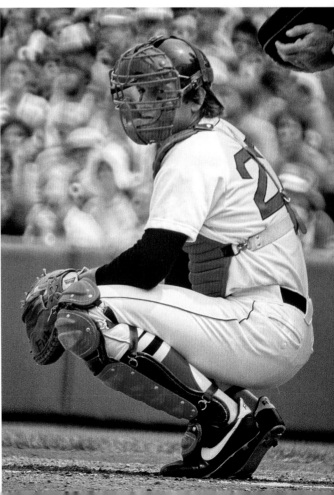

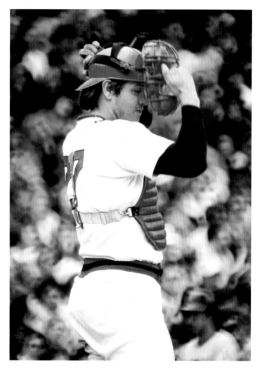

As Fisk approached the media after the opener, he said, "What's the big deal anyway? It was only a three-run homer."

He added, "I had been with the Red Sox organization for 14 years. This was my 10th Opening Day at Fenway Park, but my first with the visiting team. I was nervous, but I didn't feel any pressure. I honestly wasn't concerned about how the fans were going to react to me."

Fisk went on to hit .310 lifetime in his career against the Red Sox—29 points higher than he hit against any other team. He hit 27 homers and drove in 68 runs in 107 career games against Boston.

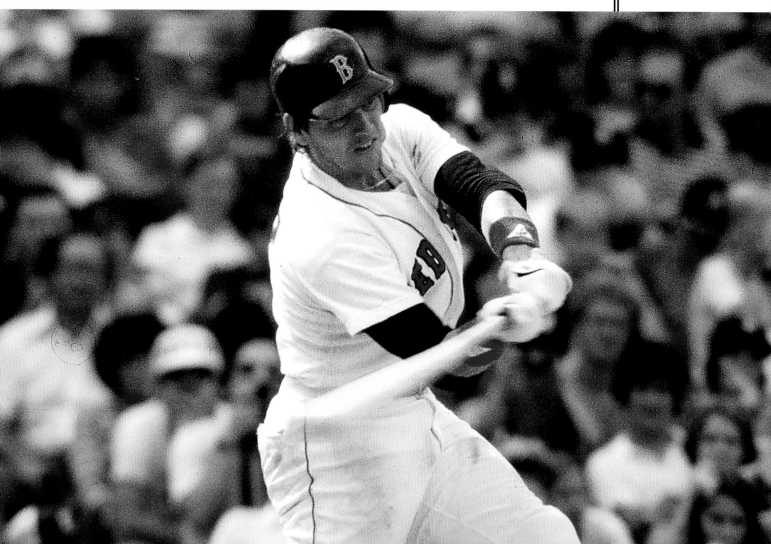

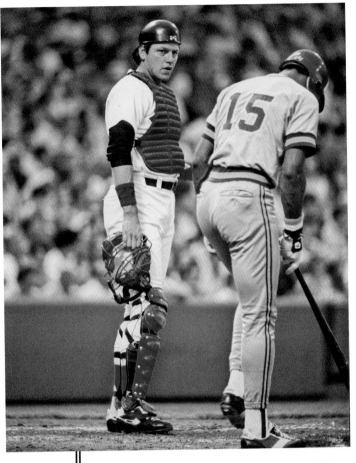

In 2005, the Red Sox honored Fisk by naming the left-field foul pole the Fisk Pole. He was also given a 2004 World Series ring. New ownership in Boston led to the hard feelings being erased.

October 21, 2015, marked the 40th anniversary of Fisk waving his arms to keep his game-winning home run fair in the 12th inning of Game 6 of the World Series against the Reds, when he connected off Pat Darcy.

The Red Sox didn't win that Series, and they certainly didn't win when Fisk was allowed to leave in 1981. The '75 homer, the fights with the Yankees, and the fixture behind the plate at Fenway were all gone.

In 2017, speaking to mlbtraderumors. com, Fisk said, "Let me make one thing

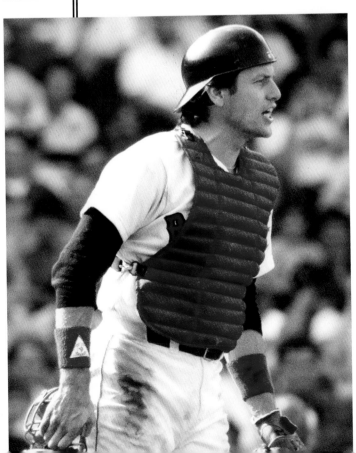

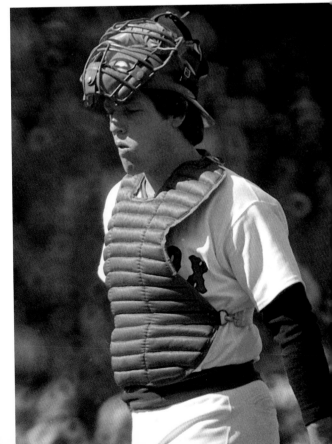

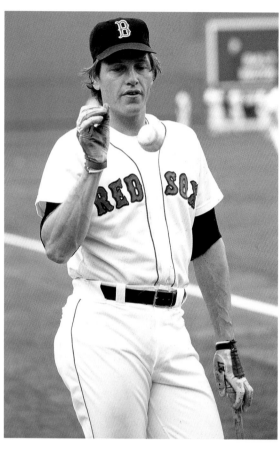

perfectly clear: I never planned to leave Boston."

Nevertheless, as Fisk went on to explain, "I had my family to think of, and my own pride. I wanted to be paid fairly—and the plain fact is that from the moment I was drafted [1967], I'd been underpaid by the Red Sox. That's how it was in those days.

"Also, Boston was in a sort of transition. Honestly, it didn't seem clear to me that the front office was dedicated to our core group of guys, or to winning."

It was indeed a dark time in Red Sox history—and now it was a generation ago. Kids growing up these days know championships. Until 2004, the fans knew frustration, on and off the field.

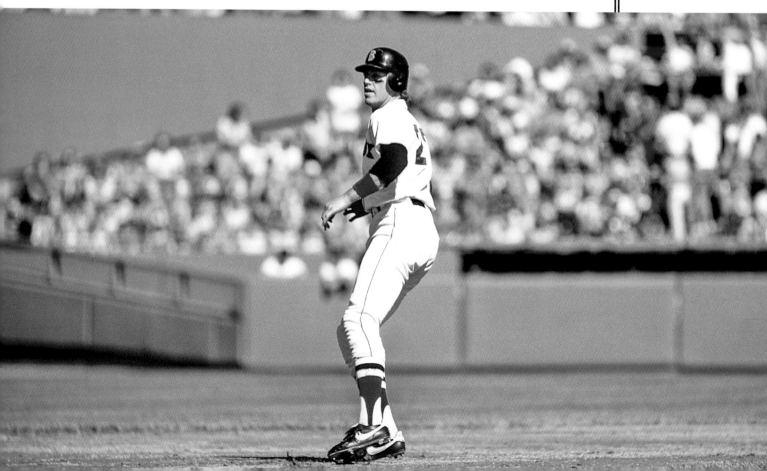

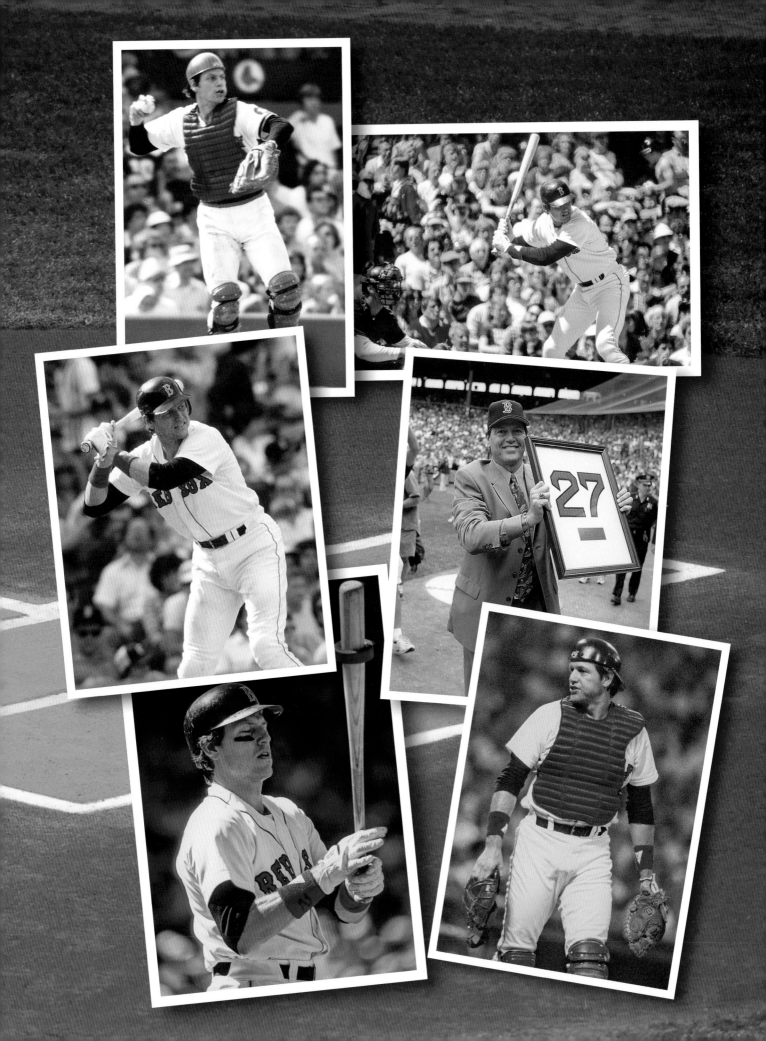

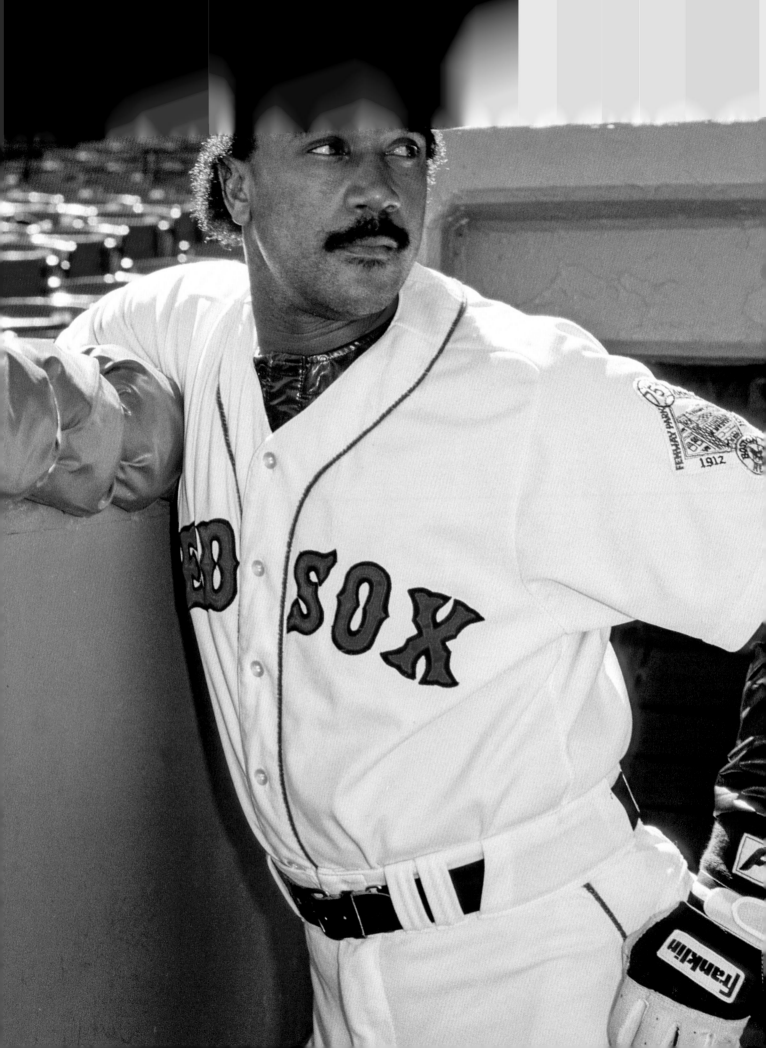

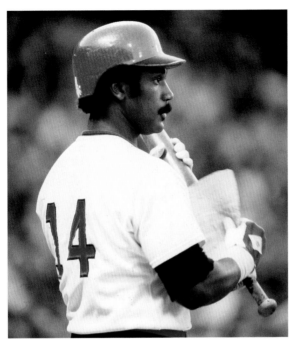
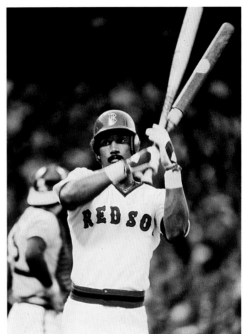

JIM RICE

Jim Rice and Fred Lynn were living a rookie dream together in 1975. The Red Sox were winning, and here were these two kids leading the way and also battling it out for both the Most Valuable Player and Rookie of the Year honors.

Then, on September 21, Rice, hitting .309 with 22 homers and 102 RBIs, was hit on the left hand by a pitch from Vern Ruhle of the Tigers. The Red Sox went on to beat the three-time champion Oakland A's in the playoffs and then lost to the powerful Cincinnati Reds in a World Series generally considered the greatest of the modern era.

The Sox accomplished this without Rice, as Lynn won both awards and Rice watched. Rice finished second in the Rookie of the Year voting, third in the MVP race.

"There was no frustration. I couldn't play, I couldn't play," Rice said standing outside the Red Sox clubhouse in 2017. "You can't cry over spilled milk. Vern Ruhle wasn't throwing at me on the ball that hit me. I couldn't get out of the way. Unfortunately, Freddy and I were battling for the MVP and the Rookie of the Year that year, and Freddy won it. There was nothing you could do."

Rice said the season "was very special, but it ended when I broke my hand. We not only won the division, but when we went out to Oakland, everyone thought Oakland was going to sweep us, but we ended up sweeping Oakland. That was the biggest thing there—when you had the powerhouse that Oakland had at the time. But they didn't do it—we did it."

Rice was with the Red Sox as a rookie in 1975, and he never left. He went into the Hall of Fame in 2009 and worked for the club as a studio analyst. But he remembers back to the beginning, when a young kid from South Carolina took over the hallowed ground of left field at Fenway Park—ground that had been patrolled by Ted Williams and Carl Yastrzemski for so long.

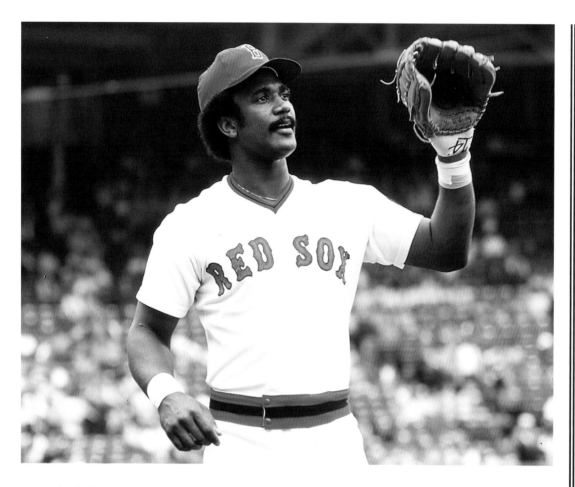

Asked if he understood what taking over that spot meant, he said, "You gotta go back to when I was drafted. No. But when I went to my first big league camp—I went to big league camp in my third year—that's when you start to realize it. When I was signing out of high school and all that? No."

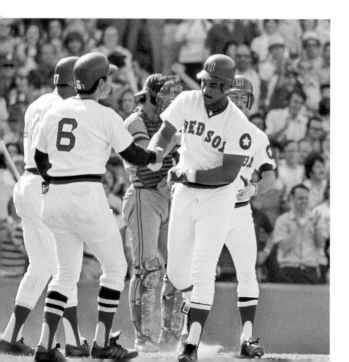

Rice knew rookies have to come into a clubhouse and bide their time.

"As far as being around the elders you sit there and you listen—and I had Johnny Pesky as my hitting instructor," Rice said. "Johnny Pesky, he was with Ted, he's older than Yaz so I picked up a lot of things from Johnny—so the best thing for you to do as a young guy, you keep your mouth shut and your ears open. And that's the way I learned to play the game."

With the disappointment of being hurt behind him, Rice went on and, in 1978, beat Ron Guidry for the MVP

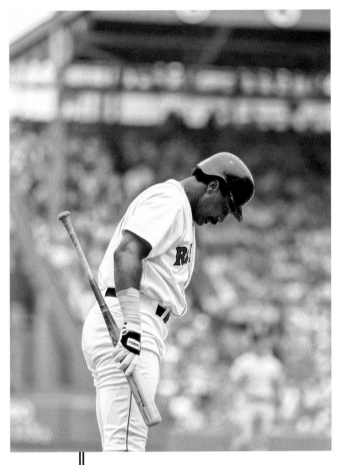

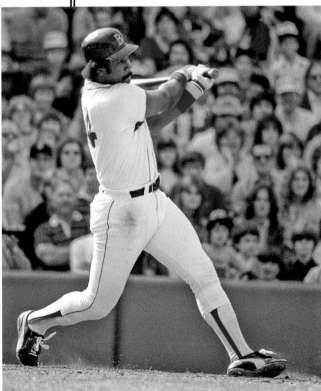

Award. Powerful numbers? How about .315, with 46 homers, 139 RBIs, a .600 slugging percentage, .970 OPS, and 86 extra base hits.

That, after he was fourth in the MVP voting—and before he would finish fifth in '79, fourth in '83, and third in '86.

Luis Tiant calls losing that '78 playoff game the worst thing that happened to him in baseball—that he could accept losing that seven-game drama to the Reds easier than the one-game playoff to the Yankees. Rice sees that differently.

"In Luis's situation it was somewhat different, but in my situation it was '75, because I didn't play," Rice said. "We were going for something—Rookie of the Year, MVP—in your first year in the big leagues, to be in a World Series. And if you felt like you had the ability and you watched the team you felt eventually that you were going to be in another World Series. But the first one is always the hardest one."

Flash forward to 1986, when Rice batted just .161 but did hit two homers and drove in six runs in the classic playoff series against the Angels and then went 9-for-27, with six walks and a .455 on-base percentage against the Mets—but with no RBIs.

And you know how that Series ended.

Asked what he thinks about looking back at '86, Rice said, "I'd rather look back at what I did yesterday, but looking back 30 years you think about the situation with Bill Buckner. Everyone threw rocks at Bill Buckner—don't think he intentionally tried to miss that ball, and [yet] that's what you remember.

"I remember I think I caught the first out [in the bottom of the 10th], Hendu caught the second out, and next thing you know the ball's going through Buckner's legs.

"That's gonna happen. There's nothing you can do. You're fortunate enough and lucky enough to have a good team, you're hoping that you will be there another year. But when you're talking about all the teams, even though you're talking about '86 and '75, you got two teams playing for the World Series and the other teams are at home watching you. That's the sweetness of it."

The personal sweetness for Rice came in '09, when he made it to Cooperstown on his 10th and final try. Rice didn't always get along with the media and that may have hurt him. Others thought his 382 homers and .298 batting average weren't enough, that the abrupt end to his numbers left him short.

But he finally made it.

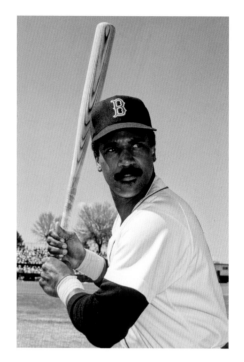

"Everything else is preparing for the party, but once you do your speech and you get your ring, that's the finale," he said. "You get there, you're up on the podium with guys that you admired, some guys you played against, some guys that you were able to see because they were National League guys, that just capped off everything."

Does it take time to be accepted into that fraternity, like it did to get accepted as a young player?

"When you get to the Hall of Fame it's a little bit different because that is a very, very special fraternity there," Rice said. "When you play baseball and you get in the H-O-F fraternity, that means you'd done something. You did a lot of damage and that comes with the respect and ability that you can play the game of baseball and you played it the right way."

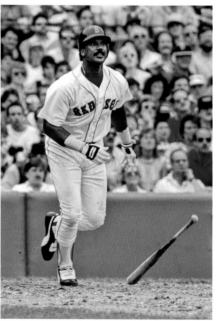

A check of the 2017 Red Sox media guide shows Rice third in club history in hits (2,452), at-bats (8,225), and total bases (4,129); fourth in games (2,089), homers (382), RBIs (1,451) and runs (1,249); fifth in extra-base hits (834); eighth in doubles (373) and slugging percentage (.502); ninth in walks (670); and 19th in batting average (.298).

He finished with an .854 OPS. Ted Williams had a 1.116 and Carl Yastrzemski an .841.

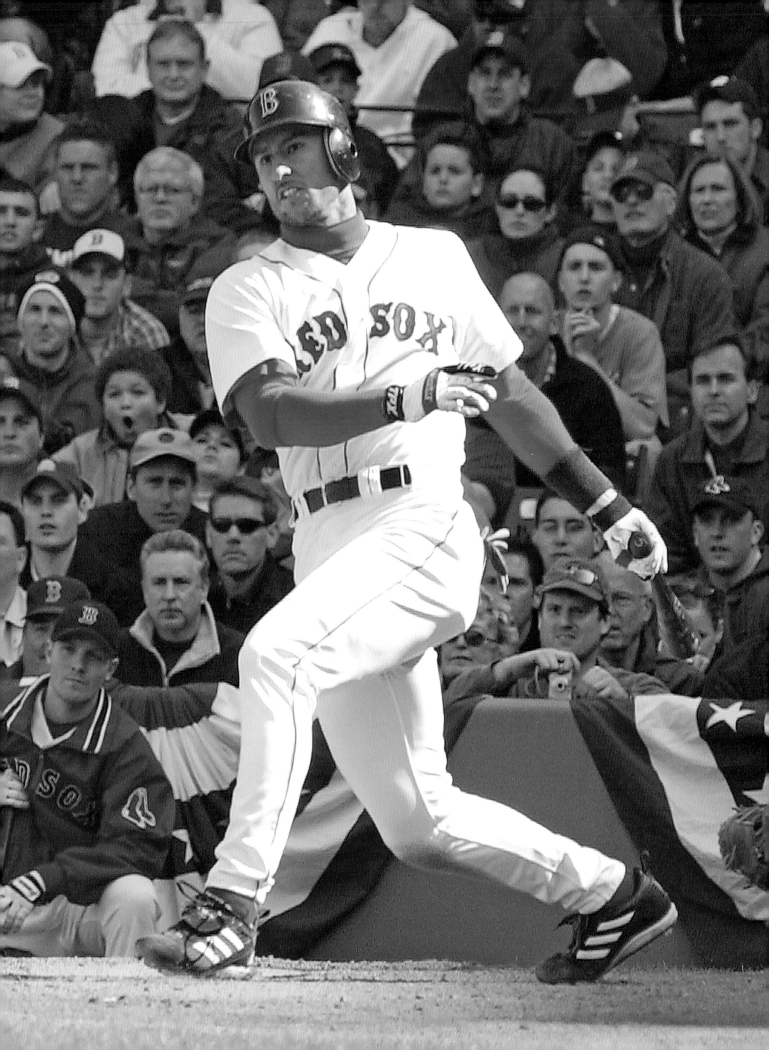

Nomar Garciaparra

With all the great things Nomar Garciaparra did for the Red Sox on the field, he may well forever be known for something that happened *away* from it: he got traded.

On July 31, 2004, one of the biggest trades in Red Sox history took place, which involved the Cubs, Twins, Expos, and several players.

To many Boston fans, it sounded like a Theo Epstein move just to get a disgruntled Garciaparra out of town. Regardless of what it looked and sounded like, though, it turned out to be step one of the path to end an 86-year drought just months later.

"I can't really picture him playing anywhere else," rival Derek Jeter said. "You think Red Sox, Nomar's the first name you think of."

People look at today's group of talented offensive shortstops, and they hark back to Garciaparra, Jeter, Alex Rodriguez, and Miguel Tejada.

Putting it simply, Nomar—or "Nomah" if you were a *Saturday Night Live* fan—was a real star coming right out of the Red Sox system, a team that had Pedro Martinez, David Ortiz, and Manny Ramirez.

Just like that, Garciaparra was a Chicago Cub. And like so many others before him, life was never the same after he left Boston.

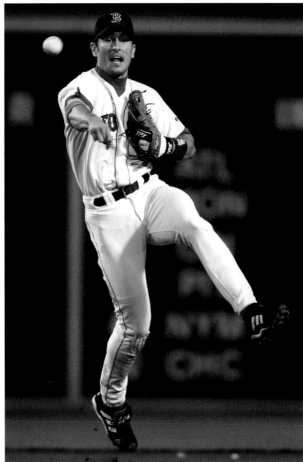

"If it was in my control, I'd still be wearing a Red Sox uniform, because it's the place I know, I love," he said at the time. "All of those fans, I'll always remember. But I'm also going to another great place. I'm going to a phenomenal city with great tradition as well, phenomenal fans, great organization."

In nine years in Boston, Garciaparra, who became part of an all-athletic family by marrying soccer star Mia Hamm, hit .323, with 178 homers, 690 RBIs, and a .923 OPS. For a career that was on its way to the Hall of Fame before injuries derailed the ride, Nomar batted .313, with 229 homers, 936 RBIs, and an .882 OPS. He was the 1997 American League Rookie of the Year.

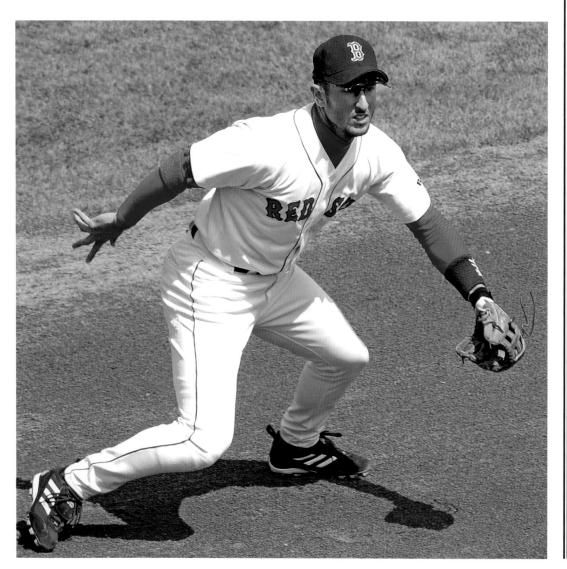

Along the way, he amazed fans with his batting prowess. In a May 10, 1999, game, Garciaparra hit three homers, including two grand slams, and drove in 10 runs at Fenway Park. He was the first Red Sox player since Fred Lynn, in 1975, and the sixth overall, to drive in 10 or more runs in a game.

"I never hit three home runs in a game, not even Little League," said Garciaparra, who had only two homers on the season to that point, one of them in the previous game. "I'm glad I waited until the big leagues to do it.

"When you're swinging well, good things happen. Today, things felt pretty good."

When apprised of all the stat updates that went with his big night, Garciaparra said, "You know me, I don't know any stats."

Ken Griffey Jr., the visiting centerfielder that night, said, "You shake your head and tip your cap, just one of those things," and added, "All those people that were on base in front of him. If he hit three solo shots, you wouldn't be talking to me right now."

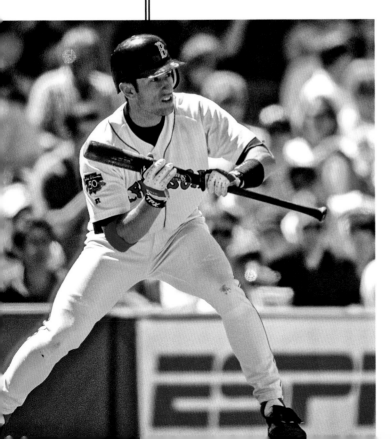

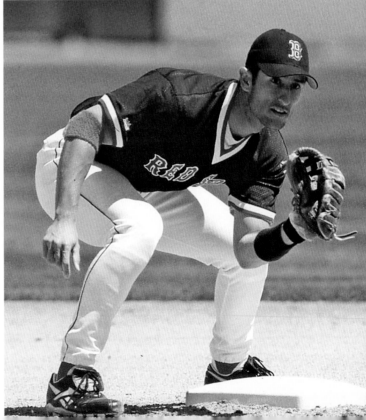

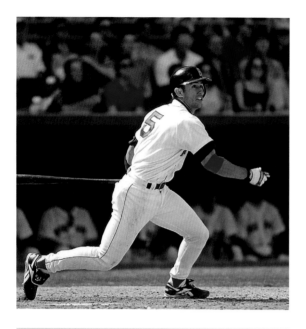

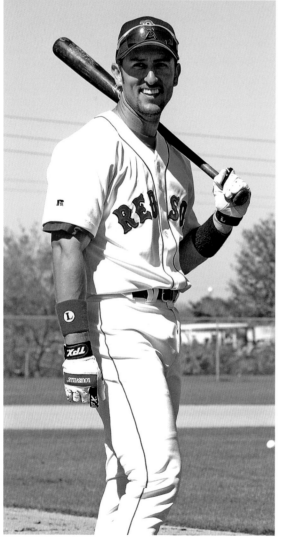

A check of the 2017 Red Sox media guide shows Garciaparra was fourth in batting average (.323), fifth in slugging percentage (.553), 11th in extra base hits (507) and doubles (279), 12th in homers (178), 14th in runs scored (709) and total bases (2,194), 16th in RBIs (690), 17th in hits (1,281), tied for 17th in triples (50), tied for 19th in stolen bases (84), and 20th in at-bats (3,968) and on-base percentage (.370).

All in nine years.

There was a time you watched Garciaparra in those early days of his career, and you saw a guy who would be around for a long time. As it turned out, he wasn't.

"I thought there was a flaw on the club that we couldn't allow to become a fatal flaw, that the defense on this team is not championship caliber," Theo Epstein said after the trade. "In my mind, we were not going to win a World Series with our defense the way it was."

Said Cubs counterpart Ted Hendry: "When you have a player of that stature, that has spent his entire career there winning MVPs, All-Star game after All-Star game, you really are subject totally to what Theo Epstein decides to do, whether he wants to move him or not.

"I don't think Theo was going to make a deal just to move Nomar because you heard he wanted to leave or he was unhappy. I don't think that was the case at all. To be truthful with you, I didn't know for sure if he would ever move him."

Ultimately, he moved him, and the Red Sox won the World Series.

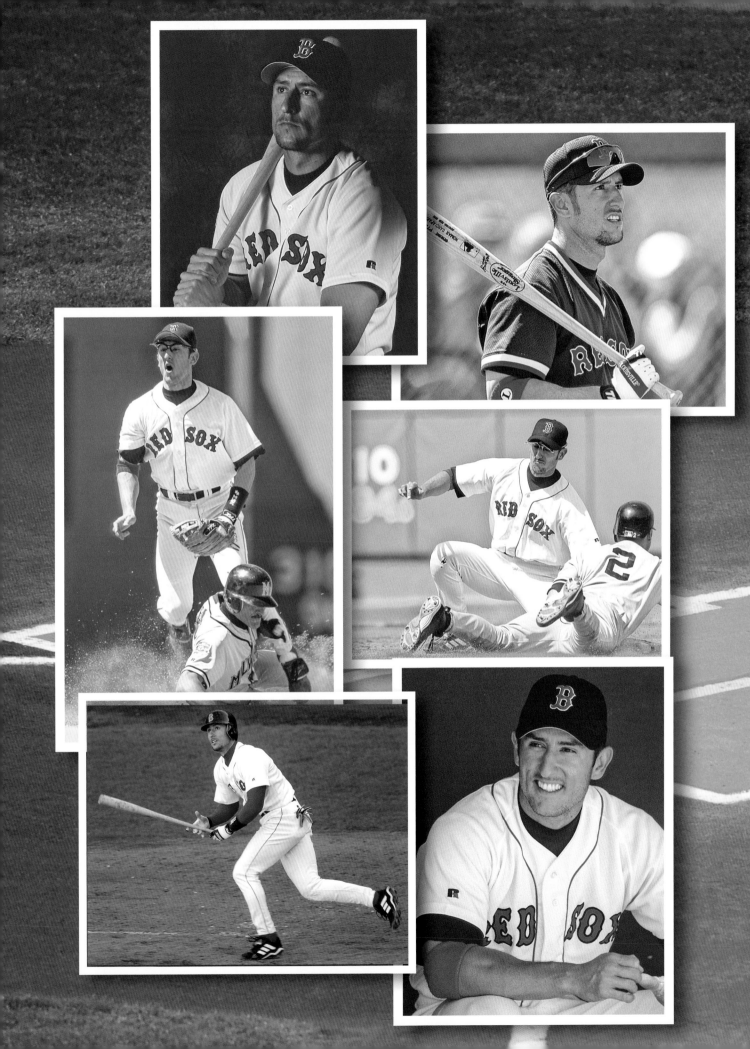

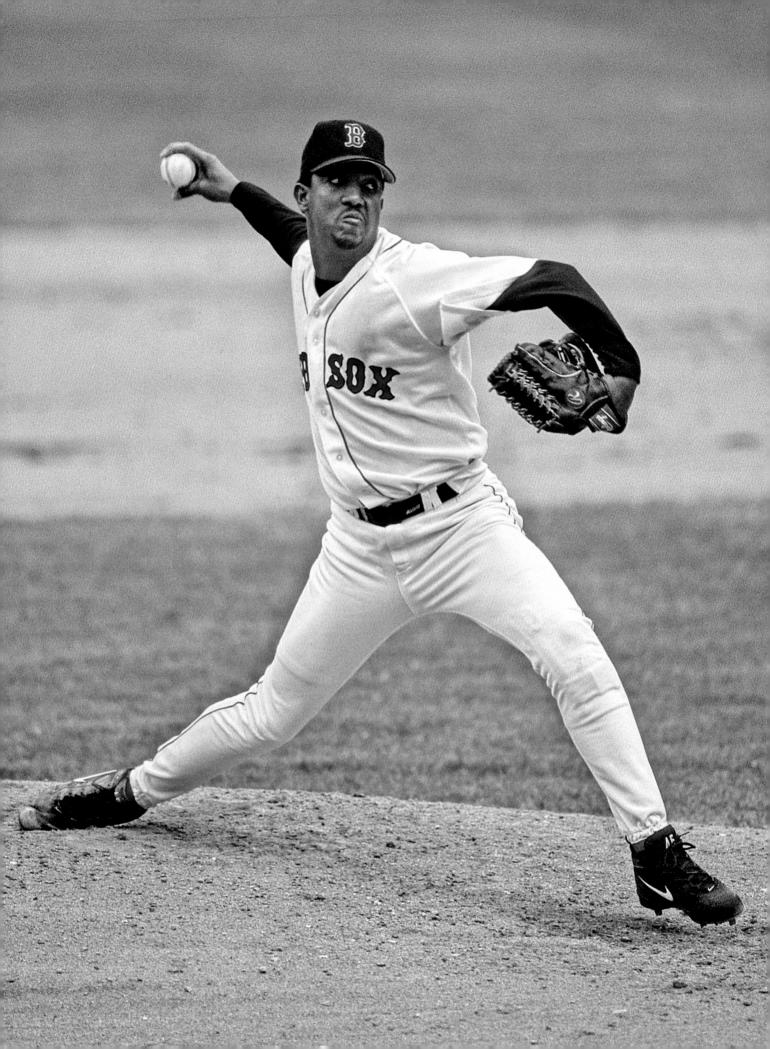

Pedro Martinez

Chili Davis, who would later become the Red Sox batting coach, marveled at what Pedro Martinez did to the Yankees on September 10, 1999—one of many great moments for Martinez that season.

"Pedro was dominant," Davis told MLB.com. "He knew he had good stuff, and he came out early with a challenge-type mentality. I think he threw all fastballs the first couple of innings and then started mixing in the 14 different sliders and the 22 different curveballs and the 10 different changeups he threw from 15 different arm angles.

"He was difficult to hit because he never allowed you to get real comfortable at the plate. You couldn't lock in on an arm slot with him. It's like he invented pitches out there."

Martinez, the rather slightly built right-hander from the Dominican Republic, gave up a solo homer to Davis en route to a 17-strikeout one-hitter.

"I'm glad I got that hit and glad it wasn't a no-hitter, but I [ticked] him off," Davis continued. "He started pitching after that."

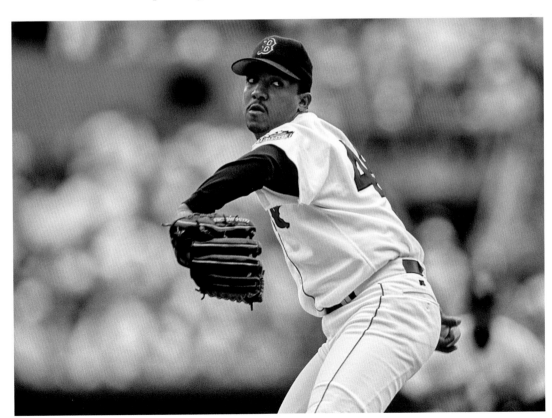

The gem lifted Martinez to 21–4 on the season and he would finish at 23–4, with a 2.07 ERA and 313 strikeouts. He joined Randy Johnson, Roger Clemens, and Gaylord Perry as the only pitchers to win the Cy Young in both leagues—and he probably should have won the 1999 MVP Award, as well.

Earlier in the season, he celebrated the Red Sox hosting the All-Star Game (the last one, to date, at Fenway)—the one where all the All-Stars in and out of uniform gathered around Ted Williams before the game—and he became the first pitcher ever to strike out the side in order in the first inning of an All-Star Game. He struck out the first four National League hitters and fanned five of the six he faced en route to the game MVP honor.

But all of the above was merely a warmup for the postseason, when Martinez crossed over into that legendary status thanks to what happened in Cleveland with his team's season on the line.

He left Game 1 of the ALDS with a back injury but returned to pitch six no-hit innings of relief in the decisive Game 5 to send the Red Sox to the ALCS. He pitched seven shutout innings to beat the Yankees, walking two and striking out 12 in Boston's only win of that series.

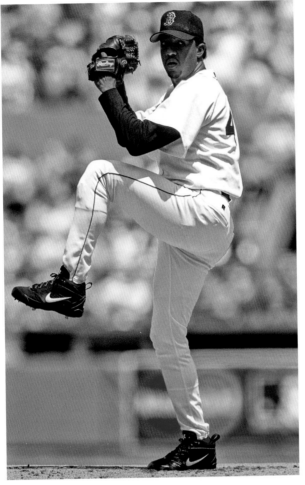

Looking back at his heroics in Cleveland, Martinez said, on the day he was inducted into the Red Sox Hall of Fame, "It was the playoffs, it was everything on the line, including my career, because [a] lot of people see the game, yes, yes, yes, yes, it was a great game. But I put my career in jeopardy. And a lot of people don't realize how bad I was [injured]."

Shoulder problems that would haunt him the rest of his time in baseball and would lead to the Red Sox allowing him to leave via free agency after the 2004 season.

In his seven years with the Red Sox, Martinez was 117–37 with a 2.52 ERA. After pitching for the Mets and Phillies—and pitching in the 2009 World Series against the Yankees—his final Cooperstown-worthy record was 219–100, with a 2.93 ERA.

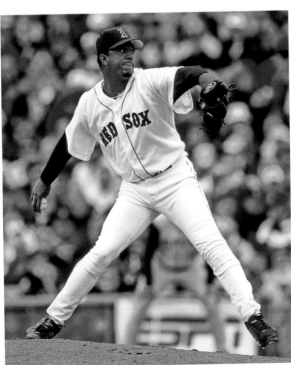

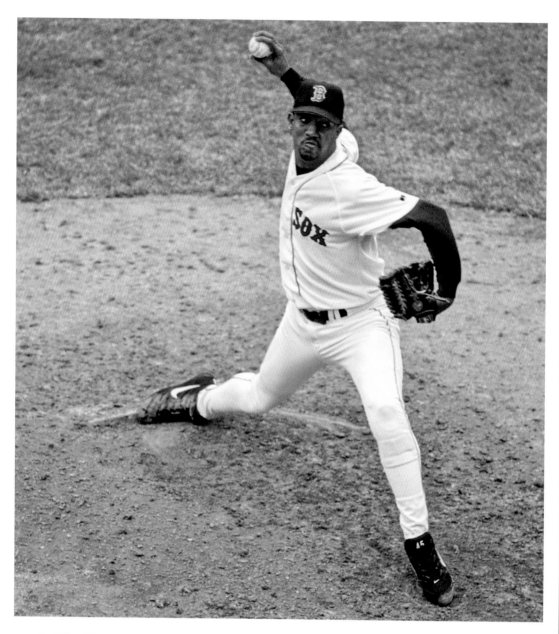

Former second baseman Mark Lemke, who finished his career as Pedro's teammate in Boston, described Pedro's unique build for a player of his caliber: "What really catches your eye is how small he is. You go up against Roger Clemens, even if you've never seen him before, and you say, 'This guy looks overpowering.' You wouldn't say that about Pedro until you get in there."

If it were possible to upstage Ted Williams on that special night in 1999—or even to come close—Martinez did it.

"This is probably more than I expected," Martinez said. "I just wanted to be part of it, have fun with it. I thought seeing Ted Williams come in, the crowd going wild, and the planes passing by, this is one we'll hopefully all enjoy, the fans and me."

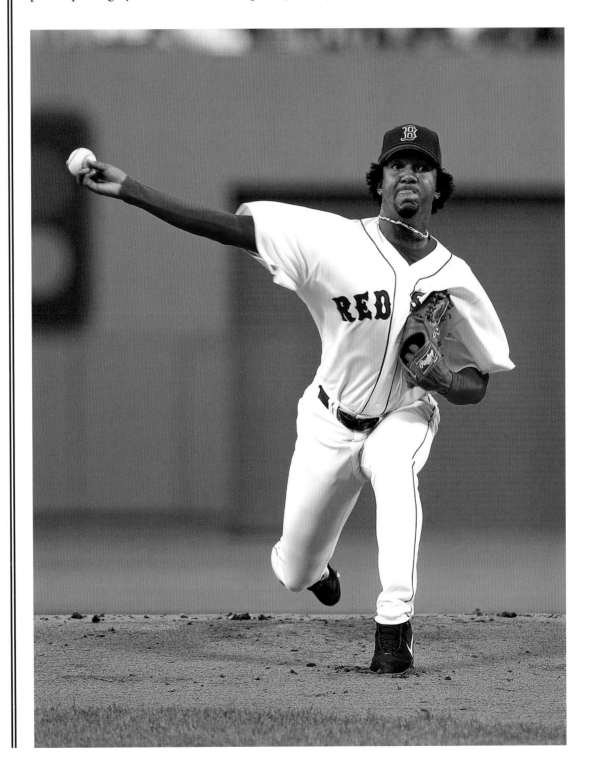

He struck out Barry Larkin, Larry Walker, and Sammy Sosa in the first inning and Mark McGwire and Jeff Bagwell in the second.

"It was weird being behind him pitching, because usually I'm the one hitting against him, and he's either striking me out or getting me out," said first baseman Jim Thome, who drove in the run that actually gave Martinez the win and future teammate Curt Schilling the loss.

"He's dominating, he really is. He is a big-game pitcher and he rises to the big occasion. He's one of those guys that when the spotlight is on him, he does a great job."

Said AL manager Joe Torre: "When you have a guy like Pedro, whether he's throwing the fastball or the changeup, with his arm speed it's like trying to hit in a dark room.

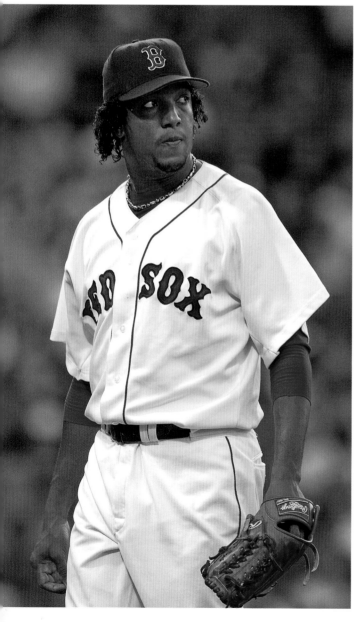

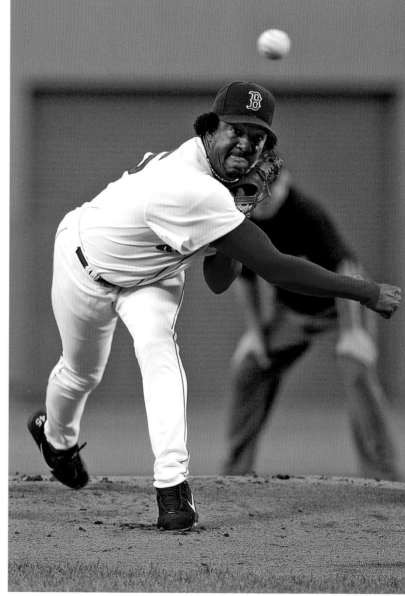

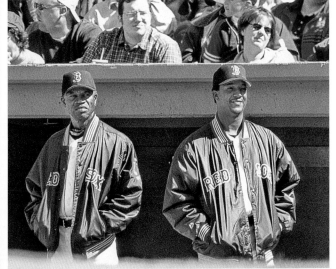

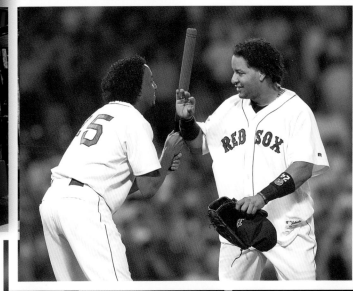

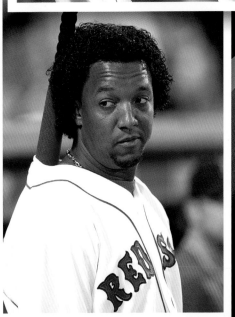

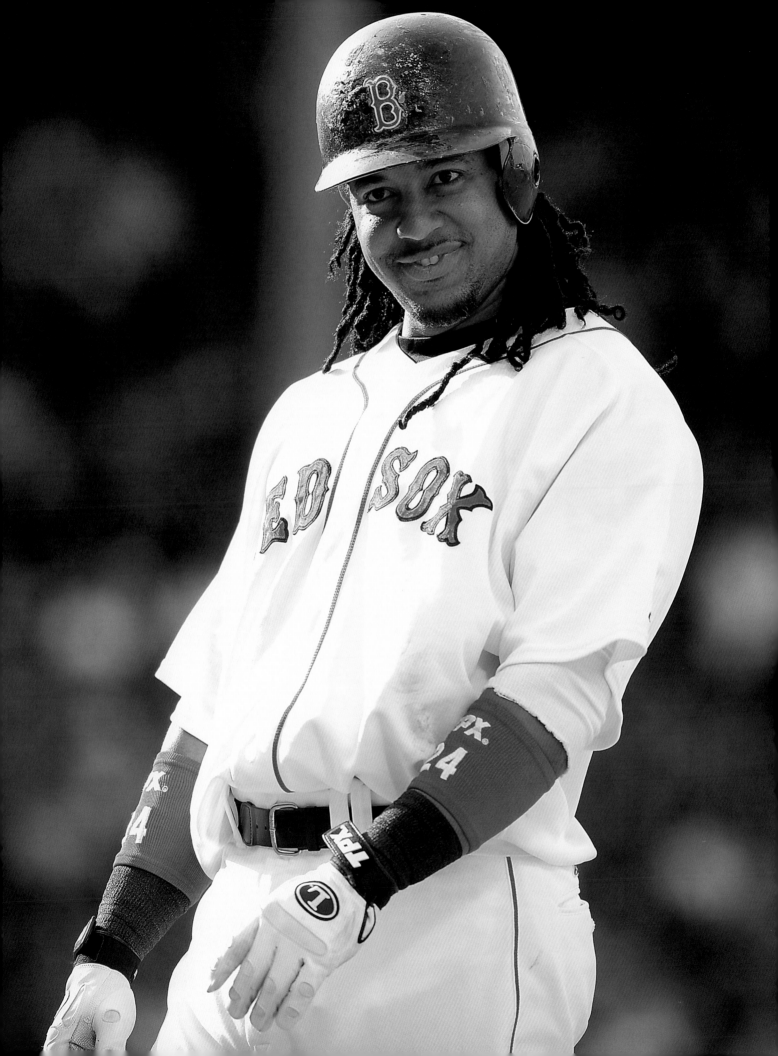

MANNY RAMIREZ

Manny being Manny.

He did goofy things on the field—like intercepting a Johnny Damon throw on its way to the infield.

He did goofy things off the field too, like twice getting suspended for using illegal substances and physically attacking the traveling secretary.

But any way you look at it, whether you think he cheated or not, Manny Ramirez was simply one of the best hitters of his or any other generation.

And paired with David Ortiz, he was part of the most powerful and dangerous 1-2 punch since . . . ok, all the way back to Babe Ruth and Lou Gehrig.

Whether they batted with Manny hitting third and Ortiz fourth, or the other way around, they were downright lethal, and they led the Red Sox to the 2004 and 2007 World Series titles.

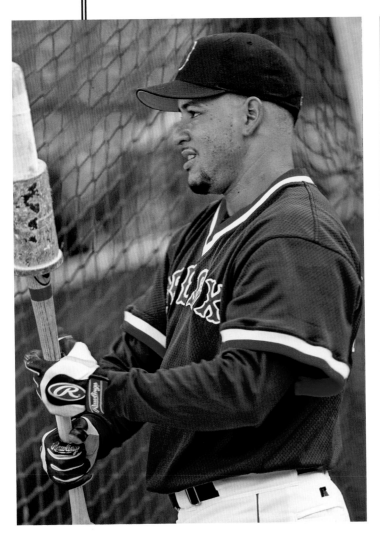

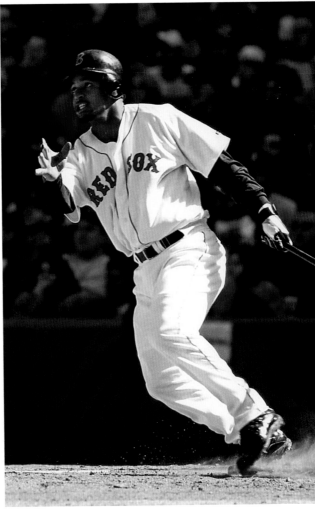

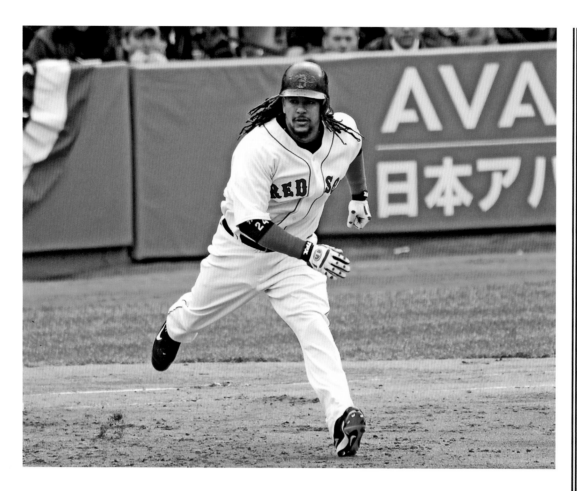

But with all the hitting, "the cutoff" of 2004 is the thing people would talk about for years. Those of us who saw it still aren't sure what we saw.

"That's one of the strangest relays I think you'll ever see," Jerry Remy said as he watched the NESN replay.

Pedro Martinez was on the mound in that July 21, 2004, game. David Newhan of the Orioles hit the ball off the wall, and Damon jumped for the ball, missed it, chased it down, and threw it in. It didn't go very far.

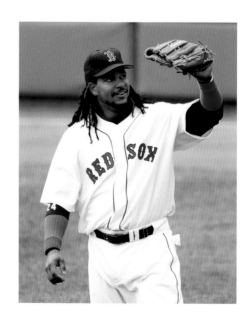

Martinez and the Red Sox lost the game, but that's not what anybody was talking about.

"I don't know, something happened between Johnny and Manny. I didn't quite see what happened there," Martinez said after the game. "I was going to back up the plate."

And Damon told the *Boston Globe*: "Manny jumps and makes a highlight catch. Unfortunately, it was an embarrassing one for me and him."

Manny being Manny.

The *New Yorker*, asking Ortiz to describe his buddy, said, "As a crazy motherfucker. You can write it down just like that: 'David Ortiz says Manny is a crazy motherfucker.' That guy, he's in his own world, on his own planet. Totally different human being than everyone else."

According to the same 2007 piece, a Manny story from his Cleveland days involved getting pulled over by a cop.

"The cop knew who he was," said Sheldon Ocker, then the Indians beat reporter for the *Akron Beacon Journal*. "He said, 'Manny, I'm going to give you a ticket.' Manny says, 'I don't need any tickets, I can give you tickets,' and reaches for the glove compartment. Then he leaves the scene by making an illegal U-turn and he gets another ticket."

Manny being Manny.

But oh could the man hit—something he was still doing at age forty-four in Japan as of 2017.

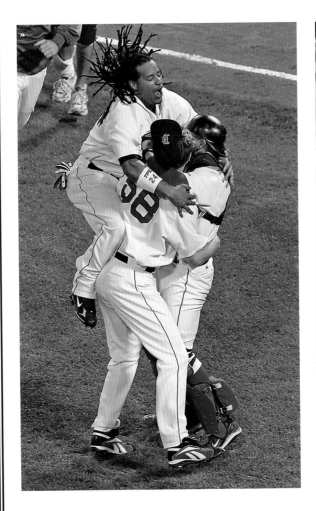

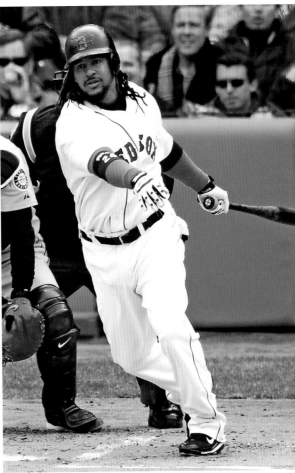

For his career, he batted .312, with 555 homers, 1,831 RBIs, and a .996 OPS. In his eight years in Boston, he also hit .312, with 274 homers, 868 RBIs, and a .999 OPS.

One of the greatest hitters of his or any other time.

If you checked the Red Sox media guide in 2017, you saw Ramirez was third in slugging percentage (.588), fifth in on-base percentage (.411), sixth in homers (274), seventh in RBIs (868), ninth in batting average (.312), 10th in total bases (2,324), 11th in walks (636), 12th in runs (743), and 15th in doubles (256).

All in just eight years.

They thought they were trading him to the Rangers in 2003, but that deal fell through and Manny remained in Boston, with Alex Rodriguez ultimately going to the Yankees.

When he signed in Japan with the Kochi Fighting Dogs for the 2017 season, part of Ramirez's contract was unlimited sushi.

Manny being Manny.

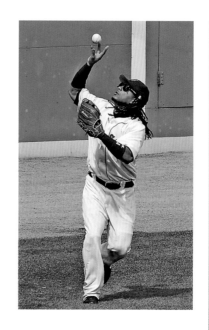

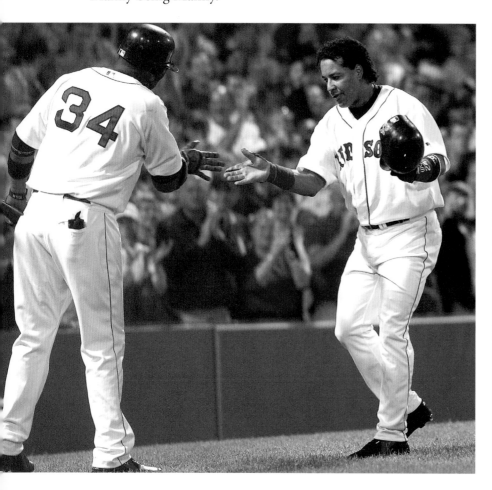

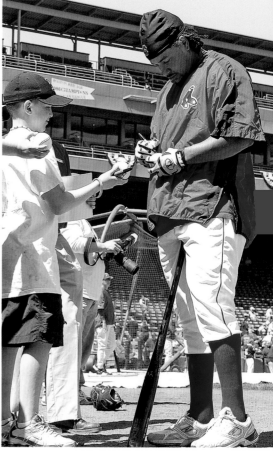

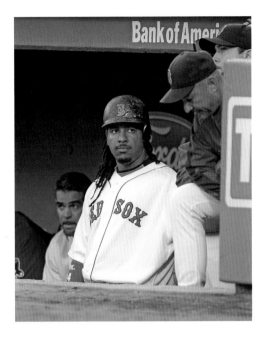

On July 31, 2008, the Red Sox said good-bye to Ramirez, who went to the Dodgers in a three-team deal that brought Jason Bay to Boston.

"This kid has been the most gifted hitter in the business," former Boston GM Dan Duquette said after the signing beat out Manny's old team, the Indians. "We're a lot stronger than we were.

"We thought we were going to lose him. Monday we negotiated all day and we knew that if we did a couple of more things we had a good chance to close the deal."

Said Ramirez: "Over here we've got the best pitcher in both leagues [Martinez] and the best hitter [Nomar Garciaparra]. I think if we get another guy, we've got a great chance to win it all."

That was the start of a rocky ride that saw the Red Sox twice with the World Series.

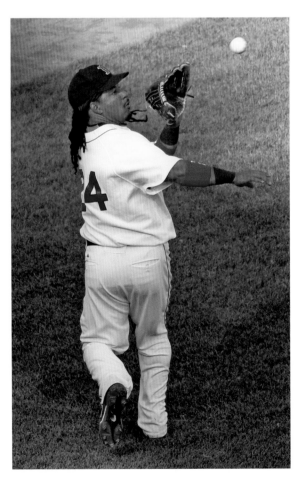

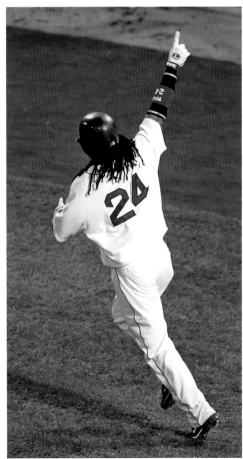

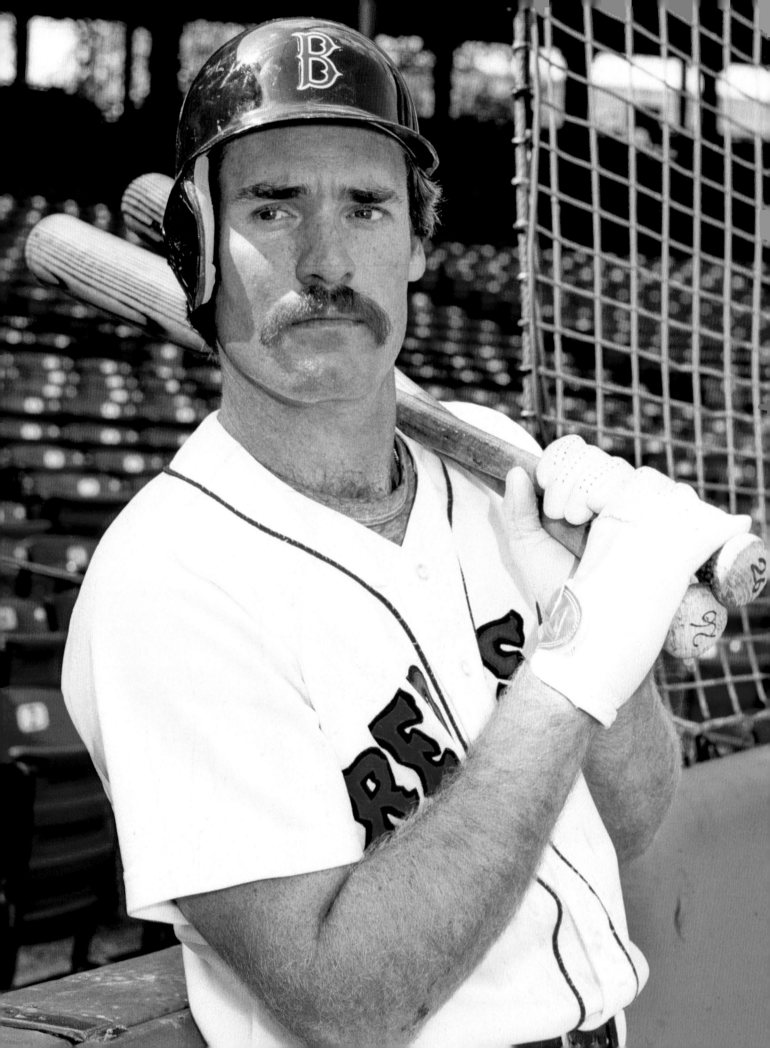

Wade Boggs

In April 1986, Wade Boggs sat down with Ted Williams and Don Mattingly to do a *Sports Illustrated* interview with Peter Gammons.

Thirty years later, Boggs's No. 26 went up next to Ted's No. 9 on the right field façade of retired numbers.

"I think I said it best out there that this was the last piece of my baseball puzzle," Boggs said that night. "My journey has ended and I've come back home.

"This is where I started my career. And, today is the end. To have my number up there with all the greats to ever put on a Red Sox uniform, including Ted, he's my idol growing up. I wore 9 in honor of Ted in Little League."

Boggs's résumé, which landed him in the Hall of Fame, includes five batting titles (including four in a row) while with the Red Sox. He crossed over to the

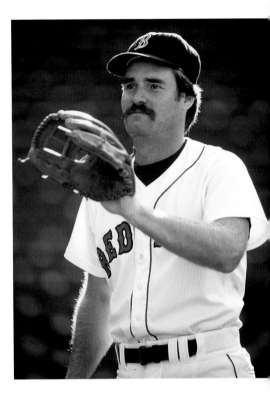

other side and won a World Series with the hated Yankees—the picture of him on horseback after clinching sticking in the craw of Red Sox fans everywhere.

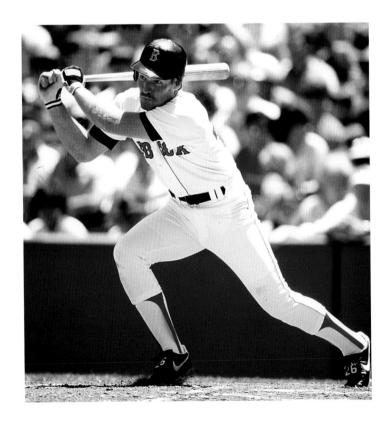

He had gone to New York, played five years with the Yankees and two more with the hometown Rays (Devil Rays at the time). His 3,000th hit, with the Rays, was a home run.

Boggs finished with 3,010 hits, 118 homers, 1,014 RBIs, and an .858 OPS. There were those who watched his career who thought he should have hit for more power. He would put on a power show in batting practice and hit 24 in 1987, the year of the homer.

All that said, watching him hit was like watching Picasso paint. You had the feeling he could foul off any pitch he didn't like. He used the Green Monster like he owned it, with a career-high 51 doubles in 1989. He was called selfish by some, but the Red Sox did come within one pitch of winning the World Series in 1986 and into the playoffs in '88 and '90. The Sox were swept by Oakland in both of those years, but Boggs hit .385 and .438 in those eight losses.

Baseball, by nature, is a selfish sport. Yes, there's teamwork, but Boggs was around all kinds of winning in his eighteen-year career. He also worked himself into becoming a Gold Glove third baseman.

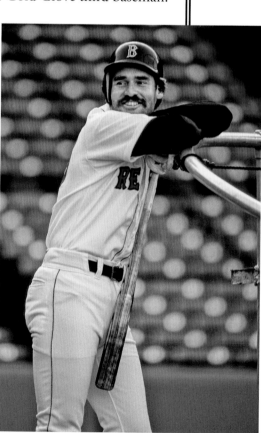

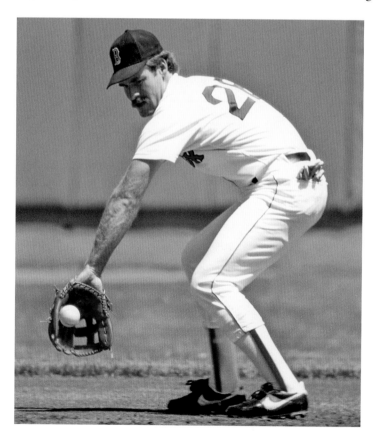

"Wow, I never thought any day could top July 31, 2005 [his Hall of Fame induction], but today just did," Boggs said at his number retirement ceremony in 2016. "For a player to have their number retired is not a right, it's a privilege; it's the highest honor any players can receive from an organization."

With all Boggs, a .328 lifetime hitter, did on the field, there were also problems off the diamond, including the claim he "willed myself invisible" when a guy put a gun to his head in Florida. But nothing kept him from focusing on what he did best—play baseball.

When it came to hitting, no one could ever stop him. Boggs batted .300 for a stretch of 14 out of 15 years, the Red Sox letting him go after he hit .259 in 1992. He then hit .302, .342, .311, and .292 as a Yankee. He hit .338 in his 11 Red Sox seasons.

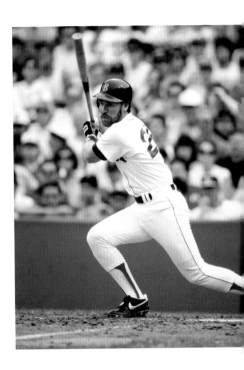

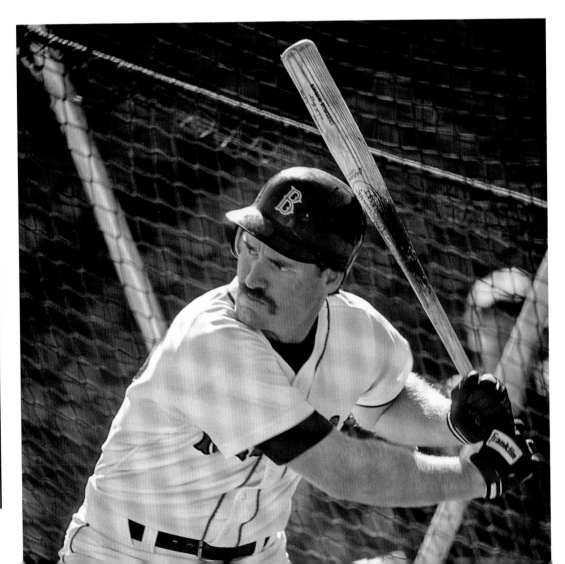

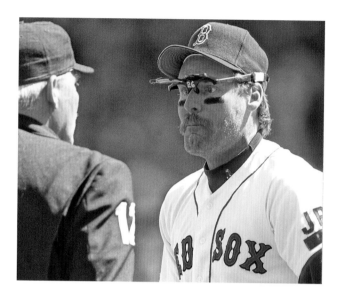

The scene of Boggs in tears in the dugout after the '86 World Series showed his disappointment of coming up just short.

"It was a heartbreak," Boggs said at the 30th reunion of that team. "Everybody kept saying, '1918, 1918, 1918,' and we got tired of hearing that. One thing people have to understand is, at the beginning of spring training we were picked to finish fifth. People said we underachieved. I don't think we were underachievers at all. We were on the brink of winning one of the greatest World Series of all time. We didn't bring a championship back to Boston, but thank God for 2004.

"It was the darkest day in my life . . . So many things were written about us being '25 players, 25 cabs,' but we got along really good together. If you were in the hospitality suite with us tonight [at the reunion], you would have seen it."

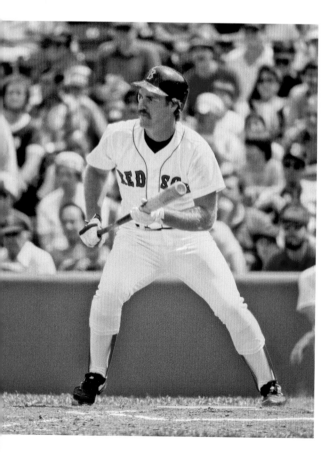

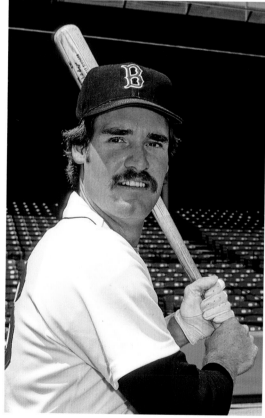

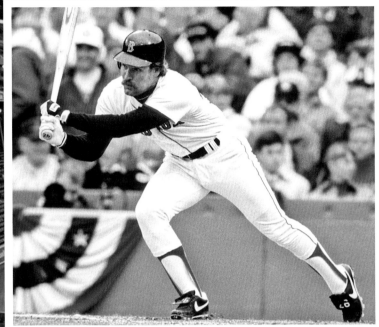

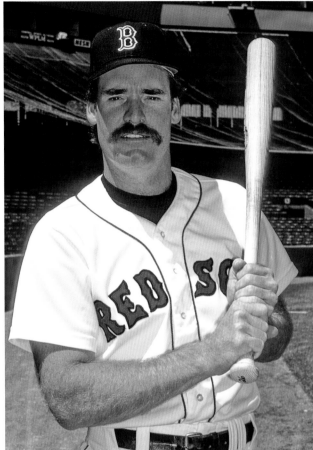

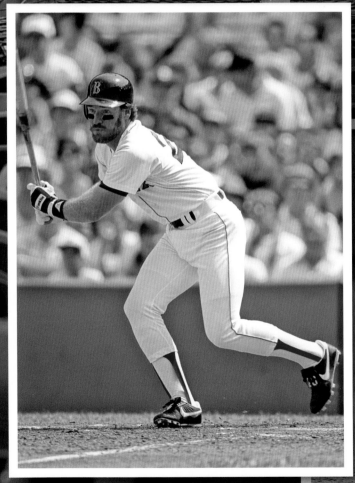

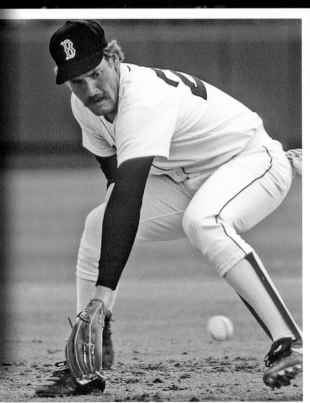

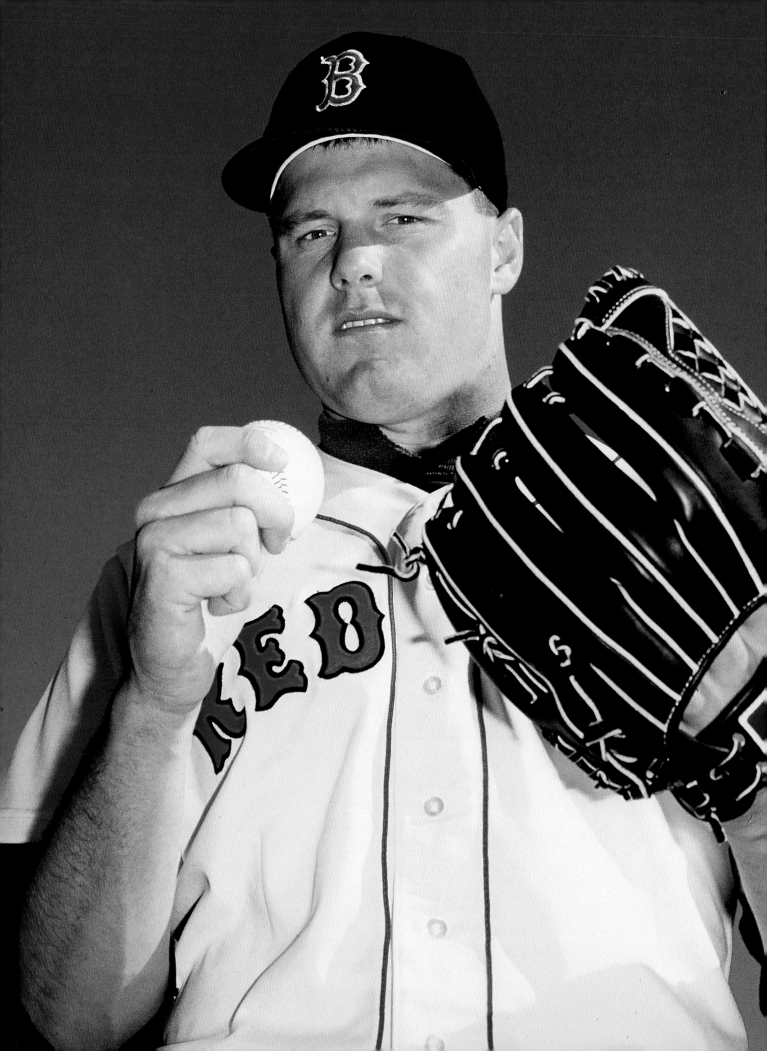

Roger Clemens

On April, 29, 1986, Roger Clemens became the first pitcher to strike out 20 batters in a nine-inning game with a gem against the Seattle Mariners on a cold night in Boston.

Just over 31 years later, on May 25, 2017 five Red Sox pitchers combined to strike out 20 Texas Rangers on a dreary night at Fenway. It was the sixth time 20 batters from one team went down in nine innings.

Chaz Scoggins scored both of them.

Scoggins, who has been an official scorer since 1978, used to cover the Red Sox for the *Lowell Sun* but was retired by the time the 2017 record-tying game took place.

Scoggins remembered something from the first game—actually from *before* the first game.

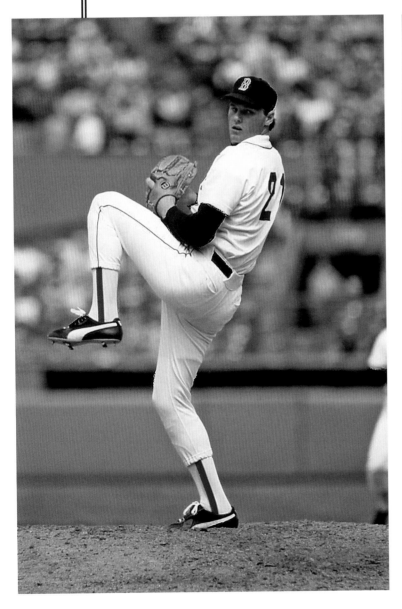

"The Mariners had come in here. They were not making contact at all," he said. "Clemens had had the [shoulder] surgery the year before so it was about his fourth start of the season I think. [Bob] Finnegan comes up to me—he was covering the Mariners at the time—before the game, he's from here and had been covering the Mariners for five years or so at that time. He said, 'if Clemens doesn't strike out 10 guys tonight there's still something wrong with his arm.'"

Well, Clemens doubled the 10. He then did it again 10 years later, in Detroit. Kerry Wood did it in 1998 and Max Scherzer in 2016. Randy Johnson (2001) also fanned 20 in nine innings, but that game went into extra innings.

Both games scored by Scoggins had "weird factors" that allowed the Red Sox to get to 20 Ks.

"If Baylor doesn't [drop a Gorman Thomas foul pop] all he does is tie [Tom] Seaver's record of 19," Scoggins said. "If that doesn't happen there's no record. And then the other night if the umpires and the New York review crew doesn't blow the call on that one, they don't get 20 strikeouts in that game, either."

Clemens, who lived a dream 1986 (at least until the Red Sox lost the World Series), was indeed making his fourth start of the season. He was 3–0 en route to a 14–0 start and had totaled 19 strikeouts in 24 $^1/_3$ innings over the first three outings. But he had 10 his previous time out, so there were signs he was coming around.

Then, April 29 happened—in front of a Fenway crowd of only 13,414, on a night most Boston eyes were focused on a Celtics playoff game crosstown.

"It was much like any other night," catcher Rich Gedman said 31 years later as he sat in the indoor batting cage at McCoy Stadium in Pawtucket. "It was a cold night in April and Roger was Roger. He was out there competing, trying to find his zone early."

At one point, Clemens tied an American League record with eight Ks in a row, a mark future Red Sox righty Doug Fister would break, with nine, in a game in September 2012.

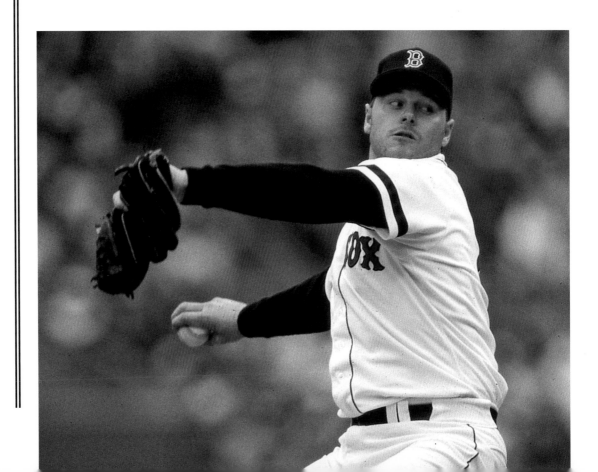

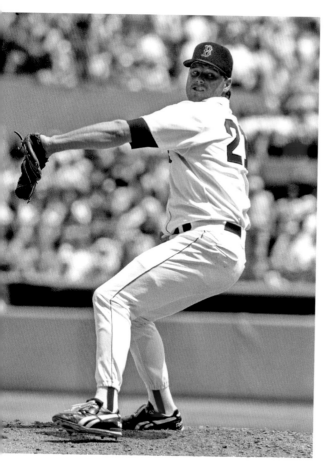
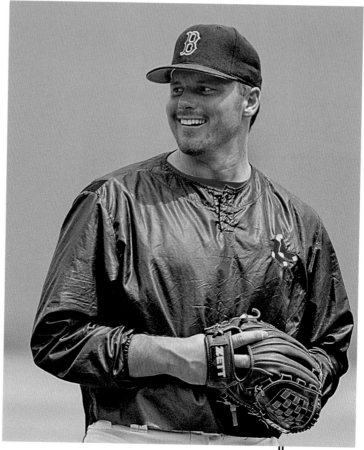

"Before we knew it he had nine or 10 strikeouts in the first three or four innings," Gedman said. "But still we're just playing the game—we weren't paying attention to how many strikeouts he had. Maybe somebody was, but certainly I wasn't.

"Now we're into the fifth or sixth inning and I guess the K-man must have shown up because all of a sudden there's all these Ks up against the right field wall. There's so many of them we can't even count them because they all run together. So, oblivious to what's going on."

And they weren't winning the game.

"No, no, Gorman Thomas hits a home run. It's 1–0, think they scored in the top of the seventh and Dewey [Dwight Evans] came back and hit a homer in the bottom of the seventh. It's 3–1.

"In that type of game you're not paying attention to any records, until the ninth inning, when you look at the board and it says Roger Clemens tied a record, then he set . . . a record.

"When it's all said and done you say, 'Geez, we really did something special.' When it's going on you don't realize it—I'm not a historian of the game. 'What's the record?' And then I don't even know what the number is at the time because we're playing the game to win.

"We're ahead and we know we're ahead. Roger finishes the game. When people talk about Roger Clemens you sit there and you go, 'Well, he threw a nine-inning game and he struck out 20 and the amazing thing was that he didn't walk anybody.' Then you sit there and say, 'Well, if Don Baylor didn't drop a popup he might not have had 20.'

"All I know is the last guy in the game [Ken Phelps] was making sure he wasn't 21. I can tell you that because he wasn't really swinging—he was playing pepper [and he grounded out to short]."

Gedman knew he was catching vintage Rocket.

"He was fabulous," he said. "I think there was only one time early in the game, I think he gave up a hit to Spike [Owen] where I can remember running out to the mound and saying, 'Texas, what are you doing?' I said, 'You did him such a favor.' He goes, 'Yeah, but I know him [they played together in college].'"

The hit by Owen must have gotten Clemens mad—that's when he struck out eight in a row.

"That was a very good-hitting Seattle team, later," Gedman said. "At that time . . . I want to make sure I give Roger the credit he deserves because he did it and I don't want to make it sound like the people up there were not good players [they weren't hitting]. If you look at the names of the players on the other team, they were a very good team."

Owen fanned twice, Phil Bradley went down all four times, Phelps struck out three times, Thomas once, Jim Presley twice, Ivan Calderon all three times, Danny Tartabull once, Dave Henderson, who would soon become a teammate, all three times, and Steve Yeager once.

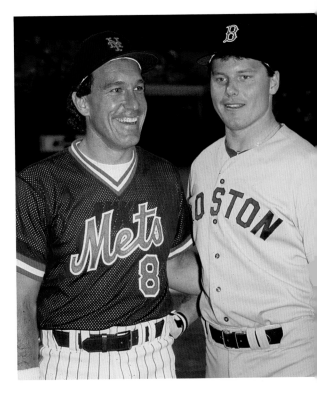

Pictured with Gary Carter

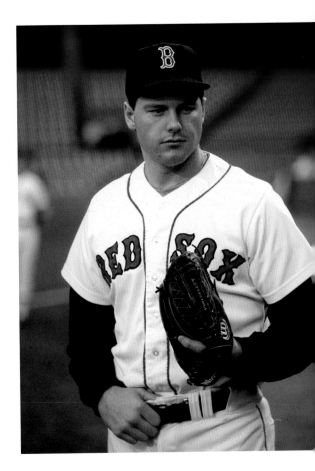

"We didn't have much of a chance," said Henderson.

"At times it was like a game of catch—whether it be taking pitches for a strike or swinging and missing, it was like a game of catch," Gedman said. "You were in a different time. You were in your own little world.

"They were there, but it was like they weren't there. And again, they had some really, really good hitters. If they were guessing, they were guessing wrong, and if they were looking for a fastball they were not looking for it in that zone. When he threw a ball away, it was like he was missing bats. It wasn't like it was invisible. It was directly to the spot. It was truly one of the most dominating games I've ever been around."

After the game, Clemens told reporters, "The Ks just kept coming. But I just wanted to keep it close. I really didn't know I had a chance at it until [Boston pitcher Al Nipper] said I had a chance toward the end. Then the fans were behind me and I knew I had a shot."

Said Gedman: "His execution and stuff—where he wanted to throw the ball he threw it. He was dominating. There wasn't a whole lot of foul balls. There was a whole lot of long at-bats; he executed pitches."

The next night, Gedman caught 16 strikeouts from Bruce Hurst, setting a record for a catcher of 36 putouts in back-to-back games.

"They were two dominant guys," Gedman said. "They were both different from the other. Hurstie had a three-pitch mix. He wasn't dominating—he didn't have a dominating fastball but if you're sitting there you better respect his hook. It was a very good one. And his changeup, which really was coming—you could see where if he was throwing all three of them for strikes you had a problem."

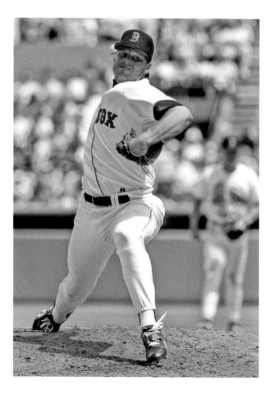

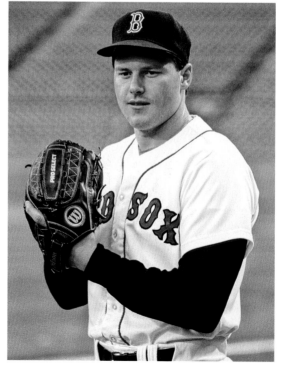

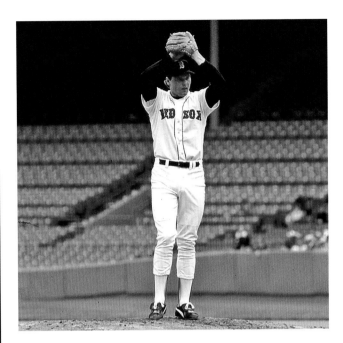

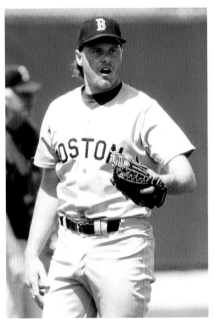

And, of course, Clemens was Clemens, as he pitched a complete-game three-hitter for his fourth straight win.

"I have to say that was the most awesome piece of pitching I've ever seen," said Red Sox manager John McNamara. "I saw Catfish Hunter pitch a perfect game. I've seen Mike Witt pitch a perfect game. But this rates right at the top."

Clemens is also memorable for his spunk. Ellis Burks was playing behind Clemens on a particularly fateful day in Oakland, when Clemens was ejected from Game 4 of the 1990 ALCS by umpire Terry Cooney.

"I couldn't understand what had happened. Being in center field you're the farthest away," Burks said. "All I saw was the umpire waving his arm and Roger screaming and walking off and going up . . . I'm like 'what the heck just happened?'

"I'd never seen that before and I don't think you'll ever see it again because I don't care what a pitcher says to an umpire or what an umpire says to a pitcher, with a game of that magnitude . . . there are some things where you just turn your head and walk away and not acknowledge. And at that time? OK, we argue strikes all the time. Right now umpires are a bit more sensitive about strike calls—they throw out managers nowadays for arguing balls and strikes. They throw out different people but . . . for a playoff game you don't do that.

"There are times where you can just bite your lip and call the guy once the third out is made, as he's walking off and say, 'I didn't agree with that—let's just drop this.' But you don't just throw a player out of a game in that situation. I thought that was a pretty big moment in that series."

Told Clemens's words may well have been obscene, Burks said, "Is that right?" Laughing, he admitted, "Well that might get you thrown out."

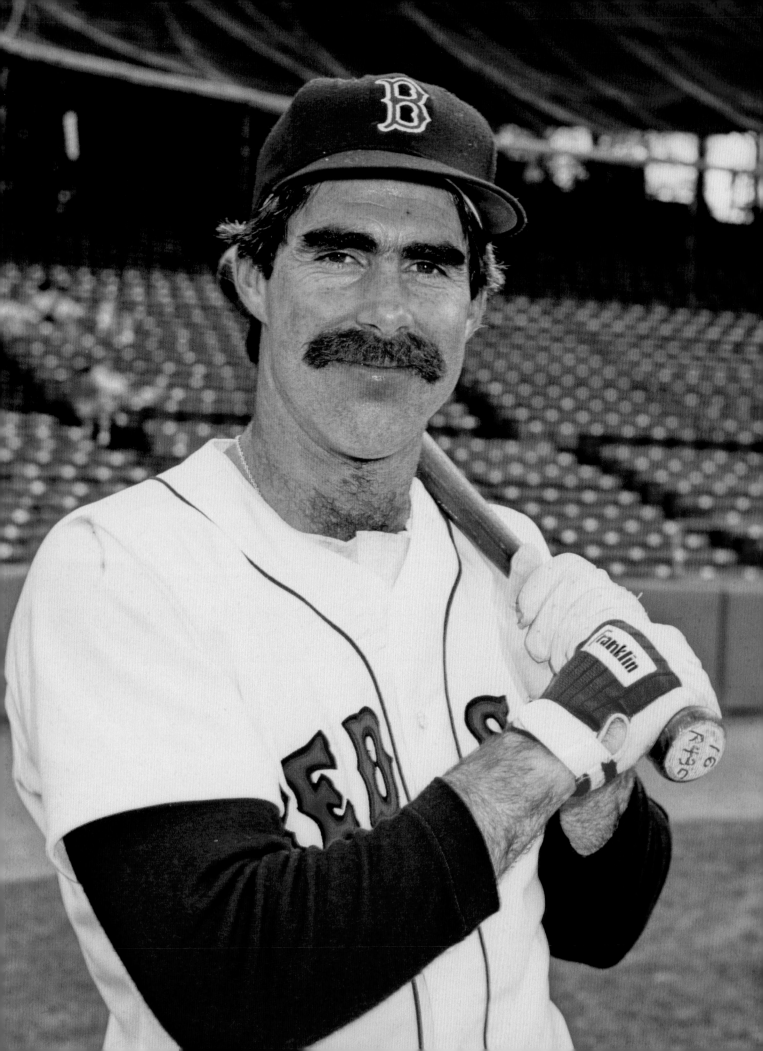

STAR PLAYERS

Bill Buckner

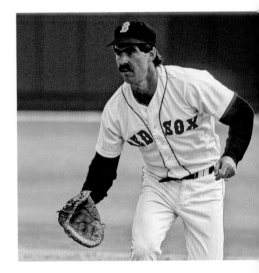

Bill Buckner played 22 years in the major leagues, collected 2,715 hits, won a batting title, drove in 1,208 runs, batted .289, and even stole 183 bases despite playing with painful injuries.

But, as you know, with all Buckner accomplished, he will forever be known for that ground ball in the bottom of the 10th inning of Game 6 of the 1986 World Series. "The Buckner Ball" gave the Mets the win in that game, and they went on to win the title two days later—sending Buckner into baseball infamy.

"It bounced, it bounced, and didn't bounce," Buckner said during spring training 1989, when he was with a new team, the Royals.

"The ball was hit real slow and I had to run a long way, and because my feet hurt, I couldn't run on my toes. The ball's bouncing everywhere, I get over there in time and I just missed it.

"It's really something I hate living with, and something I hope my kids never have to deal with."

It was a dark moment in Red Sox history and a dark moment in Buckner's life.

But in 1990, the Red Sox brought Billy Buck back to Boston, to play the final 22 games of his career. He hit one home run— an inside-the-park homer thanks to Claudell Washington falling into the right field stands. Fenway Park went crazy.

Buckner, who has been cheered in other returns to Fenway, came back for the 30th reunion of the '86 team. By this point, time has healed wounds.

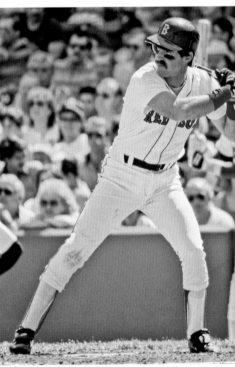

"Hey listen, if you had asked me, 'Are you good with playing 22 years in the big leagues, winning a batting title, playing in two World Series, getting 200 hits in both leagues, and playing in a World Series game and making an error?' I would have said, 'You're damn right, I'm good with that.' That's the way baseball and sports are. You've got a winner and you've got a loser. That's the way life is."

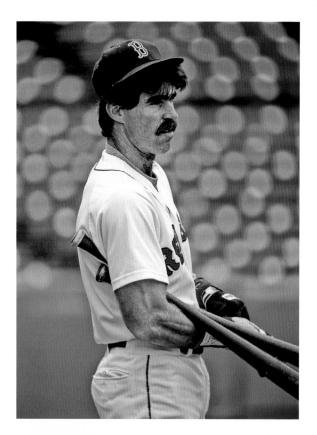

Dave Stapleton had been on the field for all seven Red Sox postseason wins—and there were reports never officially confirmed that John McNamara summoned Stapleton to do it again on that Saturday night in 1986. Some reports had Buckner balking and McNamara changing his mind. Then again, Mac was the kind of manager who might feel that a veteran like Buckner, who squeezed a popup for Dennis Boyd's final out that clinched the AL East, deserved to be on the field when it all ended.

Yet according to Jeff Pearlman, in his 2004 book, *The Bad Guys Won!*, "McNamara never even considered replacing Bill Buckner with dependable Dave Stapleton. Sure, Buckner was being held together by glue, spit, and little wads of bubble gum. And sure, Stapleton had served as a late-game replacement throughout the regular season and playoffs. Buckner, however, was a warrior, a guy who had given the Red Sox his heart and guts."

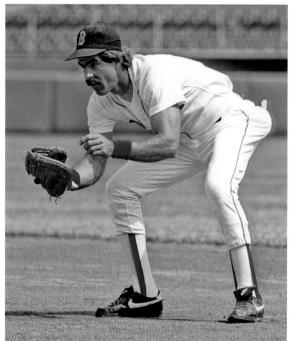

Regardless of the reason, there was Buckner, as sure-handed a first baseman as you'll ever see, just not able to pick that ball up off the ground. It beat him clean.

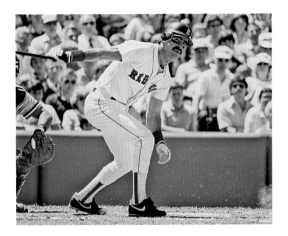

"I partially tore the Achilles tendon on my good foot in the Angel series," Buckner said at the '86 reunion. "The first two or three games of the World Series were very difficult because it felt like it was going to pop. But after the fifth game, I was able to move around decent."

The ball did some weird hopping and the Mets stayed alive and ultimately won it all two nights later.

"We had a great year," said Buckner, who drove in 102 runs that year, his second straight 100-RBI season in Boston. "Came close. It didn't happen. You know, in sports, you gotta give credit to the other team. They hung in there.

"I felt like we had a good shot but that Mets team won 105 games or something [actually 108] during the regular season."

It would take the Red Sox 18 more years to finally end that 1918 thing. Ultimately, the World Series win that year helped heal the wound created by that unfortunate night in 1986 for Buckner and the Red Sox.

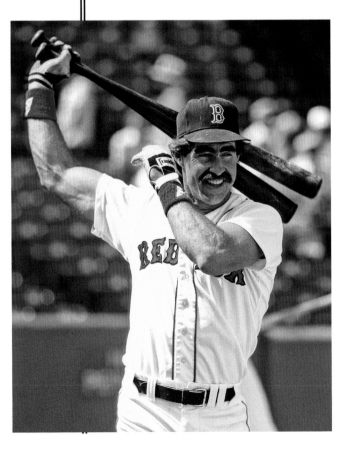

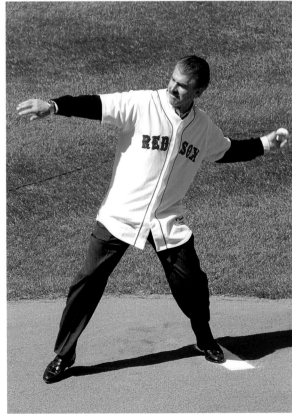

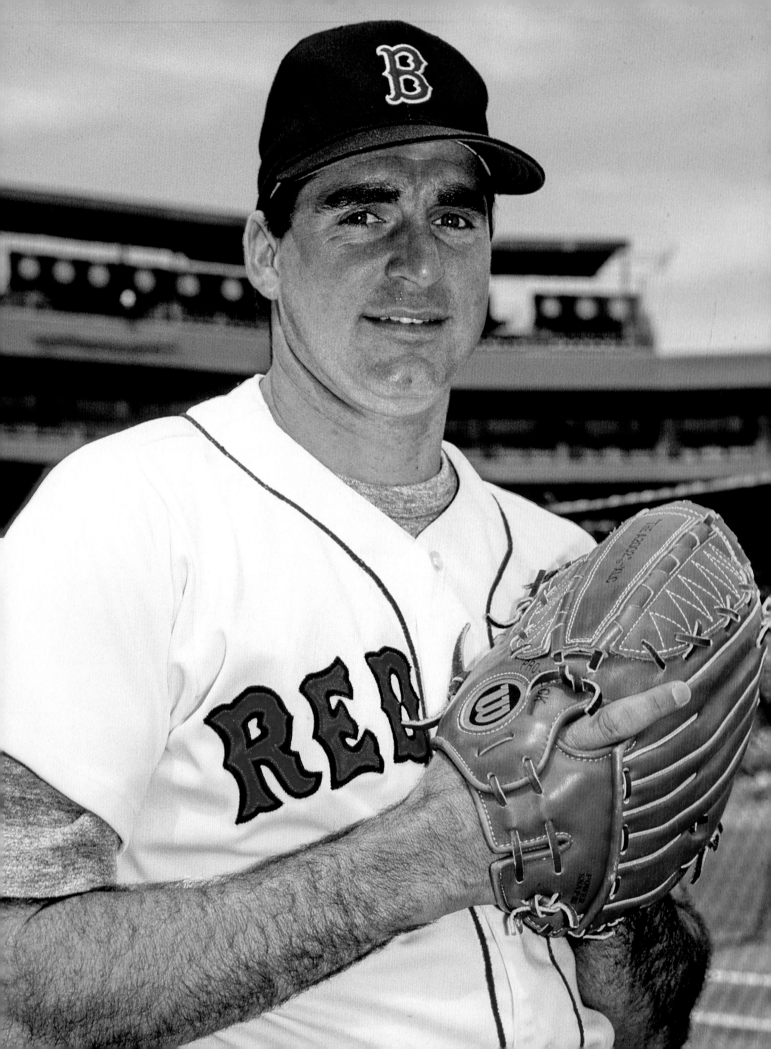

Bruce Hurst

It is almost three decades later, but Bruce Hurst will never forget the first time he pitched in the major leagues NOT wearing a Boston Red Sox uniform.

"My first game in San Diego," Hurst, who had signed with the Padres as a free agent in 1989, said in a phone chat in 2017.

"For me, how I liked to prepare, I had my game face, I just liked to be left alone. I had my game day and what I needed to do. The other four days [when I wasn't starting] I was a lot easier to get along with, but [that day, April 4, 1989] I remember walking into the clubhouse, they had a lunch room, a place to eat, it was a small clubhouse, smaller than Fenway's and . . . on the TV, were the Red Sox playing the Orioles.

"It completely caught me off guard. I just remember looking up there and going, 'Man, I miss those guys.'

"And I went out and I got shellacked by the Giants. Will Clark takes me way back. Kevin Mitchell takes me deep. The place is booing me. I remember my family was up in the stands and some guy yells up at Mrs. [Joan] Kroc, 'has the check cleared yet?'"

Hurst pitched five innings in that games, allowing 10 hits, eight runs, seven earned, one walk, and one strikeout.

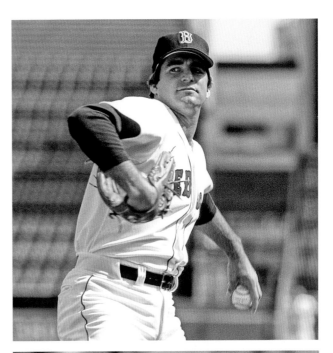

He pitched a one-hitter and struck out 13 his next time out and went on to go 15–11 for the year and 55–38 in four years with the Padres. It clearly never felt like it felt in Boston, where the Red Sox didn't give him an extension prior to 1988 after a bout with mononucleosis.

Hurst never wanted to leave, saying in a SABR piece he was "sobbing" after agreeing with the Padres. Ask him about the change, and he says, "Oh boy, way more than I was prepared for."

"I had some good games. I had some good years in San Diego," he said. "I really wanted to make it where, on a personal level, that I could play on both coasts, that I could play in the high-intensity environment of Fenway and that I could find a way to keep myself motivated in San Diego. It was a change for me, no question."

His 57 wins at Fenway trails only Mel Parnell (71) but is better than Lefty Grove (55) and Jon Lester (51). Hurst finished 57–33 with a 4.14 ERA and eight shutouts at the old place.

Asked if he regretted leaving, he says, "A lot of it, yeah. On the baseball side of it, yeah. I made some tremendous friends in San Diego. I had some great teammates there, guys I really learned to really like a lot and appreciate. But of all the things of Boston in totality, the environment, which incorporates everything—the fans, the ballpark, the media, the intensity, the microscope—there is just no better place to play.

"I'm sure they feel the same way in Yankee Stadium or some of these other places—Chicago—but Fenway Park is kind of the mecca of all baseball fields. It certainly has stayed

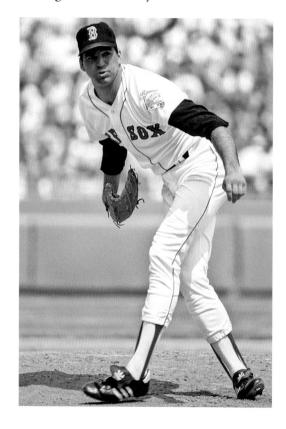
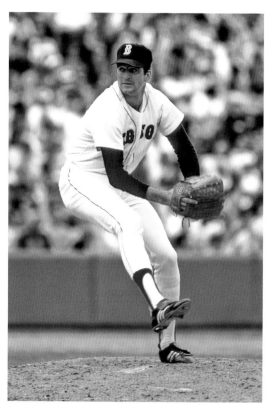

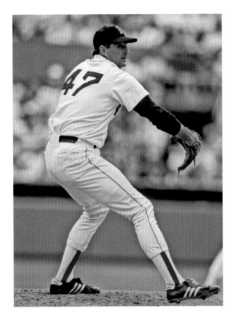

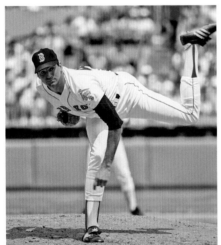

as true to its roots as any ballpark in this era can say . . . it's an incredible environment to play in. You miss the intensity. You miss the fire. It mattered. To play for the Red Sox is part of a culture. It was great. It was a lot of fun. It was challenging, but it was a lot of fun."

Hurst will forever be known in Boston as the World Series MVP who wasn't. He was going to get the award for beating the Mets twice in the first five games. He then got the nod in Game 7 after a rain-out but, much to the dismay of Dennis Boyd, failed to hold a 3–0 lead and got a no-decision, finishing with a 1.96 ERA in three starts.

"In that moment, it was just kind of the post-season experience," Hurst said. "Years later I'd look back and think, 'That's crazy, what happened.' I personally wasn't aware—at least I don't remember being aware—of being the MVP of the Series before the Series was over. I never heard that until after the World Series. I never had any clue while I was in the middle of all that." It capped a year Hurst will never forget.

"We had some strong personalities to say the least—and it worked for us," he said of John McNamara's '86 team. "As chaotic as it was sometimes, I don't . . . from my own personal feeling, I felt like we were brothers. We were in it together. We were around each other so much, you knew all the bad stuff about everybody. You knew what their short-comings were. But you also knew the strengths that they had, too. We were in the fight together and I've said this before and I'll say it again—if it's gonna be this group to lose a World Series, I'll be in a fight with those guys every time. I'd rather be with them. I really care about them a lot."

Hurst was 145–113 as a major league pitcher. Over the 10-year span from 1983-92, he was the only major league pitcher to win at least 10 games every season. He survived as a lefty in Fenway and never should have been allowed to leave.

Jason Varitek

Jason Varitek's career numbers don't jump right out.

He hit .256, with 193 home runs, 757 RBIs, and a .776 OPS, never batting higher than .296 in a season. He was a .237 hitter in 63 postseason games, batting .233 in the ALDS, .237 in the ALCS, and .250 in the World Series.

Nothing special.

But numbers don't tell the story with this heart-and-soul leader of the Red Sox.

The captain.

The guy who handled the pitchers.

The guy who was covered with ice bags on a nightly basis after games.

Borrowing a page from the hockey world, Varitek, who played all 1,609 games (counting postseason) in a Red Sox uniform, wore a "C" on his jersey. And he backstopped the Red Sox to a pair of World Series titles, the first ending the 86-year drought in 2004.

"I think the biggest thing that can be measured, and this isn't necessarily by me, is the opportunity that you have with a team to win a few championships," he said. "That's the biggest measuring key that you have as a team."

He led when he was playing and he even led when he was on his way out.

"I didn't expect him to be so helpful and so 'Hey, man this is your team,'" Jarrod Saltalamacchia said when talking about Varitek's attitude toward him after Saltalamacchia was traded to the Sox. "It's like, 'You're the captain, it's your team.' But that's just the kind of person he is.

"He stuck up for me a lot of times and I can't thank him enough for jump-starting my career again."

He caught four no-hitters and won two World Series in his career. He made the All-Star team in 2003, '05, and '08. He won a Gold Glove. And a Silver Slugger, too.

"Tek was somebody that I think this organization is going to need forever," David Ortiz said after Varitek announced his retirement. "Especially now that he's going to retire. I think he's the kind of person this organization needs to keep very close. This is a guy who does nothing but add good things and like I [said], it was an honor for me to be his teammate."

His old boss, Theo Epstein, told ESPN in 2005, after Varitek was rumored to be on the Yankees' radar as a free agent:

"Jason is a player we did not want to lose to anyone. He stands for all the things we want our players to represent. He plays the game hard, respects the game. He is very selfless, a very supportive teammate. He's a great communicator, exceptionally well prepared.

"He goes to children's hospitals all the time without telling anyone in the media. When you get a player who does all those things, who sets the right example, if you let him go, you send the wrong message to the rest of your clubhouse about what you're looking for in a player. And you might spend many years looking to fill that void."

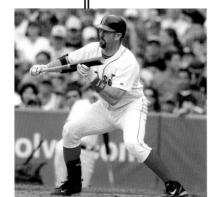

Varitek, who was still working for the Sox and seemed to be on people's radar for a managerial future, joined Tim Wakefield as new members of the Red Sox Hall of Fame in 2016.

"Having been a part of the front office and having the ability to still get on the field everywhere that I go, I know I have more impact on the field," Varitek said that day. "Where that role takes me, through time, I'm not positive when that will be, but I think my greatest impact to give back to the game is on the field."

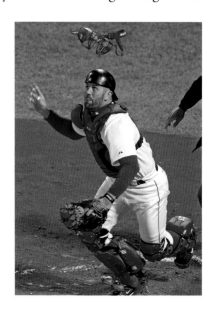

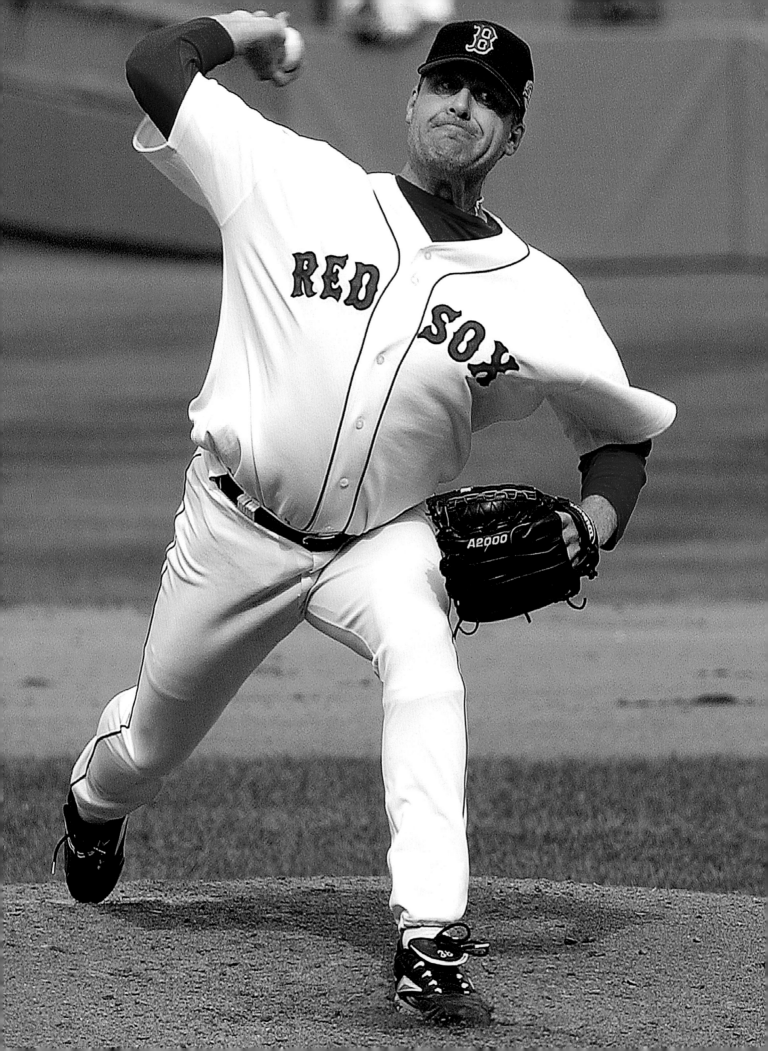

Curt Schilling

Curt Schilling's postplaying career was dotted by controversy. There was an unfortunate video game business deal in Rhode Island. There were his controversial conservative political statements that had so many speaking out against him. In 2016, he got fired by ESPN—for social media comments.

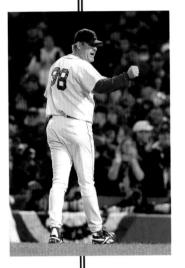

But let's not lose sight of one important thing in all this—Curt Schilling was a hell of a pitcher, and his arrival in Boston was a major factor in the Red Sox winning their first two titles since 1918. His "Bloody Sock Game" in 2004 is legendary.

The Red Sox sent pitchers Casey Fossum, Brandon Lyon, and Jorge De la Rosa to the Arizona Diamondbacks prior to the 2004 season. All Schilling did was go 21–6 that season before going 3–1 in postseason starts.

In four years in Boston, often wearing his authentic NHL jerseys in the locker room, Schilling was 53–29—including 6–0 in the postseason (he also went 3–0 in 2007).

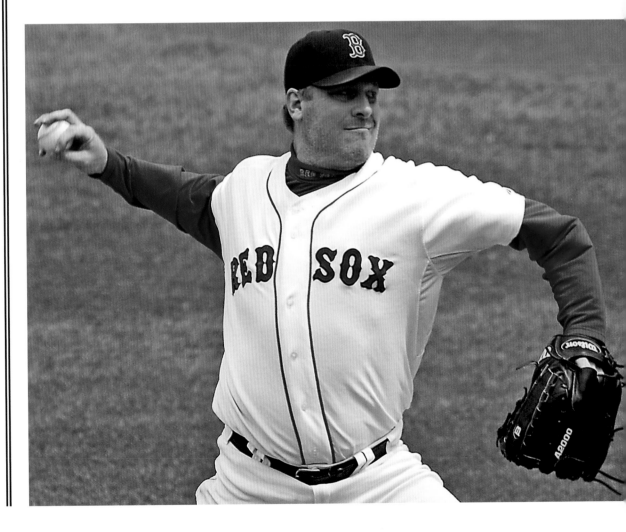

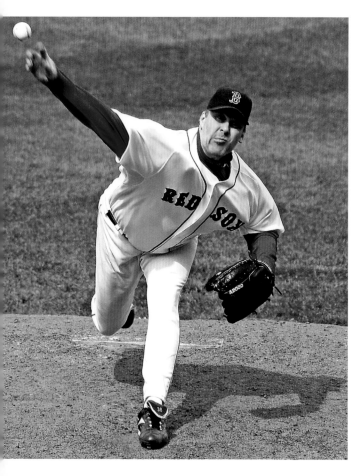

He was an on-the-cusp Hall of Famer as this was being written. His regular season record of 216–146 may leave him a bit shy in the eyes of some voters (even though Catfish Hunter and Don Drysdale, to name two, were 224–166 and 209–166, respectively).

But where Schilling clearly stood out was his 11–2 postseason record.

Schilling was upset over the way his career ended amid shoulder trouble in 2009. Talking in a 2016 interview about the Red Sox, he said, "They're up in the ivory tower and they're trying to pass judgment. They said things . . . that made me realize that they never gave a shit about me."

In his own autobiography, Martinez said: "Curt had a large personality and a lot of opinions on a variety of subjects, but I didn't spend any time listening or reading up on what he was saying to the media. I cared about him as a pitcher."

That, after all, was what Curt Schilling was all about.

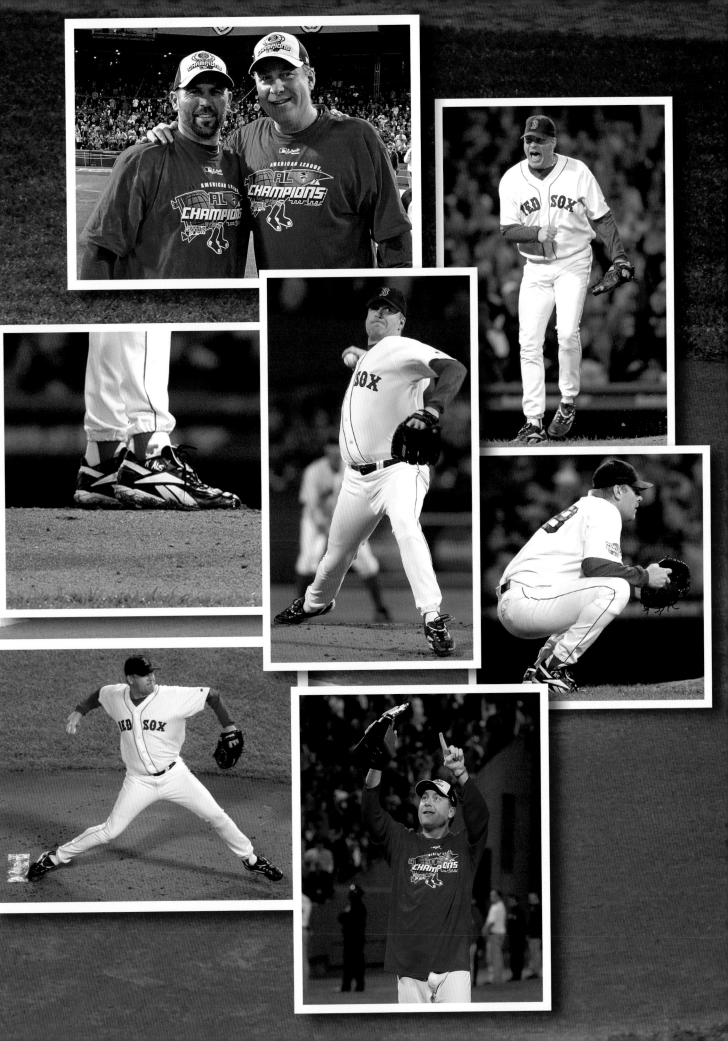

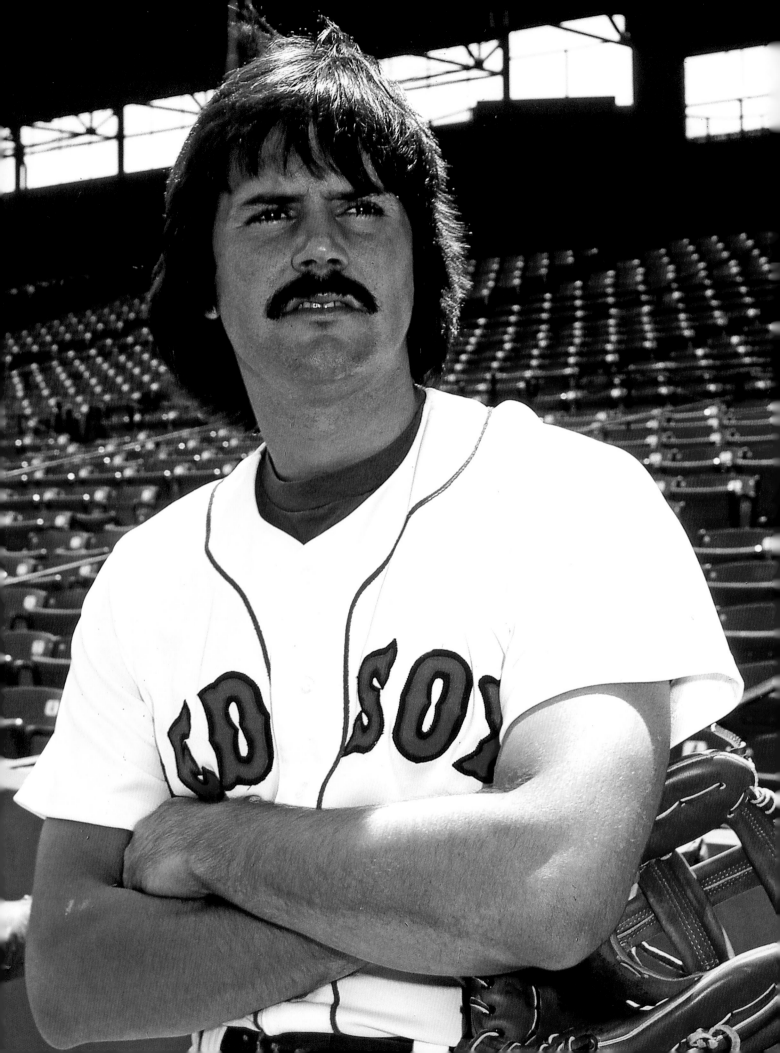

Eck

It can get lost in the shuffle because of what happened in the 1978 playoff game, with Bucky Dent hitting the fateful home run off Mike Torrez and Carl Yastrzemski popping up a Rich Gossage pitch to end the game. The disappointment among Red Sox fans everywhere, in response to their team blowing the huge lead, rebounding to come back, and then losing the one game.

What gets lost is what Dennis Eckersley did for that team.

After being acquired from the Indians, along with Fred Kendall, in exchange for Rick Wise, Bo Diaz, Ted Cox, and Mike Paxton, Eckersley came to Boston and went 20–8.

More important, he went 4–0 down the stretch, allowing three runs in 33 $2/3$ innings—the last three being complete games, one of them a shutout. He pitched a complete on the final Saturday of the season.

"Going into that playoff game, we had to win every day that last week . . ." Eckersley said in 2017. "I was peaking, we were peaking right there. I was excited—at that point the most excited that I had ever been in my career because we were on the verge."

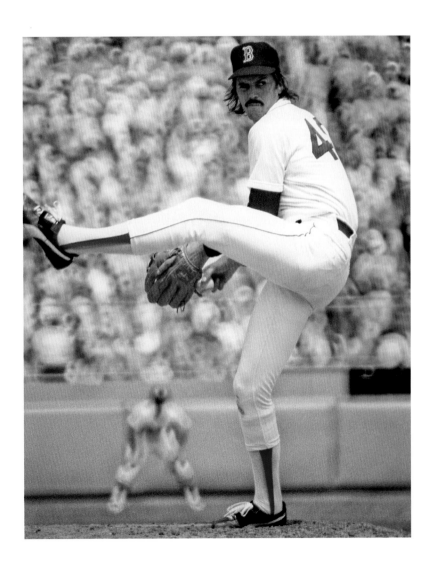

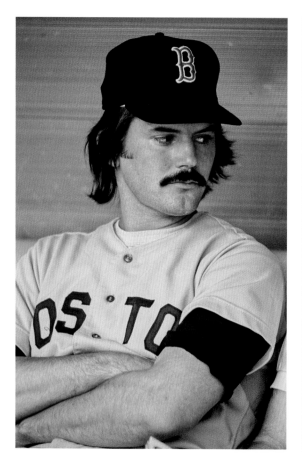
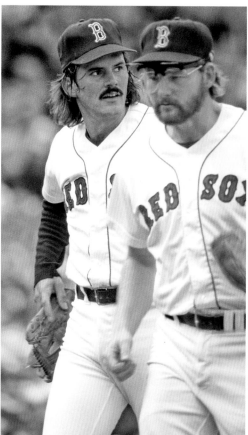

As you know, they didn't win the pennant—that year or any other during Eck's time in Boston. Lots of wins and nothing to show for it.

"We did [win a lot]," Eck said. "We just had a bad run—wild card, you never know. "What happened after that? I had a couple of good years and I just faded."

And wound up making it to the Hall of Fame, albeit with a different path.

After a stop with the Cubs, Eckersley, dealt for Bill Buckner in 1984, almost made it to the World Series again in 1984 (the Cubs blew a 2–0 playoff lead). He was traded to the Oakland A's in 1987—and made the transition into being one of the great closers of all time.

"The easiest thing for me was the fact I was kind of an aggressive kind of pitcher anyway and I'd been around the block and had better command," he said. "So you're better off being like that than being a raw twenty-year-old guy. If I had to do it when I was twenty, I would have had a tough time, control-wise.

"Then I got lucky to be in a situation where the manager [Tony La Russa] knows what he's doing. Just a good situation.

"I fought it for the first year. In '87 when I got to Oakland, I got over there at the end of spring training, they already had their rotation set. Tony said 'go to the bullpen and we'll figure it out,' so slowly but surely I was setting up Jay Howell . . . I'd pitch games . . . I'd come in in the second inning and go four, five innings—I did that a number of times. I was like doing everything.

"And then Jay Howell got hurt and then he let me do that the second half of the season. And then during the offseason we traded for Bobby Welch—Hello!!! Perfect—and Jay Howell was in that deal. So that was like . . . lucky. Not only that, I responded. I had a good year that year—I did everything and I was throwing strikes and the fastball came back, little spurts of it.

"If I had to go seven, I could—and I started a couple of games. I started two games in '87, one against Clemens, and I came out of the game with a guy on first—I'll never forget it—guy on first, two outs, I'm not going to be able to throw 120 pitches, because I've been in the bullpen. So he takes me out, guy on first, two outs in the seventh, 2–2 game, Gene Nelson comes in and gives up a bomb, I get the damn 'L.'"

That year was the prelude to the A's going to the next three World Series, winning one.

"I was very lucky to find that situation and to be on the ground floor of that whole team, right?" Eck said. "We turned it on, '88, '89, '90. There's luck involved but I was ready. I was sober and ready. I got sober that offseason. The timing was unbelievable."

Standing at the podium making his Hall of Fame speech, Eckersley, who has gone on to be a talented and straight-shooting TV analyst, thought about what he'd been through and how he could have thrown it away.

"I got help and then the next 12 years of my life led to being in the Hall of Fame—and I could have fucked it all up right there," he said. "I mean, I know that."

As far as getting help for his drinking, he said, "I think you, personally, have to . . . somebody can tell you, 'Hey, man, you're having problems, but you gotta want to do it because ultimately it's not gonna last if you don't wanna do it. It was the threat of losing EVERYTHING, marriage and everything."

Kevin Millar

Today's fan knows Kevin Millar as the crazy shoot-from-the-hip guy on television.

He has pretty much always been the same.

His "Cowboy Up" cry helped Millar and his band of "idiots" to the 2004 World Series title—something, by the way, that likely never could have happened had Millar not drawn a walk from Mariano Rivera leading off the ninth inning of Game 4 of the ALCS.

"The group of guys, the family, it wasn't just a team," Millar said in 2012. "It was a unit that literally hung out together and ate together and liked each other. You can't buy that."

Millar came to Boston after first committing to play in Japan. He played 12 years in the major leagues, but only three of them in Boston, where he hit .282 with 52 homers and 220 RBIs.

In 2017, in typical Millar fashion, he hit a home run in an independent league game in his only at-bat for the St. Paul Saints. He was 45 and facing live pitching for the first time in seven years.

"I don't know what just happened," Millar said. "It must have been the smelling salts!"

Mike Lowell

It's funny how things work out.

Back in 2005, when Theo Epstein and the Red Sox were having separation issues, the substitute Sox brass, led by veteran baseball man Bill Lajoie, talked trade with the then-Florida Marlins.

The Red Sox wanted Josh Beckett. The Marlins wanted prized Boston prospect Hanley Ramirez. They also wanted to get rid of salary—and Lowell, coming off a disappointing year in his first season with the Marlins, was due $36 million over the next two years.

Boston accepted Lowell, along with Beckett and reliever Guillermo Mota from the Marlins for Ramirez, Anibal Sanchez, Jesus Delgado, and Harvey Garcia.

"It's not that we had to take Mike," Lajoie told the *Boston Herald*. "It's that we wanted Mike."

The sincerity was questionable, but oh did this turn out to be a great trade for Boston.

Asked in early 2017 if the Marlins allegedly wanting to get rid of him pushed him a little harder in Boston, Lowell said, "Overall, yes. I think anyone would be lying [if they claimed otherwise] . . . So yeah, I think there was motivation from myself to prove that that's not true, because you do hear, 'Oh, his bat speed is slower,' and this [and that], and I said, 'Well, I never saw one person with a bat speed monitor out, you know, while I was taking batting practice.' So . . . it's only natural to be motivated to prove people wrong because I think it's easy to jump on the bandwagon when guys are struggling to say, 'Oh, I saw it,' or 'This guy's career is on the downswing.' I was 31 as well—it's not like I was 39 and toward the end of my career.

"So absolutely, there was motivation. I don't think it made me do anything different. I just think I might have relished successes a little bit more."

While Beckett struggled in '06, Lowell, a solid fielder who won a Gold Glove in '05, hit a respectable .284 with 20 homers and 80 RBIs. If the doubts were silenced during that season, they completely disappeared the next year, when Lowell hit .324 with 21 homers, 120 RBIs, and an .879 OPS.

Oh, and Lowell went 6-for-15 with a homer and four extra base hits and was named the MVP of the World Series—thus ensuring he would never have to purchase a drink again in or around Boston.

"I think everything coming together, and for me the part that I loved the most—besides winning the World Series—was when Manny [Ramirez] went down in the second half and I hit cleanup for a little while, I still was able to put up good numbers. So I felt like, not that I'm going to replace Manny, but that we had a good enough team that if someone went down we'd still be really good.

"When you have a good season and then you go into the postseason, I think if you prove that you can play when the games mean the most, I think you truly have been able to put your mindset, your performance of the regular season into the postseason. I think a lot of guys at times make the moment bigger than it is and they try things different. So being able to come through, I guess on a bigger stage, and be a big part of winning a championship is as rewarding as anything I've ever experienced as a baseball player."

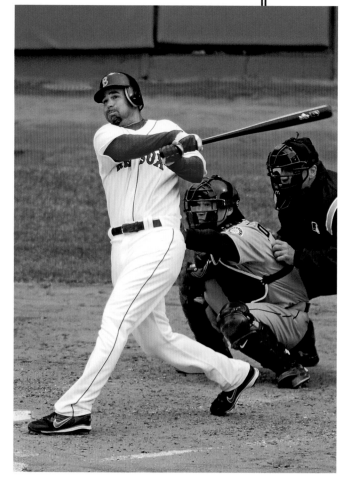

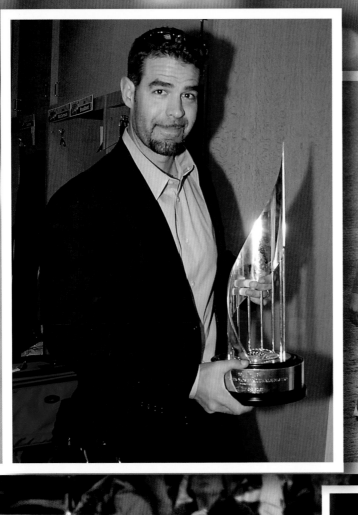

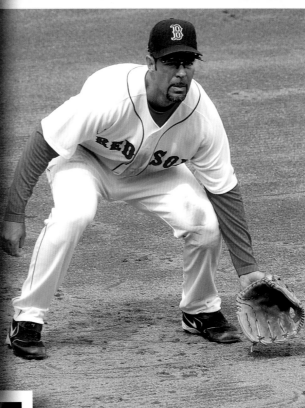

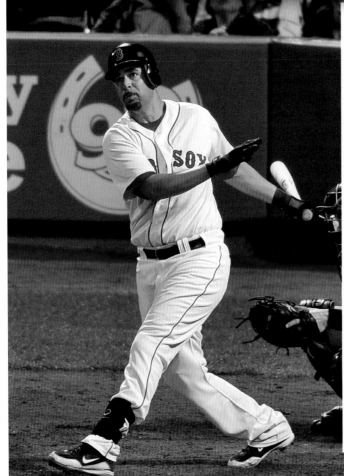

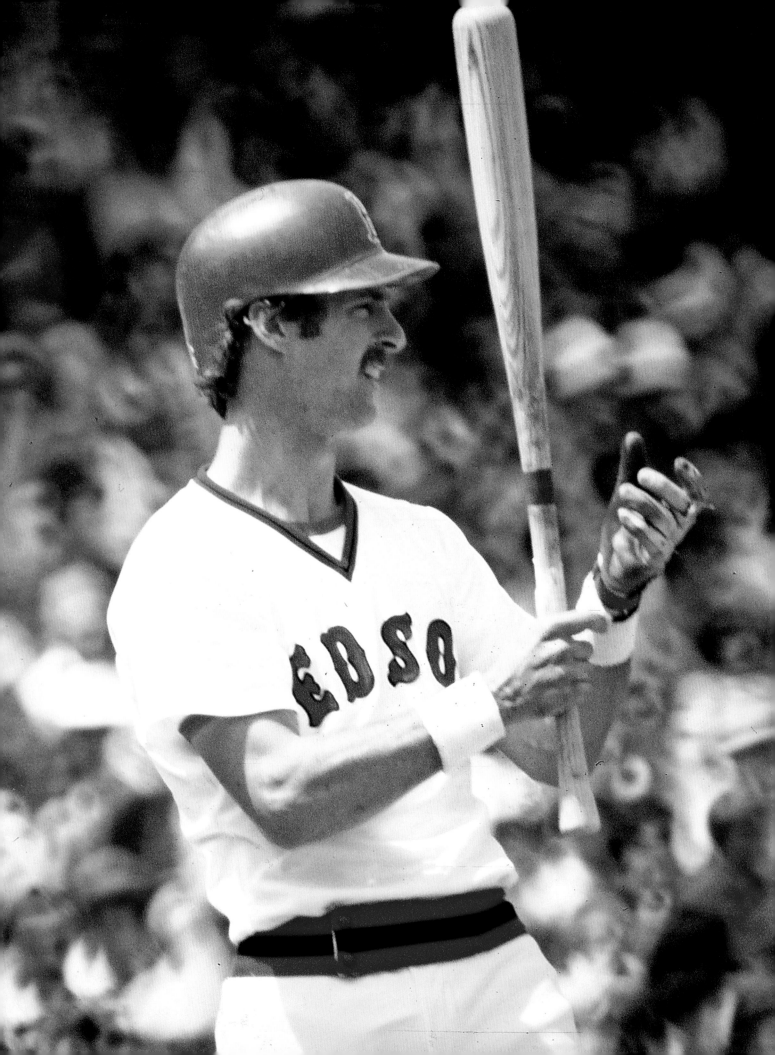

Rick Burleson

Don Zimmer knew what kind of player Rick Burleson was soon after taking the managerial job in Boston.

In his book, *Zim*, written with Bill Madden, Zimmer wrote, "Burleson, who got the nickname 'Rooster,' because of his fiery and aggressive style of play, became an immediate favorite with the Boston fans."

The problem with Burleson and the Red Sox was that the marriage ended after those seven seasons—as Burleson got caught up in the financial housecleaning that shuttled Carlton Fisk, Fred Lynn, and Burleson out of town.

None of which surprised the shortstop.

"[Owner] Haywood [Sullivan] had said that even though they signed us in '76, he had said when the contract runs out they wouldn't re-sign us," Burleson said in a phone conversation in 2017. "He held up to his end of that.

There was a silver lining to going to the Angels, however.

"When I got traded, I got traded to my hometown, and obviously I'm glad it was that rather than going to a Cleveland or a Minnesota or a place . . . at that time they did NOT have a chance to win. It looked like the Angels were going to try to build and they did."

But Burleson wanted Boston.

"After seven full years there I would have liked to have played another seven there and finished my career," he said. "That's the way I felt about it and felt like I had a following and we . . . even though we always came back to California because our families were here, during the offseason, that was our baseball home and that's where I felt like we belonged."

During his time in Boston, Burleson was part of very good teams, one that went to the World Series and another that tied for the AL East and lost the playoff game to the Yankees.

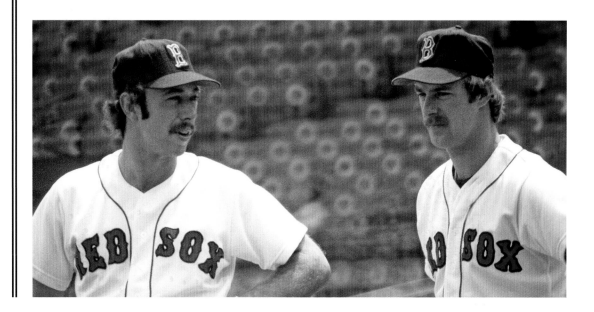

Like others quoted in this book, things didn't go well for Burleson after he left Boston. The Angels as a team didn't play well in 1981, and Burleson missed all but 10 games in 1982 with a torn rotator cuff.

"Those were two tough ones for the Angels, but in the middle there I came back in the middle of '83, reinjured myself, which cost me all of '84. I was ready to play in '85 and ended up hurting myself again somehow, I forget, separated my shoulder or something working out, but finally made it back for the '86 season.

"By then, I was only used part-time."

Speaking from his California home, Rooster said, "Even though we live here, my thoughts and memories are obviously in Boston."

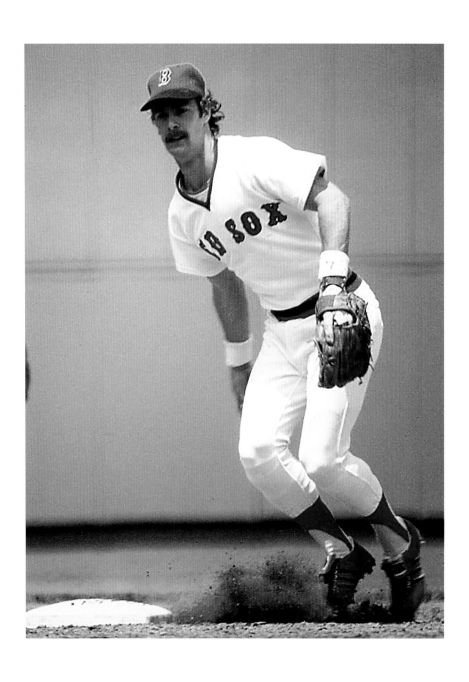

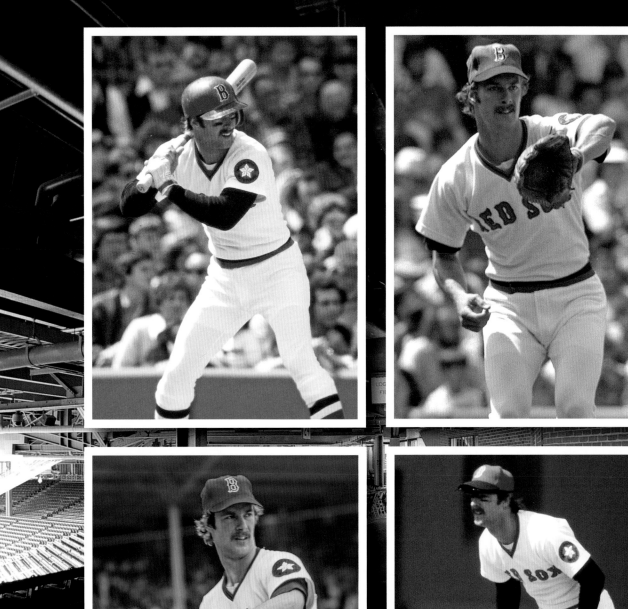
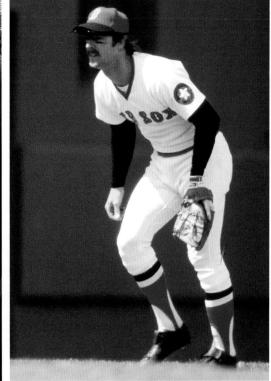

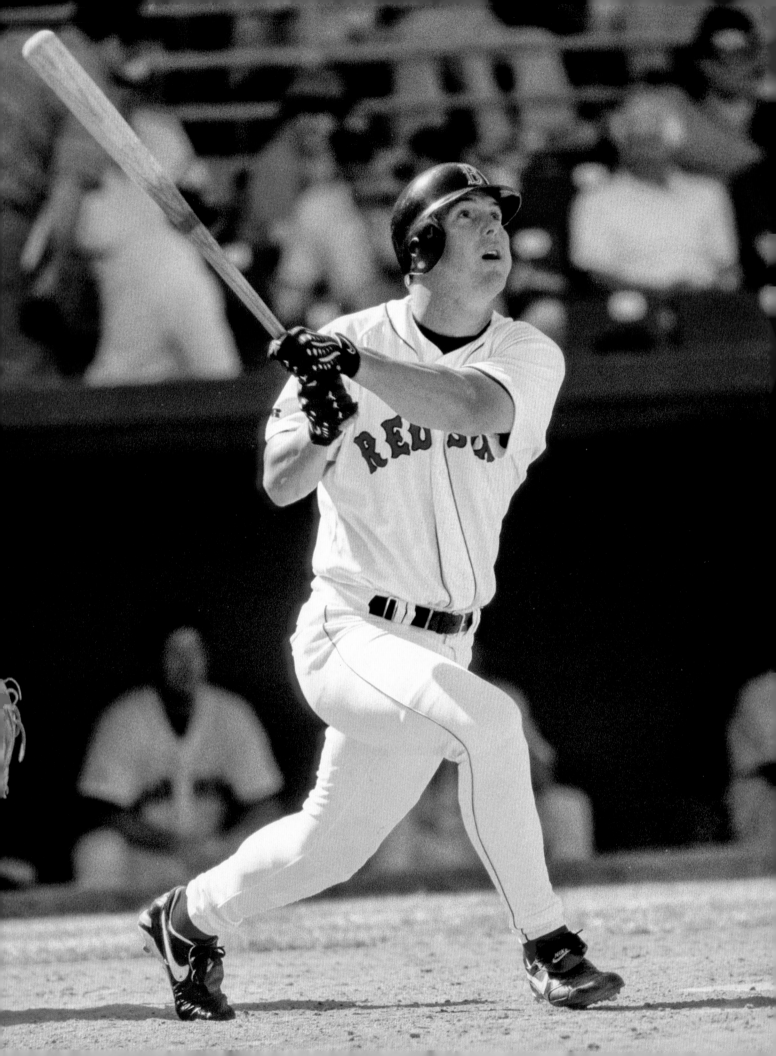

Trot Nixon

Christopher Trotman Nixon left the football field for the baseball diamond.

Literally.

Nixon, the 1992 North Carolina high school player of the year, was set to play quarterback for North Carolina State when the Red Sox made him the seventh pick in the baseball draft. He was on campus, ready to go, and changed his mind.

The future Red Sox right fielder left football for baseball and ultimately helped end the 86-year title drought.

"It was a tough decision," Nixon said five years after leaving football. "Sometimes when I watch football when August comes around, you get that little tingle that it's football season, you know. I miss it sometimes, but I'm happy."

He played 10 years for the Red Sox, batting .278 with 133 homers, 523 RBIs, and an .845 OPS. He then played a year in Cleveland, where he batted .251 in 99 games and went 5-for-11 in the 2007 playoffs, including 3-for-7 against the Red Sox in the ALCS.

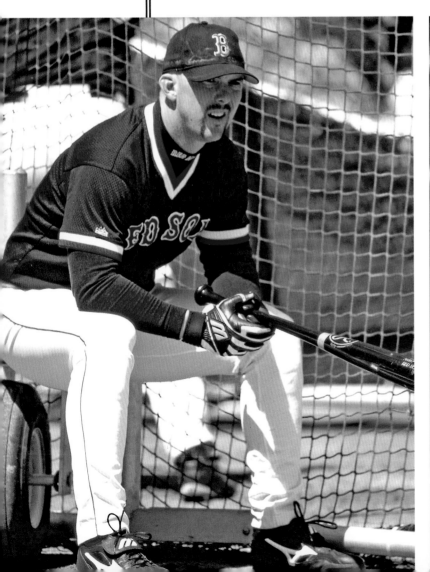

His time with Boston was well spent and included a 5-for-14 showing in the '04 World Series. Nixon was a fan favorite, the home crowd even willing to overlook the occasional strange play—like when he tossed the ball into the stands thinking there were three outs in an inning, when there were only two in a 2011 game.

The play turned a close game into a blowout, Nixon saying later, "It was a mistake I made that caused that inning to get way out of hand. I've made mistakes before, and I can bounce back from them."

But that was part of the Nixon charm. He always looked like a football player playing baseball.

"You look at him now, and he's a completely different person than he will be at 7:05," teammate Derek Lowe said before a 2001 game. "No human can have his intensity all day long."

Added teammate Brian Daubach: "He can snap with the best of them, but everything he does is to help the team win."

He did more than *help* in the 2003 ALDS, when he hit a pinch two-run homer off Rich Harden in the 11th inning to give the Red Sox a 3–1 win over the Oakland A's, keeping the series alive. The Red Sox won the next two games.

"It seemed like Trot's at-bat was in slow motion," teammate Johnny Damon said. "You just kind of felt he was going to do something special."

In 2011, ESPN.com ran a piece ranking the then-42 postseason walkoff homers—rating Nixon as No. 23.

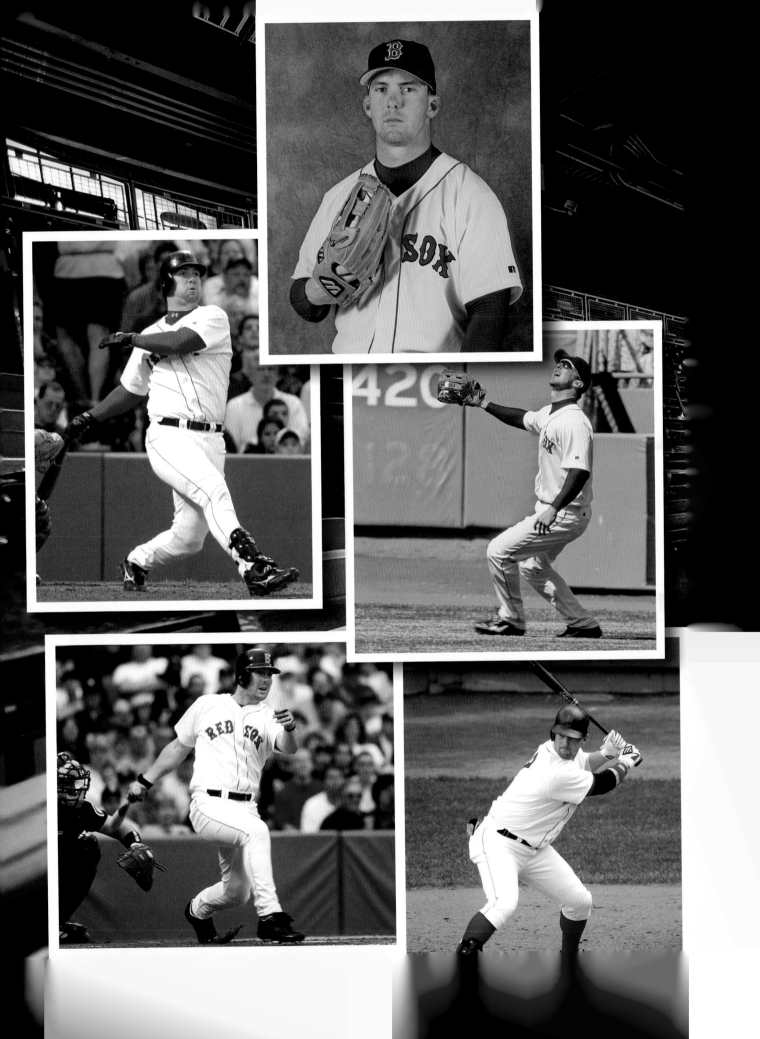

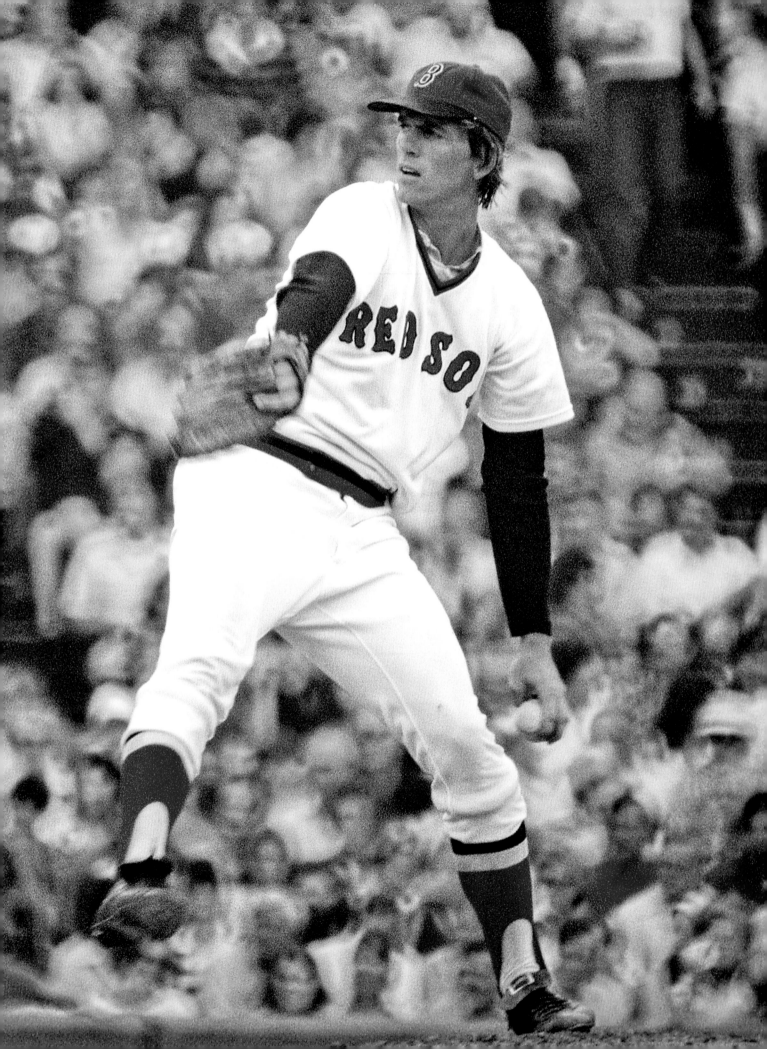

Bill Lee

Bill Lee has had a love/hate relationship with baseball but a love affair with the fans and most of the players he played with. The man they called Spaceman pitched for 10 years in Boston, going 94–68 with a 3.64 ERA. He pitched in the World Series and got burned with a slow-pitch softball pitch—an Eephus—that Tony Perez clobbered for a two-run homer that got the Reds back into Game 7 of the 1975 World Series.

"His father is here tonight, and he says Bill Lee is not as far out in space as everyone says he is," Curt Gowdy said as Perez came up. "He says, 'Sometimes I don't understand him, but he's a very sensitive, intelligent young man who's a lot of fun to be around.'"

Then came one of the most infamous pitches in Red Sox history. He struck Perez out with it in Game 2, and Perez's teammates laughed at him.

This time, no one was laughing.

"He almost looked like he was waiting for it," Tony Kubek said on NBC. "You wonder if [Johnny] Bench had something to do with it, down on second relaying signs."

Perez said it was a hitch in Lee's delivery that told him what was coming.

The Reds won the game and the World Series.

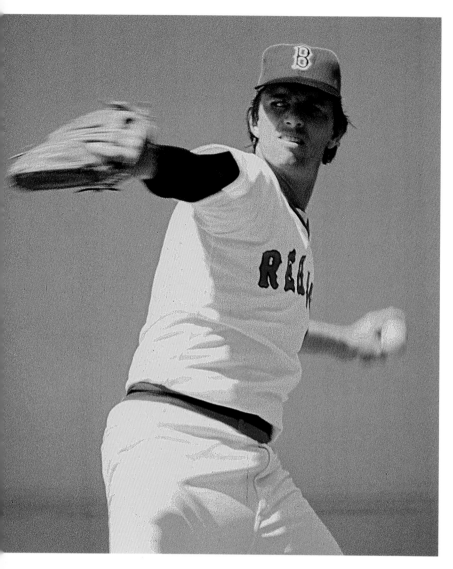

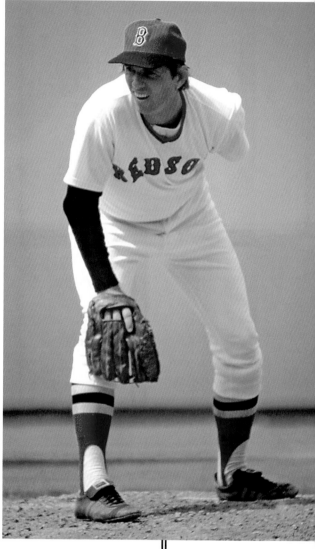

Lee then had a stormy relationship with Don Zimmer when Zim took over for Darrell Johnson. Lee is the one who nicknamed Zimmer "Gerbil," and he clearly wasn't one of Zim's favorites.

"I can't stand him," Zimmer told Gordon Edes. "I've been in baseball [for more than 60 years], and he's the only man in baseball I wouldn't let in my home."

The Spaceman.

"I would change policy, bring back natural grass and nickel beer. Baseball is the belly button of our society. Straighten out baseball, and you straighten out the rest of the world."

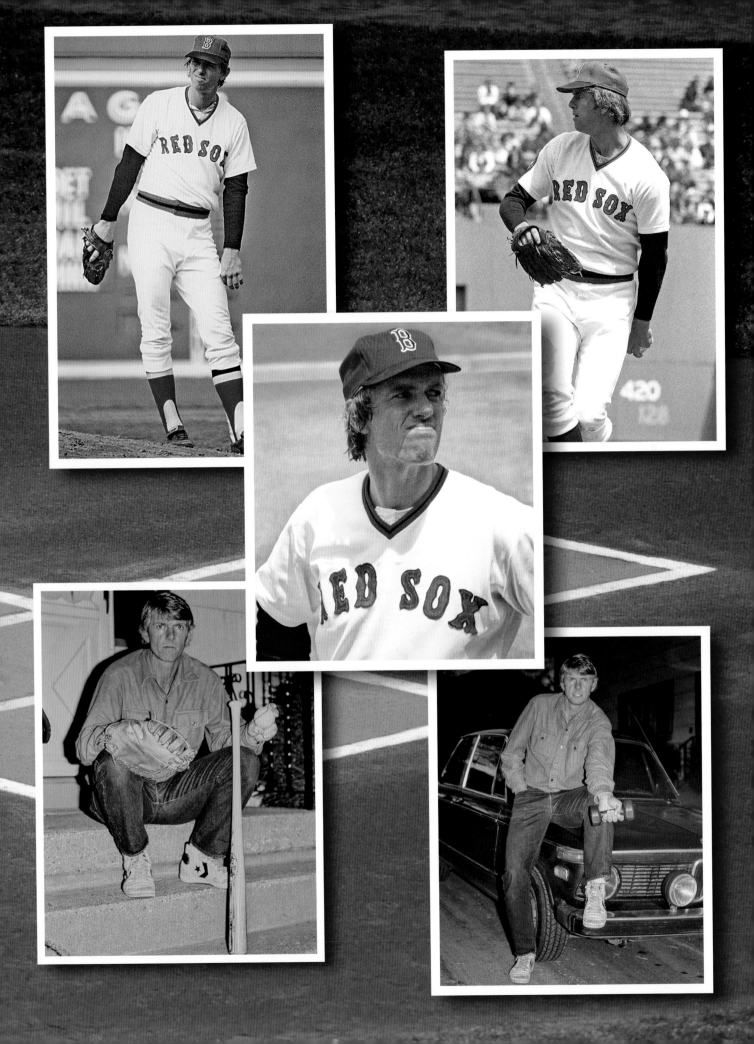

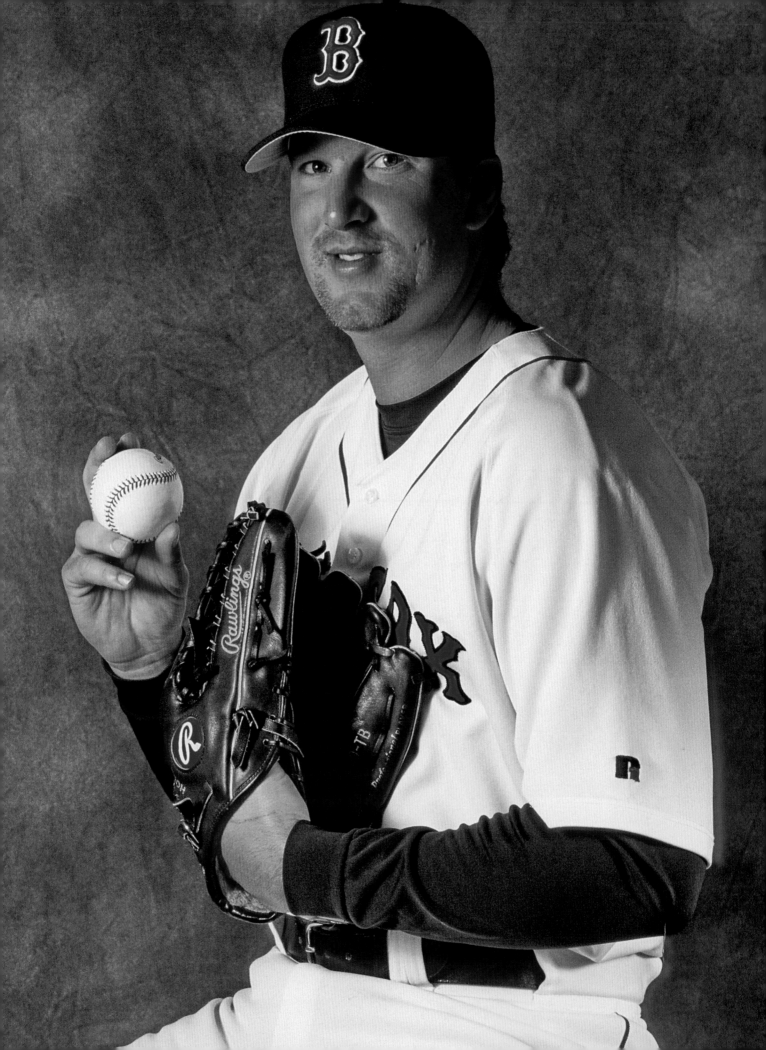

Derek Lowe

On July 31, 1997, Dan Duquette sent closer Heathcliff Slocumb to the Seattle Mariners in exchange for young catcher Jason Varitek and right-hander Derek Lowe.

The best trade in Red Sox history?

Certainly one of them.

Varitek, of course, became the team captain and backstopped the first two World Series titles. Lowe? Well, he did just about everything for the Sox in his eight years.

Need him to close? He led the American League in saves with 42 in 2000. Need him to start? He went 21–8 in 2002. Need him in the postseason? He was 3–0 in the 2004 postseason that ended the 86-year title drought.

In short, Derek Lowe was a competitor, a guy who would finish his 17-year major league career with a 176–157 record and 86 saves, 85 of those with the Red Sox.

Tim Wakefield did everything for the Red Sox. So did Lowe.

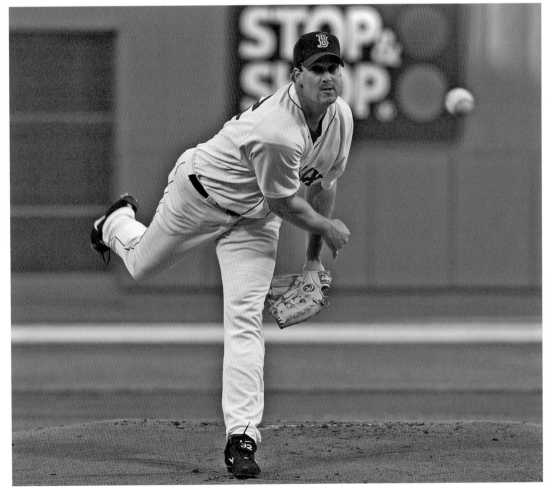

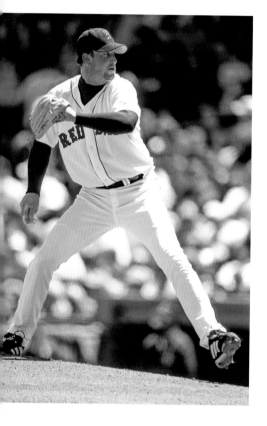

It came to an end in 2013, with Lowe saying, "I'm officially no longer going to play the game. It's still enjoyable, but the role I was having wasn't fulfilling.

"Like I told my dad, I'll never retire. If you're not playing, it's completely self-explanatory. I'm not going to go to the Hall of Fame, so I don't feel like I need to have a retirement speech."

That was the essence of Derek Lowe, who holds a rather underappreciated place in Red Sox history.

He was 70–55 in his eight years in Boston. Later, he led the National League in wins with 16 in 2006 (though he also led the NL in losses in 2006).

After his no-hitter at Fenway in 2002, Lowe said, "It's surreal. I still don't think I did what I did, as crazy as that sounds. I still think it happened to somebody else because you don't ever think something like this can happen to you."

And Varitek was the catcher, completing a circle of sorts for the pair.

Apprised some of his equipment would be headed for Cooperstown, Lowe, in typical Lowe fashion, said, "Now, I can go there and see a grubby old hat and a pair of shoes and say, 'Yeah, I pitched a game to get in there.' That gets you a little bit because whoever thought that would happen to anybody?"

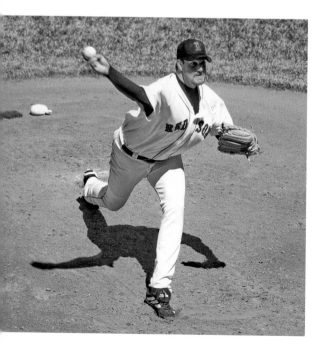

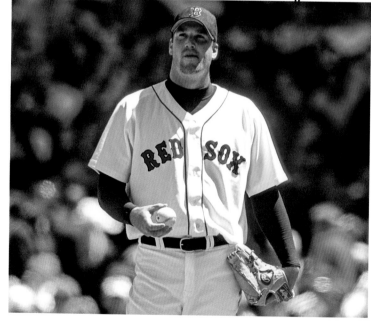

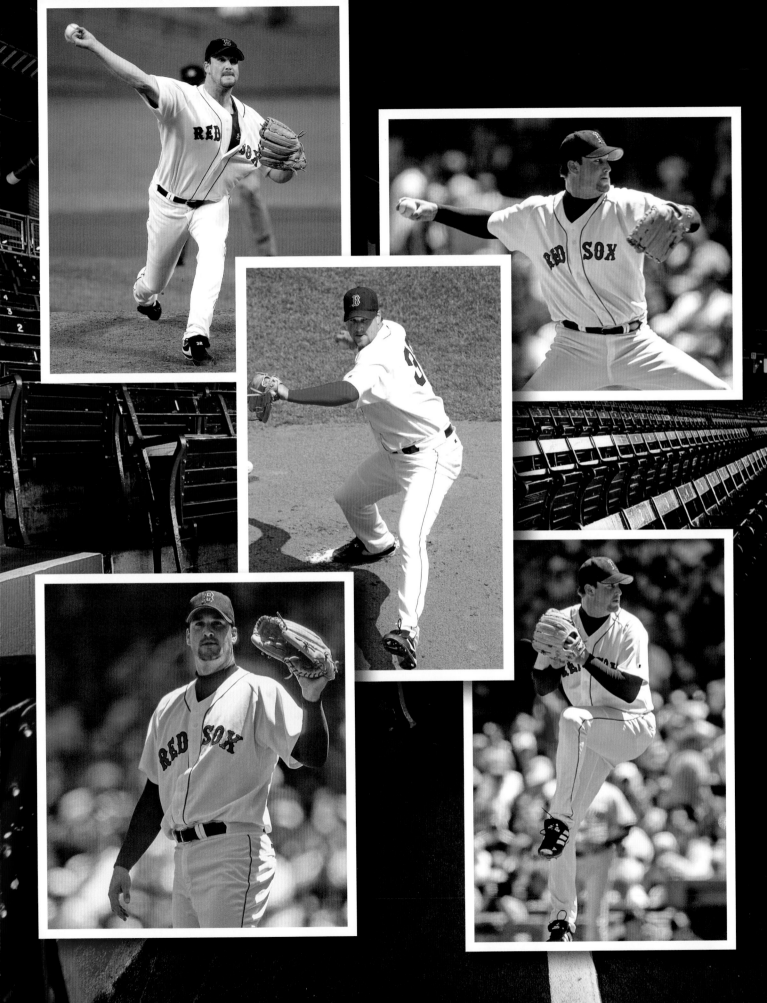

George Scott

Biographer Ron Anderson said George Scott was misunderstood during his playing career.

"George was a man of great character," Anderson told Gordon Edes, then of ESPN.com, after Scott's death in 2013. "He felt misunderstood. He didn't think the game gave him a chance it should have given. Some people say George Scott wasn't very smart. He was not a greatly educated man; there were a lot of malapropisms.

"But if you listened carefully, there was a great deal of wisdom."

There was also a career—including two stints with the Red Sox—that produced 271 home runs, 1,051 RBIs, and eight Gold Gloves, earned with a glove he called "Black Beauty."

When the Milwaukee Brewers, a team that benefitted so much from Scott's stay in that town, issued a bobblehead of Scott, it had a pile of Gold Gloves on the minifigure.

Scott, known as Boomer, was a very big man who, according to anyone who ever knew him and spoke of him, had a giant heart. That heart, unfortunately, was broken when he was never offered a job in baseball after his playing days had ended.

"I think he spent a lot of time waiting for that phone call that never came," Anderson told Edes.

George Scott played nine of his 14 major league seasons during his two tours with the Red Sox. He hit .303 with 19 homers and 82 RBIs in the Impossible Dream season and was just 6-for-26 with no homers and no RBIs in the World Series. He slumped in '68, and a strained relationship with manager Dick Williams continued.

Strangely enough, the pair went into the Red Sox Hall of Fame together in 2006.

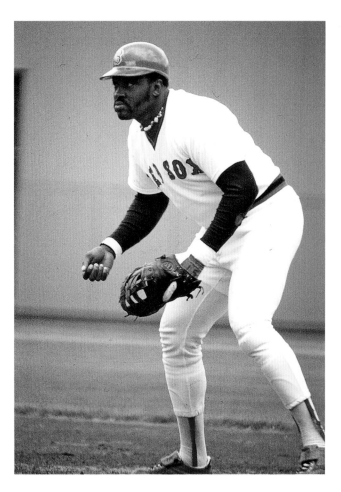

In 1975 with the Brewers—in a year that saw the Red Sox go to the World Series—Scott hit .285 with 36 homers and 109 RBIs, leading the American League with his career-high power numbers.

On October 10, 1971, Scott, Jim Lonborg, Billy Conigliario, Joe Lahoud, and Don Pavelich were sent to Milwaukee in exchange for Tommy Harper, Marty Pattin, Lew Krausse, and Patrick Skreble.

On December 6, 1976, Scott and Bernie Carbo were shipped to Boston for Cecil Cooper.

Scott hit 33 homers and drove in 95 runs for the 1977 Red Sox but was gone, to Kansas City, during the 1979 season. His career was winding down.

After Scott's death, Bruce Markusen of the *Hardball Times* wrote:

"Scott's weight, helmet [worn in the field], and necklace tended to distract from one other important consideration: He was a very, very good player. Amazingly agile for a man his size, Scott's quickness, footwork, and soft hands made him arguably the best defensive first baseman of the late 1960s and early 1970s. [Perhaps only the Dodgers' Wes Parker was better.]"

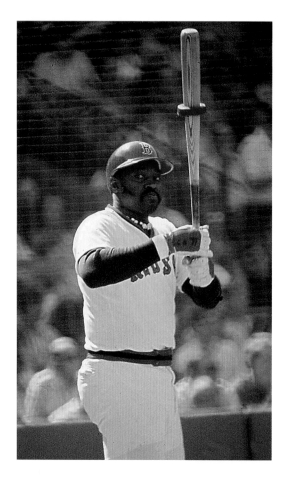 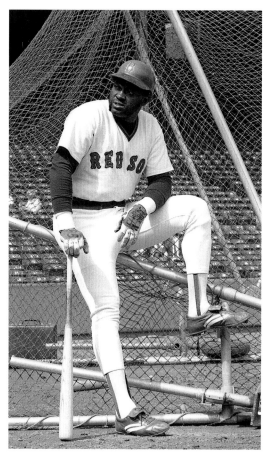

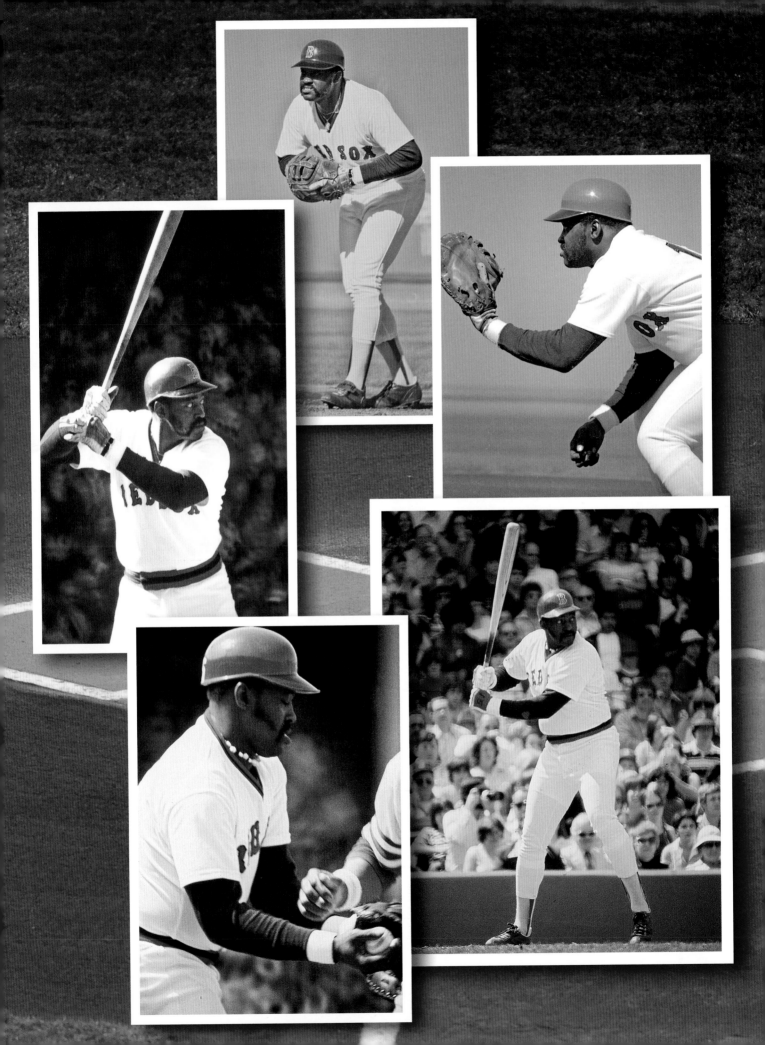

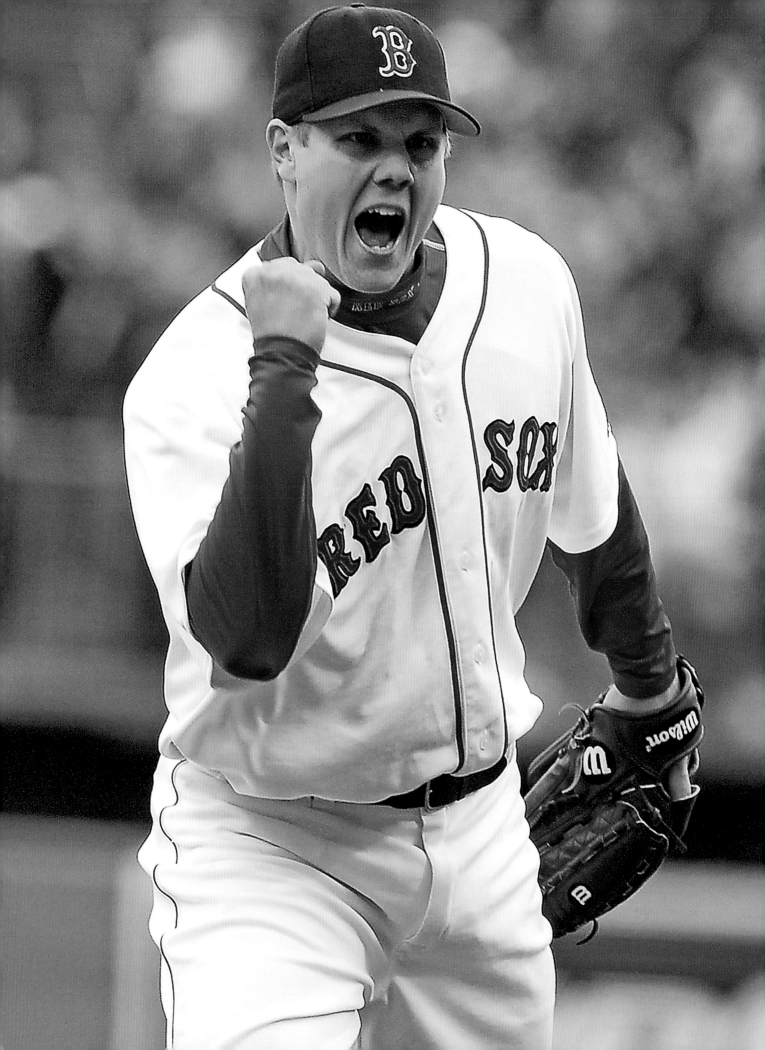

Jonathan Papelbon

He didn't leave under the best of circumstances, but Jonathan Papelbon certainly left his mark on Red Sox history—and took a World Series ring with him.

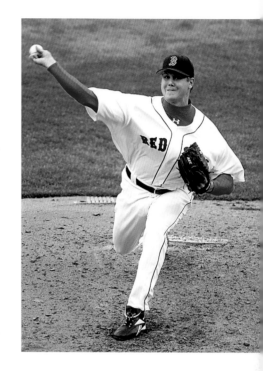

Until the Angels beat him up in the third and clinching game of the 2009 ALDS, Papelbon hadn't allowed a postseason run. In 2007, he pitched 10 $\frac{2}{3}$ scoreless innings in the playoffs and World Series, saving three games against the Rockies in the four-game World Series sweep.

He had 219 regular season saves in seven years with the Red Sox.

In 2016, after his release by the Washington Nationals, there was talk of Papelbon returning to Boston. David Ortiz even said he would welcome the reliever back. It never happened, though, and Papelbon's MLB career was over.

Papelbon had the ball that ended the '07 World Series—a valuable keepsake for any athlete. But the ball . . . well . . .

"My dog ate it," Papelbon, whose dog, Boss, loved to play with baseballs, told the *Hattiesburg American*. "He plays with baseballs like they are his toys. His name is Boss. He jumped up one day on the counter and snatched it. He likes rawhide. He tore that thing to pieces.

"I'll keep what's left of it."

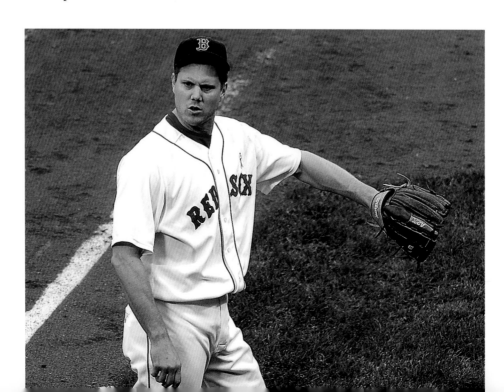

But he also told NESN he tossed what was left of the ball in the trash.

Ahhh, the world of Jonathan Papelbon, whose scary stare into home plate, with his mouth forming a circle, was part of the image that led to him becoming a dominant major league reliever.

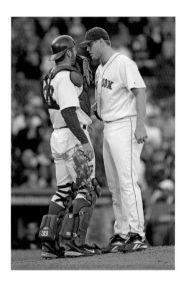

He charged past Bob Stanley and set the Red Sox record for career saves. But his Red Sox career ended when he served up the hit that capped the team's epic collapse in 2011. He, like his team, slumped down the stretch.

"I don't think this is going to define me as a player, I don't think this is going to define this ballclub," Papelbon said that night. "I've always been one to bounce back. I'm not worried about myself, I'm not worried about anybody else in this clubhouse about bouncing back next year and going after it again."

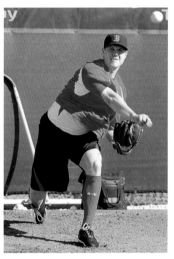

But that was not to be—not with the Red Sox, anyway. Papelbon signed with the Philadelphia Phillies during the offseason. His time in Boston had come to an end.

He then went on to also set the Phillies' career saves record (123) before moving on to Washington.

Through the end of the 2017 season, Papelbon's 368 career saves had him ninth on baseball's all-time list, one ahead of Jeff Reardon.

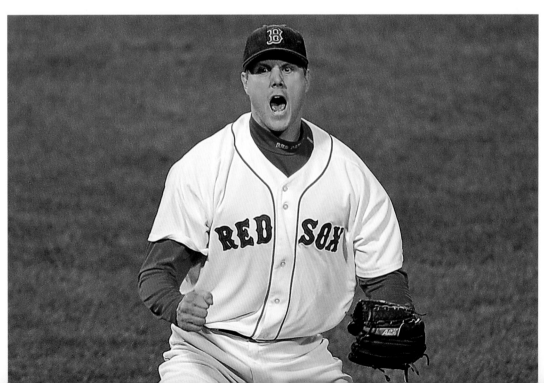

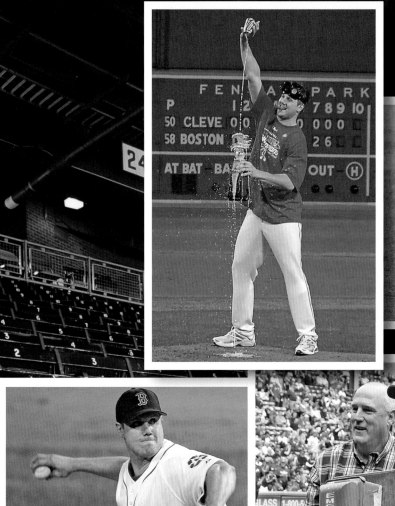

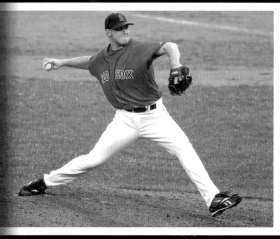

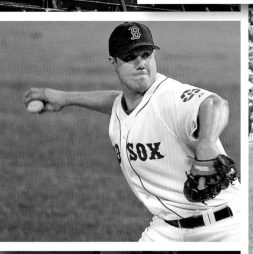

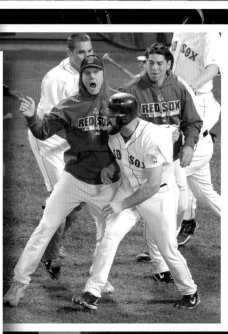

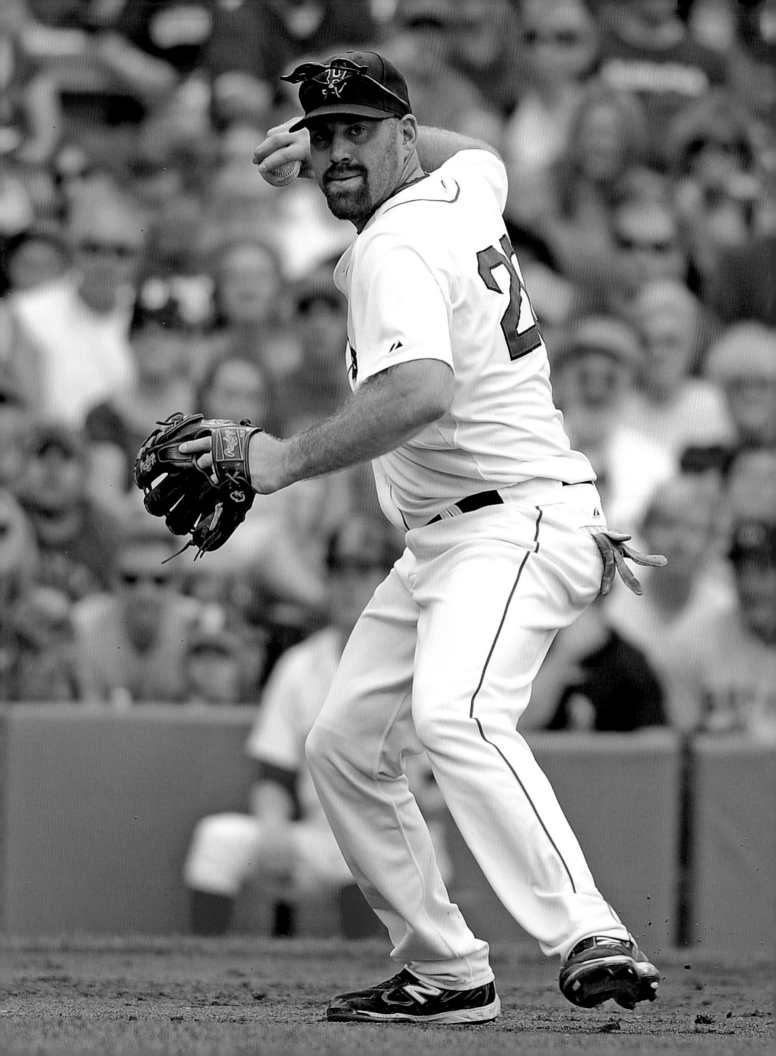

Kevin Youkilis

Tom Brady's brother-in-law also happened to be a pretty good baseball player.

He earned two World Series rings with the Red Sox and then got another as a member of the Cubs' front office after that franchise also ended its seemingly endless World Series title drought.

"I got spoiled rotten again with another ring," Youkilis, married to Brady's sister, told Kevin Thomas of the *Portland Press Herald* in 2017. "I've been very fortunate to see some World Series championships . . . and a few Super Bowls."

Youkilis started his major league career with a call-up and then a spot on the postseason roster. He made only one appearance in the postseason but would soon be a Fenway mainstay—playing both third and first base for the Red Sox.

Blessed with the ability to draw walks, earning him the nickname "Greek God of Walks," Youk was about more than walking. He batted .281 with 150 homers and 618 RBIs over the course of his career. From 2008 through '10, he batted .312, .305, and .307, hitting 75 home runs and driving in 271 runs.

And of course, he was right in the middle of the 2007 title, winning a Gold Glove at first base that season.

"Funny how that team does not get talked about as much as 2004 or 2013, but it was a really talented team," Youkilis told Thomas.

He was a three-time All-Star, finishing third in the 2008 MVP race and sixth the following season. He also hit .306 with six homers and 17 RBIs in 29 postseason games.

In the '07 ALCS, Youkilis hit three homers and drove in seven runs, missing out on the series MVP award to teammate Josh Beckett (2–0 in two starts).

Back trouble would eventually lead to the end of Youkilis's career.

Asked about missing being on the field, Youkilis said, "No, not at all. The grind of a major league season . . . I'm a family man. I love being around my kids.

"If I could hit BP now and then. Other than that, I'm good."

When his career began, Youkilis was a surprise to many—because of his body type, his unusual batting stance, etc.

"At first glance, not a lot [was impressive]," former Red Sox scorer Matt Haas said of Youkilis. "He was unorthodox. He had an extreme crouch—his thighs were almost parallel to the ground. And he was heavier than he is now. But the more I watched him, the more I just thought, 'Throw the tools out the window. This guy can play baseball.'"

And at least now he knows there won't be any Joba Chamberlain fastballs gunning for his head. For some reason, Chamberlain had a penchant for throwing at Youkilis.

Naturally, they wound up as teammates with the Yankees in 2013.

"I left him a voicemail," Chamberlain said in 2013. "No, he did not call me back.

"I did everything I could and I can't control what Kevin Youkilis does. Am I surprised [he didn't return the call]? Not really. I'm bound to run into him at some point—sooner, rather than later, I'm assuming. We'll see what happens."

But soon after, Chamberlain, who was suspended two games for throwing at Youk, received a text message from his new teammate. As Joba explained, "It's one of those things where people made it a bigger deal than it was. There's nothing to it. There's nothing between us. I'm glad to have him on our side. We're two grown men. We're playing on the same team. Our one goal is to win."

Youkilis was only able to appear in 28 games for the Yankees, his back and foot forcing him out of the game after back surgery and a stay in Japan.

Talking about playing overseas, Youkilis, who officially saw the end because of a foot injury, told Jen McCaffrey of MassLive: "It was more of just trying to do something unique. It was nice for my family, it was a cool experience."

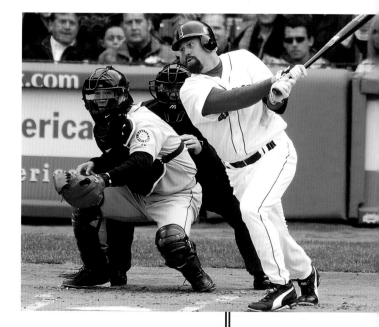

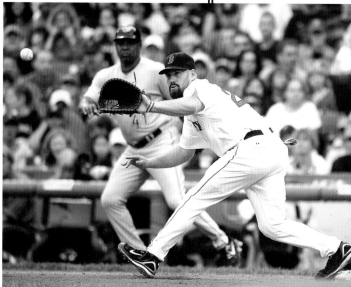

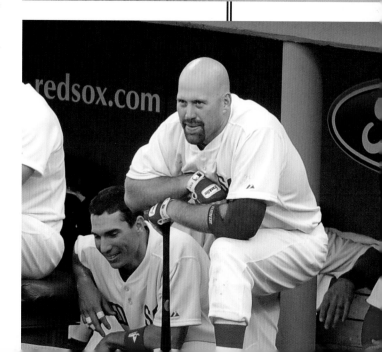

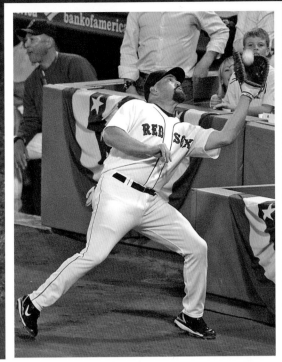

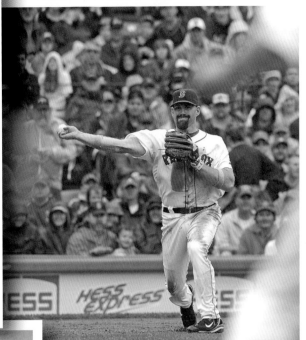

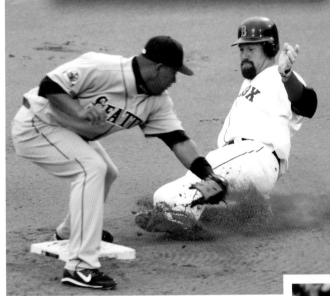

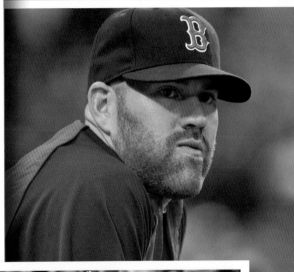

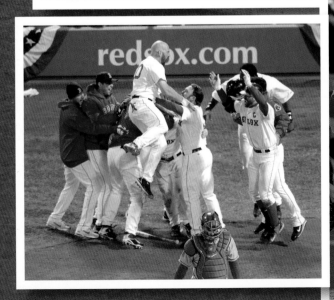

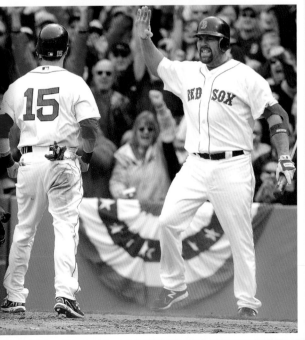

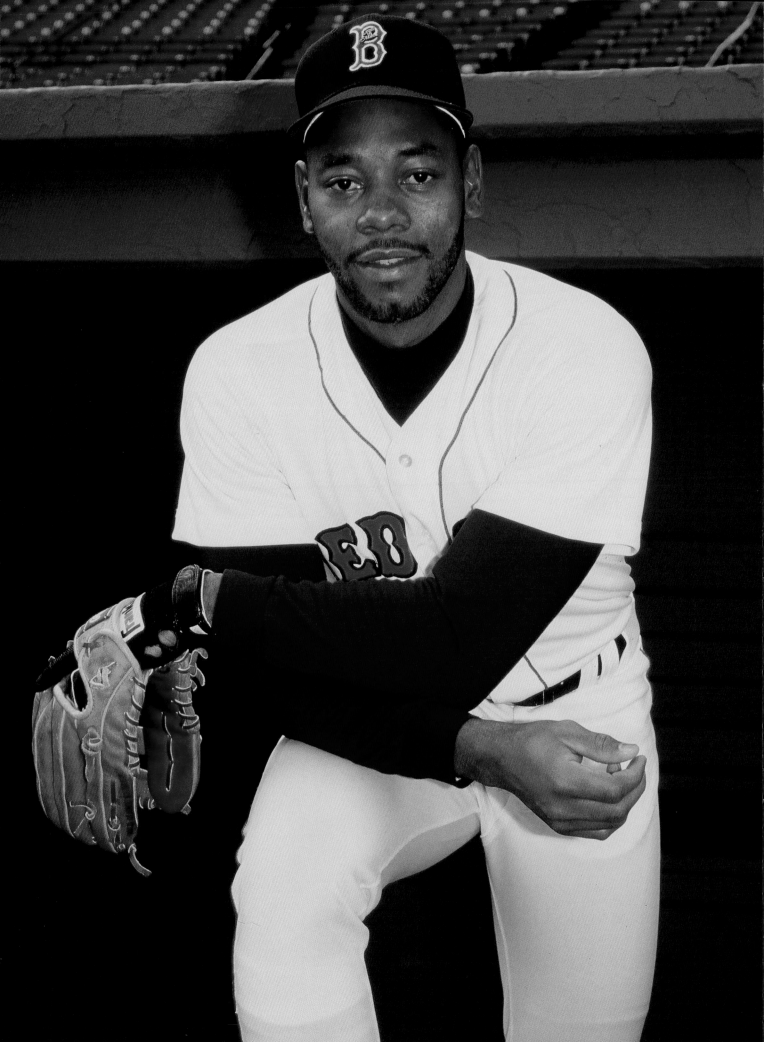

Ellis Burks

Ellis Burks thought he might be going back to the minor leagues after his first game with the Red Sox.

Instead, he stayed in the major leagues for eighteen years, finally retiring at age forty, on his second, albeit abbreviated, stay with the Sox.

His first game, in 1987, was in Seattle. He went 0-for-3 with a strikeout, didn't come up with a shoestring catch of a line drive ("It hit in my glove and came out"), and then, playing the first game of his career on turf, took a "terrible angle" to a ball and played it into a triple.

Not a great debut.

"I thought for sure I was getting sent out," Burks said by phone in 2017. "Johnny Mac called me into the office after the game and I'm like, 'Oh my God I'm already getting sent outta here?' But he says, 'You know what, kid, that was a tough game for you but don't worry about it,' he says, 'because you're gonna be here for a while and all I want you to do is just relax, have fun out there.' He was one of those managers that encourages you and I appreciated that.

"The next day, we played the Angels . . . and I got my first big league hit, so I felt a little more relaxed with him trusting in me and having the faith in me and what I could do. Obviously, he had seen me play before."

McNamara had seen Burks have a "very good" spring training and called him in for a little chat after the centerfielder was sent to Pawtucket—a chat Burks never forgot.

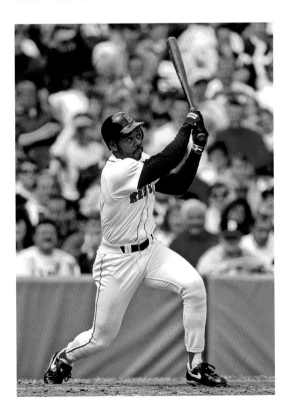

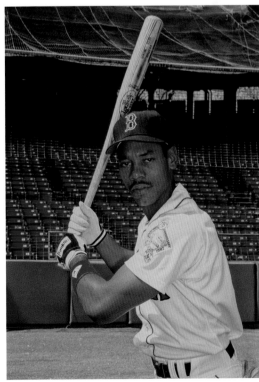

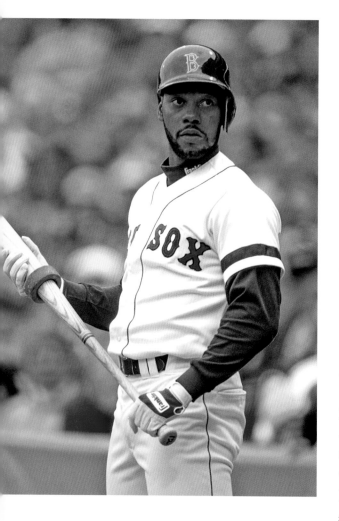

"John McNamara called me in his office and he told me 'it's just a numbers game and I'm sorry it's happening to you right now.' But he said, 'I guarantee that you will up in less than a month,'" Burks said. "He says, 'You can put your money on it, you can take it to the bank, you're gonna be up here.' As a player that's something you hear a lot . . . and I didn't realize that he was a man of his word and lo and behold I'm in Triple-A [and not off to a great start], I had just gotten back from Blockbuster Video, we had a day off in Triple-A, I come back to my apartment and there's a note on my door to call [PawSox owner] Ben Mondor.

"I gave him a call and he told me, 'I got good news and bad news,' and I said, 'Well, OK, what's the good news?' He said, 'Well, you just got called up to Boston.' And I'm like so pumped up I don't give a DAMN about bad news right now. I said, 'Well, OK, what's the BAD news?' He said, 'You have to get on a flight before 2 p.m. today,' and it was like 10 o'clock.

"I was like, 'Man, that's no problem. That's not bad news.' So I packed up everything that I had, basically, and dragged it to the airport and hopped on a flight headed to Seattle and met the team in Seattle that night."

He didn't play the first night and faced Scott Bankhead the second. His first hit, a two-run double out of the ninth spot in the lineup, came off Urbano Lugo. It was the first of three hits in the game.

Burks was there to stay.

He was part of the next chapter in Red Sox history, where age gave way to players like Burks, Mike Greenwell, and Todd Benzinger.

"It was quite a transition," Burks said. "After they won the pennant in '86 and it was a veteran-laced team and then we had quite a few rookies on the team in '87 and '88, so there was quite a shift. I don't know if that was due to salaries or what, but I was happy to be a part of something new in Boston.

"It was quite a shift, but I knew it was going to take some time for us to get our feet underneath us and play to the expectations that the fans were used to—especially winning

the American League pennant. I think they were ready for some patience—they weren't expecting us to repeat, nothing like that right away, but the foundation was already laid.

"With Roger, Bruce Hurst, Nipper . . . our bullpen was stellar . . . we had a great team. Nice mixture of veteran leadership along with young up-and-coming rookies."

And Burks dreamed of staying in Boston, something that likely would have happened had it not been for injuries.

"I thought I was going to be one of the guys that was going to be there, but I realized the last couple of years it became more of a business," he said, "and I wasn't as healthy as I should have been throughout my career and toward the end of my career in Boston. That made it a tough decision on both parts. I wasn't on the field on a daily basis and they probably needed to get someone that could reassure that the player was going to be on the field on a regular basis.

"It was a tough transition for me leaving Boston. I remember getting a phone call in the off-season from Lou Gorman saying that they were going to move in a different direction. He thanked me for my service in Boston, which was great, but that's when I realized that it was more on the business side than anything else and as a young player you don't want to leave an organization that you grew up with—that you kinda came up [with] in the minor leagues as well as in the big leagues.

"You knew everybody, you knew the system, you knew all the players, so it was a comfort zone for me and to kinda get taken out of that was quite the experience."

After a year with the White Sox, Burks broke loose in Colorado. In 1996, he hit .344 with 40 homers, 128 RBIs, and 32 stolen bases, to go with a 1.047 OPS. It was one of three times as a National Leaguer he had an OPS over 1.000.

He came back to Boston for a finale—one that lasted only 11 games because of a pair of knee surgeries, the final 11 of his exactly 2,000 games in the major leagues.

"It was definitely something that I wanted to do," he said of the return. "I had an offer to go elsewhere for a lot more money and I chose not to because I wanted to end my career where I started it. It was just a great feeling that I had

about my comfort level going back there. It was like going home after being away for so long.

"It was good for me. I needed it for peace of mind for myself, to put my mind at ease that it was OK and everything that went on prior to me leaving was just in the rearview mirror."

He hit the last of his 352 home runs in the first game of that season, in Baltimore. "I got hurt running the bases in New York the next series," he said. "That was pretty much the end of it because I had to have two surgeries on my knee that same season."

Despite success in other places, Burks made it clear Boston was his favorite stop.

"I had a lot of fond memories as a Red Sock, in the city of Boston, so that was always a no-brainer for me," he said. He also said, "We had some great teams. Maybe at the time we were one player away from doing it again. I remember Oakland taking it to us in '88 and '90, they swept us both series—but it was just a matter of one or two games that could have swung either way there. There were some good battles against those guys. They felt like they had our number for years and I thought they were all pretty close games."

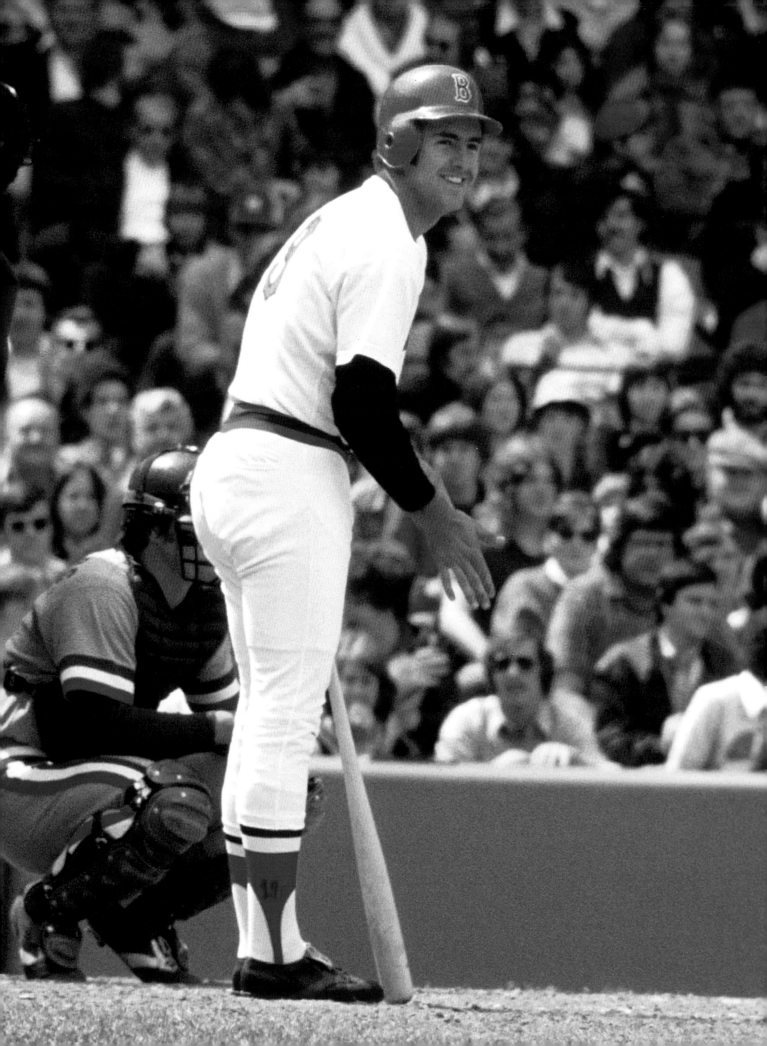

Fred Lynn

Fred Lynn doesn't hesitate when asked a question about something that changed his baseball life.

Does he think the Red Sox and Haywood Sullivan purposely mailed out contracts to Lynn and Carlton Fisk late?

"Yes," Lynn says, breaking out in a jovial laugh.

Fisk was set free by an arbitrator, while Lynn had his arbitration case interrupted by the Red Sox announcing they had traded him and Steve Renko to the Angels for Frank Tanana, Joe Rudi, and Jim Dorsey on that fateful day in 1981.

That trade came a month after Rick Burleson, another contract headache for Sullivan and the budget-conscious Red Sox, was shipped, also to the Angels, with Butch Hobson in exchange for Carney Lansford, Rick Miller, and Mark Clear.

"I didn't want to leave. The powers that be made that decision," Lynn said at Fenway Park on a May night in 2017. "I'm from LA but when the Red Sox drafted me, this is where I thought I'd spend the rest of my career. I wasn't real happy about being traded away.

"All my friends are here. This is what I know. Why would I want to go someplace . . . I hit .350 lifetime in this ballpark [.347, with 71 homers and 314 RBIs in 440 games]. You know?"

Lynn played seven years for Boston, batting .308 with 124 homers, 521 RBIs, and a .902 OPS in 828 games. He went on to play with the Angels, Orioles, Tigers, and Padres. Hounded by injuries, he was good but never as good as he was with the Red Sox.

He was the MVP of the 1982 ALCS and the next year hit the first and only grand slam in All-Star Game history.

Lynn finished his career at .283, with 306 homers, 1,111 RBIs, and an .845 OPS.

He and Jim Rice arrived in Boston together in 1975 and helped carry the Red Sox to what many people considered to be the greatest World Series of all time—the seven-game loss to Cincinnati's Big Red Machine.

Lynn won both the Most Valuable Player and Rookie of the Year Award that season. Rice broke his wrist when hit by a Vern Ruhle pitch September 21 and missed the postseason.

"Jimmy and I—that wasn't our first go-round," Lynn said. "We were together in Double-A and Triple-A and then the big leagues, so I'd known Jimmy a couple of years, so that was pretty cool. We already had a relationship.

"You mention the two of us, but you know what? The nucleus of the club was young. Rick Burleson, Timmy Blackwell, Cecil Cooper, Dwight Evans—these guys were all twenty-three or under and I'm twenty-one or twenty-two and Jimmy's the same age, so there's a whole bunch of us, not just Jimmy and [me]. The spotlight wasn't just on us—all of us were doing well, so that's really what made it special.

"The media just picked up on Jimmy and [me] because we hit 3–4. If you go back in history, I don't know that there's a tandem of rookies that came up and hit 3–4. You might get one of them, but not two. Not two. It was so unique—so unique in the era we did it, rookies were persona non grata, you had to earn your stripes type thing, they kinda looked down on rookies. So that was a big deal. It turned around the way everybody looked at rookies."

Lynn batted .331 with 21 homers and 105 RBIs while leading the American League with

47 doubles, a .566 slugging percentage, and a .967 OPS. Rice batted .309 with 22 homers and 102 RBIs.

Carl Yastrzemski hit .269 with 14 homers and 60 RBIs but was still the leader of that team.

"As rookies back then you had to prove your stripes to the veterans. They had their camp and we had ours," Lynn says. "Fortunately for Jimmy and [me], like I said, there was a whole bunch of us, so we all hung out.

"We didn't hang out with Yaz and Rico and the older guys— we just didn't do that, until we started playing well and then it became pretty obvious, even to the older guys, that we're part of the driving force on this club. Now it's May and June and they're starting to talk to us [laughs] because we made the team—not only did we make the Red Sox team but we made the veterans' team. That's a big deal."

There are those who feel Fred Lynn never would have lasted as long as he did if he had to deal with the Green Monster for all his home games. He had a penchant for running into walls.

"One of the legacies I have for this game is that I was a direct cause of the padding being installed in all [the ballparks]," he said. "In the '75 World Series I ran into the concrete on the Green Monster in Game 6. The commissioner is here and everybody in the world back then was watching that. It was must-see TV—it's not like today where TV's fractured, everybody was watching that World Series, so millions of people saw it.

"They saw me crumple when I hit that wall and the next year they started putting padding on the wall. If it weren't for that play in that time frame you still might have concrete walls in baseball."

Lynn has a theory about that 1975 World Series in particular:

"If we have Jim Rice we beat them in six and you don't even have to worry about 2004."

Three years later, the Red Sox lost that one-game playoff to the Yankees and Bucky "Bleeping" Dent. "The reason that [hurt] was there was no wild card, so you had to win the division," Lynn says. "The two best teams in all of baseball happened to be in the same division—the Yankees and Red Sox. We won 99 games and we didn't go anywhere. They won a hundred. It took that hundredth win to get them in there and it was a fluke play that got them in there.

"It wasn't Bucky Dent's homer, it was the play that Lou Piniella made in right field. Two of them—saved three

runs. I know this, some of our players know this, Lou knows it—the media remembers Bucky Dent.

"There were some unbelievable plays made in that game but unfortunately for a Red Sox fan and the guys that played on that '78 team, only one team advanced—that's the way it was."

Lynn is a frequent visitor to Fenway, often seen as the ex-player who waves to the fans during games.

"I love coming back," he said, on one of those nights that he returned. "I have a special place in my heart for Boston. They drafted me, they got me to the big leagues—and I never forgot.

"When the new ownership took over, they kinda brought me back in the fold and I was very grateful that in 2002 they did that, because there was some scar tissue there and it just kinda all went away. The fans still like me and I love to see the fans. I love talking to them—and it's really, really nice to be able to come back."

Bob Stanley

On a 2017 Mets TV broadcast during a discussion about "altered" pitches, Keith Hernandez chimed in with, "Bob Stanley threw a wet one in the World Series in '86."

So was Bob Stanley guilty of loading up the baseball?

"Loading up the ball?" Stanley, talking in the dugout prior to a 2017 game in Pawtucket, said with a smile. "It wasn't a wet one in Game 6."

"If Steamer loaded it up, I wasn't aware of it," said catcher Rich Gedman. "Usually, I would think I WOULD know about it."

Stanley was Mr. Everything for the Red Sox—starter, long man, closer, you name it. In fact, there was a time, before the Clemenses, the Tudors, and the Hursts, where Stanley was the only legitimate pitching prospect of an organization known for developing bats.

"I loved it," he said of his time in Boston. "They gave me an opportunity in '77 to make the team out of Double-A." His first appearance was in the Cleveland home opener, when there were 51,165 in the stands. Stanley went four innings to earn the first of 132 saves in a career that would see him go 115–97 with a 3.64 ERA. Cleveland won the game.

He appeared in 41 games that year, 13 as a starter. Stanley finished his career, spent entirely with the Red Sox, with 637 appearances, most ever by a Red Sox pitcher, including 85 as a starter, with seven shutouts and 21 complete games.

"I just loved to pitch," he said. "I remember in '79, when I started, I beat Kansas City, 10-inning shutout, and I was [winning] and Zimmer called me into his office and said,

'we're putting you in the bullpen.' I said, 'OK,' because I'd do anything they asked me to do. I didn't care—just to help the team. I asked him why and he said, 'You're more valuable for me every day instead of every fifth day.'"

So he went to the bullpen, but not for long, as he was soon back as a starter, making 30 starts that season and finishing 16–12—his winningest season in the majors.

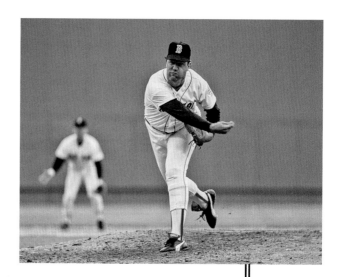

"I still hold the [American League] record for most innings in one year—168 innings out of the bullpen."

That was in 1982, when he went 12–7 with 14 saves.

"I got guys here they go, 'wow, I threw 90 innings last year,' and I say, 'really—I had 90 innings by July.' It was a different game then."

The sinker was his best friend, but often was also Stanley's worst enemy, as grounders "found the holes."

"Sinkerballer, you gotta be lucky," he said.

"My theory was if I give up a hit the next one's a double play—that's the way I looked at it."

And he'd hear it from the crowd when those grounders went through.

"Boston fans are tough but I understand it—they want to win," he said. "They're great baseball fans."

Per the Red Sox 2017 media guide, Stanley was first in games (637, 47 ahead of Tim Wakefield) and relief wins (85), second in saves (132), tied for fourth in losses (97), sixth in innings pitched (1,707), eighth in wins (115), 16th in home runs allowed (113) and walks (471), and 20th in ERA (3.64).

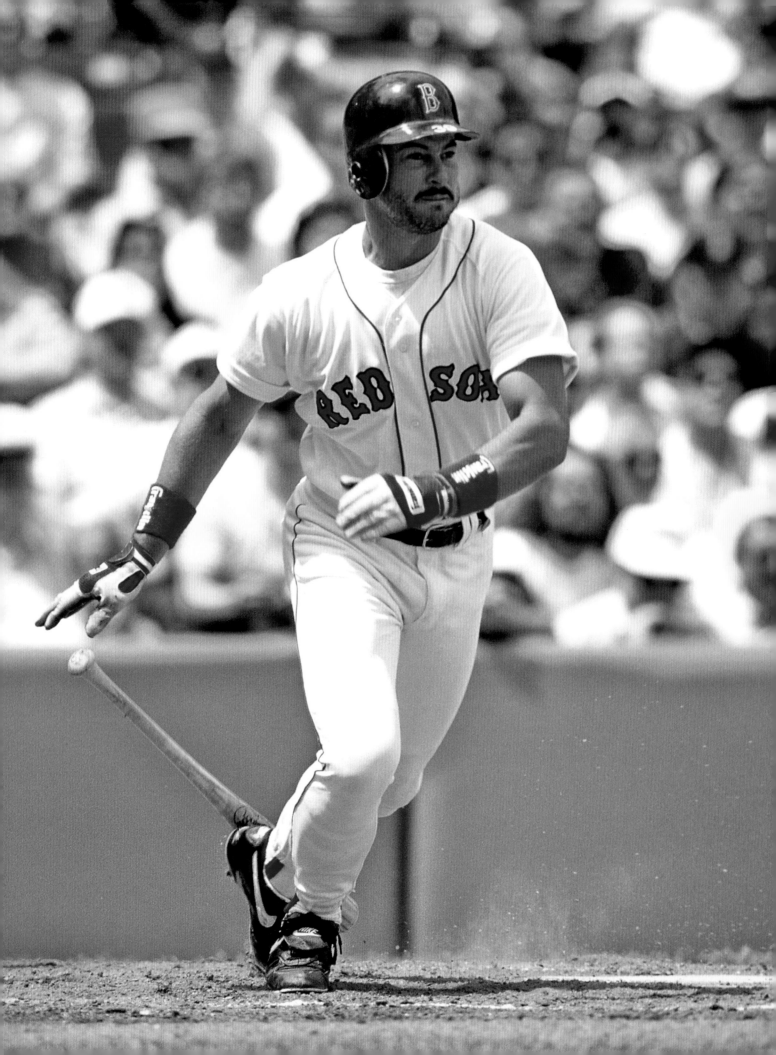

Mike Greenwell

If you ever want to take a second and think about candidates for the title of "Most Under-appreciated Red Sox Player," you might want to toss Mike Greenwell's name into the mix.

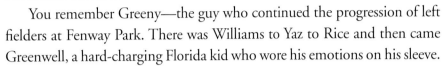

You remember Greeny—the guy who continued the progression of left fielders at Fenway Park. There was Williams to Yaz to Rice and then came Greenwell, a hard-charging Florida kid who wore his emotions on his sleeve.

Think about it—Greenwell hit .303 and had 1,400 hits over a 12-year career, played entirely with the Red Sox. He was fourth in the Rookie of the Year voting in 1987 and then lost the '88 Most Valuable Player Award to a juiced-up Jose Canseco [later saying he wanted the trophy because Canseco cheated]. He drove in 119 runs that year, the middle season of him driving in 303 over three years.

"Where's my MVP?" Greenwell told the Fort Myers *News-Press* after the release of Canseco's book, *Juiced: Wild Times, Rampant 'Roids, Smash Hits & How Baseball Got Big.*

"He's an admitted steroid user. I was clean. If they're going to start putting asterisks by things, let's put one by the MVP."

Canseco batted .307 with 42 homers, 124 RBIs, and 40 steals and won the award unanimously. Greenwell, known as "Gator" during his playing days, hit .325 with 22 homers and 16 steals along with the 119 RBIs. He finished second.

Greenwell and Canseco wound up being teammates in Boston in 1995 and '96.

"We all make bad decisions in life, and that's his bad decision," Greenwell told the *News-Press*. "If you are going to go out and bring other people down, you better be willing to face the consequences."

In 2007, top100redsox.blogspot.com tabbed Greenwell as the 34th greatest Red Sox player of all time, behind No. 33 Curt Schilling and ahead of No. 35 Bill Lee.

Greenwell, who would also become known later for driving in the NASCAR truck series and for owning and operating an amusement park in Cape Coral, Florida, debuted with the Red Sox late in the 1986 season and was there for the wild postseason ride. He was officially a rookie the following season.

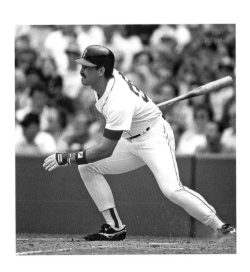

Jim Rice was moved to the DH spot in 1988, with Greenwell taking over in left field. He wasn't the smoothest guy out there and would make life perilous for centerfielder Ellis Burks at times, but he became a serviceable outfielder.

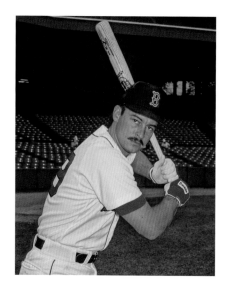

"He made some mistakes at the beginning," Joe Morgan, who took over as manager in 1988, told Neil Shalin in *Red Sox Triviology*. "But he had a good throwing arm and became a pretty good outfielder. Because people remember him as such a good hitter, they assume that he wasn't very good in the outfield. But that's not true."

To Burks, the defense was one of the things that left a .303 lifetime hitter underappreciated in the annals of the Red Sox history.

"To me Mike was always an underrated type player," Burks said. "He came in behind Yaz and Jim Rice—that's what, [30-40 years] in two players right there and for Mike to come in and to fill those shoes . . . there were some expectations. But he was a hell of a hitter."

Greenwell, whose son, Bo, played in the Red Sox and other systems, was a two-time All-Star. He once had a 21-game hitting streak, he hit for the cycle, and he drove in all nine runs in a game in Seattle one night. As former Mariners manager Lou Piniella said, "It was a career night for him. It was a week's work. Two weeks' work."

It was the most runs ever driven in by a player who drove in all of his team's runs in a game.

After 1996, it was over in Boston. As Greenwell said, "It's time to move on and I'm not coming back. It's unfortunate, it's sad, it doesn't break my heart, but it sure makes it awful heavy."

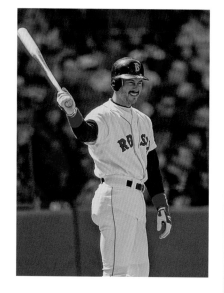

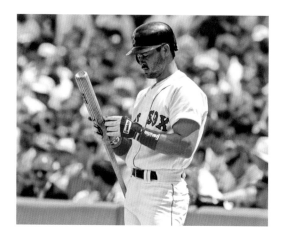

He tried to play in Japan but quickly broke his foot and retired. He coached briefly in Cincinnati in 2001 but then turned to driving, where he did well.

"I retired [from baseball] very early," Greenwell said prior to his first race. "I hit .297 my final year and I had 20 offers to go back and play the next year. But I wanted to go racing. I literally quit baseball so I could go racing."

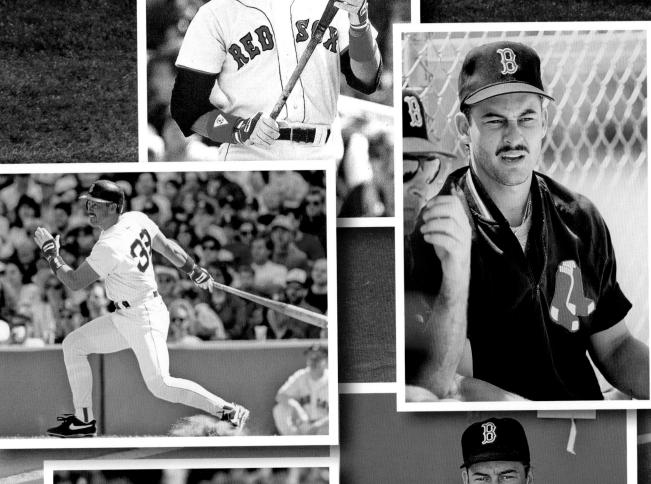
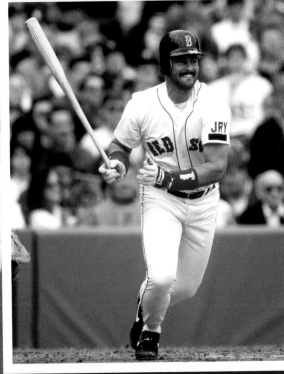

Mo Vaughn

Per a phone interview that took place during the summer of 2017—just months before his 50th birthday—Mo Vaughn might have some advice for the younger version of himself.

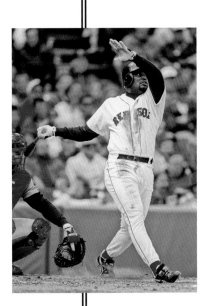

"You sit back . . . I'm a CEO, I've got 800 people under my charge now . . . you look at different things, what could have been, things that I did that probably I should have kept my mouth closed and gone out and played. It's something that happened. You think about what could have been and I do all the time. But you make some choices, I think you learn from those choices and you go."

Vaughn cofounded Omni New York LLC, which, according to the website, "is a real estate development company that was founded by Maurice 'Mo' Vaughn and Eugene Schneur for the purpose of bringing revitalization and development to various neighborhoods in New York and other states."

During his time in Boston, Vaughn, the American League MVP in 1995, had his battles with management that eventually led to his leaving town via free agency.

Today, over two decades later, he wishes things had gone differently.

"I think it was my choice [to leave]," he said. "You look at your battles with management, you're probably talking too much, things probably that don't benefit or help. People always ask me what I learned and the biggest thing I learned being

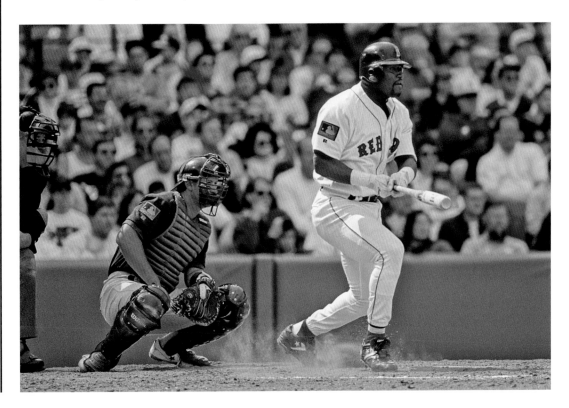

an athlete. What I learned is that when you're an athlete you're not in the business, you *are* the business, and you have to conduct yourself like a business and owners want you to be a certain way, act accordingly, do the things that you're supposed to do and they want you to just go out and play. I wound up getting into these pissing matches with ownership and things and when I look back it was definitely not the thing to do."

He also had a problem with manager Butch Hobson, resulting from Vaughn missing a Wes Gardner throw to lose a game in Detroit. An upset Vaughn stewed in the dugout while Hobson referred to him only as "the first baseman." Things spilled into an unpleasant scene at a club party later that night.

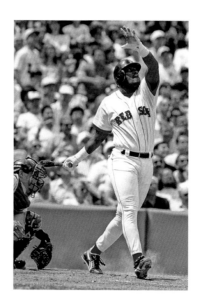

"You look at that and you say that was a learning experience about getting yourself together, getting your game together, knowing how to go out and prepare," Vaughn said. "I look at that as all on me . . . people don't realize in baseball the mental capacity's gotta be there every day, especially playing first base successfully. You're in every play, end of plays, you have to make the throws, the scoops—you gotta be into it. I think that was a wakeup call—hey, man, this is the big leagues and this is what you gotta do."

"The Hit Dog" developed a swing made for Fenway Park, a shift-proof stroke that saw him adopt the Green Monster as a member of the family. In fact, he hit .326 with 119 home runs in 541 games at Fenway.

"I remember you go on the road, you go 0-for-14, 1-for-16, and you're coming back home to Fenway Park and you know you can just tap it and you get yourself back. That's what I loved about it," Vaughn said.

Vaughn hit .300 with 39 homers and 126 RBIs in 1995, winning the MVP Award over the less-popular Albert Belle. Vaughn then had better numbers the following year and placed fifth in the MVP balloting.

Vaughn returned to the playoffs in '98 and delivered.

"It was crucial to me to get back to the playoffs and succeed," he said. "People don't realize, when you play the regular season the game is totally different. And what I realized in the playoffs, pitchers are trying to get you out with a low pitch count—0–2 is not gonna be a waste pitch.

Pictured with Frank Thomas

"It's a different game. Guys are looking to get you out as quickly as possible, certain guys don't want to let Mo Vaughn beat you, they're gonna work for that. That's how I look at it—I just wanted another chance to get back there because I wanted to show I had the mental capacity to produce in the playoffs."

He left Boston for Anaheim and suffered an ankle injury in his first game with his new team in 1999. A stint on the DL turned out to be a lot more. Vaughn says it signaled the beginning of the end.

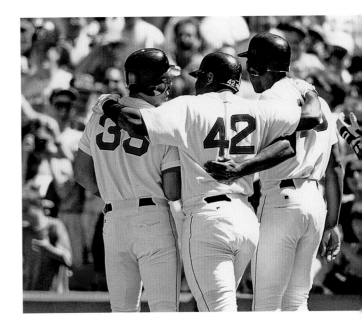

"More than your knee [which ultimately did him in], you need your ankle. It's a shock absorber, many, many things, and then you start compensating and making changes to compensate and before you know it you've got other bad habits going on. That's what happened. I wound up blowing my bicep out the middle of that year. I still hit 33 home runs, but that was like the beginning of the end."

Biceps surgery cost him the 2001 season, and he was productive for the Mets in '02 before it all ended the following season.

Years later, Vaughn looks back fondly on his time in Boston: "You look at what it's like to put on the Red Sox uniform and you don't realize . . . that was some of the greatest times of my life was wearing that uniform home and away and going hard each day."

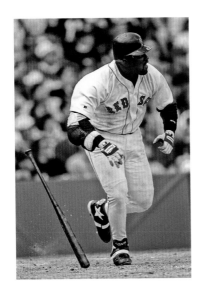
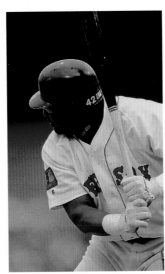
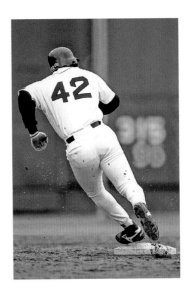

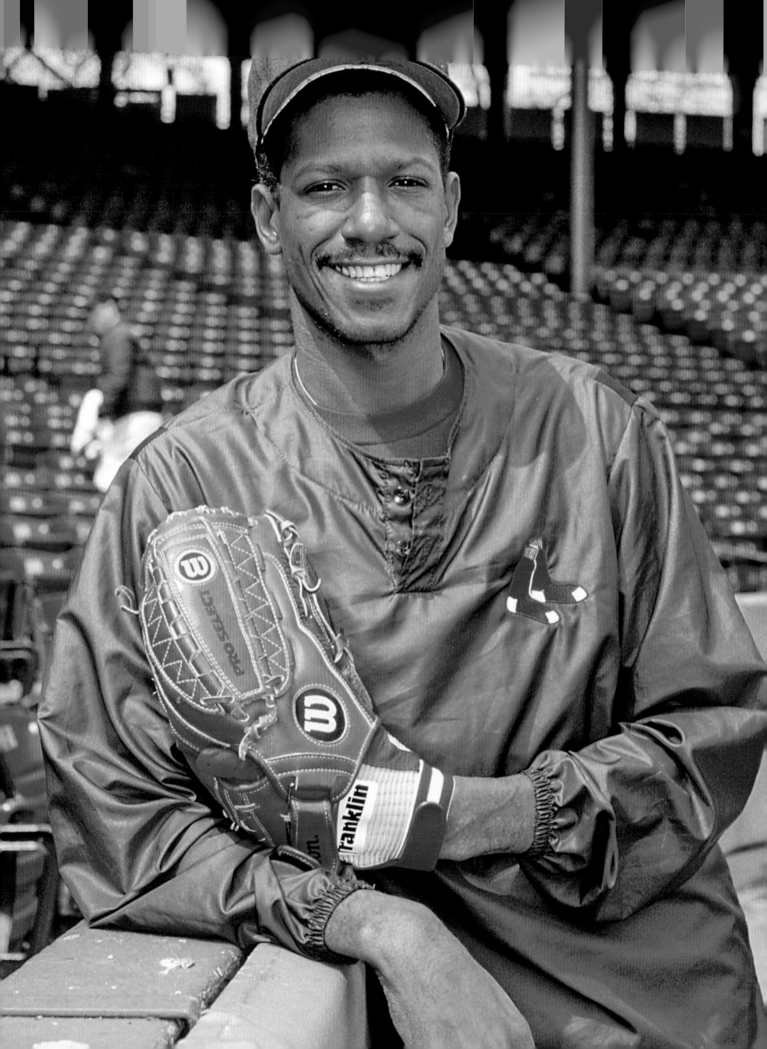

Dennis Boyd

In 2012, I had the unique experience of publishing a book called *They Call Me Oil Can*, which I coauthored with Dennis "Oil Can" Boyd. One thing was clear as I worked on

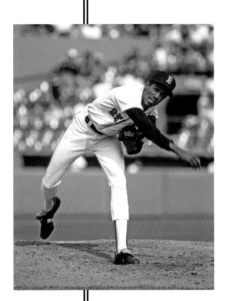

this with my friend: Dennis Boyd was bitter against the Red Sox and baseball in general—and Dennis Boyd loves the Red Sox and baseball in general.

He called Wade Boggs a racist, but he loved Wade Boggs, even asking Boggs to be the godfather of his son. He was bitter at some of the things his teammates did, but he loved his teammates.

He had his moments on the mound, a slender pitcher with a wide array of pitches who won 43 games for the Red Sox from 1984-86. And oh did he have his moments, his negative moments, off the field. In fact, we lead the book with The Can getting word he wasn't pitching Game 7 of the 1986 World Series and immediately hitting the streets of New York for drugs. There was also his disappearing act from the team during that season.

But Boyd, who pitched a complete game in the Red Sox' division clincher in 1986, could pitch. The fans loved him, and he was a fixture at Fenway Park thirty years after his prime on the mound.

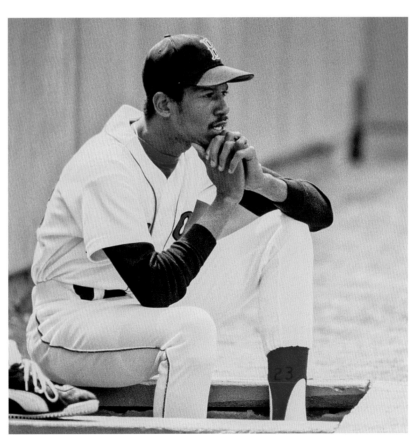

"My first memory of Oil Can came from the name and the talk of great stuff. The name caught your attention but the stuff stayed in your mind," Don Mattingly said on the back of the book. "Can had a quick arm and was tough to pick up. I was never comfortable with Oil Can on the bump."

Said Mike Pagliarulo: "Getting ready to face Oil Can Boyd was like preparing for the Army, Navy, Air Force, and Marines. It was the ultimate test of discipline and concentration as a hitter, because in every at-bat he issued his challenge in front of 50,000, whether he had his good stuff that day or not."

Injuries to his shoulder kept The Can from being the pitcher—career-wise, anyway—that he could have been. He finished his career with a 78–77 record and kept playing baseball . . . well, he was still playing the

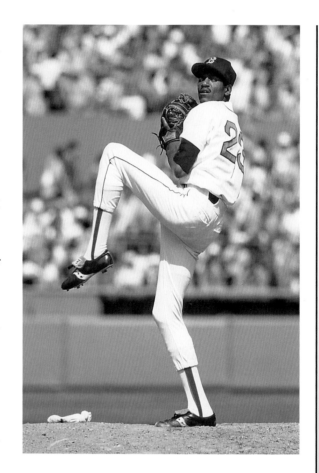

game as this was being written. His love for kids had him working with young players in Rhode Island and Massachusetts.

Controversial? Yes. Outspoken? Sure. Self-destructive? We tend to like the word "passionate." Either way, Dennis "Oil Can" Boyd deserves his place in Red Sox history.

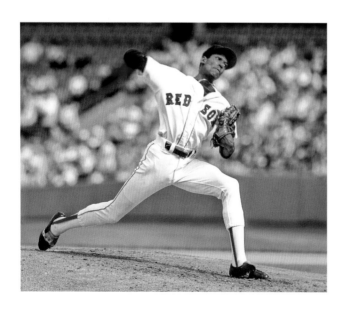

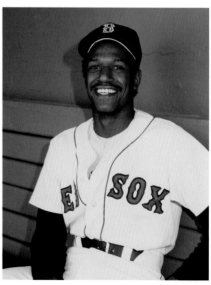

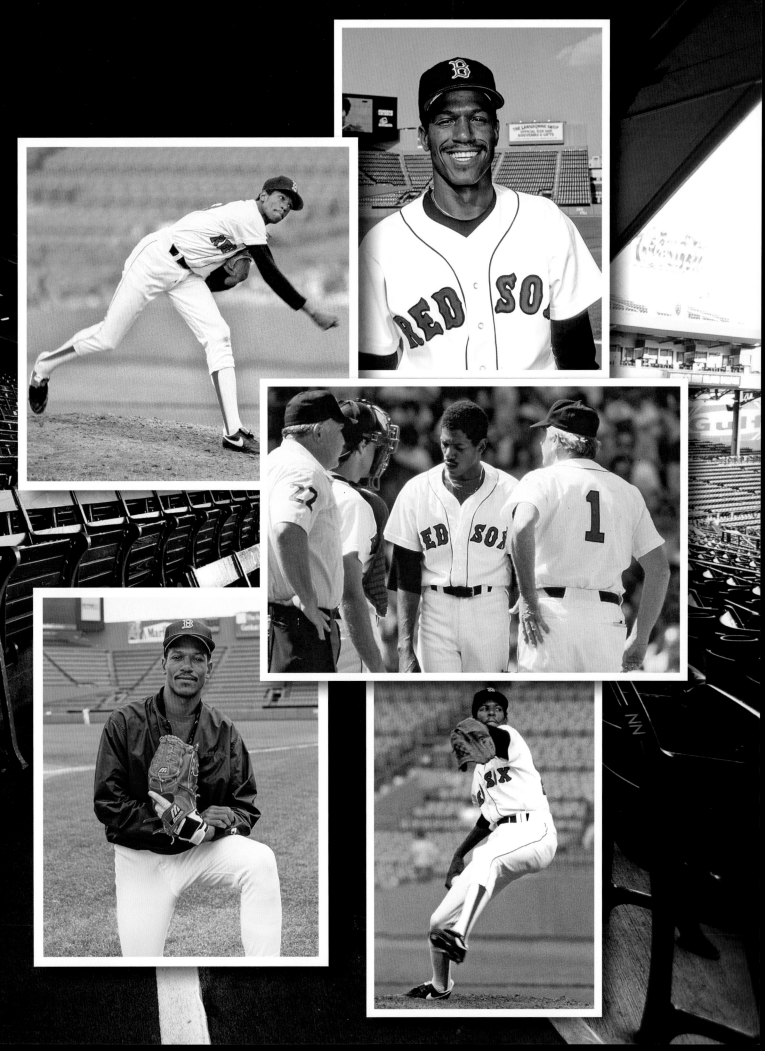

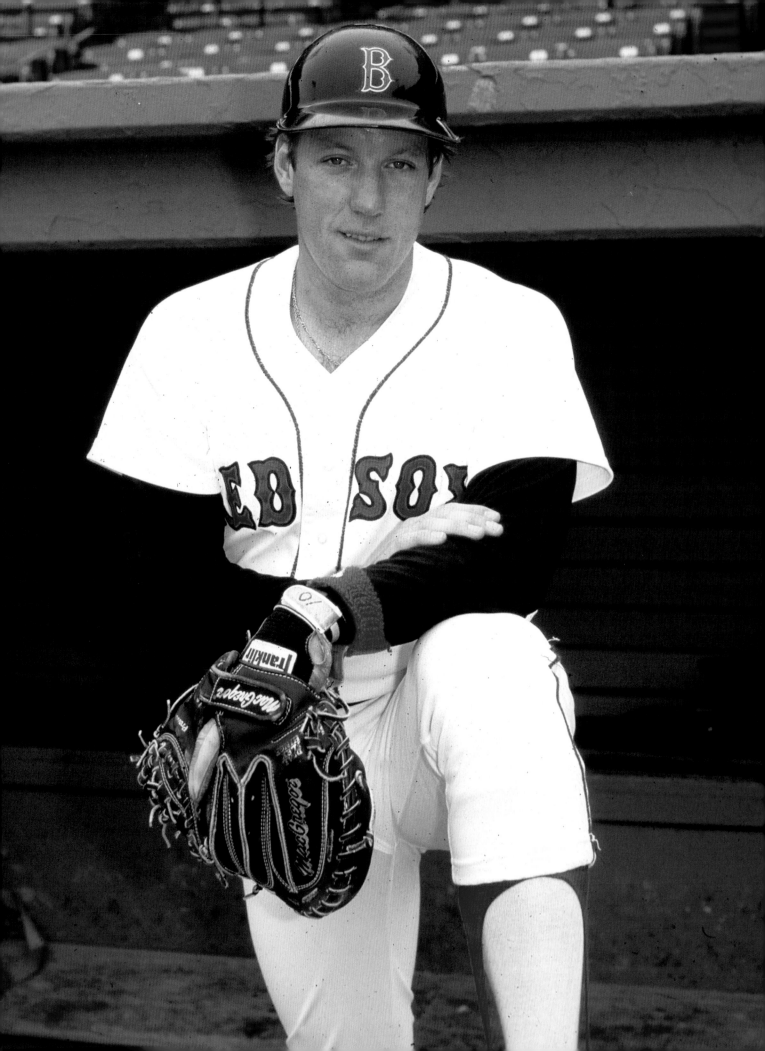

Rich Gedman

Obviously, Rich Gedman wishes he had caught THE PITCH.

"You know me, I'm not going to sit here and make excuses for it," Gedman, speaking at McCoy Stadium in 2017, said, talking about the Bob Stanley pitch that eluded him in that fateful 10th inning at Shea Stadium in 1986.

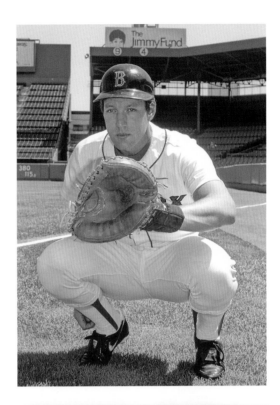

"It's a ball I got a glove on. In hindsight, you sit there and you say, 'Well I wish I would have caught it.' I think I could have caught it, but I didn't.

The ball got by him, the wild pitch allowing Kevin Mitchell to score the tying run before Mookie Wilson's historic bouncer toward Bill Buckner.

"Steamer was a middle-of-the-plate, middle-away guy and that ball was in," Gedman said. "It was meant to be in and it just kinda got in there a little too far. The thing that probably bothers me more than anything is if I pick that ball up clean he's out at the plate and I know it and I just fumbled it.

"Gosh, it's not that I've had plenty of practice at running back to pick up balls and throw it to home. But in this case because it was a little shorter than normal because they kinda build a couple stands that are closer [in the World Series], that I actually had a chance at it, or we had a chance to make a play. So I actually made TWO mistakes—I missed the ball and then I didn't throw the ball to the pitcher."

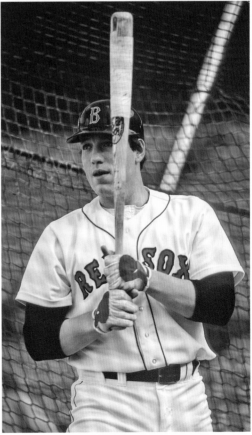

When it was over, and in the 30-plus years since, Red Sox fans and others have argued if it was a wild pitch or passed ball.

Does it really matter?

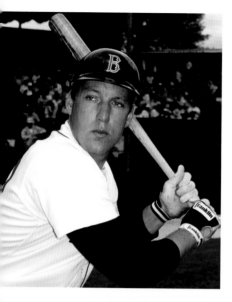

"Passed ball, wild pitch, it's still . . . because it was such a big game it's a mistake made at a crucial time," Gedman said. "Regardless . . . I guess it's better that they blamed two people instead of one. If it's a passed ball you sit there and go, 'Well either way, the ball got by.' Whether the pitcher had a wild pitch or I had a passed ball, I didn't look at it like, 'Well, it was *his* fault.' It was my fault if I don't catch it, it was his fault if I *can't* catch it.

"It's all opinions. I sit there and I hear so many things . . . 'Hey, it wasn't your fault.' You don't understand. I appreciate you saying it wasn't my fault but I really like Bob Stanley and it kind of severed our team a little bit, as to, 'It was his fault, it was your fault,' and even your friends, 'You're gonna say it was MY fault?' And people that love Bob Stanley are like, 'That Gedman guy . . . he sucked the house out. Can't believe he missed that.'

"So you're damned if you do, you're damned if you don't, so looking back at it, it's like I wish I could have changed it. It happened—for whatever reason, I wish I could come up with a logical reason why it happened but it happened and it happened at a bad time. Either way . . . "

Reminded it was three straight soft hits, a wild pitch, and an error that kept the Mets alive in that Series, Gedman said, "You could justify it any way you want. We play this game for a long time and you don't get many opportunities to win a World Series, or even be in it, let alone win it.

"It's a shame because that was a *such* a good team. We were playing a *great* team—they were the best team on paper all year. Even the circumstances around the playoffs and the World Series, it was totally different than anything I've ever been a part of, because it really wasn't real baseball until you played. It was just *dramatic*. It was too much pull and tug. The stuff you had to do was different than anything else—it was magnified way more than it should have been. Those are seven games—seven baseball games of your life, and played on the biggest stage. But they shouldn't have been played like they were on the biggest stage. All of a sudden you're playing for what it's for instead of just playing the game and so that brings in emotion—and that's what makes it so difficult to swallow sometimes."

The bizarre ending of the World Series was just one chapter in a more-than-eventful 1986 for Gedman, a year that included the passing of his father.

Gedman caught Roger Clemens's 20-strikeout game (see Clemens section on page 85), made his second straight All-Star Game, suffered through having to catch—or try to catch—Charlie Hough's knuckleball in the game, went 10-for-28 in perhaps the greatest AL Championship Series ever played, and hit a home run in Game 7 of the World Series. He was hit by the only pitch lefty reliever Gary Lucas threw in Game 5 of the ALCS, setting the stage for Dave Henderson's season-saving home run.

Oh, and he went to Japan with an All-Star team and had his cheekbone broken by a Willie Hernandez warm-up pitch.

More? OK, he was trapped in the middle of some ugly owner collusion that shut the door on his free agency and saw him have to wait until May 1 of the following season to return to the Red Sox—basically under their terms. He started off the 1987 season, without having undergone spring training, in a 1-for-31 slump.

He hit .258 with 16 homers and 65 RBIs, but essentially, for a variety of reasons, he was never the same from 1987 on.

"After the World Series I went to Japan and played in an All-Star series and I broke my cheekbone," he said. "My offseason was a little delayed anyways. The next thing was 'You're a free agent.' I think everybody knew that I wasn't going anywhere.

"I'm a homegrown kid. Looking back at collusion, it's always difficult to talk about it. It's taken me so long to get over it. And some of it was my personality. I was a player rep at the time, so I was well aware of the union and how important it was to be loyal to the union, but I also was trying to figure out how to be loyal to my family, going, 'I really don't want to go anywhere.' I think the Red Sox knew that. Looking back at it I could not explain how and why because I was being represented as everything I thought I was not. I didn't ever picture myself being a greedy guy. It was an opportunity that every player gets with six years of time, only to find out that it really was a fixed market.

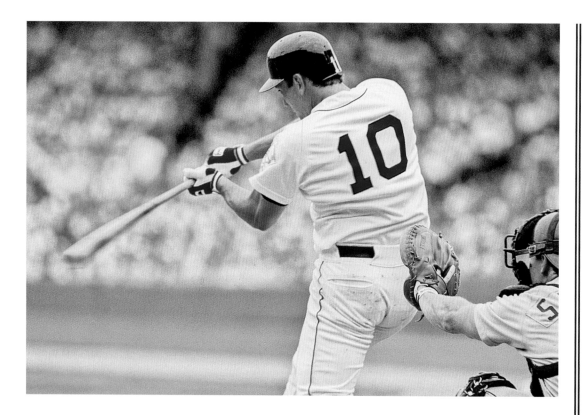

"I ended up coming back with mud on my face and . . . it wasn't bad. I got a two-year deal [worth less than $2 million] and it wasn't like it was a bad contract. I just never was the player again that I was for '84, '85, and '86. Some of it was injuries—you try to look back and I just wasn't as good a player again and I still don't know why. I know it wasn't because I didn't still love the game. It's just things changed."

According to the *New York Times*, Gedman was awarded $1,114,961 in damages, but that's not what this guy was about—ever.

As for that All-Star Game and his injured cheekbone, Gedman takes the blame.

"I could just feel this anxiety coming over me where I was just tense—which is totally the opposite of what you're supposed to do when you're catching a knuckleball guy," he explained. "I kind [of] messed myself up a little bit, too. Charlie handed me a new catcher's glove and it was one of those big ones. It felt like a peach basket and I tried it and I probably would have been better off with my own. That way I at least would have felt better missing it—I could say, 'Well, I missed it with *my* glove.'

"In all fairness, it didn't matter. It was fun. I had a blast doing it. I just never remember ever missing so many balls with my catching glove. The funny part is it didn't hurt at all. It didn't cost us the game, even though it felt like it did. We won but I felt like we lost in some ways and it's remembered for how difficult it is to catch a knuckleball.

"It was embarrassing. It was a lot more difficult than I thought it was going to be—and I probably handled it wrong. But I think in the long run it helped—it actually made me a better catcher, gave me a better understanding of being a catcher and sometimes what you need to do in a tough situation."

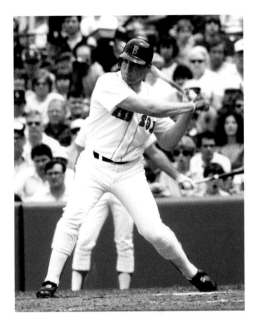

Summing up his time in Boston, Gedman said, "I mean there were some tremendous, tremendous highs. At the end, there was really, really . . . it was sad. It really was.

"Some of it was my own doing, I guess. When I look back it's made me the person that I am today because of it and I don't have any regrets. I was very fortunate, thankful for the opportunities that were given me. I just wish I was a little more mature at the time to speak my mind and believe what I thought. I wasn't sure I was right about some of the things I was feeling, so it just made it hard and I had a hard time dealing with it.

"I wanted to be adored by the fans, because I was one of them, you know what I mean. I grew up in Worcester, Massachusetts, I was Red Sox player for 10 years and those were special moments—every day I put on that Red Sox uniform. Looking back 30 years, I was a lucky, lucky person. If I got to play there for one day I was a lucky person but to do it for 10 years, it was special. The good times and the bad times were always good times because I can't think of ever wanting to do anything else."

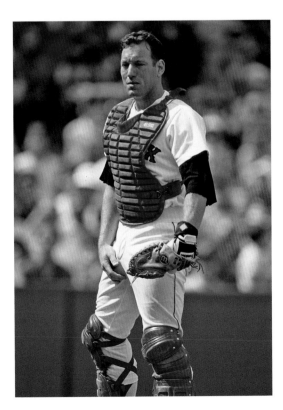

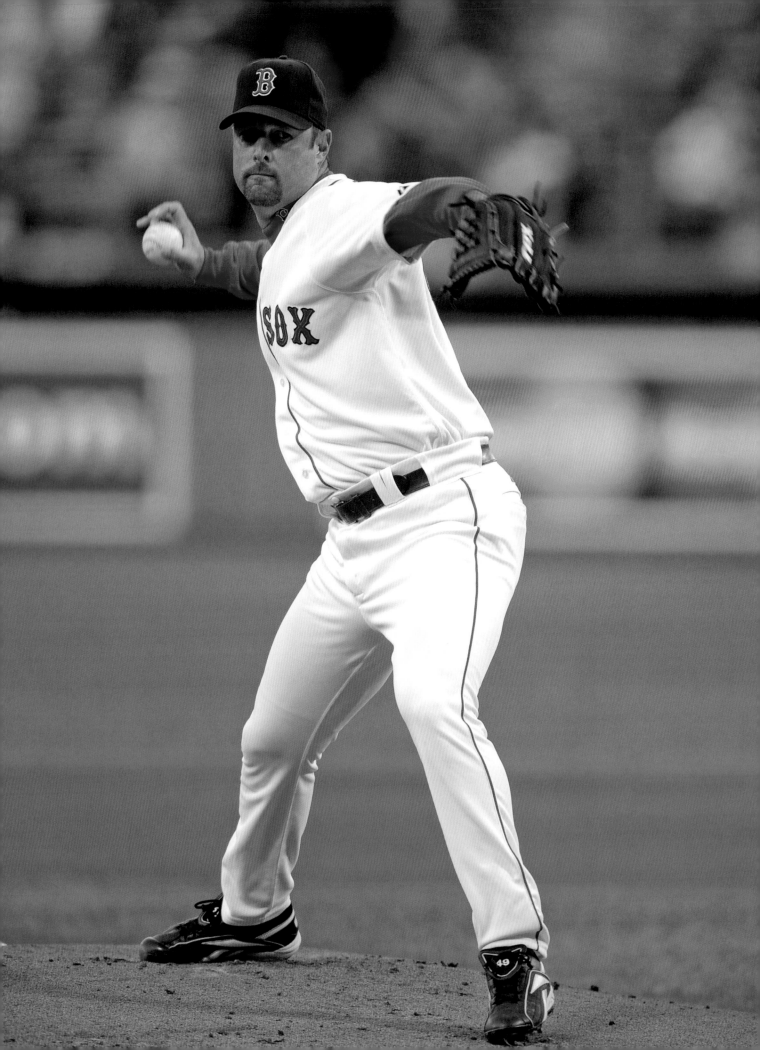

Tim Wakefield

His career as a power-hitting first baseman on the fast track to nowhere, Tim Wakefield was able to turn things around in 1990.

As a knuckleball pitcher.

The rest turned out to be . . . well, Red Sox history.

"It's an incredible feeling because it's, you never know, like I didn't know back then," Wakefield said on a spring 2017 night at Fenway. "I thought I was going to be a power-hitting first baseman playing in the major leagues for the Pittsburgh Pirates.

"Obviously it didn't pan out that way, but I'm thankful the knuckleball kind of found me. If it wasn't for a guy named Woody Huyke, who was my manager down in Bradenton, who saw me throwing it, goofing around, I probably would have gone back to school and finished my degree and got a job doing . . . I don't know what I was going to do. Somewhere."

Goofing around led Wakefield and the knuckler to wind up in Pittsburgh in 1992—and he went 8–1 before pitching two complete games and winning both in the 1992 NLCS. The eight wins would turn out to be the first eight of 200 career victories—earning him a spot in the Red Sox Hall of Fame.

Realizing he had reached the end of the road as a position player in 1990, Wakefield focused on his future.

"Yeah. I don't think I had a choice, especially with the Pirates," he said. "It was either—you know, I was hitting under .200 and they were like, listen, the organization had their meetings per

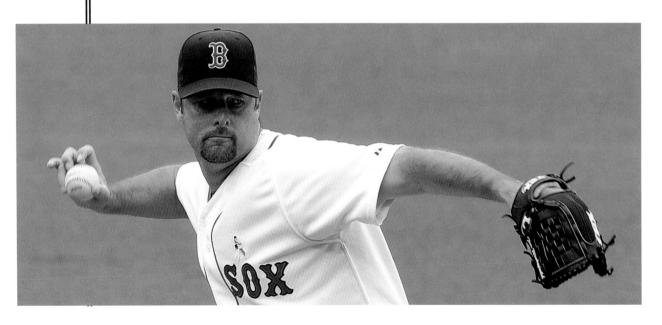

player and I was going to get released. So it was either get released and flip a coin to try to hook on with somebody else in the minor leagues somewhere, or do what they were asking me to do. I'm thankful that I took their advice.

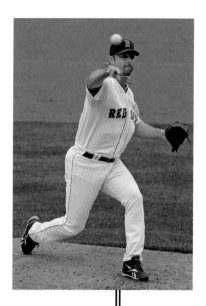

"The first step was after the game that afternoon I went over to the bullpen and threw in front of our pitching coordinator, Bruce Kison. Nothing else was said, and next thing I know I get promoted from there. I went to Augusta for about a month and then the June draft happened and then they sent me back to the short season team, which was in Welland [Ontario].

"I went to Augusta as a position player. Yeah, I was catching bullpens, I was playing third. I was just trying to hang on somehow, trying to find a position that I could play. They had their meetings, and they go through every player in the minor leagues and 'yes, yes, yes'—they got to me and said 'no' and then [Huyke], he spoke up on my behalf.

"I remember actually coming in relief from second base. U.L. Washington was the manager. Something happened in the game and U.L. comes out to the mound and pointed at me and called me in. It wasn't my first appearance but that's how the rest of that season went, and then they sent me to Welland, Ontario, short season in the New York-Penn League. And then the season was over and they said, 'We want to send you to instructional league and break you into a full-time pitcher.' I'm like, 'All right.' And two and a half years later I'm in the big leagues with the Pirates."

His major league debut was a 146-pitch complete game win over the Cardinals en route to an 8–1 regular season. But that's not the end of the Wakefield success story, which would take a huge dip before the Brothers Niekro helped write a special story in Boston.

"I struggled mightily the next two, three years and I ended up getting released in '95 in spring training after a shortened spring with the strike," Wakefield says. "I think the biggest key to my success after that was, one, learning how to deal with failure at that level for the first time. Because in '92 I was 8–1—I lost one game and won two postseason games, so I didn't know how to deal with it at that level. Two, getting a chance, when I signed with Boston, getting a chance with both Joe and Phil Niekro really helped my confidence . . . because now I finally had somebody that I could talk to that had been in my shoes before."

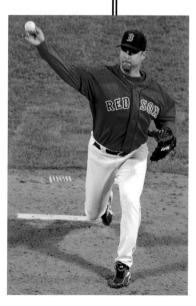

Wakefield would go 186–168 in 17 years with the Red Sox, even saving 15 games as the closer one season. He had his ups and downs with management over his role through the years but wound up throwing 3,006 innings in a Boston uniform.

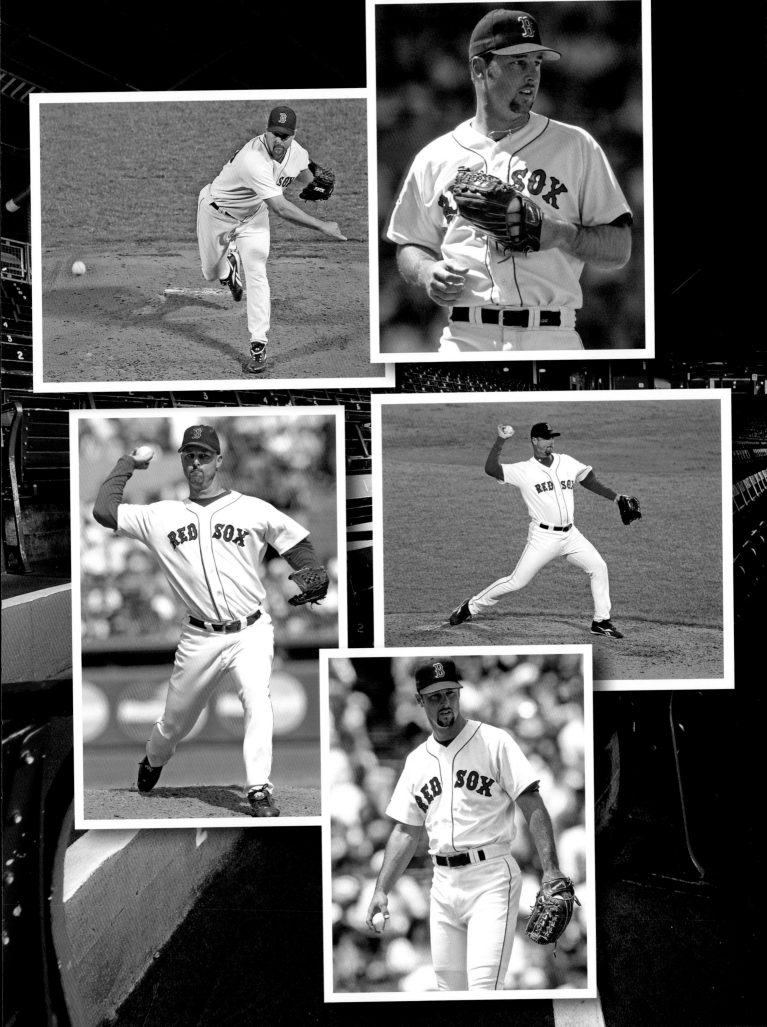

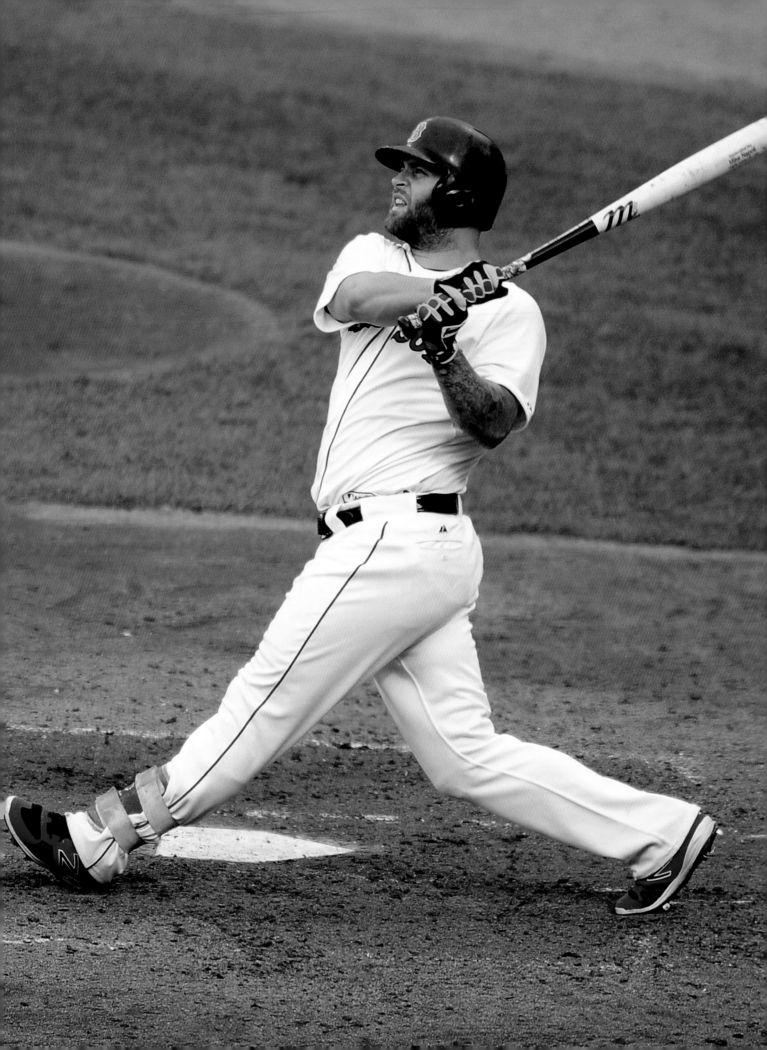

ROLE PLAYERS

Mike Napoli

Napoli was standing in front of his Texas Rangers locker in the visitors' clubhouse in 2017 when he was asked about what made that 2013 team so special.

"First the group of guys we had with the coaching staff, how well we got along," he said. "We'd have 25 guys at a dinner on the road, hanging out with each other constantly. Just the way we meshed with each other.

"Then, obviously the Marathon thing, coming together, being there for the people, city coming together. I mean I'll never forget how everyone handled that situation, and then obviously winning it."

The 2013 team went from last, with Bobby Valentine at the helm, to first under new manager John Farrell. More motivation?

"I didn't live that, so I don't really [know], but . . . it was a dramatic swing from what happened the year before to what we were able to do," he said.

Napoli batted .259 with 23 homers and 92 RBIs in the regular season for the Red Sox that year, then hit two homers and batted .300 against the Tigers in the ALCS.

He has always been able to hit at Fenway—not surprising for a a right-handed hitter with power.

"I don't know. It's just I guess all the history, just a great atmosphere, you know what I mean?" he said. "It's fun playing here."

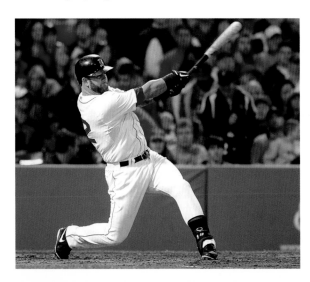
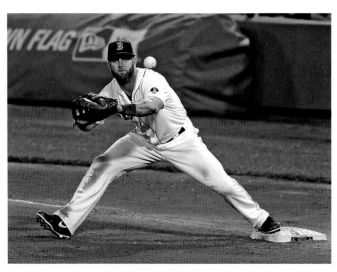

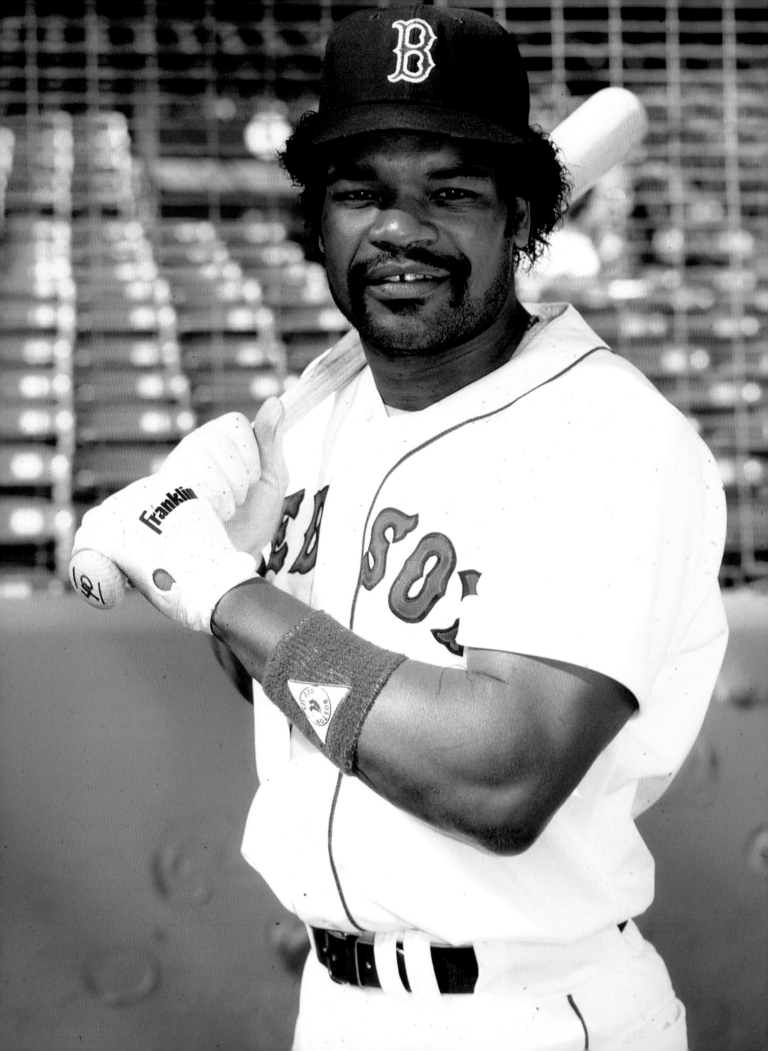

Dave Henderson

His infectious smile could light up a room. But in 1986, it was Dave Henderson's bat that made Red Sox fans all around the world light up and smile.

It was Game 5 of the American League Championship Series. The Red Sox were down a run and had one strike left in their season. Then, Donnie Moore threw and Dave Henderson swung, his two-run homer actually putting his team ahead. The Angels caught up, the Red Sox won in extra innings on Henderson's sacrifice fly, and then they subsequently took Games 6 and 7, earning them a trip to the World Series.

"The pitch I fouled off was a fastball I should have hit," Henderson said. "I had to step out of the batter's box and gather myself, think about what I had to do. With two strikes I had to protect the plate. I really just wanted to reach down and make sure I at least put the ball in play."

Dave Henderson won a World Series with the 1989 Oakland Athletics and passed away December 27, 2015, from a heart attack two months after receiving a kidney transplant. He was just fifty-seven.

"Hendu was a hell of a player. He's kind of underrated, don't you think?" former teammate Dennis Eckersley said in 2017.

Said former teammate Mark McGwire: "I never saw him have a bad day. He'd strike out, and he'd come back to the dugout flashing that gap-toothed grin. He loved to play the game. He was a beautiful man."

And he was a Red Sox hero.

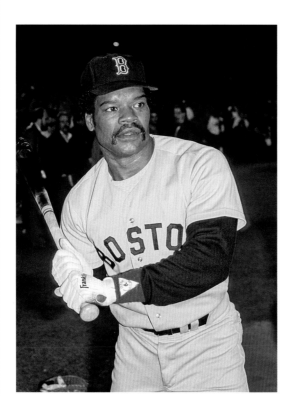
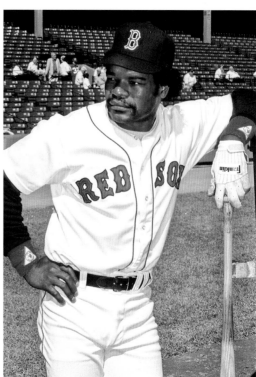

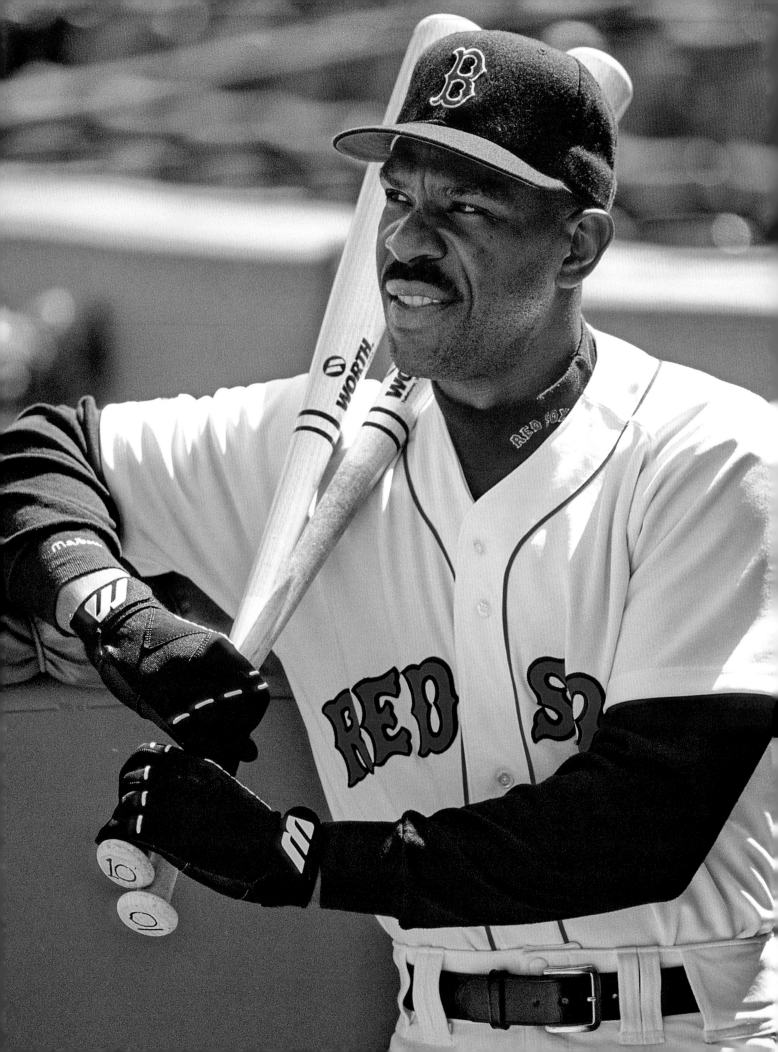

Andre Dawson

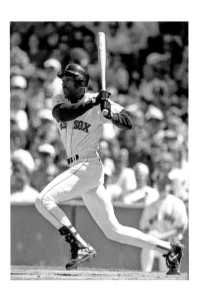

"The Hawk's" knees were shot by the time he got to Boston in 1993. But that doesn't mean he didn't leave a mark.

Andre Dawson made a difference everywhere he played.

"Hawk is the kind of guy you want your kids to grow up like," former teammate Greg Maddux said on the back of Dawson's biography, *Hawk*, released while he was still in Boston.

He played two years in Boston, batting .260 with 29 homers and 115 RBIs in 196 games—and even stealing four bases.

Those numbers pale to the rest of Dawson's Hall of Fame résumé. He hit .279 with 438 home runs and 1,591 RBIs, 1,373 runs, and an .806 OPS, as well as 314 stolen bases. He was Rookie of the Year, MVP, finished second in the MVP voting twice, was an eight-time Gold Glove winner, a seven-time All-Star, and a four-time Silver Slugger winner.

Just about the only thing missing is a World Series appearance.

"Andre Dawson is a man of many attributed," Ernie Banks said in the foreword of the book. "He is an excellent father, a supportive and caring husband, a compassionate son, a considerate brother, a faithful friend, and the hardest-working, most determined ballplayer I have ever known."

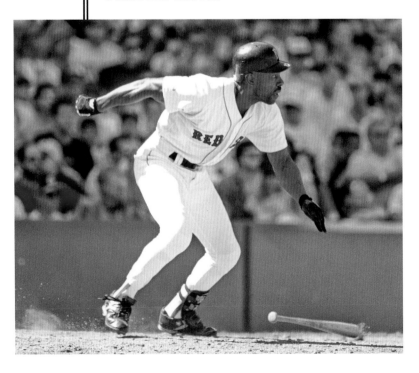

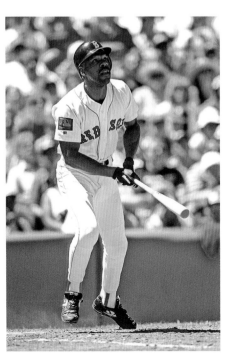

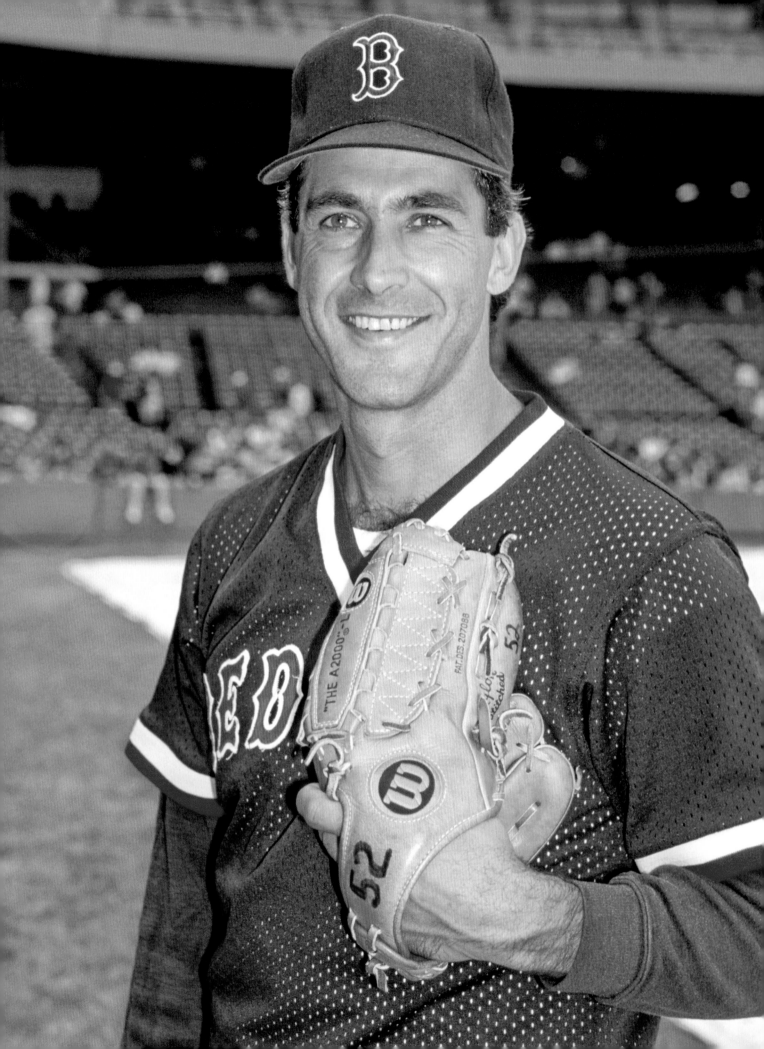

Mike Boddicker

On July 29, 1988, the Red Sox made a trade with the Orioles that would have a major effect on both franchises.

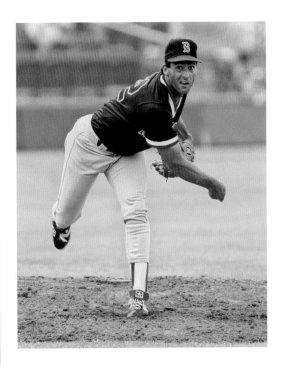

Lou Gorman shipped youngsters Brady Anderson and Curt Schilling to Baltimore for Mike Boddicker, a veteran pitcher they signed to a two-year contract extension as the deal was made.

"We're not concerned about Brady Anderson becoming a great player," Gorman said. "We're concerned about winning the pennant."

Boddicker, freed from a losing situation, went 7–3 the rest of the way, and the Red Sox did in fact win—the division, anyway. They were wiped out in four straight games by the Oakland A's in the AL Championship Series.

Boddicker went 32–19 over the next two seasons. He won a World Series with the Orioles in 1983 and was part of the 1988 Orioles team that lost their last five spring training games and then the first 21 games of the regular season.

When he reported to Winter Haven in 1989, his outlook was a bit better.

"It's more fun, to be honest with you," he said that spring. "It's a good ballclub. It's fun being with a good ballclub."

Nevertheless, Boddicker admits it was hard to leave: "Saddest day of my life. Driving away from the ballpark, I cried. I'd been with the Orioles my whole career. I was comfortable there, and the fans were great. So many times, walking off that mound, I deserved to be booed, and they didn't do it."

Boddicker, 2–0 in the postseason with Baltimore, lost his only start of both the '88 and '90 ALCS.

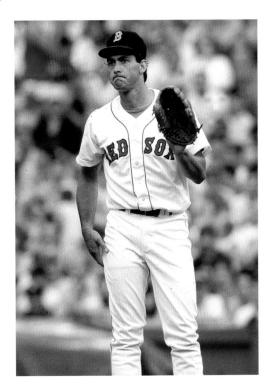

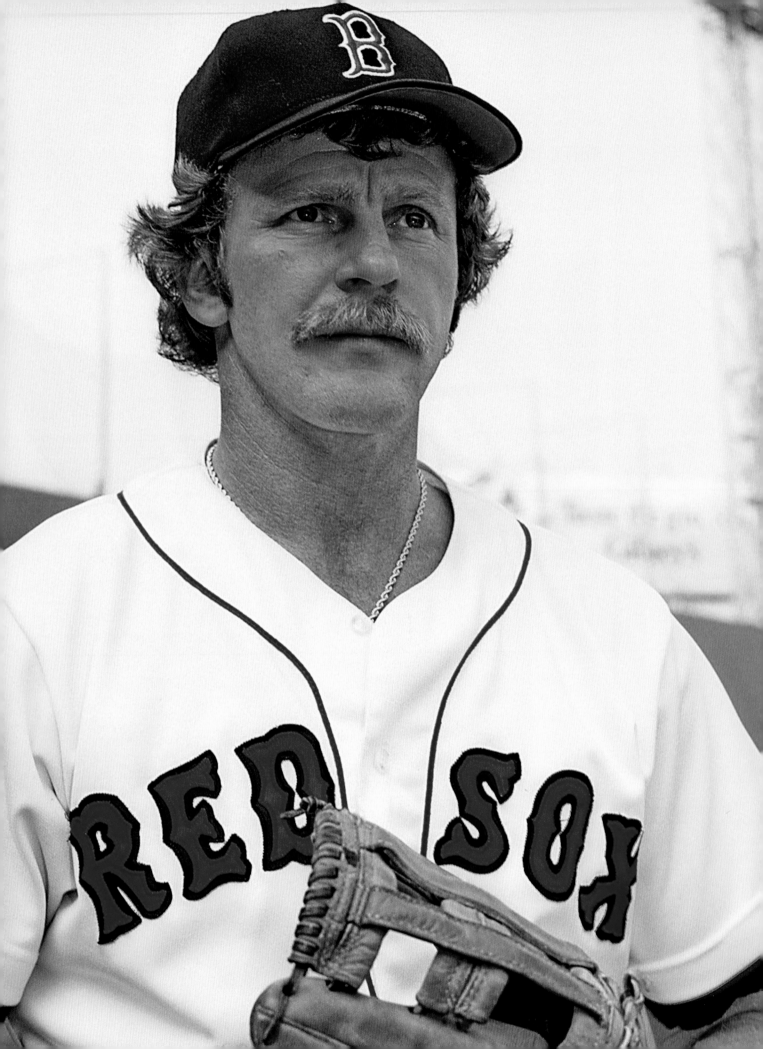

Bill Campbell

Bill Campbell spent five years in Boston, where he was the American League Fireman of the Year in 1977. That year—his first with the Red Sox—he saved 31 games and won 13.

"We finished two games out with Bill Campbell," manager Don Zimmer said after the season. "I don't know where we would have finished without him."

He had been a star with the penny-pinching Twins and left via free agency, signing with the Red Sox on November 6, 1976, during the early days of free agency.

"Soup," a screwball pitcher, ended his stay with the Twins with the following 1976 numbers: 17–5, 20 saves, and a league-leading 78 appearances.

He made $23,000 that season and reportedly asked the Twins for $35,000 per year, but was denied. He subsequently signed a five-year deal worth a whopping $1 million.

While other free agents have struggled in Boston through the years, Campbell was the opposite, at least at the beginning. He did, however, hurt his arm in 1978 but managed to pitch in the major leagues until 1987.

He was 28–19 in his five years in Boston.

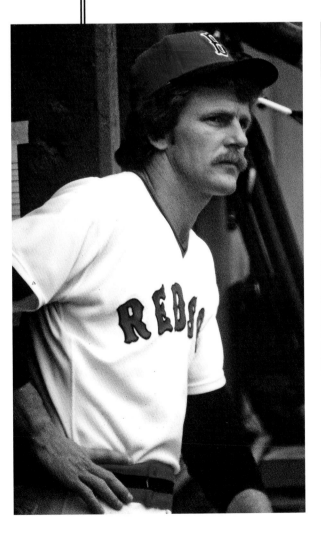

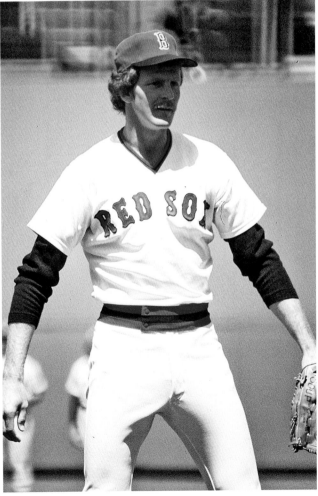

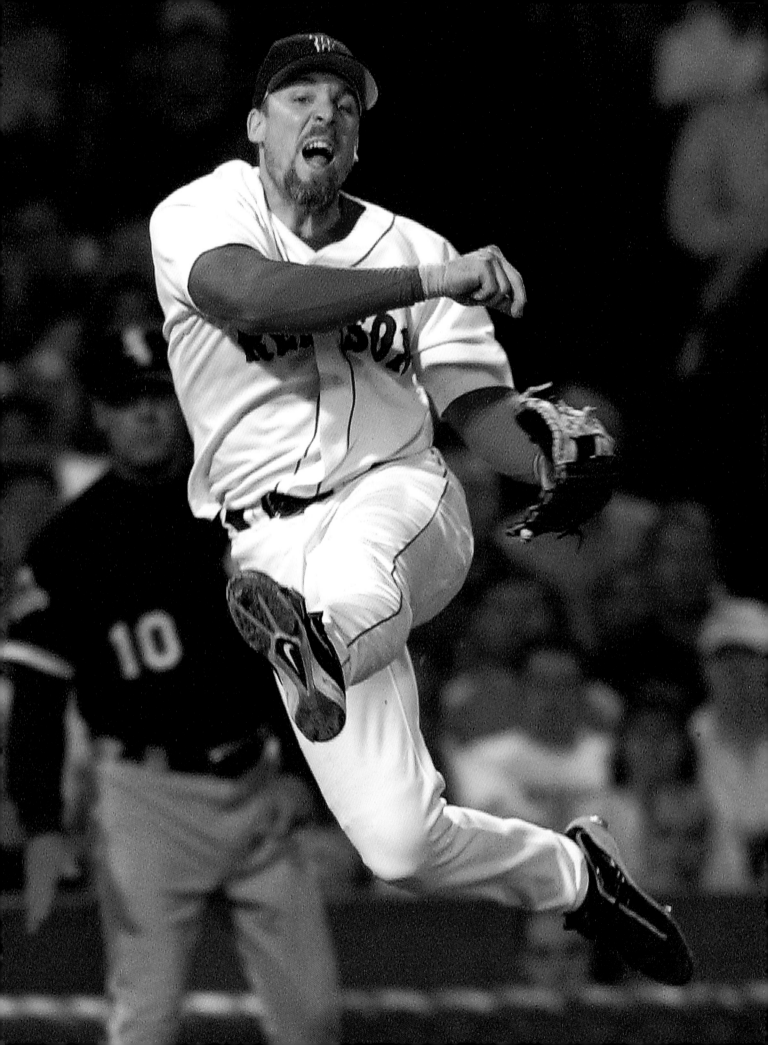

Bill Mueller

Of all the big hits in Red Sox history, was there a bigger one than the one Bill Mueller stroked off Mariano Rivera in the 2004 ALCS?

You likely know the story by now: the Red Sox, facing a four-game sweep at the hands of the dreaded Yankees; Kevin Millar—a guy who didn't walk—was walked by Rivera, who didn't walk hitters; Dave Roberts ran for Millar and took off and stole second, by a hair; Mueller then grounded one up the middle, and the Red Sox were on their way to eight straight wins and the end of the 86-year title drought.

Roberts gets most of the credit and fanfare for that night. But Mueller got the hit, a grounder up the middle.

"Everyone in the ballpark knew Dave Roberts was going to try to steal second base," Mueller told Bostonbaseballhistory.com in 2014. "The whole season was on the line, so it doesn't get any more exciting than that.

"But from a baseball point of view, Kevin Millar's walk was equal to Dave's steal and equal to my RBI."

The American League batting champ in 2003 (nipping teammate Manny Ramirez), Mueller hit .321 in the 2004 postseason. He batted .303 in his three years in Boston and .291 during his 11-year major league career.

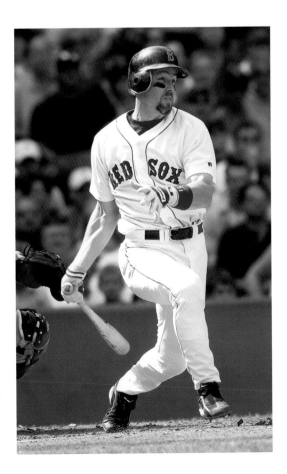
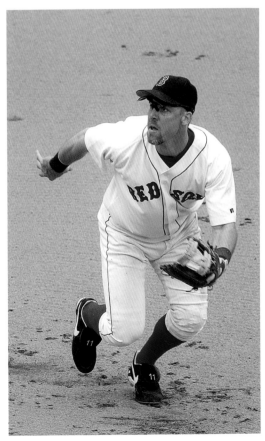

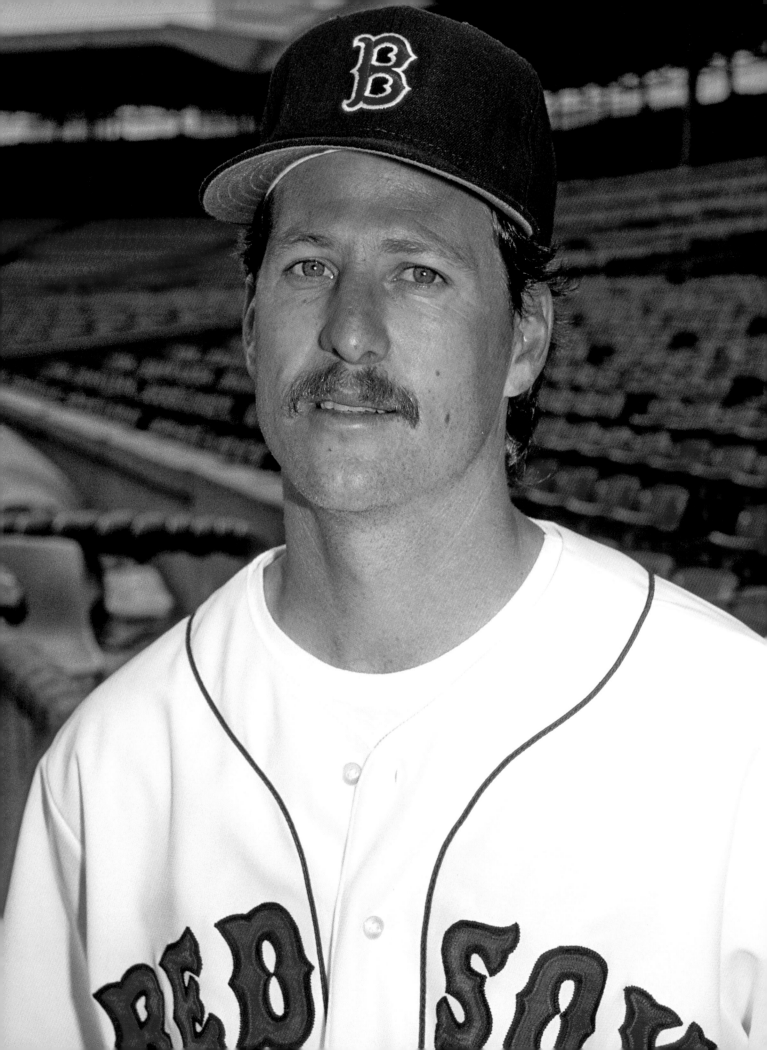

Greg Harris

After nine years of waiting, and after the Red Sox refused to let him do it, Greg Harris finally got to do something special on September 28, 1995—pitch left-handed to a left-handed batter.

Yogi Berra used to refer to the ability to throw with either hands as "naturally amphibious."

Harris had his special glove ready to go, but then-general manager Lou Gorman didn't want to "make a mockery of the game."

"Mockery of the game . . . and then his other thing was, 'he already gets left-handers out from the right side,' which I did," Harris said. "I had a pretty good record against lefties but, hell, you faced them enough, you better know how to get them out.

"You gotta respect what they were doing. I just went along, stayed ready and I just told myself when the time comes in my career where I don't think I'm going to get the chance and I might be done, then I'm just gonna go do it. . . . I just kinda waited my time."

It didn't happen with the Red Sox, but Felipe Alou gave Harris the green light for the Expos, in what turned out to be the next-to-last game of Harris's 15-year major league career.

"One, I want to see it," Harris said of what Alou told him. "And he thought it was good for the game of baseball. His thought process was a little different."

The announced attendance inside at Stadium Olympique that night was 14,581, and they got to see history.

After facing four batters that inning, it was over. The six-finger glove, fitted with an extra thumb, wound up in the Hall of Fame. He sent backup gloves to Sidall, bullpen coach Pierre Arsenault, and his own dad. He still has one of the backups.

"My intention with the whole thing was it's not going to be a mockery. If you're a switch hitter, why can't you be a switch pitcher if you have the ability? I think I was 83–84 [mph] left-handed but I still had all my pitches that I do right-handed."

Harris went 39–43 with 16 saves in six seasons with the Red Sox. What is remembered by all is his role in a weekend in late August 1990, when Harris was part of a dazzling pitching display by his team.

The Red Sox had suffered a walkoff loss in the Thursday night game, their AL East lead shrinking to a game. But then Dana Kiecker, Roger Clemens, and Harris combined (with two Jeff Gray saves) to allow no runs and just 12 hits over the next three days, stunning the Jays and increasing the Boston lead to four games.

The Jays would take the division lead in September, but the Red Sox won the division by two games.

"That was just the most unbelievable weekend—especially with how Toronto was put together, just what they had," Harris said. "For some reason, everything clicked for us."

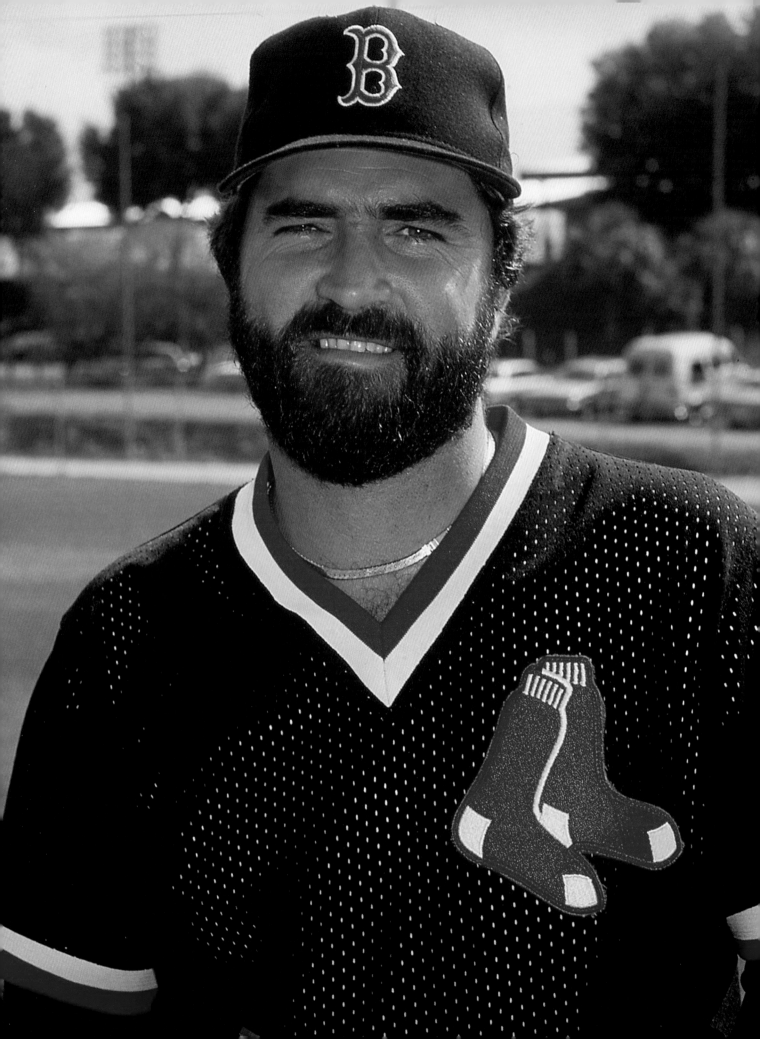

Jeff Reardon

Jeff Reardon threw the pitch. Ozzie Guillen hit the pitch. Tom Brunansky made the marvelous catch.

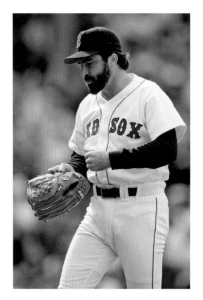

The Red Sox clinched the 1990 American League East.

"I thought it was going to be a double, so I thought . . . he hit it pretty good," Reardon said from his Florida home in 2017. "It was a fastball I got a little too much over the plate trying to jam him. He hit a nice line drive and then when I saw Bruno breaking for it I thought maybe we have a chance—and then he made that awesome catch."

Even the subsequent disappointment of getting swept by Oakland in the playoffs couldn't take away the thrill of a kid from Dalton, Massachusetts, securing the division for his hometown team.

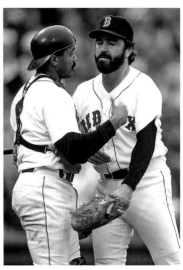

"My first year with the Sox [after coming home via free agency], I had that back surgery [during the season]. They weren't expecting me to come back. I hung around, got it fixed, and to be on the mound for the clincher was a big thrill. Growing up in Massachusetts, big Red Sock fan."

He almost didn't get to come home at all, but it was special for him.

"I always knew inside my heart I wanted to play for the Red Sox but I was always tied up in contracts and when the Twins wouldn't give me a third year, I just told TK [Kelly], 'Hey, it's over, I'm gonna go play for my hometown team who I always wanted to play for anyway.' He said, 'Good luck.'"

The man they called "The Terminator" recorded 88 of his 367 career saves with the Red Sox, leaving him fifth on the team's all-time list through 2017.

In 1992, he broke Rollie Fingers's all-time saves record with his 342nd, a mark broken by former Soxer Lee Smith the following year. Through '17, Reardon was 10th on the all-time MLB list with 367.

When he was in Boston, Reardon's saves would often go overlooked by the post-game media, who were always there to talk to him when he failed to come through. He wasn't pleased by that.

"That was pretty much true my whole career," he said. "I tell everybody that now—I say I made a point of going to my locker instead of icing my arm when I blew the game and when I got a save, after a while I just went in the trainer's room, nobody came over to talk to me. . . . I got used to it—that was the nature of the beast."

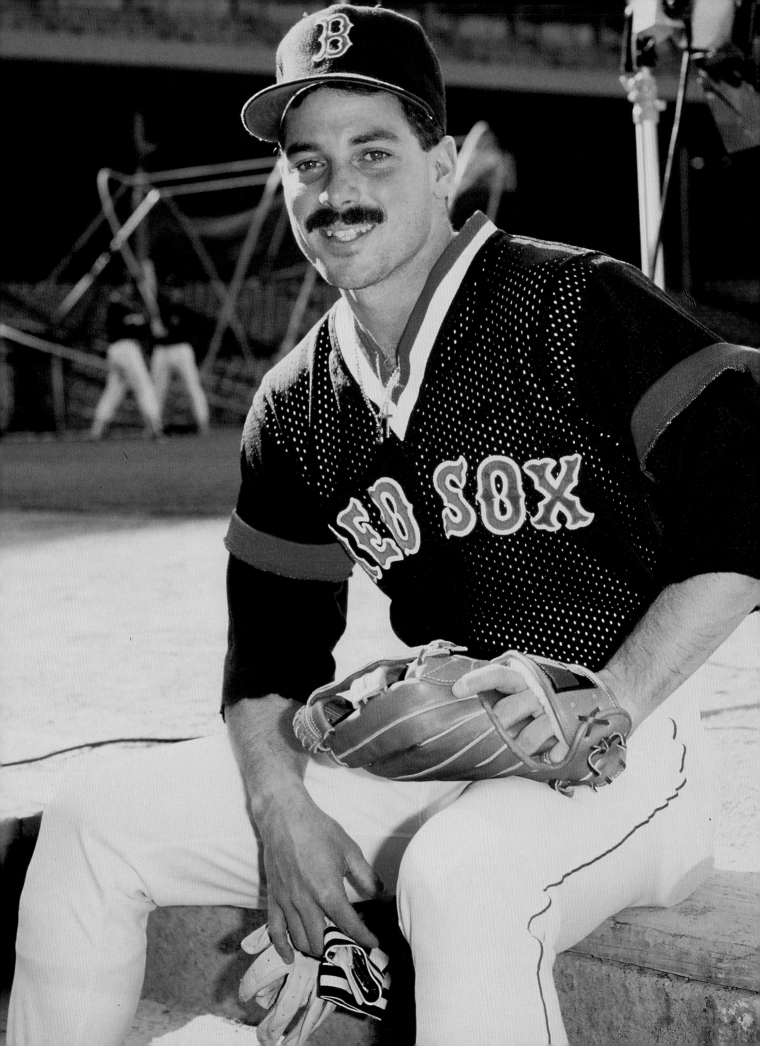

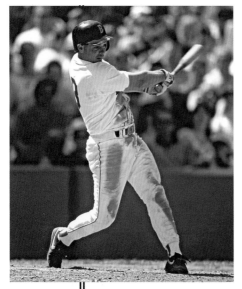

Jody Reed

As a Florida kid, Jody Reed had no idea what to expect when playing baseball in Boston.

And he almost couldn't believe it when he found out.

"You deal with the cold weather, you deal with the critique, the media and the fans and stuff like that and you're sitting going, 'Oh man, it would be nice to be somewhere else where you don't have to deal with that,' [but] as you [see] you go somewhere else and you're like, 'Wow,' you really understand and I think you come to embrace and miss . . . the passion that they have, and you start to understand where a lot of that passion comes from. It comes because of that passion that they have for their teams and their players," Reed said by phone in 2017.

As a shortstop in '88, Reed hit .293, then .288 in 1989 when he split the season at second base and shortstop; .289 with a league-leading 45 doubles in 1990, and .283 in '91 before leaving after the 1992 season, via an expansion deal that saw him wind up with the Dodgers.

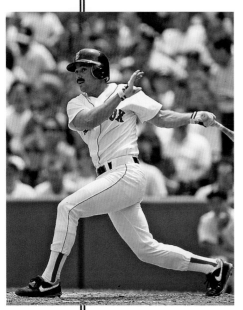

Those numbers for No. 3 might be easy to forget—but Reed, who went over to the "Dark Side" and was running the Yankees' minor leagues as this was being written, says there's no way he's forgotten in Boston.

"The one thing that I learned early in being involved with the Red Sox is Red Sox Nation never forgets—I don't think they do," he said.

After leaving Boston, Reed would unfortunately become a poster boy for contract mistakes—he turned down a three-year/$7.8 million deal from the Dodgers and wound up making some $900,000 the following year, with the Brewers.

Nevertheless, Reed says he has no regrets.

"You look back and you say, 'You know what? If this wouldn't have happened, maybe my life would have turned out differently,' and you say, 'I wouldn't sacrifice my wife and my children for anything.' Does that make sense?"

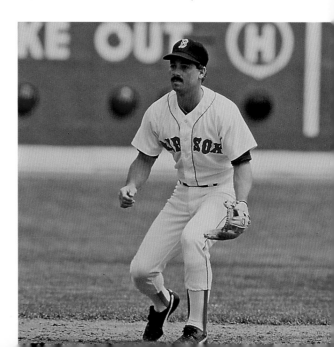

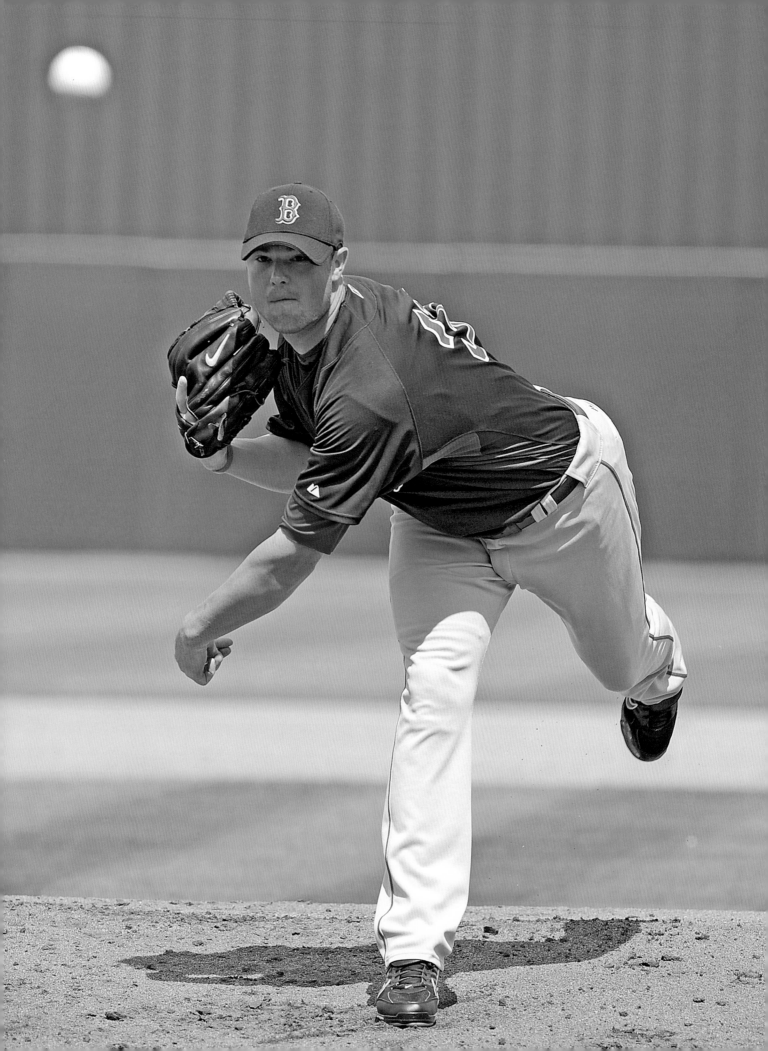

Jon Lester

For any pitcher, especially a young pitcher, the thought of injury, of the dreaded Tommy John or rotator cuff surgeries, is something you never want to face.

But when it's something more serious, when it's something that threatens your life, that's an entirely different matter.

In September 2006, Jon Lester was diagnosed with a rare form of non-Hodgkin's lymphoma, an aggressive blood cancer.

Just like that, a career that was only 15 starts old became the furthest thing from Lester's mind.

The good news was it was highly treatable. Lester came back and pitched for the Red Sox through a pair of World Series wins (he was 3–0) in the 2007 and '13 series and became an inspirational figure around the game.

Oh, by the way, he also pitched for the Cubs when they ended their World Series drought in 2016.

After his treatment, Lester returned to the mound in July 2007, went 4–0 in 11 starts and one late relief appearance—pitching out of the bullpen in the ALCS—and then pitched 5 2/3 scoreless innings (three hits) in the clinching game of the four-game sweep.

He won 65 games over the next four seasons, as folks started to wonder how long he'd be around. The fried chicken and beer (Lester and John Lackey) of the Bobby Valentine 2012 season gave way to another title, under John Farrell in '13. But the Red Sox did not offer Lester the money he deserved prior to the '14 season and he was moved to Oakland for Yoenis Cespedes late in the season before signing with the Cubs.

"It was something new, but I grew up with Theo [Epstein]," Lester said. "He did my first deal and I trusted him. Without that, I might have gone back to the comfort of Boston."

A check of the 2017 Red Sox media guide shows Lester all over the pitching records. He was third in strikeouts per nine innings (first among left-handers) with 8.21, as well as third in 10-strikeout games with 20 and fourth in strikeouts (first among lefties) with 1,386. He was also fifth in winning percentage, second only to Babe Ruth, at .636, and 11th in innings pitched (third among left-handers), with 1,519 1/3. On the negative side, he was eighth in both homers allowed and walks.

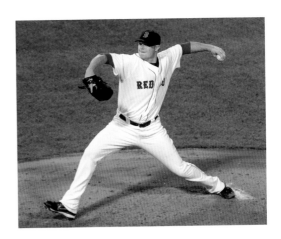

All that in nine years, a Boston career Lester—and the fans—had hoped would be longer.

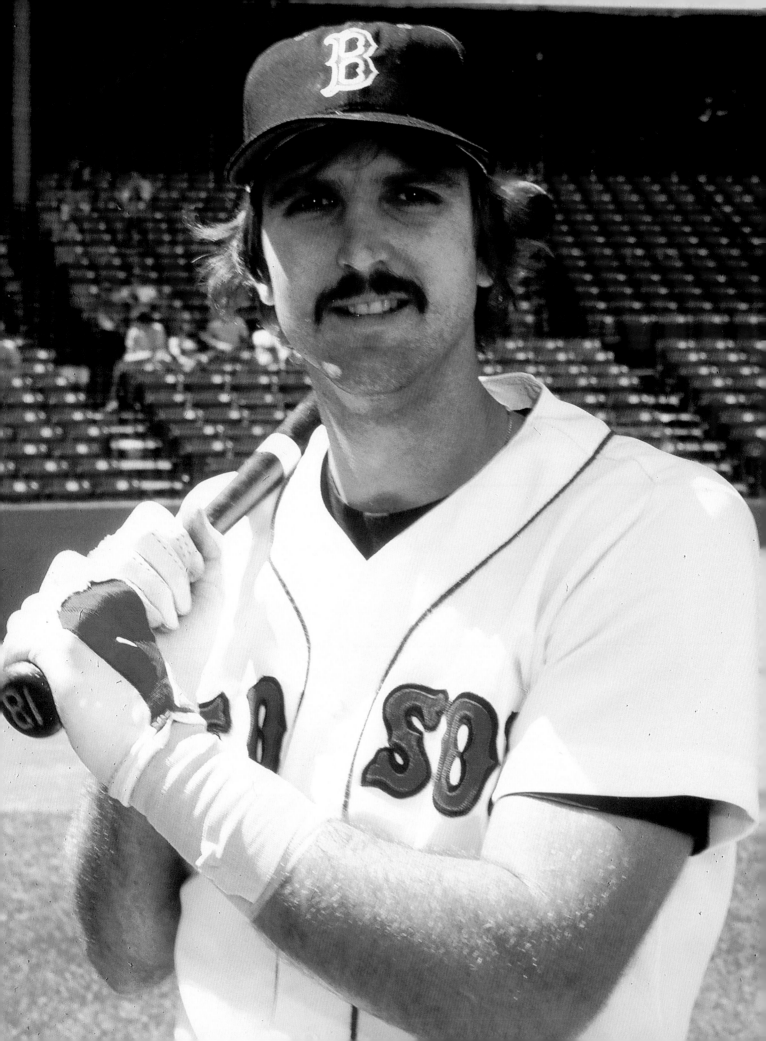

Glenn Hoffman

Anyone who knew or covered Glenn Hoffman during his time with the Red Sox had a feeling he might have a future in baseball. One of the classiest kids ever to come through the Red Sox chain, Hoffman didn't come close to equaling what his brother, Trevor, did in the major leagues. But that didn't keep the former shortstop from leaving his mark on the game.

Glenn Hoffman played for the Red Sox for nine years and was the full-time shortstop in 1982 and '83. He had a good year (shortened to 96 games by knee trouble) and appeared in 12 games on the 1986 team (not on the active roster in the postseason). And, after being traded away the next year, signed back with Boston before the 1988 season. He didn't make it through spring training.

Hoffman then began a long career as a coach, instructor, and even the interim manager of the Dodgers. There were rumors the Red Sox wanted him as their manager in 2002 and 2003, but Hoffman wanted to stay on the West Coast for family reasons. In 2006, he joined the Padres, and that's where he was, coaching third base, as this was being written (2017 season).

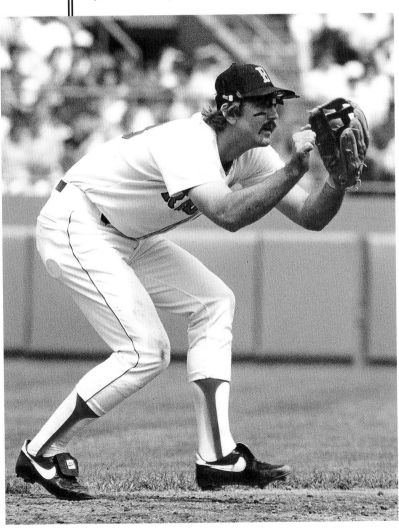

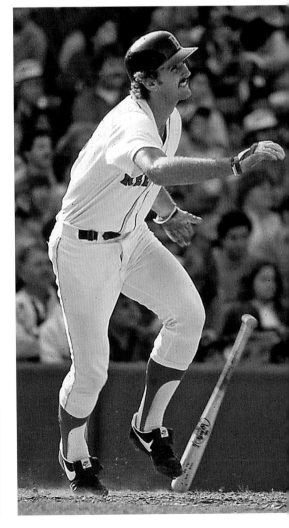

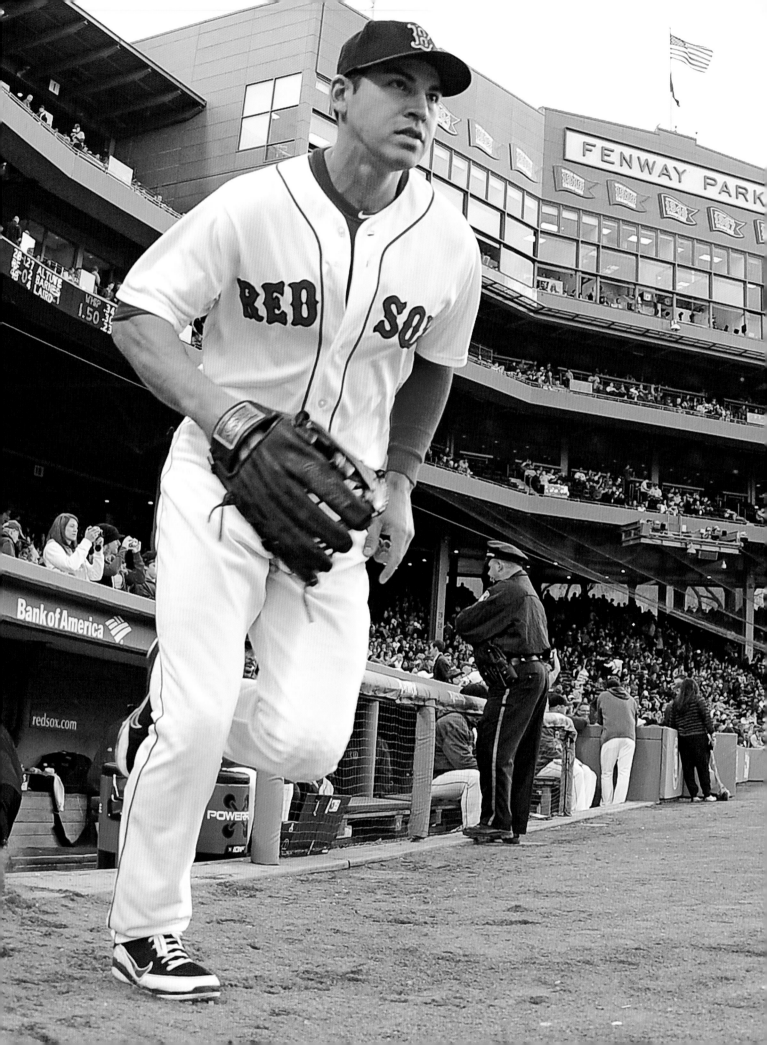

Jacoby Ellsbury

The loudest boos you hear when the Yankees are at Fenway ring out when Jacoby Ellsbury comes to the plate.

Why? Ellsbury, whose arrival in Boston helped the Red Sox win the World Series, and was then around for the 2013 championship, had the audacity to accept $153 million from the rival Yankees.

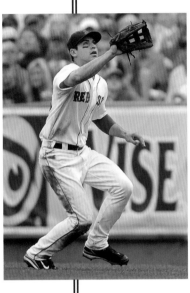

The Red Sox didn't offer him enough to stay, so he left.

He led the league in total bases in 2011 and led in steals three different times. Although he wasn't blessed with a big-time arm, he still caught everything that was catchable in centerfield.

Ellsbury batted .297 with 241 stolen bases in seven years with the Red Sox. He went 9-for-18 in the 2013 ALDS.

And then he became a Yankee.

Forget the circumstances, or that you would have done the same thing— he became a Yankee.

Upon his return to Fenway in 2014, he said, "All my memories are positive," and added, "I was excited to come to the ballpark today. The thing you miss most is the people.

"It was great seeing familiar faces, staff members, and people who've been letting me in at the gate for years. It's nice to hear they're happy for me."

Not so much for the fans.

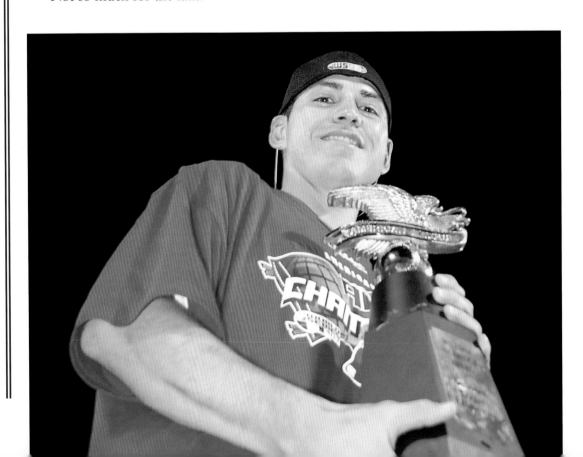

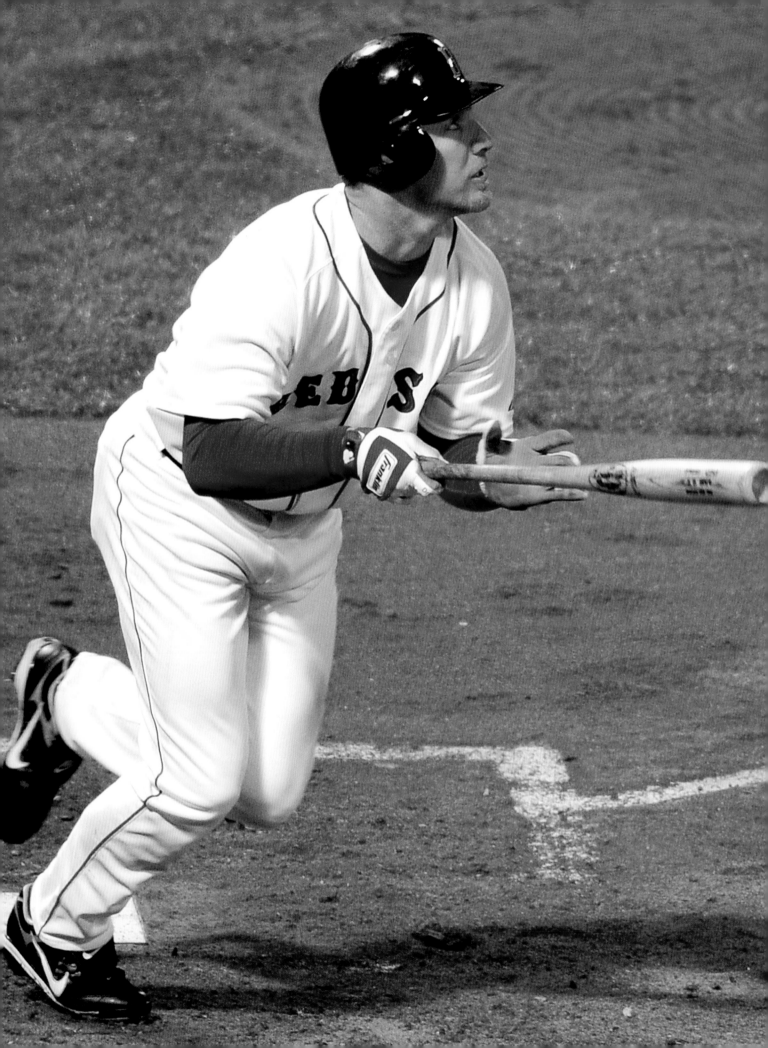

J.D. Drew

He was never the most popular guy to wear a Red Sox uniform, much of that resulting from a laid-back playing style and injuries.

But J.D. Drew was part of a special section of Red Sox history.

His career, which started late over a contract dispute, was marred by injuries, and the $70 million the Red Sox paid him for five years was a lot, but considering what he did to help the team win its second championship, it seems worth it.

After batting .270 with 11 homers and 64 RBIs in the regular season, the right fielder started his postseason by going 2-for-11. But he then went a combined 14-for-40 (.350) in the ALCS and World Series, with a homer and six RBIs in the LCS.

In his five years in Boston, Drew batted .264 with 80 homers and 286 RBIs.

He walked away at the end of the contract, retreating to a quiet life out of the limelight—and taking with him a 14-year career that saw him hit .278, with 242 homers, 795 RBIs, and an .873 OPS.

"I definitely didn't miss the stress and the pressure and the sleepless nights over whether I could hit a curveball or not, or who has the nasty changeup tomorrow," said Drew. "But as far as the competition goes, you're always a competitor, so there were things about the competition I missed."

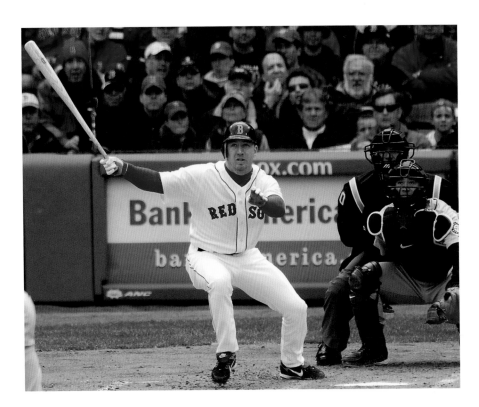

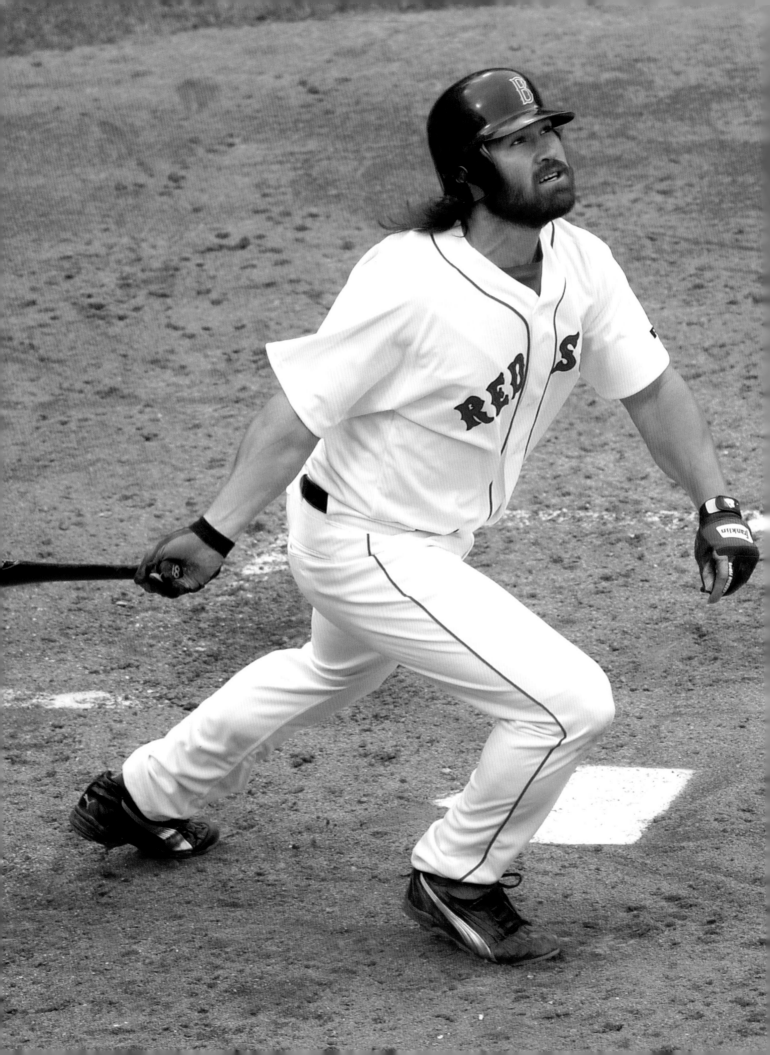

Johnny Damon

He eventually joined the so-called Dark Side when he signed with the Yankees, earning him boos when he came back to Fenway Park, but Johnny Damon left his mark on the Red Sox.

Damon played four of his 18 seasons in Boston, batting .295 with 56 homers and 299 RBIs. His 98 stolen bases had him tied for 15th place on the team's all-time stolen base list (as of the 2017 Red Sox media guide)—and he did it in four years.

He hit .268 in the 2004 postseason, batting just .171 without the help of two ALCS homers, including a Game 7 grand slam as part of a six-RBI game at Yankee Stadium.

"We changed [the attitude] for the better," he said of that team. "If you keep believing you're going to lose eventually, you will. But if you can change the attitude not only of the players but of the city, you tend to forget about the 86 years of misfortune."

He was 3-for-29 in the series with the Yankees when he came through in that Game 7 but was gone after the 2005 season. The Yankees offered more money, and he walked—into his regular chorus of boos at Fenway Park.

"It's a business. I know Jacoby Ellsbury is dealing with the same thing," Damon said in Maine in 2015. "Boston didn't feel comfortable with me being their center fielder four years down the road. I still felt comfortable with my abilities."

Damon batted .284 with 408 stolen bases in a career that saw him play for seven teams. He played in 59 postseason games, batting .276 with 10 homers and 33 RBIs. He hit .364 with three stolen bases—two of which came when he swiped second and continued on to third—in the 2009 Yankees' World Series win over the Philadelphia Phillies.

Marty Barrett

There was only one thing missing from Marty Barrett's dream 1986 postseason.

The painfully elusive final out in the 10th inning of Game 6 of the World Series.

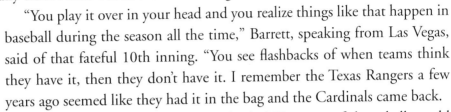

"You play it over in your head and you realize things like that happen in baseball during the season all the time," Barrett, speaking from Las Vegas, said of that fateful 10th inning. "You see flashbacks of when teams think they have it, then they don't have it. I remember the Texas Rangers a few years ago seemed like they had it in the bag and the Cardinals came back.

"You kinda think back and you think, 'Wow, one of those balls could have not fallen in. I definitely take that through my mind every now and then—especially when it gets in the playoffs and World Series because I still follow the Red Sox really closely. You just can't help but think about it."

When asked if his personal accomplishment in that World Series soothes the pain of losing just a bit, Barrett—who followed an 11-for-30 ALCS with a 13-for-30, 1.014 OPS World Series—said, "It definitely soothes it for me because I'm sure that if anyone struggled in a Series like that, it would always be like, 'Man, if I could have done a little bit more' and I don't know how much more I could have done personally and there were a lot of people who had really good Series for the Red Sox, but I think it's only natural when you get that close and it doesn't really go [your] way the typical thing would be, 'God if I could have done this' or 'if I could have come through,' but that does take a little of the sting out of it."

Barrett was close to Bill Buckner as the ball went under his glove to end Game 6.

"I always wish that that play didn't even happen. Let's put it this way—I wish they hadn't tied it before that play. I would have loved to have seen Bill holding the guy on first and hit that same ground ball and he probably catches it on the grass because he wouldn't have been playing that [deep]."

Barrett recalled Buckner being underrated as fielder, saying, "He took a tremendous amount of pride in his defense. Bill always did that."

Barrett wound up leaving the Red Sox after a serious knee injury, and he was awarded $1.7 million in damages after suing club physician Dr. Arthur Pappas, alleging the doctor hadn't told him of the severity of his injury.

Barrett played all but 12 of his major league games with the Red Sox, finishing his career with the San Diego Padres.

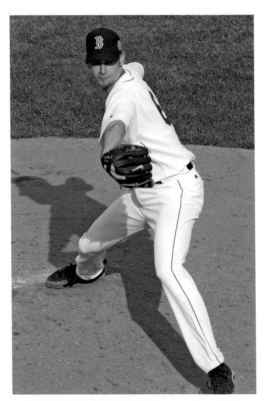

Bronson Arroyo

Sometimes, the schedule breaks just right.

The Red Sox' final road series of the 2017 regular season just happened to be in Cincinnati, which allowed them to be on hand when the Reds honored the retiring guitar-playing 40-year-old right-hander.

They presented him with a rocking chair, a Reds guitar, and his No. 61 from the scoreboard at Fenway.

It was a 16-year career that included a 148–137 record and a 4.28 ERA. Only three of those years were with the Red Sox, where he was just 24–19. But he also won a World Series in 2004.

And he was also the "victim" of "The Slap."

He was trying to tag Alex Rodriguez out near first base in Game 6 of the '04 ALCS, and A-Rod slapped the ball out of his glove and was ultimately correctly called "out"— but only after first being called safe.

"That was unprofessional. That's against the rules," said Kevin Millar. "If you want to play football, strap on some pads and go play for the Green Bay Packers."

Arroyo, flashing that big leg kick, left Boston and went on to become an ironman, throwing 200 innings or more eight out of nine seasons (2005–2013) and tossing 199 in the other. He led the National League with 240 $^2/_3$ innings in 2006—his first year with the Reds. He was an All-Star that season, going 14–11 with a 3.29 ERA.

He overcame Tommy John surgery and a torn rotator cuff to make it back to pitch for the Reds in 2017 prior to his retirement.

Doug Mirabelli

On May 1, 2006, a police escort roared through the streets of Boston. In the back seat of one of the cars was a baseball player, changing out of his street clothes into a Red Sox uniform

Doug Mirabelli had been reacquired by the Red Sox to come home and again catch knuckleballer Tim Wakefield.

"I don't think I've ever been that nervous for a ballgame ever in my career," said the 34-year-old Mirabelli, a veteran backup catcher.

Wakefield beat the Yankees that night.

"Very strange night," Wakefield said after the 7–3 win. "I probably have never seen this in my whole life. Guy gets out of a cab dressed in uni, puts his gear on, and goes right into the game. Phenomenal job."

Mirabelli, a .231 hitter in 12 seasons, won a ring with the Red Sox in 2007.

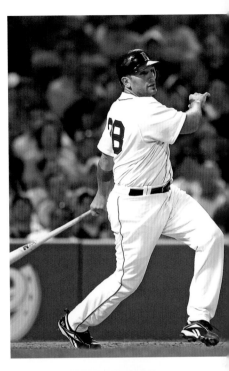

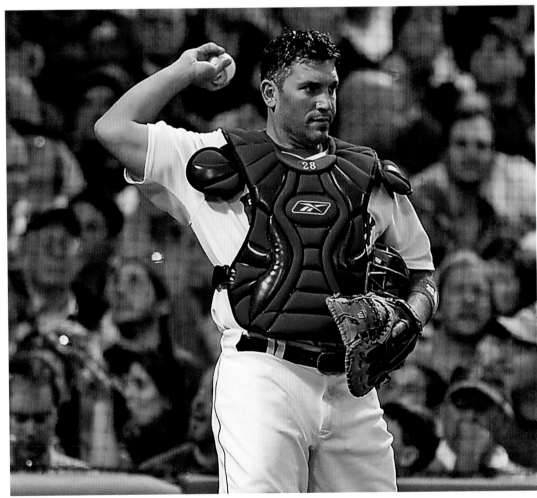

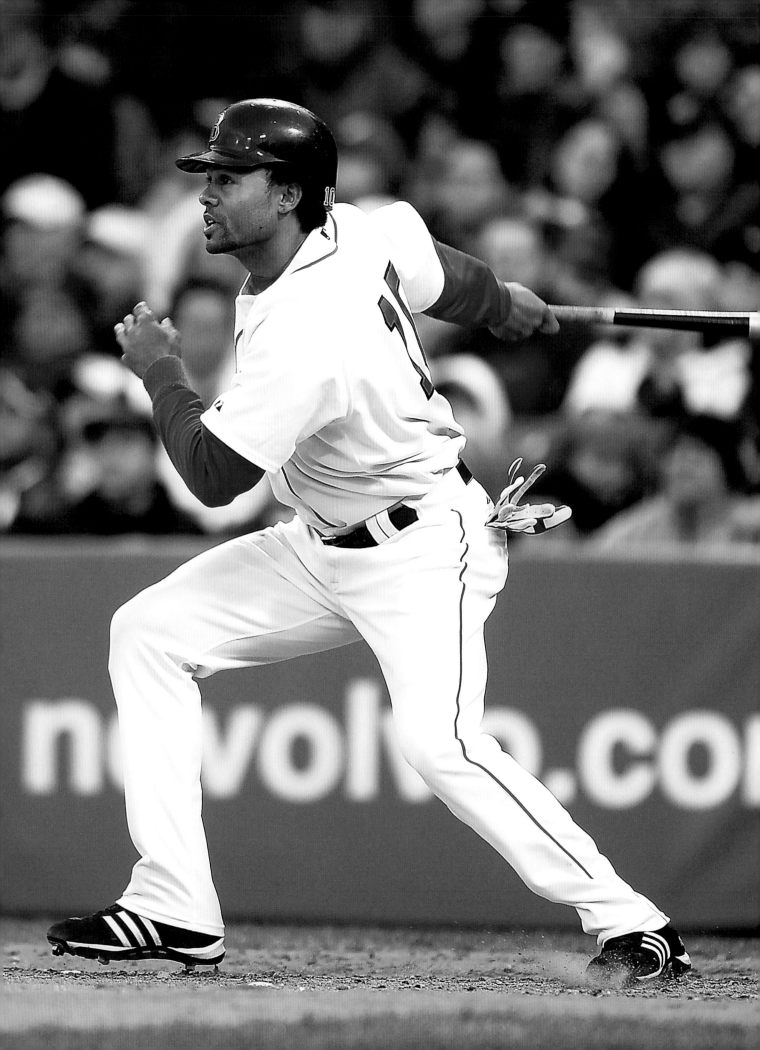

Coco Crisp

Red Sox fans love watching Jackie Bradley Jr. track down would-be extra base hits, easily making his case as the best centerfielder in the history of the old franchise.

Coco Crisp wasn't bad, either.

Crisp batted .268 with six homers, 60 RBIs, and 28 stolen bases for the champion 2007 Red Sox before giving way to Jacoby Ellsbury. Crisp hurt his knee ramming into the wall catching the final out of the ALCS.

Acquired from the A's in a seven-player trade January 27, 2006, Crisp played three years in Boston before being traded to Kansas City.

He would return to Fenway with the Indians (his second tour with that team) in 2016, being on the right side of the ALDS and then riding to within a win of another World Series title.

His Game 3 homer off Drew Pomeranz all but sealed the Red Sox' demise in 2016. It was his second postseason homer in 119 plate appearances.

"This means a lot simply because it's a big stage," Crisp, who had a .265 batting average and 309 career stolen bases, said after the game. "I've got nothing against Boston. You want to do something on a big stage—New York, Boston, big stage. Then you go over to the Cubs, that's a big stage, as well."

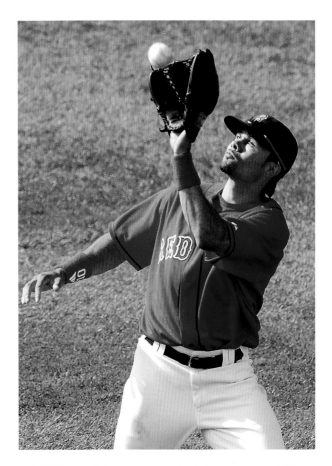

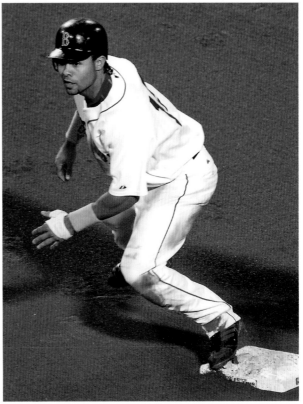

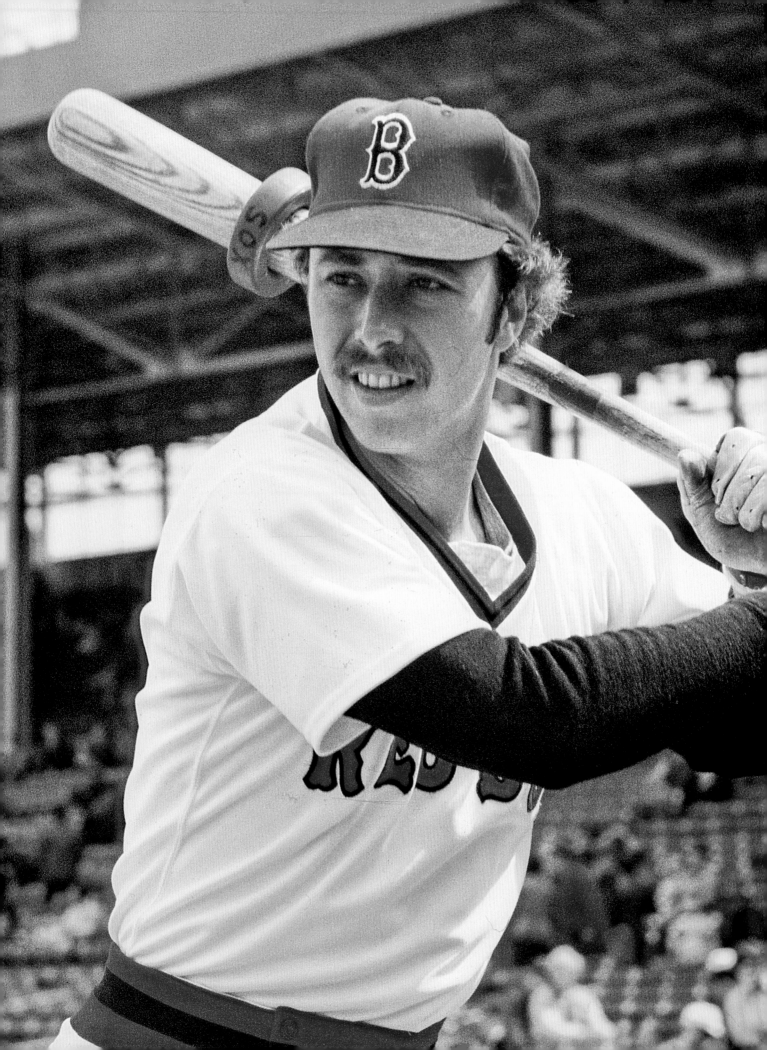

Jerry Remy

There's a whole generation of Red Sox fans who have no memory of Jerry Remy, the scrappy little second baseman who, after starting his career with the Angels, came home to play his final seven seasons with the Red Sox.

No, they know "RemDawg," the NESN broadcaster.

Becoming an announcer at the start of social media, Remy became a fixture both via the TV and the computer. As he battled cancer, which hit him again in 2017, the fans were right there with him, offering their encouragement.

"Stay strong Remy, Sox Nation loves you," tweeted @BostonStrong.

Remy, working his 30th season in the booth, surprised everyone by coming back to work before chemo rounds one and two.

Remy hit .278 for the 1978 Red Sox—hitting his only two career Red Sox homers and stealing 30 bases that year. In his seven years in Boston, the master of the drag bunt (another thing today's fan isn't all that familiar with) batted .286 and swiped 98 bases.

The Red Sox honored him for his 30 years, with a video tribute and gifts, and he was also honored by being voted into the Massachusetts Broadcasters Hall of Fame.

"I was quite surprised when they gave me the call a couple of weeks ago," Remy said. "Then they finally announced it. Hey, I'll take it. I don't know if I deserve it, but I'll take it. It's something I'm very proud of."

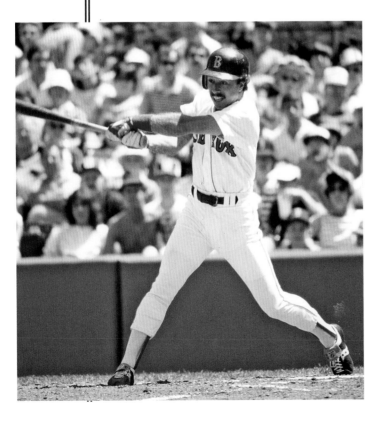

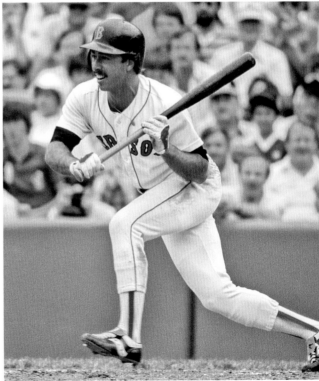

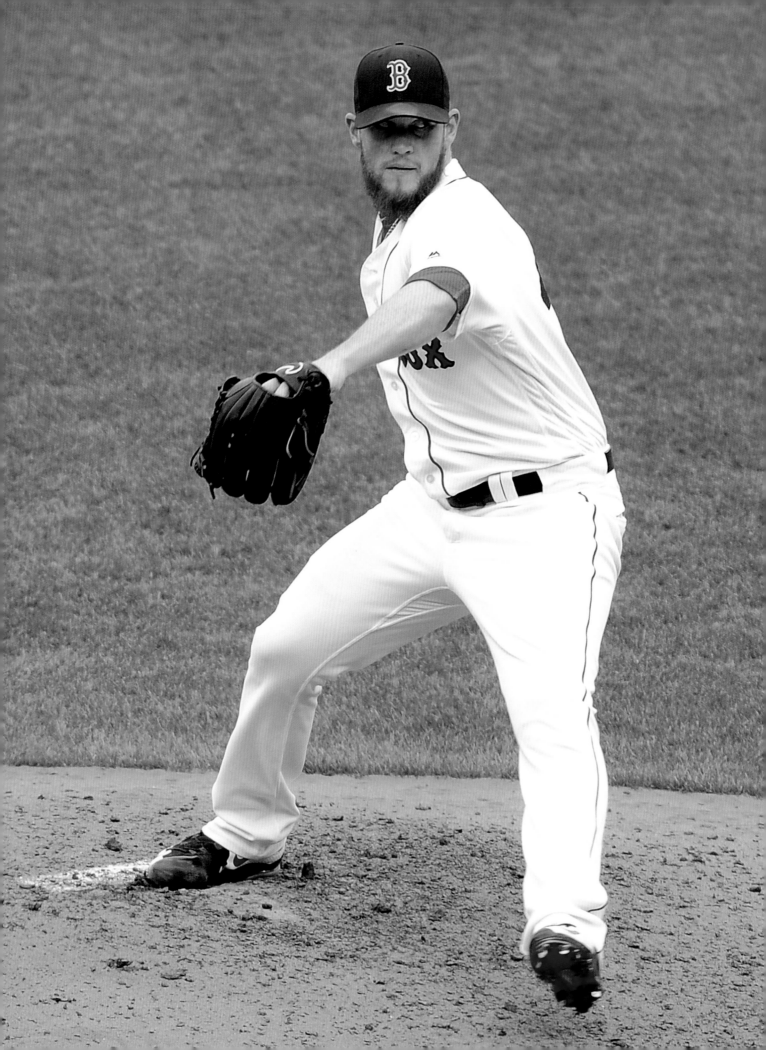

Craig Kimbrel

The arm swings at his right side as he looks in for the sign. His bobblehead, given out in 2016, sports that pose. His velocity usually is up there in the 100 mph range.

Craig Kimbrel has the perfect makeup for the modern big-league closer.

His Red Sox career started on a down note, with Chris Davis taking him deep for a three-run homer in the home opener. That was in a tie game, something that would haunt Kimbrel through much of his first season in Boston.

But by 2017, Kimbrel had become a fan favorite as he piled up scary numbers striking people out.

In late September of that season, Bill Ballou of the *Worcester Telegram* wrote:

"A strong argument can be made that Craig Kimbrel is enjoying the best season ever by a Red Sox closer, at least since the position evolved into a one-and-done assignment about 30 years ago."

As Ballou went on to explain, Kimbrel's credentials in 2017 were stellar, ultimately finishing with a 5–0 record and 35 saves in 39 opportunities. He also posted a 1.43 ERA and struck out opposition batters at a cosmic rate—126 in 69 innings. The Sox went 60–7 (.896) in Kimbrel's appearances.

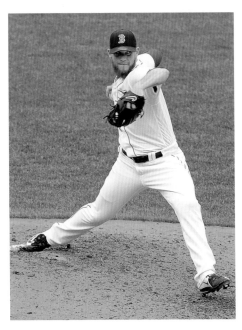

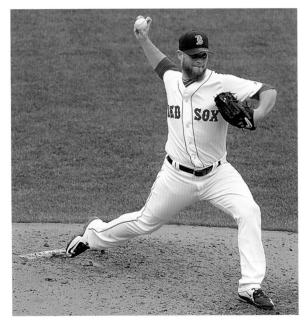

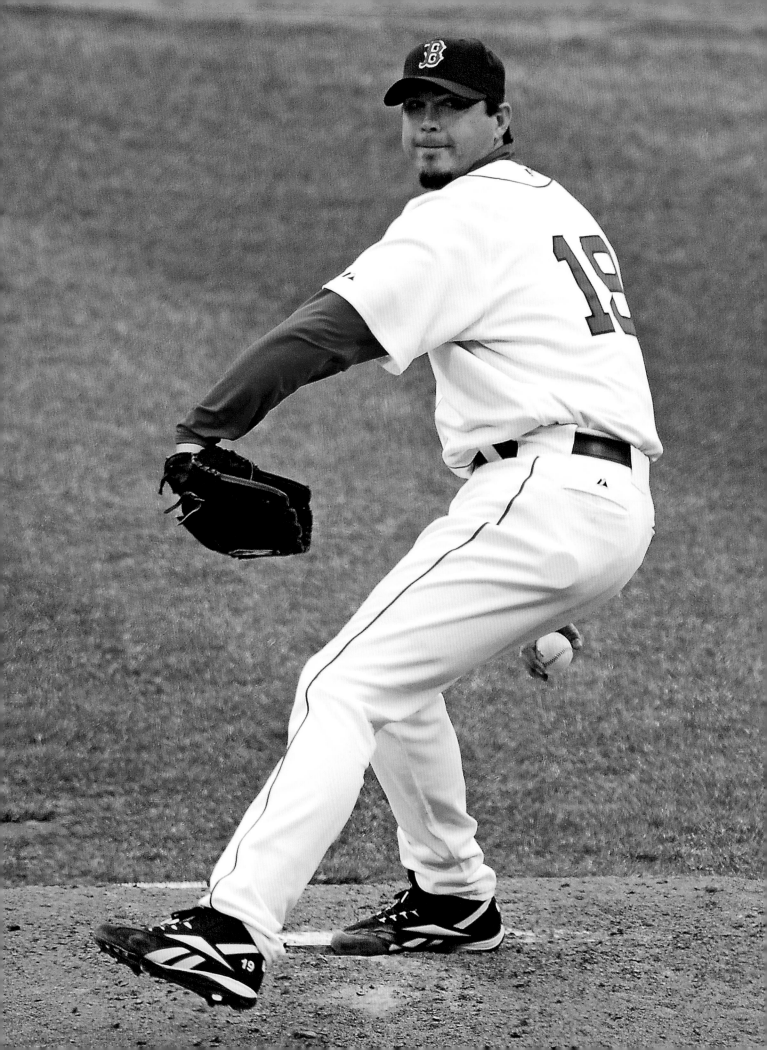

Josh Beckett

Josh Beckett had already pitched a World Series-clinching game for the then-Florida Marlins when the Red Sox traded for him and Mike Lowell in a deal that sent Hanley Ramirez away in 2005.

The trade was made during Theo Epstein's absence from the front office, and Beckett, whose stay in Boston wasn't a happy one at the end, did in 2007 what he had done in '03— win the World Series *and* capture the Series MVP honor.

He was 7–3 with a 3.07 ERA in 14 postseason appearances, 13 of them starts, and went 5–1 in the postseason for the Red Sox.

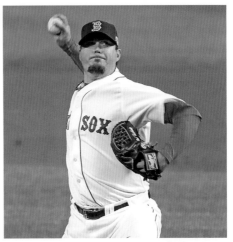

In his seven seasons with the Red Sox, Beckett went 89–58 with a 4.17 ERA. He won only eight games, with the Dodgers, after leaving Boston, finishing his career at 138–106 with a 3.88 ERA.

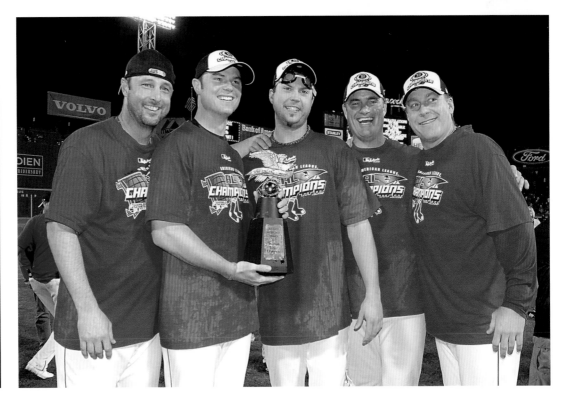

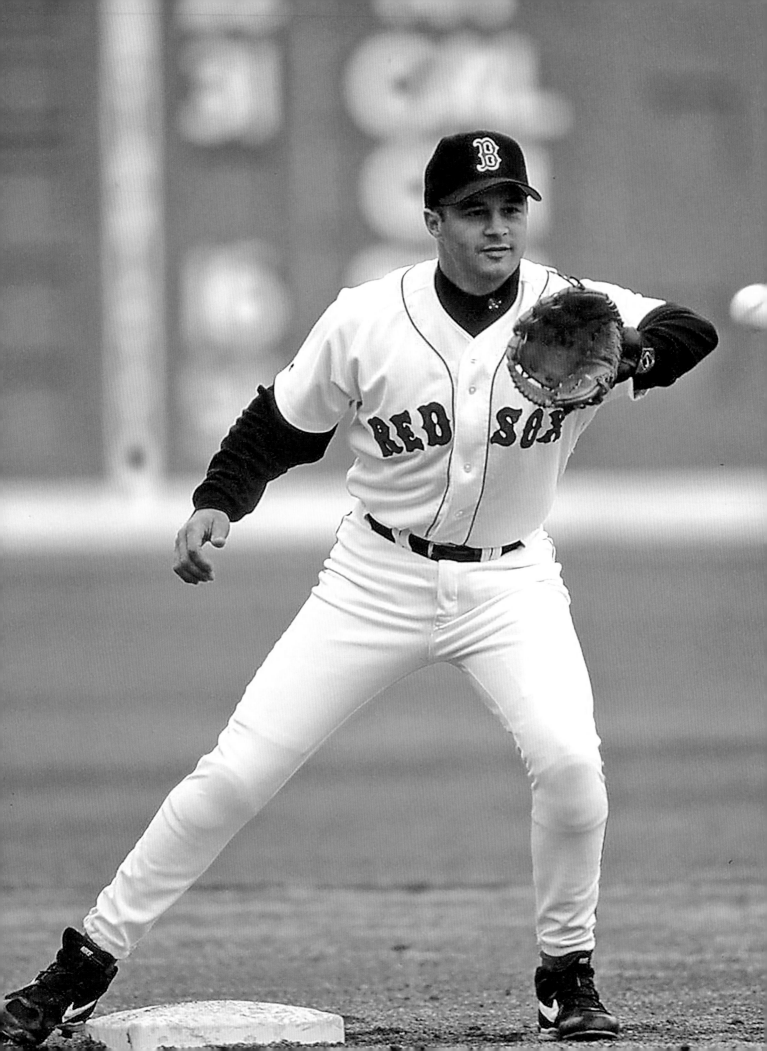

John Valentin

John Valentin did some fine hitting during his time with the Red Sox, including a 1995 season that saw him hit .298 with 27 homers, 102 RBIs, and a .931 OPS.

In '94, he hit .316 with 49 RBIs in 84 games. But it was something else Valentin did that year that put him in the Sox record book.

In July, Valentin pulled off the second unassisted triple play in American League history.

Playing shortstop against the Mariners, who had men on first and second and nobody out, Valentin caught a low line drive off the bat of Marc Neufeld. He stepped on second to double up Mike Blowers and then saw Keith Mitchell, who had been on first, near second. Valentin tagged Mitchell to end the inning.

"The guy didn't run, so I thought there was one out," Valentin said. "I looked up to see the board and realized there was nobody out. So I tagged him."

Oh, and he followed the 11th such feat in baseball history by hitting a home run in the bottom of the inning.

Valentin, who played at Seton Hall with Mo Vaughn and Craig Biggio, played short-stop and third base for 10 years in Boston, with a .281 batting average, 121 homers, 528 RBIs, and an .821 OPS. He led the American League with 47 doubles in 1997 and finished with an .814 career OPS.

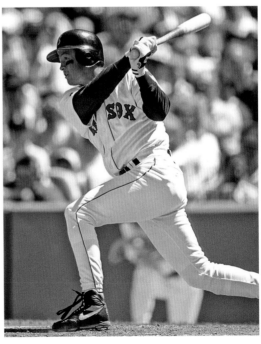

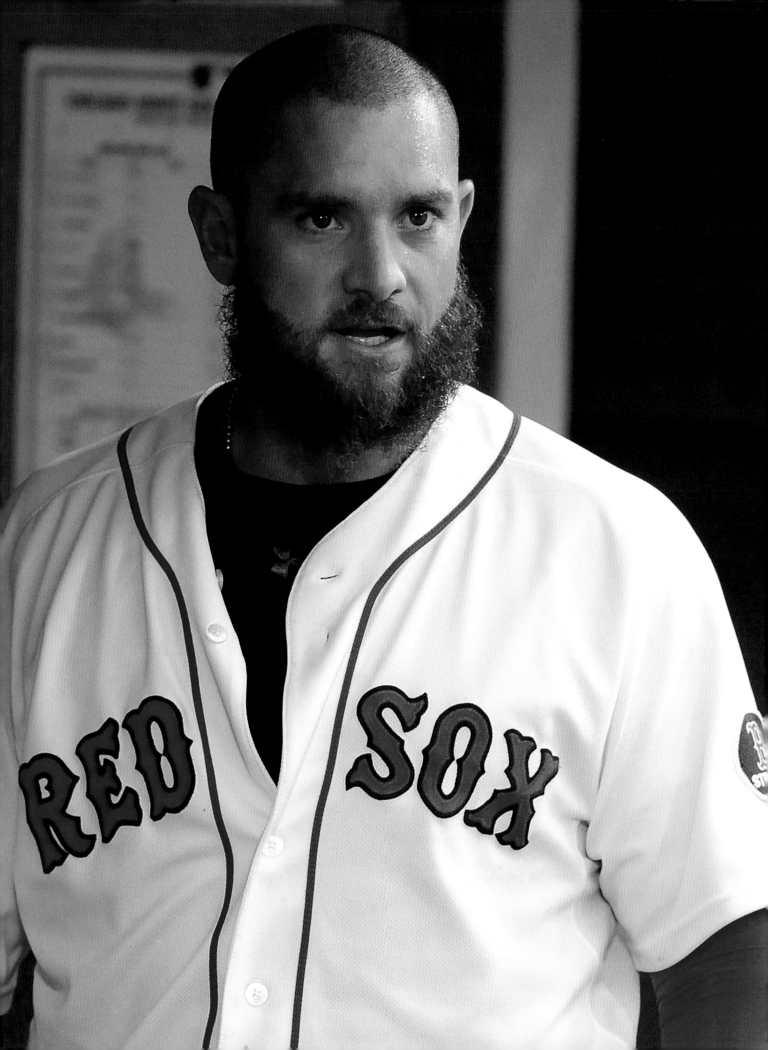

Jonny Gomes

Jonny Gomes played for seven teams—one of them twice—during his 13-year major league career. Fewer than two of them were in Boston.

But he won a World Series with the Red Sox in 2013.

He went just 2-for-17 in that World Series. But in Game 4, after an intentional walk to David Ortiz, Gomes hit a three-run homer off Cardinals right-hander Seth Maness, and the Red Sox won the game 4–2 to pull even in a Series they'd win in six games.

"A pretty special moment," Gomes said after the game. "If you're looking for words, I don't got much for you."

It came after Ortiz rallied the troops in the dugout.

"Every time that guy steps in the box, he's a presence," Gomes said. "Any time that guy puts on a uniform, he's a presence. If this guy wants to rally us together for a pep talk, it's like 24 kindergartners looking up to their teacher."

Gomes, hitless in the series to that point, went just 7-for-42 in that postseason and played just 196 regular season games in a Red Sox uniform. He hit .242 with 19 homers and 84 RBIs in those 196 games.

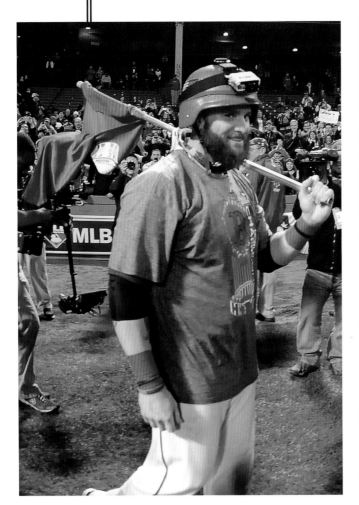

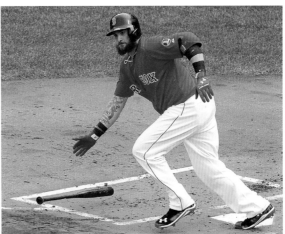

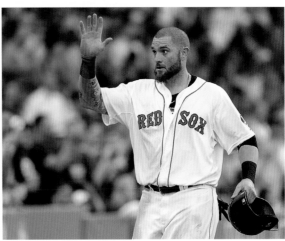

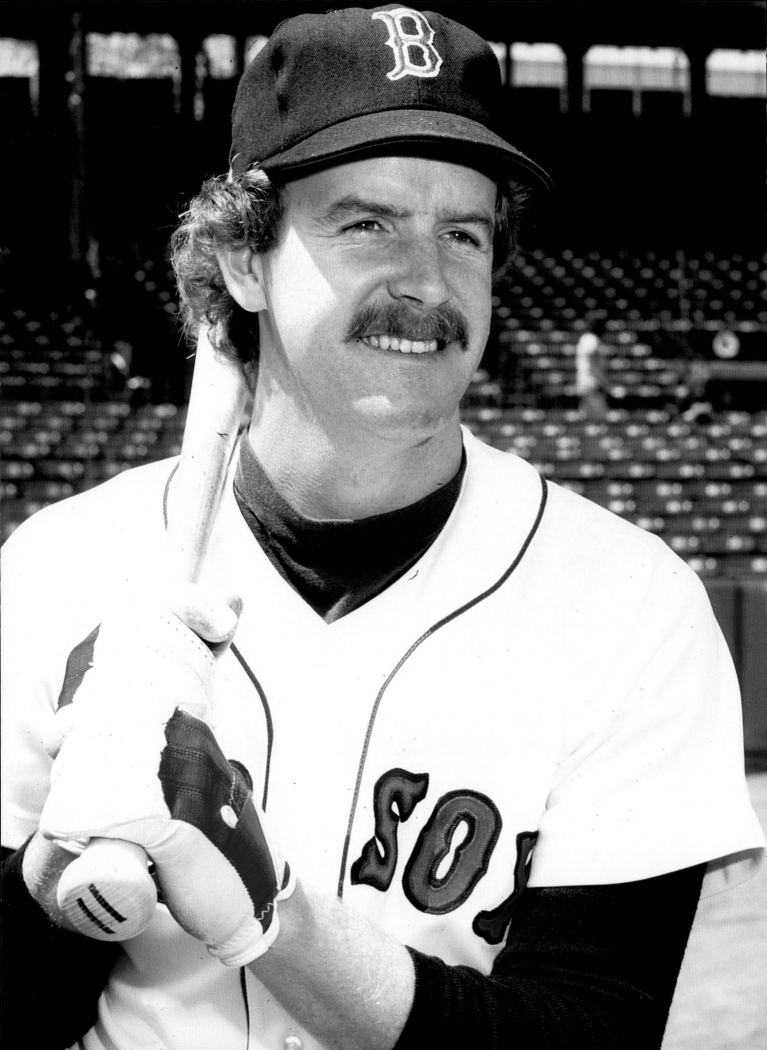

Dave Stapleton

Red Sox fans wish Dave Stapleton had been at first base in the bottom of the 10th inning of Game 6 of the 1986 World Series.

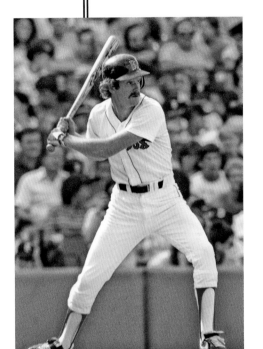

John McNamara decided to stick with Bill Buckner, giving the gladiator-like warrior the chance to be out there when Boston finally won a World Series.

Stapleton had been at first base for the end of every other Red Sox win in that postseason.

He was snubbed that night in New York, but over three decades later, Stapleton, one of the really good guys in the business, was inducted into the Mobile, Alabama, Sports Hall of Fame.

When he returned for the 30-year reunion of the '86 team, Stapleton, who played all 582 games of his major league career with the Red Sox, made it clear where his baseball heart lies.

"My daughter and my sons are die-hard Red Sox fans," he said. "They have memorabilia in their rooms and on their cars. My daughter went to Ole Miss and she had a professor there who said he was a member of 'Red Sox Nation Mississippi.' She told the professor that I was her dad. I think she got an 'A' in that class."

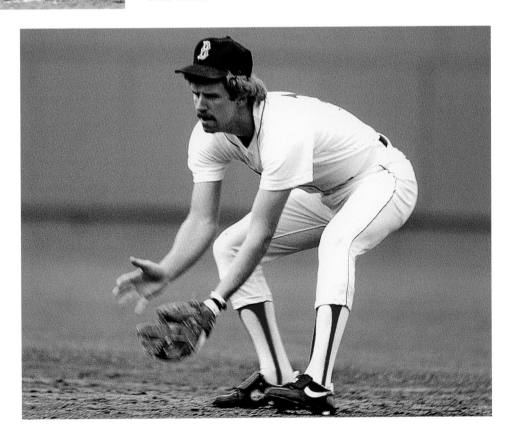

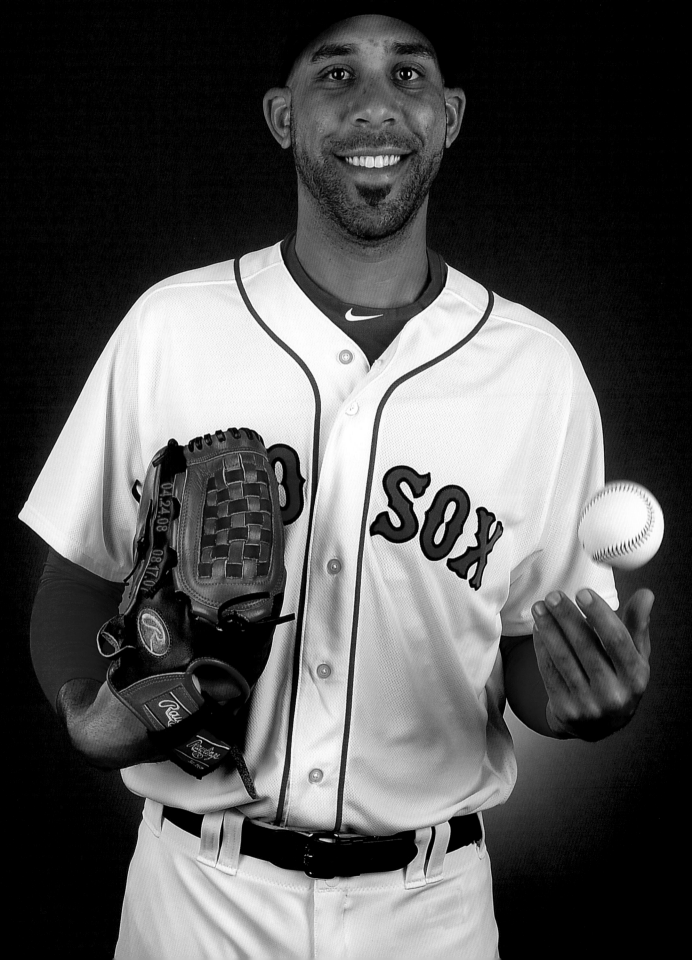

David Price

Bill Campbell signed a five-year contract as a free agent with the Red Sox in 1976 worth a whopping $1 million.

David Price signed a seven-year contract as a free agent with the Red Sox in 2016 worth $217 million—or about $1 million per start.

Price had a rocky start to his Boston career, but he did finish 17–9 in 2016. Nevertheless, he failed to win in the postseason.

Price was hurt for a large portion of 2017 and wound up finishing the season in the bullpen. Only time will tell as to what Price will bring in the years to come.

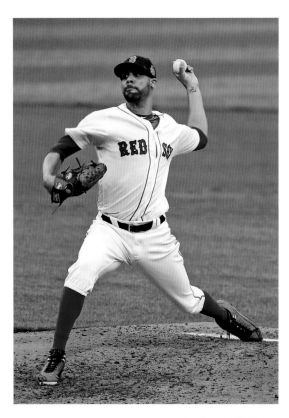

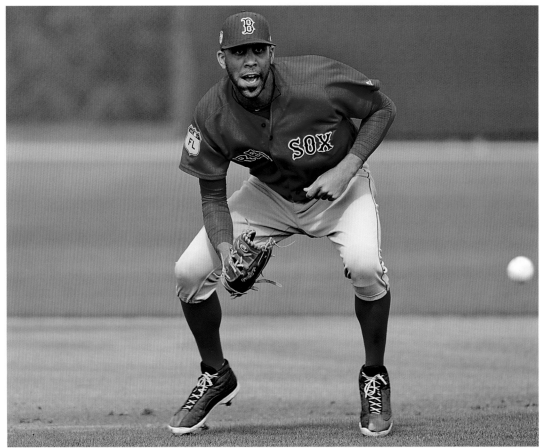

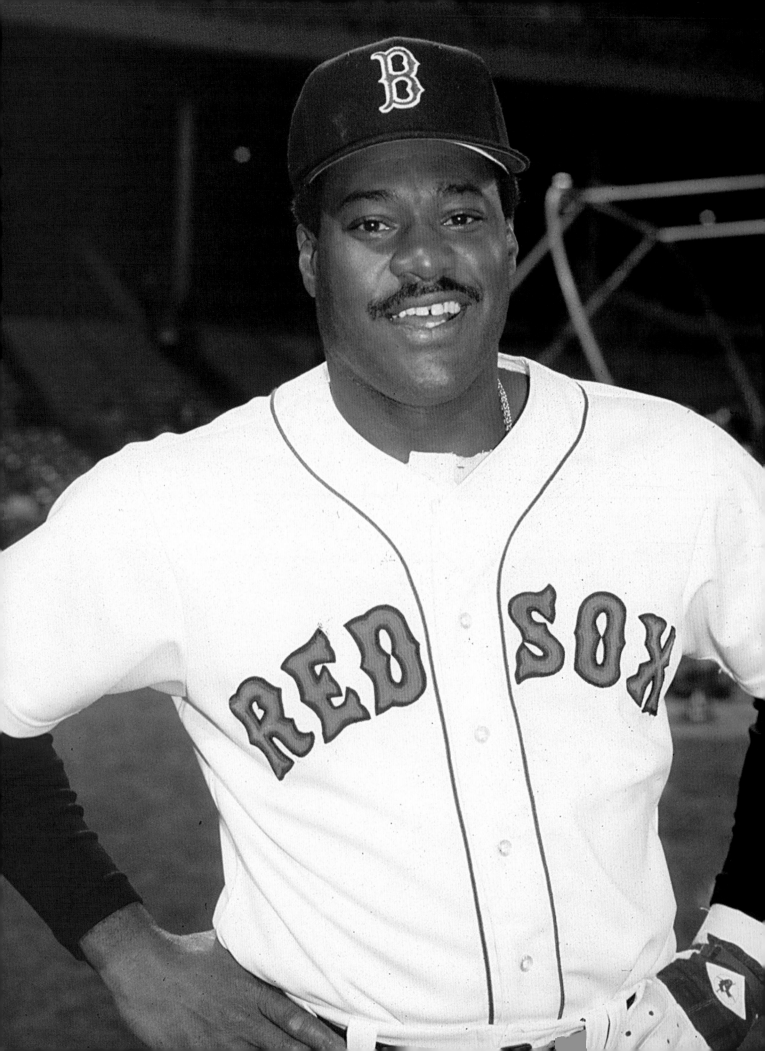

Don Baylor

The baseball world was saddened in the summer of 2017 when Don Baylor lost his battle with cancer, at the age of sixty-eight.

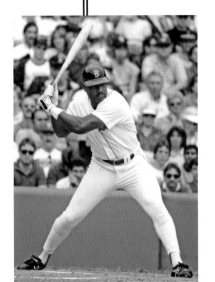

"He was pretty special," said a subdued Dwight Evans, in the *New Hampshire Union-Leader*. "He's probably one of the best teammates I ever played with and to have him in '86 when we made that trade [for Mike Easler] to New York to get him, immediate . . . his presence was immediate on the whole club and he carried that on and off the field. Just a tremendous guy. Great baseball man and for me a great friend."

Baylor was a key cog in that '86 near title—both on and off the field. He hit .238 with 31 homers and 94 RBIs in the regular season and then hit the oft-forgotten two-run homer that set the table for the Dave Henderson heroics.

"I remember playing against him," Barrett said. "He was so intimidating—just this big ol' bad dude that stands on the plate, dares you to throw it inside and he's not gonna move. Next thing you know we grab him and I'm like, 'Wow, this is unbelievable.' And then you find out he's just like a gentle giant, just a sweet guy that knows a lot about baseball and obviously he made our lineup incredibly better and we all benefited from it that year."

Even though he had indeed left the game after so many years as a player, coach, and manager, it was hard to imagine baseball without Don Baylor.

"He'd just left the game after all those years, he was enjoying his grandchildren and he was trying to move away from the game and just try to be a human being there a little bit," said Evans. "This guy was in the game for [so long]—he had two granddaughters and he loved being around them. He did.

"A pretty special guy."

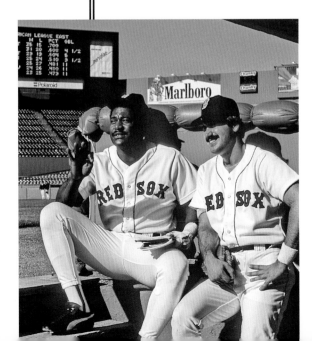

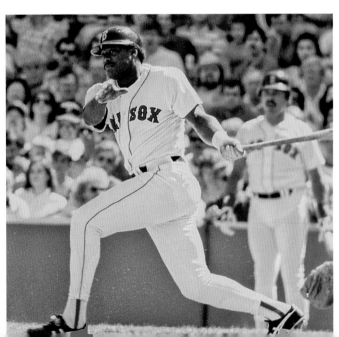

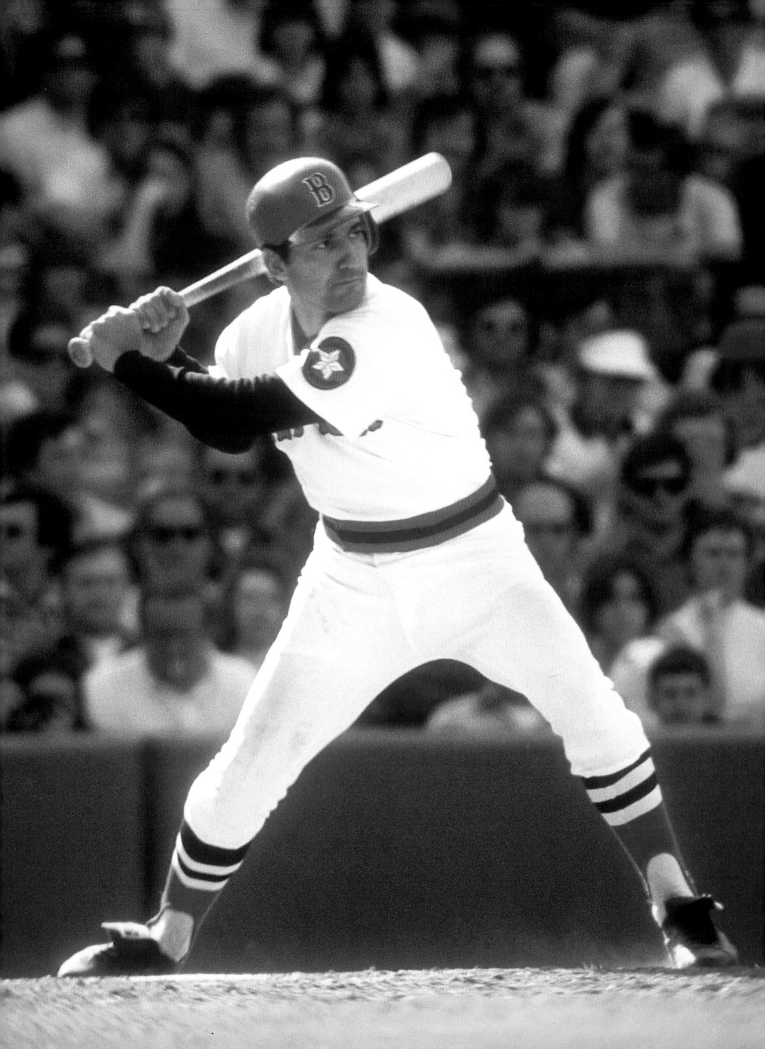

Rico Petrocelli

Few people are as popular around Boston as Rico Petrocelli.

And he played his last game with the Red Sox in 1976.

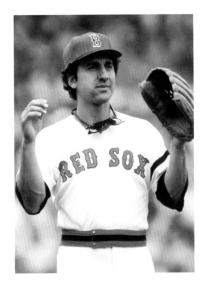

Petrocelli, a New Yorker who played his entire career in Boston, was a shortstop when he caught the final out of the 1967 regular season and wound up as a third baseman.

His best year was 1969, when he hit a career-high .297 with 40 homers (the American League high for shortstops at the time, later smashed by Alex Rodriguez, with 57) and 97 RBIs. He drove in 103 runs the following season and delivered 289 RBIs from 1969-71.

He was a two-time All-Star and hit .308 in the classic 1975 World Series. In Game 6 of the 1967 World Series, Petrocelli hit two home runs to help the Red Sox win and stay alive.

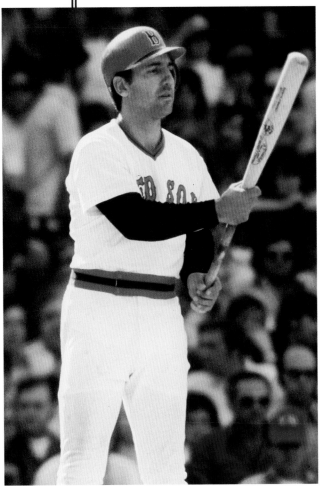

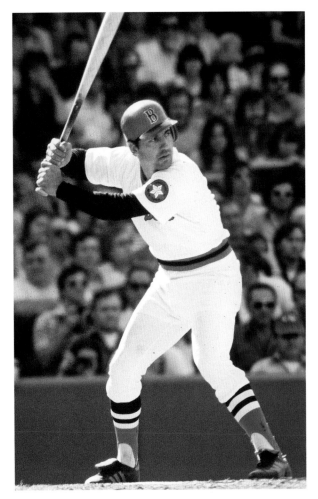

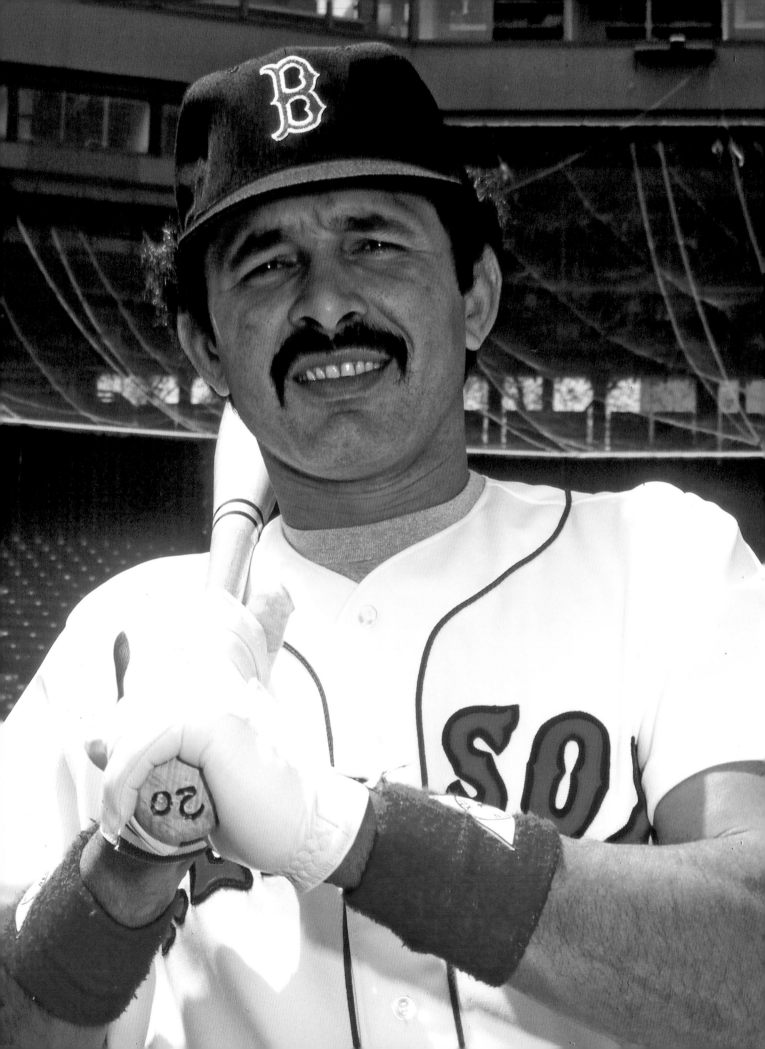

Tony Armas

His name is an easy one to overlook after all these years, but Tony Armas was one of the game's top power hitters when he was with the Red Sox.

The center fielder with the pleasant personality led the American League in homers during the strike-shortened 1981 season, with 22. He came to Boston in the deal that sent Carney Lansford to Oakland and hit 43 homers and drove in 123 runs in 1984, leading the league in both categories.

Injuries were always a problem—Armas made six trips to the disabled list in 10 years.

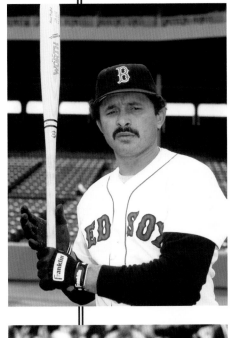

Because of an ankle injury, he was replaced by Dave Henderson in the fifth game of the 1986 ALCS, where Henderson would become the hero. Armas got just one at-bat in the World Series and was gone as a free agent after that.

His career was never the same.

The site top100redsox.blogspot.com tabbed Armas as No. 70 on the list of the top 100 Red Sox players of all time.

"He hit 113 HR in [2,155] plate appearances with Boston, which comes out to a HR every [19] PA," they said in 2007. "Out of every player to hit at least 50 HR in a Red Sox uniform, only Ted Williams, Manny Ramirez, Jimmie Foxx, David Ortiz, Jose Canseco, and Dick Stuart homered more often than Armas."

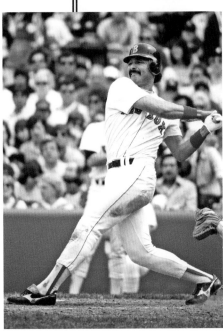

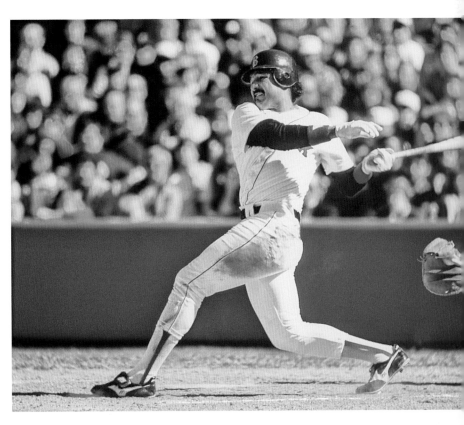

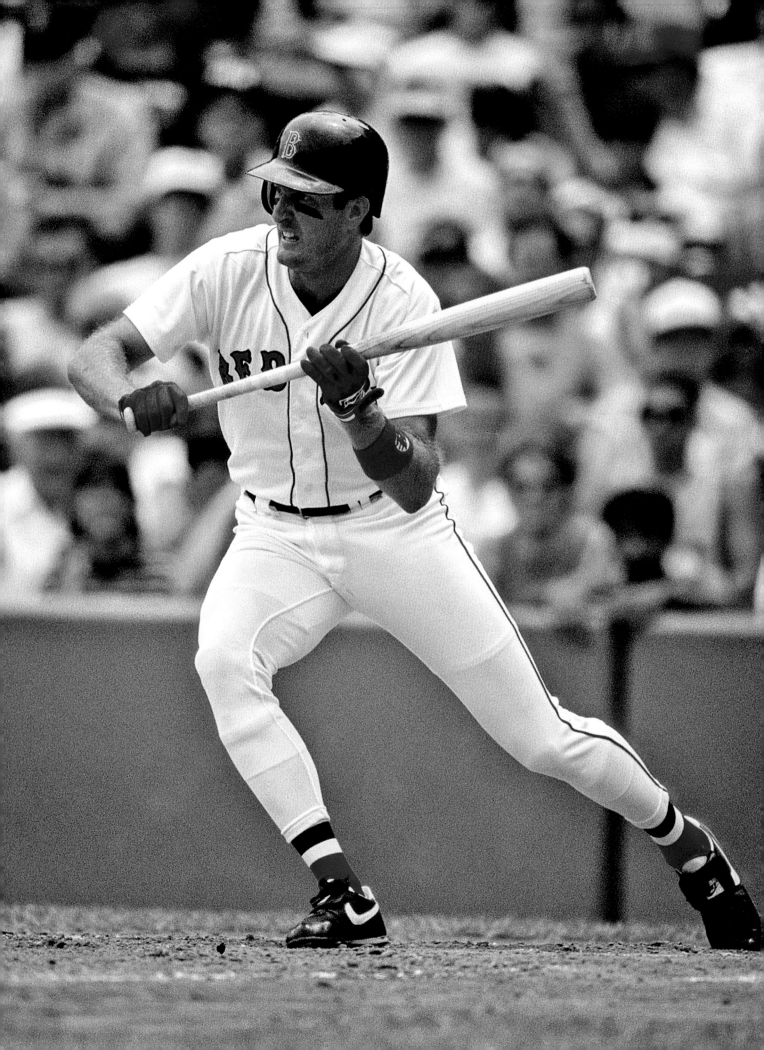

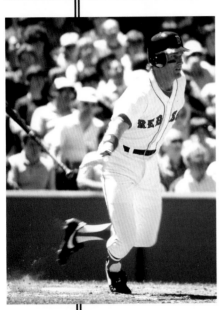

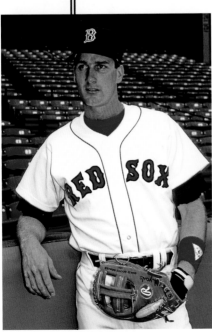

Steve Lyons

If your nickname is Psycho and you write a book, what is the title of the book that makes sense?

Psychoanalysis, of course.

And if you are writing said book, who is the most likely person to write the foreword?

Stephen King?

"Met him a few times. Admire him and I knew he was a big Sox fan," Steve Lyons said in 2017. "His foreword is great, too.

"It's the only time in [the] history of book writing where the foreword is better than the book."

Wrote King, the master of mystery writing who, after all, was writing *about* a mystery:

"I had admired Steve Lyons a great deal during his Red Sox years . . . he seemed to me to be an island of hardworking, blue-collar sanity at a time when many of the higher-paid Red Sox players were lazy and complaining, the baseball equivalents of gasbag floats in the Macy's Turkey Day Parade."

You get the drift, right?

Lyons was a valuable extra player on a baseball team. Versatile. Play him in the infield, he was fine. Play him in the outfield, he was fine. He would do the occasional goofy thing, like when he tried to steal third base with Wade Boggs up in the ninth inning— something his manager, John McNamara, really loved.

"One of the all-time personalities of the game," White Sox teammate Carlton Fisk wrote on the back of the book.

Said former teammate Frank Thomas: "Psycho is a guy who really kept the game fun and was willing to play anywhere to help his team win."

Swapping Red Sox for White, Lyons was traded to Chicago at the June then-trade deadline for Hall of Famer Tom Seaver. Advised he was the second-best player in the Tom Seaver deal, he said, "Maybe third."

But he was no joke as a player. He was a useful part during his nine years in the major leagues.

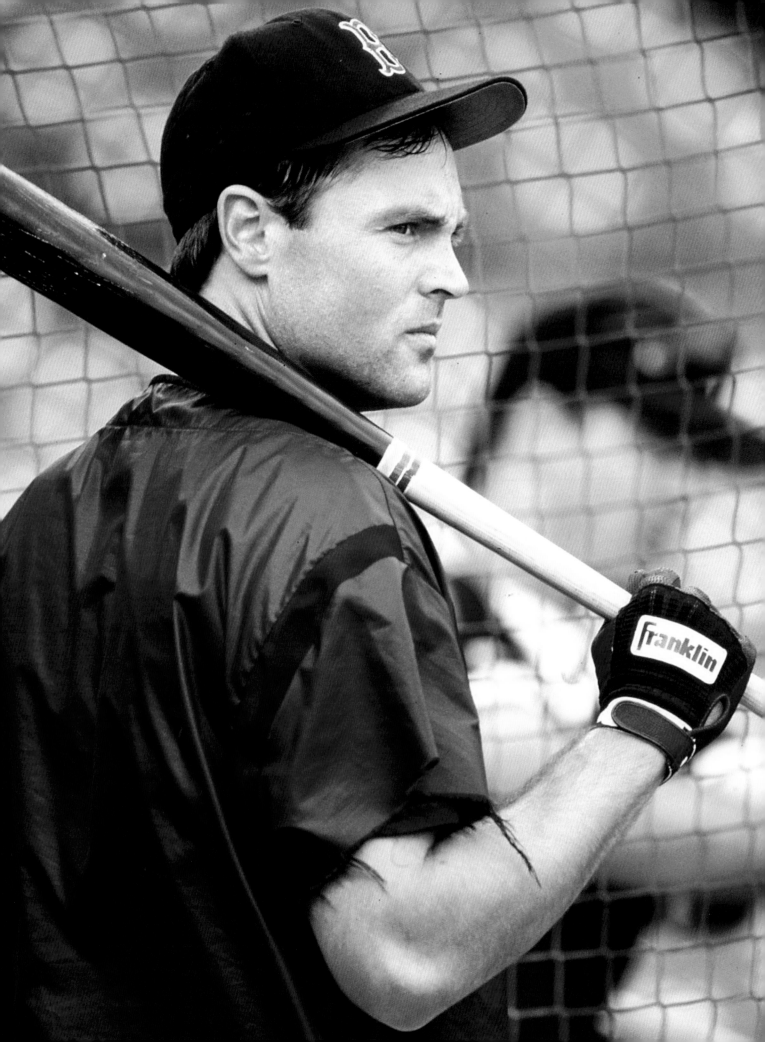

Tom Brunansky

Tom Brunansky played 14 years in the major leagues. He won a World Series with the Twins in 1987. He made an All-Star team. He had an outstanding American League Championship Series with the Twins, hitting two homers and driving in nine runs.

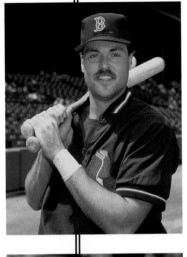

But around Boston, where Bruno played four years on two different stints, the right field is known for "The Catch."

Ozzie Guillen hit the line drive toward the right field corner. Brunansky caught it with a dive, only to lose his hat. As he looked for the hat, people wondered if he was looking for the ball, which was in his glove. The Red Sox had clinched the 1990 AL East.

"Actually, I wasn't looking for it—I went to grab it," he said of the hat, during a 2017 phone conversation. "When I hit the ground, and then I hit the wall, I knew I had the ball in my glove. I looked up to show the umpire, who was, if I'm not mistaken, it was Tim McClelland, that was trying to run down the angles so he could look around the corner to see if I caught the ball or not.

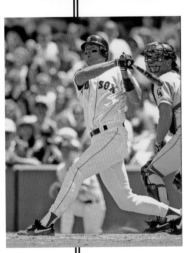

"He had gotten hit by somebody coming on the field and was down on the ground. So I said, 'Well, I'm not going to show HIM the ball because he's down on the ground. So then I saw my hat and I went back to reach and grab for my hat, but there were already people on the field and my hat was gone—never once thinking that it would appear that I was reaching for a ball. That never, EVER entered into my mind."

He ran in toward the infield, shedding fans along the way.

Brunansky would go only 1-for-12 in the playoff loss to the A's and wound up playing three years on his first stay before returning in 1994.

Bruno, who hit 271 homers in his career (56 for the Red Sox), was more than impressed with his short time in Boston.

"It's a special place to play. I mean, I love Fenway because . . . Fenway and Wrigley, because of the history, my two favorite parks that are still there, because I love the history of the game and being able to walk in the steps of those that were way beyond our time, some of the greatest players ever—to know that they walked down the same tunnels that we were able to walk through.

"Stand in the batter's box and hit in the same place as some of the greatest players ever in the game and some of the memories and some of the things that have happened."

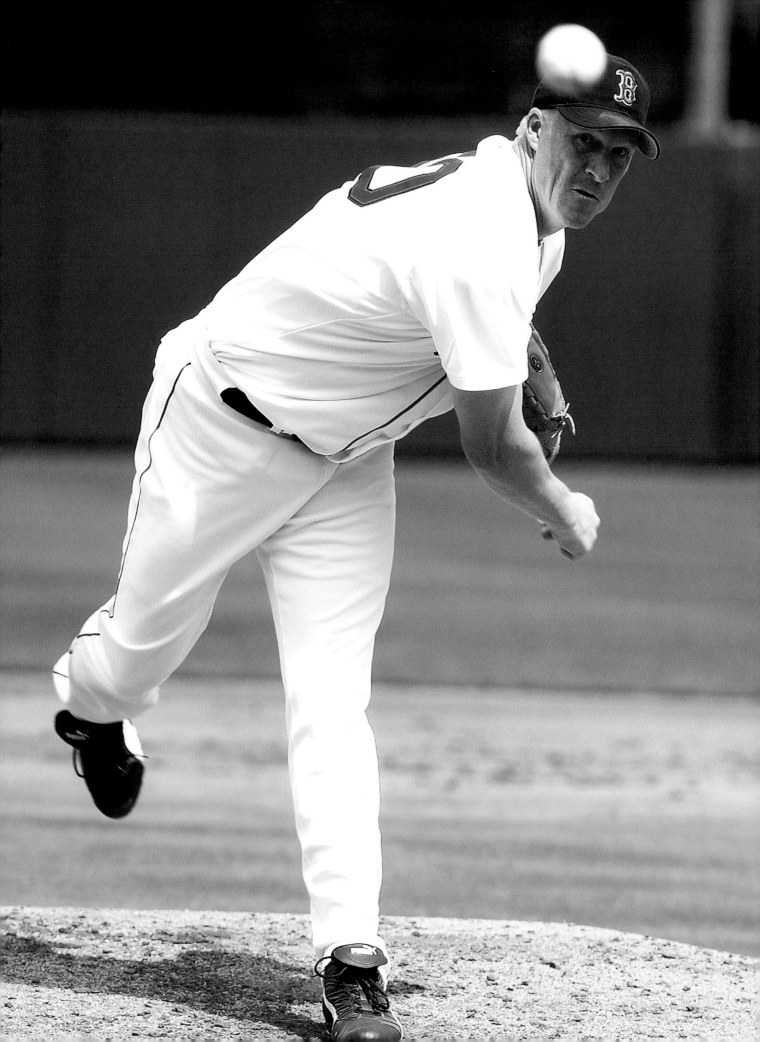

Mike Timlin

Mike Timlin pitched 18 seasons in the major leagues. He went to the postseason 11 different seasons. He took home four World Series rings, winning it all with the Red Sox in both 2004 and '07.

He finished his career in Boston in 2008, going 75–73 with 141 saves lifetime. He was 0–3 in 46 postseason games but also won the 1992 and '93 World Series with Toronto.

In 2011, bluebirdbanter.com voted Timlin, who appeared in 1,058 games in the major leagues, as No. 53 on the list of the 55 greatest Blue Jays in the club's history.

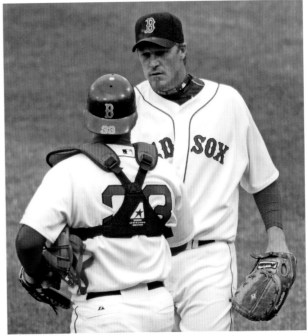

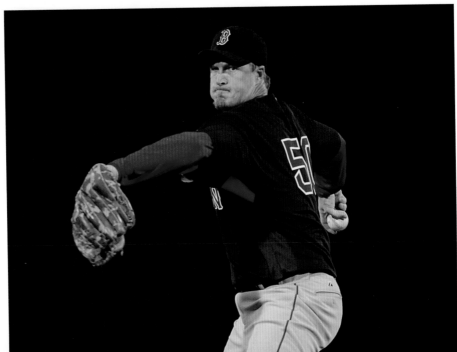

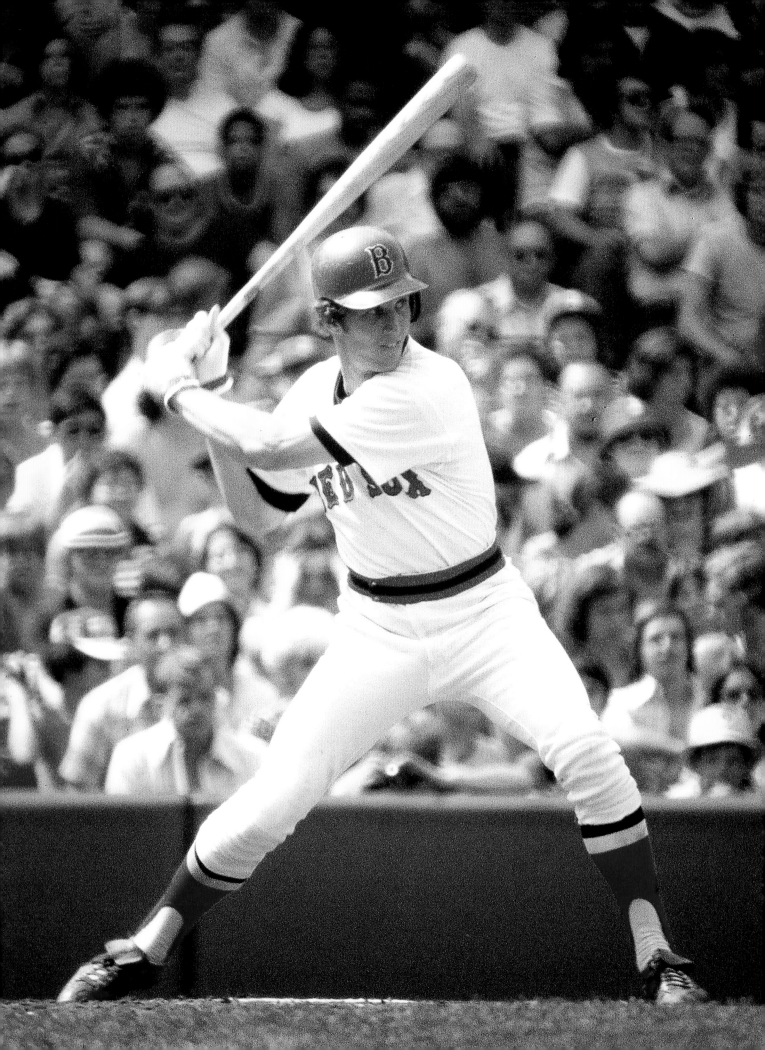

Butch Hobson

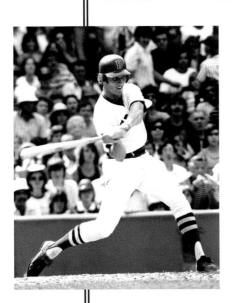

Butch Hobson was front and center in the dramatic 1978 season, and he was there with bone chips in his elbow so painful there were times he couldn't straighten out the arm.

His manager, Don Zimmer, kept running him out there in the dogfight with the Yankees. Hobson finished with 43 errors, while hitting .250 with 17 homers and 80 RBIs in 147 games.

"I got a lot of criticism for keeping Hobson in the lineup every day because he was committing a lot of throwing errors. But the man hit 17 homers and knocked in 80 runs. Who else was going to do that?" Zimmer wrote in his autobiography.

Hobson, dealt to the Angels with Rick Burleson, hit .252 with 94 homers and 358 RBIs in six years with the Red Sox. He would, of course, go on to be the Red Sox manager, a position that he held from 1992 to 1994.

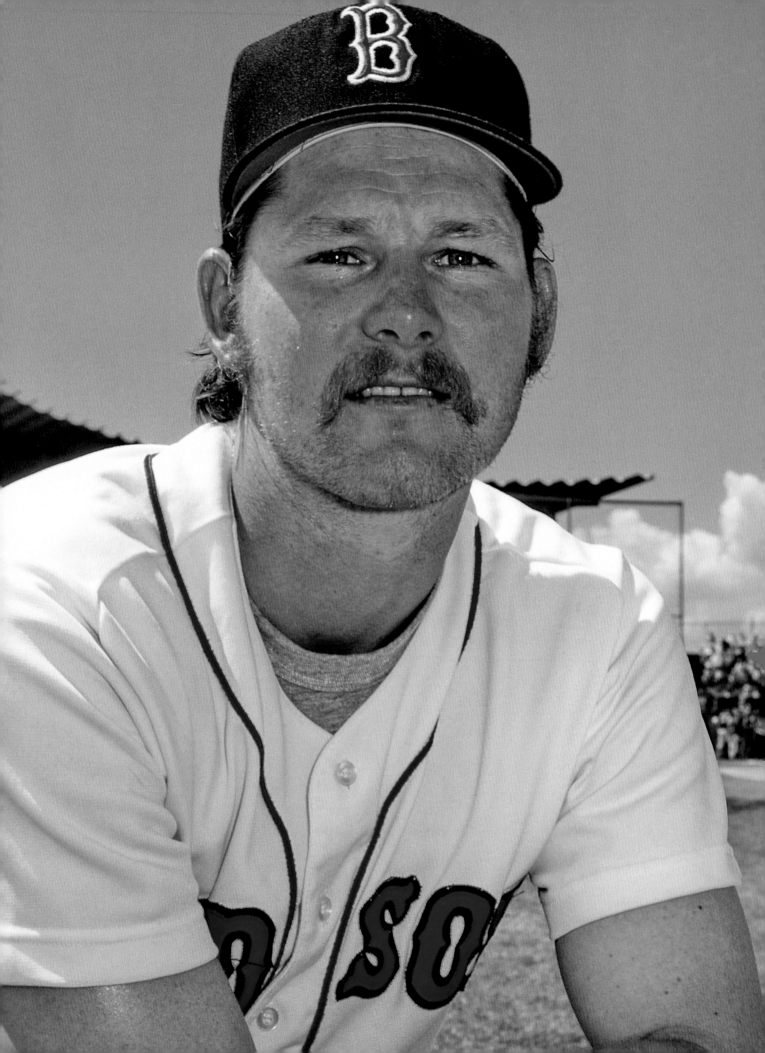

Carney Lansford

Check out the American League batting champions from 1971-1988. That list includes only one right-handed hitter— Carney Lansford, who won the title in the fractured 1981 season (switch hitter Willie Wilson won it in '82).

Alex Johnson captured the title in 1970. Kirby Puckett did it in 1989.

In between, there was Lansford, who spent just two seasons in Boston before being sent to the Oakland A's with Garry Hancock and Jerry King in exchange for Tony Armas and Jeff Newman. The trade opened a spot for Wade Boggs.

Lansford, acquired by the Sox in the deal that shipped Rick Burleson to the Angels, went on to great days with some great Oakland teams and was there through 1992, winning a World Series along the way (1989).

The hard-nosed player finished his career as a .290 hitter, with 151 homers, 874 RBIs, and 224 stolen bases.

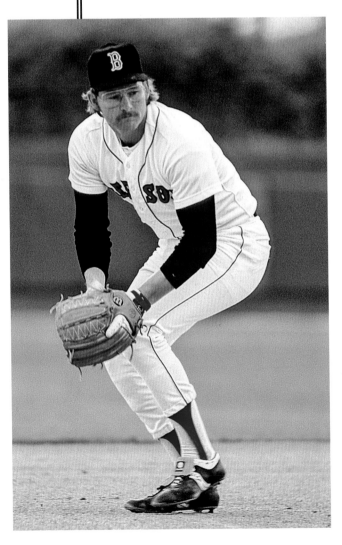

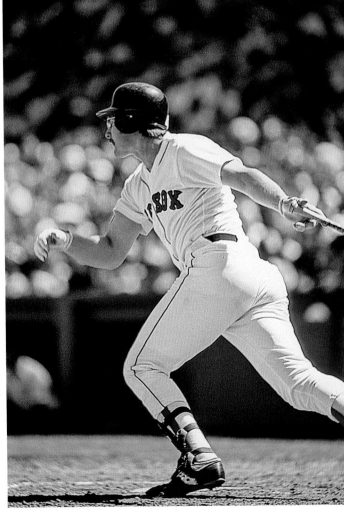

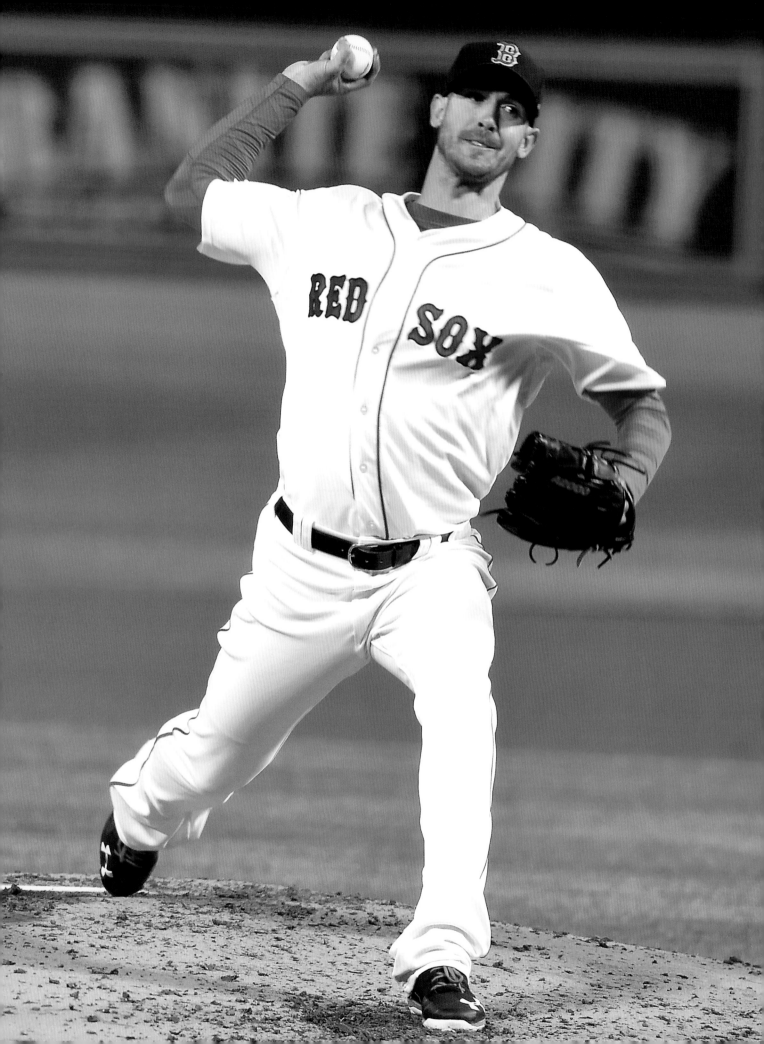

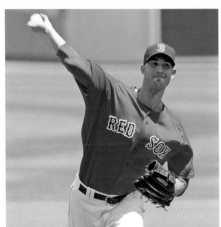

Rick Porcello

Rick Porcello was 9–15 in his first season with the Red Sox.

That was in 2015.

Then, in '16, riding the best run support of any pitcher in the major leagues, Porcello went 22–4 and became the first Red Sox pitcher since Pedro Martinez in 2000 to win the Cy Young Award.

"I don't think I like to admit how difficult it was playing in Boston the first year," Porcello said on the MLB Network. "I take a lot of pride in what I do and I think the pressure I was putting on myself—and obviously there's pressure playing in a city like that—it's something that I almost couldn't get out of my own way.

"That offseason I was able to kind of regroup mentally, refocus and take things the way I wanted to, and take them slow. Started with my foundation, my delivery, getting back to doing the basics and doing simple better. It worked."

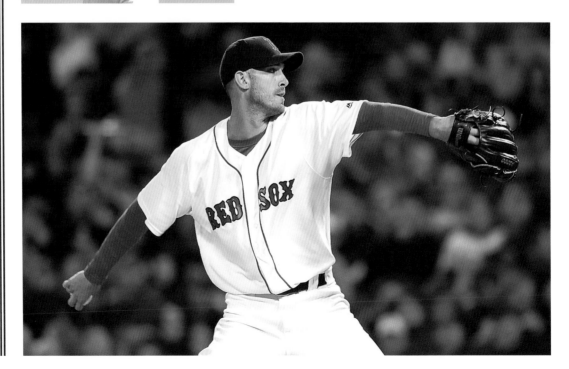

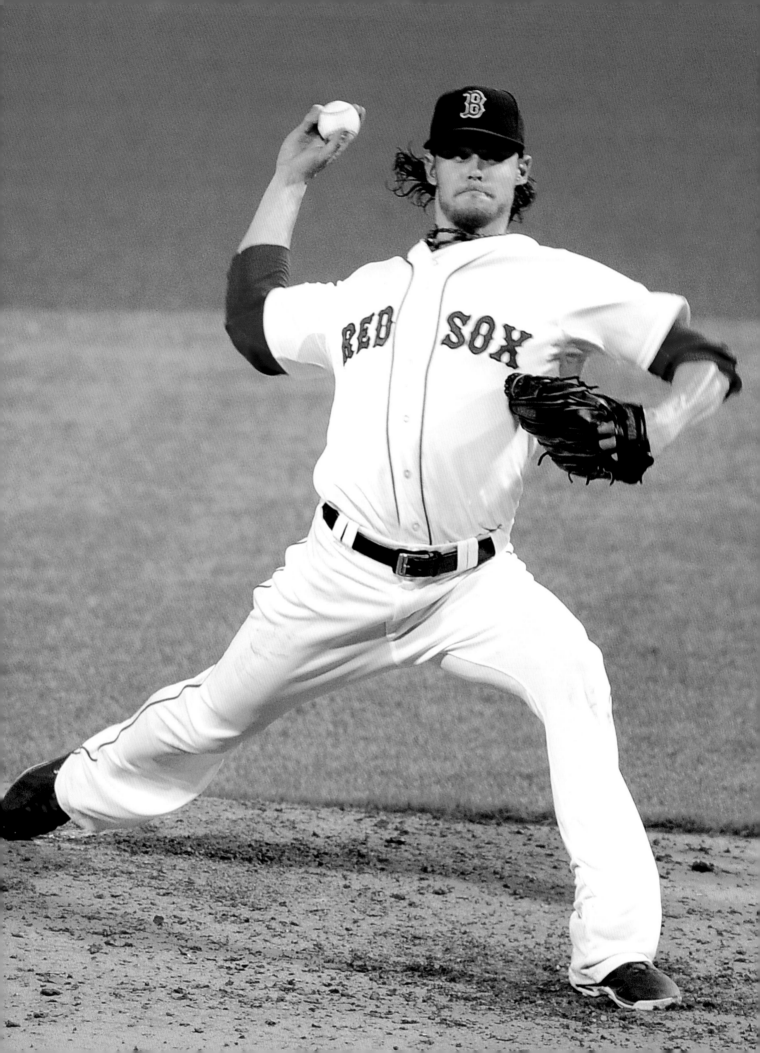

Clay Buchholz

If you want to look up the word "enigma," you might see a picture of Clay Buchholz next to the definition.

So good at times. Hurt too many times.

Buchholz pitched a no-hitter in his second major league start. He made the All-Star team twice and went 81–61 in 10 years in Boston.

He was 0–1 in six postseason starts and was dealt to the Phillies after the 2016 season. He again got hurt in 2017, going 0–1 with Philadelphia as he faced free agency.

"I thought I was going to Chicago in the Sale trade," Buchholz told the *Boston Globe* during spring training 2017. "It's a numbers game and that's the way it is. They have a really good rotation," Buchholz said. "I knew there would be a time this would happen. There aren't too many people like [Dustin] Pedroia. He's going to stay with the same team for his whole career.

I think it's good for me, just getting out of Boston in general. If we ever do go back there, that'll be a fun thing for me and the family, as well."

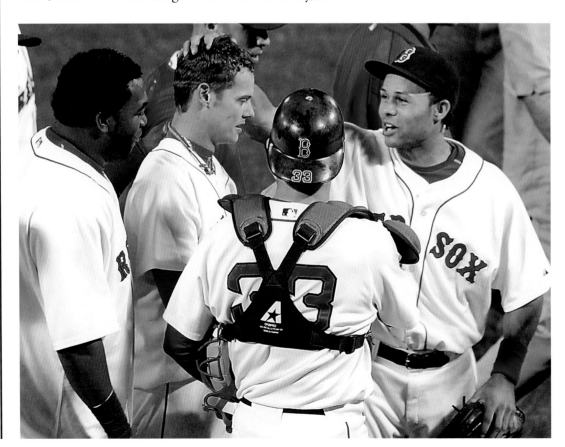

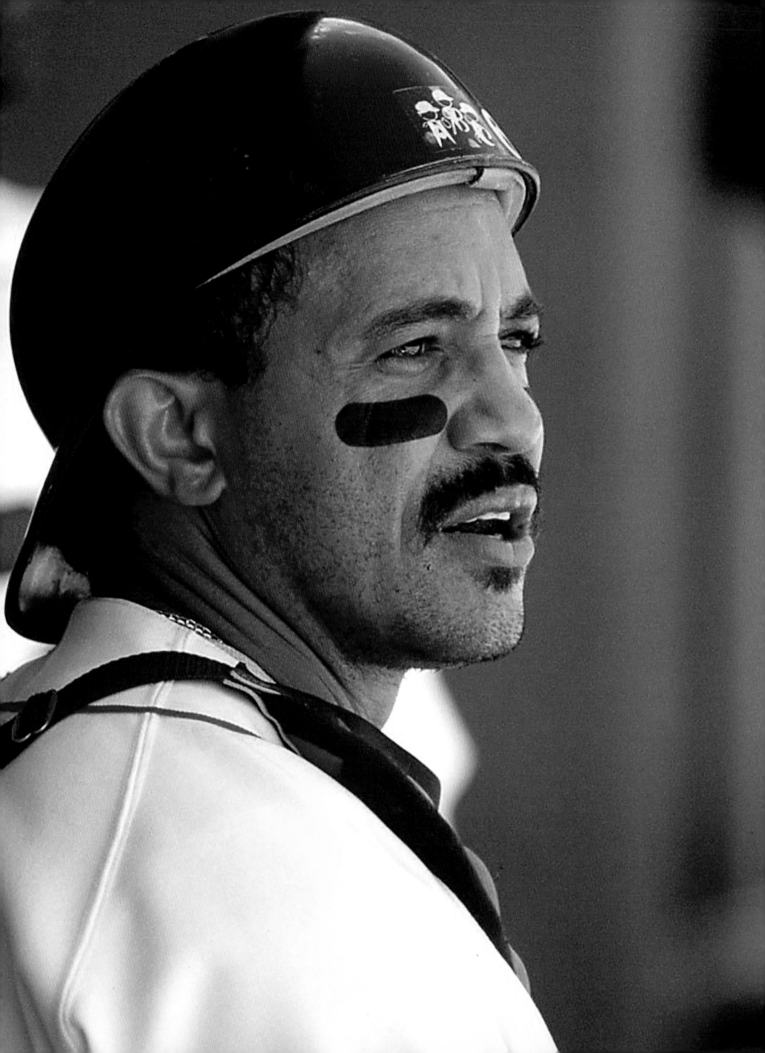

Tony Pena

It was one of those perfect scripts that so often get written in sports.

Player gets discarded by a team. Player signs with another team. Player beats his old team in dramatic fashions.

It has happened hundreds of times through the years.

For Tony Pena, it happened in 1995.

"I have a lot of highlights in my career but I have to say that has to be my No. 1 and that's something nobody can take away from me," Pena said in 2017 of the 13th-inning walkoff home run he hit against the Red Sox to win Game 1 of the 1995 ALDS.

After Pena suffered through a .181 season with just 19 RBIs in 1993, the Red Sox let him walk. Cleveland GM John Hart called and invited him to join the Indians as a backup catcher. The 1994 season was a washout because of the baseball strike, but the Indians went 100–44 in the strike-shortened '95.

Game 1 of the playoffs was a wild affair delayed at the start by rain. The Red Sox tied the game on a Luis Alicea homer in the eighth and took the lead in the 11th on a Tim Naehring homer. But Albert Belle tied it again with a homer in the bottom of the inning.

Pena entered the game after the Indians ran for Sandy Alomar Jr. and came up with two out in the 13th. Lefty Zane Smith was on the mound and fell behind 3–0.

Pena got the take sign but ignored it.

"And when I hit the home run, it was something that I felt so grateful for—I played against my old team and my old teammates," he said. "Here I am, 3–0 and I have the take sign. Zane Smith . . . was throwing like 85 and I said, 'If something comes up, I'm gonna swing at it.' I just swung."

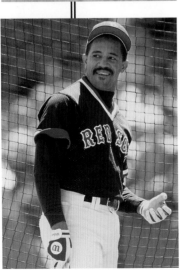

Pena, who played 18 seasons in the major leagues, was a five-time All-Star and four-time Gold Glover, the last of those with the Red Sox in '91. He hit .338 in 29 postseason games but came up just short in a pair of World Series (1987 with the Cardinals and '95). He then went on to a managerial and coaching career with the Royals and Yankees.

He loved his time in Boston, where future major leaguers, sons Tony Jr. and Francisco, would use Fenway as a playground.

"I had some of my best and great, great times here," he said. "I came down here for the first time to the American League, and everybody just took care of me. Everybody embraced me, everybody just showed me the way."

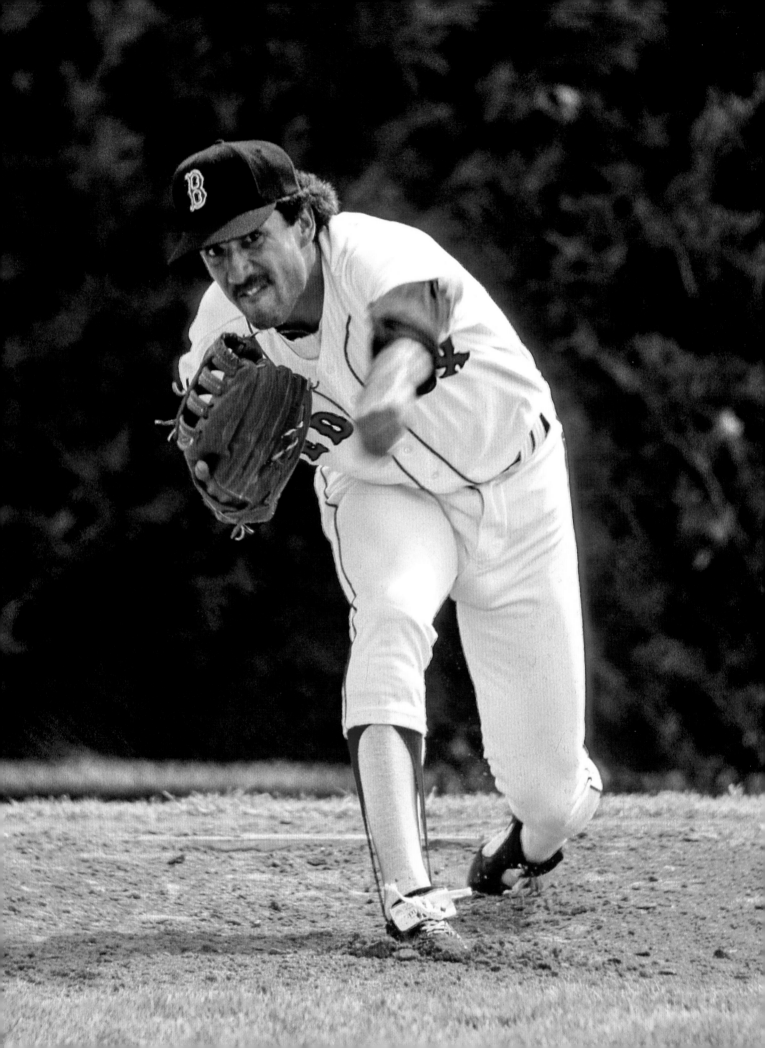

Bobby Ojeda

The left-hander got to pitch in the World Series in 1986, but not for the Red Sox.

Ojeda returned to Fenway Park with the New York Mets and starred in Game 3 of the '86 World Series, with his team down 0–2. He won the game, part of a 2–0 record and 2.33 ERA for Ojeda in the postseason. All this came after an 18–5 season that didn't make the Red Sox look very good.

Lou Gorman got together with his old team and traded Ojeda, John Mitchell, Tom McCarthy, and Chris Bayer to the Mets for Calvin Schiraldi, Wes Gardner, John Christensen, and La Schelle Tarver.

Coming up through the Sox system, Ojeda was 44–39 in a Boston uniform and went on to finish his career with a 115–98 record and 3.65 ERA. He never did return to the postseason.

Ojeda had a sore elbow in that '86 postseason and started Game 6 of the NLCS— a game that would turn out to be a 16-inning classic. Then came the Series.

"Once I started pitching, I'm not sure my left arm ever didn't hurt," Ojeda wrote in the *New York Times* in 2012. "For more than three decades, whether in Little League or the minor leagues or Fenway Park in Boston, there was pain. . . . It would be dulled by aspirin or beer or more powerful cocktails of medicine and booze. But it would never leave."

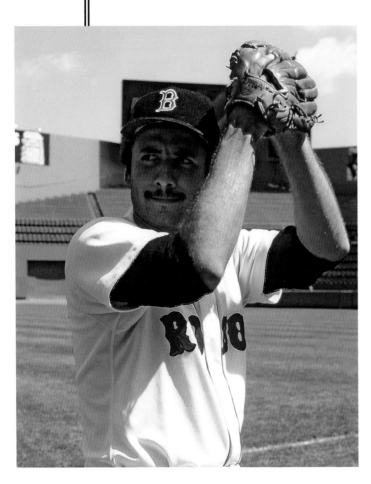

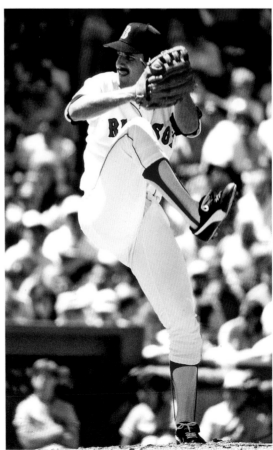

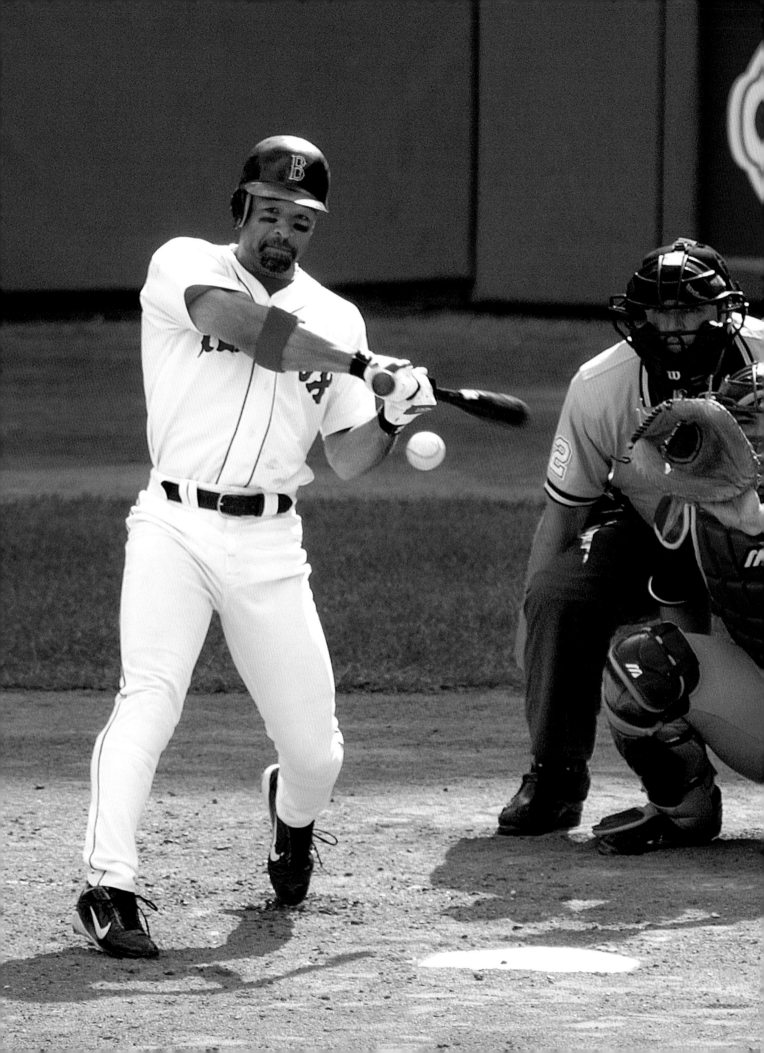

Dave Roberts

Dave Roberts had a decent major league career, playing 10 years for five teams and hitting .266 with 243 stolen bases in the regular season.

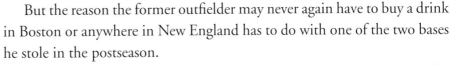

But the reason the former outfielder may never again have to buy a drink in Boston or anywhere in New England has to do with one of the two bases he stole in the postseason.

Roberts ran for Kevin Millar, who had walked, with nobody out and the Red Sox three outs away from being swept in the 2004 American League Championship Series.

You probably know what happened next—Roberts stole second and scored on Bill Mueller's single off Mariano Rivera, and the Red Sox were on their way to eight straight victories and the first title since 1918.

"I remember Maury Wills on the backfield in Vero Beach," Roberts, a former Dodger, said in 2014, on the 10th anniversary of the title. "He said, 'DR, one of these days you're going to have to steal an important base when everyone in the ballpark knows you're gonna steal, but you've got to steal that base and you can't be afraid to steal that base.'"

Jorge Posada, never known for his throwing, made a fine throw, and Roberts was safe by, as Maxwell Smart might have said, "THIS much."

Dave Roberts had become an instant hero.

Roberts scored twice as a pinch runner in that series and only had one at-bat in that postseason—and didn't even get an at-bat in the World Series. But the future manager of the Dodgers had left his mark.

The following summer, Roberts told Bob Ryan of the *Boston Globe*, "It has truly impacted my life. People are often remembered for one thing in their career, whether it's good or bad. Fortunately for me, that stolen base is embedded in people's minds."

More recently, though, what is embedded in people's minds may be Roberts's managing of the Dodgers, who lost in seven games in the 2017 World Series.

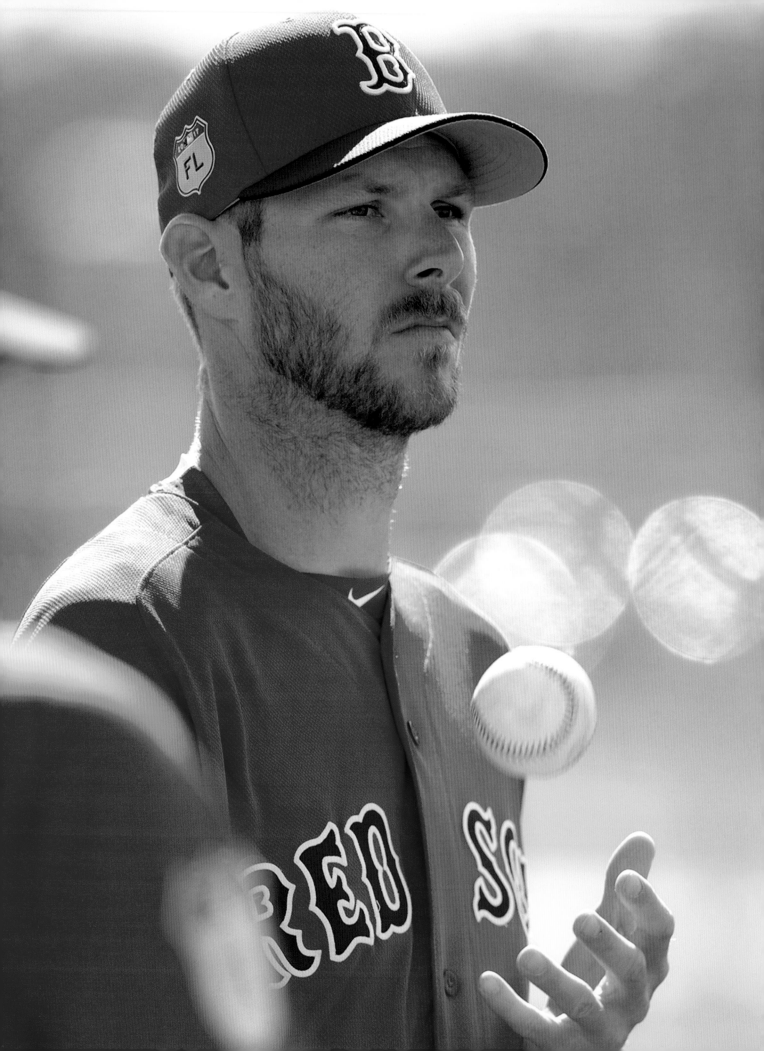

Chris Sale

On September 20, 2017, Chris Sale became the first American League pitcher of the century to record 300 strikeouts in a season.

He was the first A.L. pitcher to reach the magic mark since 1999, when Pedro Martinez—the only other Red Sox pitcher to do it—turned in the feat.

Talk about the greatest pitchers in Sox history? Roger Clemens, Pedro Martinez . . . and Sale?

"That's special. We all know that's about as good a company as you can get. Just appreciative of it," Sale said of joining Martinez on a very short list. "It's fun. Being here and having that name thrown around is special to me; I don't take it lightly.

"He's one of the best to ever step on that mound. To be in the same sentence as him is pretty crazy to me."

Dave Dombrowski dealt prized prospects Yoan Moncada and Michael Kopech to the White Sox to bring Sale to Boston. And unlike others who have come to what can be a difficult place to play, Sale took to the environment right away with a strong opening season.

Sale became the second American League left-hander to strike out 300 since the introduction of the designated hitter. Baltimore's Ryan Flaherty was the 300th victim.

It didn't take long for the Boston fans and media to learn Sale was more about winning—and making his first trip to the postseason—than anything else. Nevertheless, what he did on a personal level was outstanding and has carved its own niche in Red Sox history.

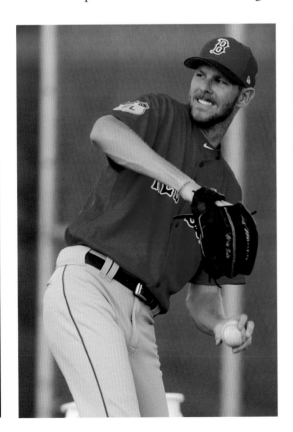 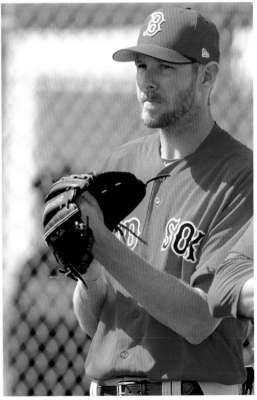

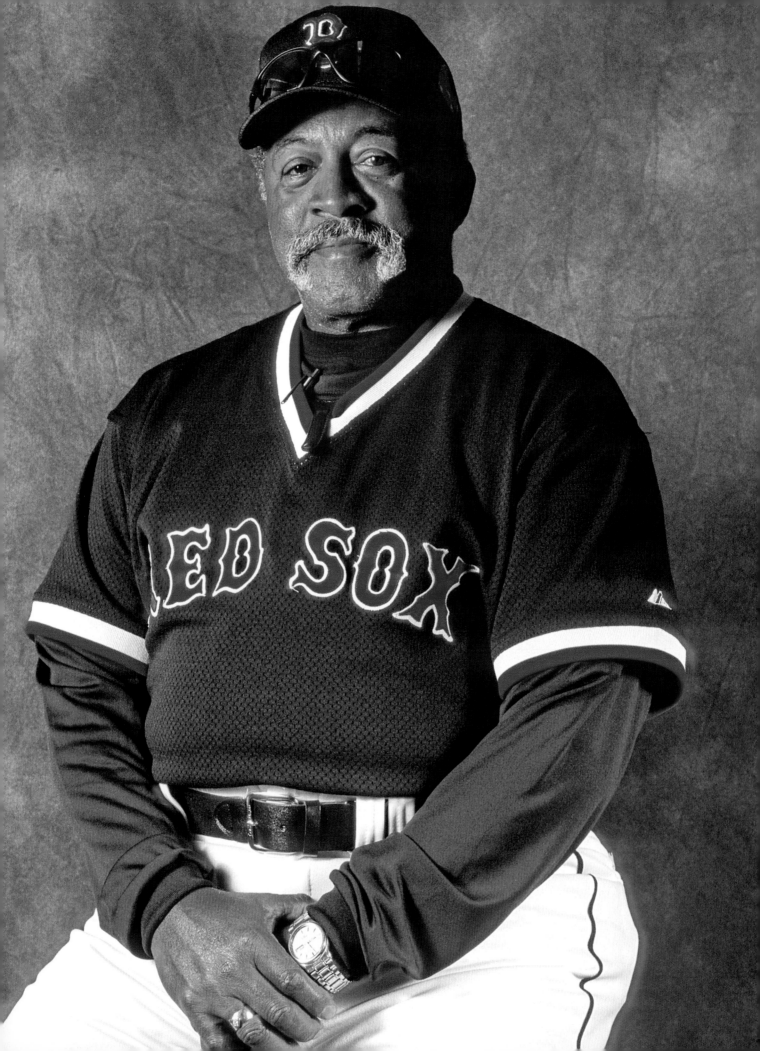

Luis Tiant

Luis Tiant was an important part of the 1975 Red Sox team that narrowly lost what many think is the greatest World Series of all time.

Losing on his only trip to the World Series hurt.

Something else hurt worse, though—a lot worse.

"You know what? I tell you what's worse—'78, when we lose in the playoff against the Yankees," El Tiante said in early 2017. "That was worse. That's the worst day of my life in baseball. I think it's for everybody—for all the players. We go into the clubhouse after the game, you see the guys crying in their locker and everything."

"It really was a sad day for me. Like I said, my saddest day in baseball."

The 1978 Red Sox won 99 games, two more than in '77 for Don Zimmer. The '75 team won 95 games and then the American League Championship Series before losing in seven games to the Reds. A truly special Series.

"For me, first, it was the only World Series that I played [in]," said Tiant, who was 2–0 with a shutout and two complete games in three World Series starts. "Second, my mom and dad were here—first time they'd seen me pitch was in the World Series. It was really way up in my life in baseball. I never thought I'd ever see my mom and dad again and it happened."

Tiant pitched in Cleveland and Minnesota first but came to Boston in 1971 and has never left.

"I have nothing bad to say about Massachusetts, the people here, the fans all around here. People are great, no matter where I go around here."

In the Spring of 2017, the *Sporting News* talked to some former MLB players who have been arguably overlooked in terms of their Hall of Fame eligibility. As *TSN* pointed out, "Tiant's 65.9 Wins Above Replacement as a pitcher are eighth-best for the years he played, 1964 to 1982, according to the Baseball-Reference.com Play Index tool. Every pitcher in front of Tiant for WAR for the years he pitched is in the Hall of Fame. Overall, Tiant has the second-best WAR behind Rick Reuschel of any pitcher since 1900 retired at least 20 years and not in the Hall of Fame."

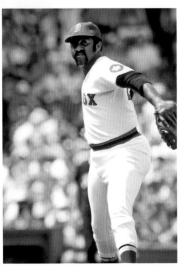

"Everybody . . . they see me pitch all those years, they know I belong in the Hall of Fame," Tiant said. "Wherever I go, people told me, 'You should be in the Hall of Fame.'"

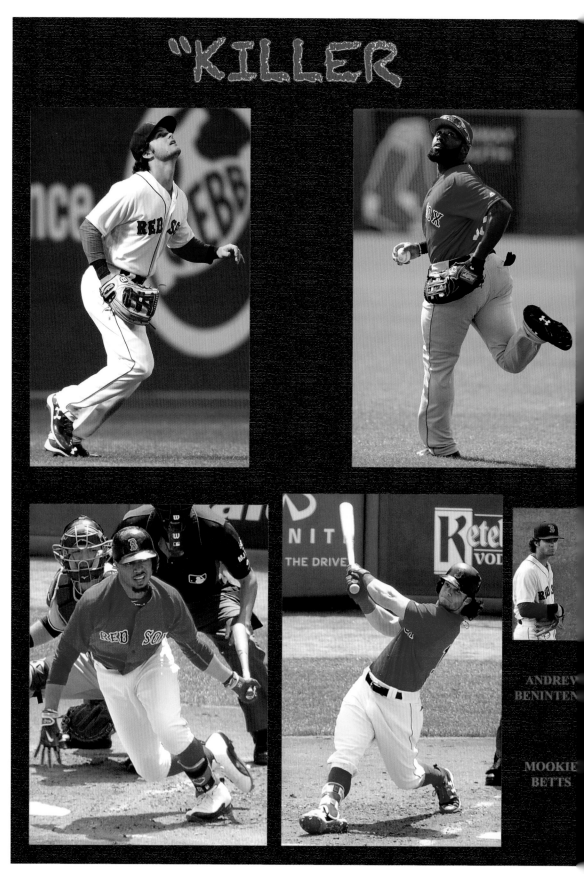

"KILLER

ANDREW
BENINTEN

MOOKIE
BETTS

The first of the Red Sox's Killer B's arrived in 2013, when Xander Bogaerts and Jackie Bradley Jr. won World Series rings. Mookie Betts came up the following year and became an MVP candidate by 2016. That was the year Andrew Benintendi joined the "B" squad, and in 2017 he took David Ortiz's place as the conqueror of the Yankees in their own ballpark.

B'S"

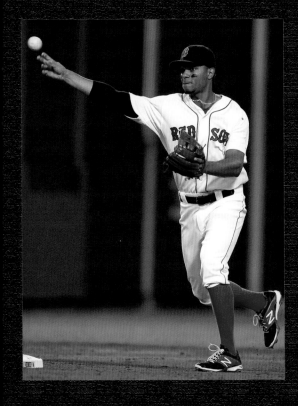

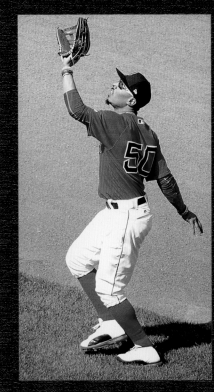

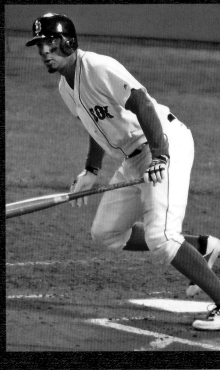

JACKIE
BRADLEY JR.

XANDER
BOGAERTS

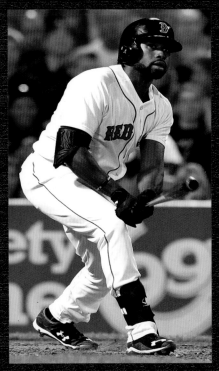

"AND DON'T FORGET"

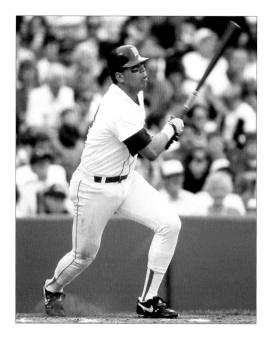

Carlos Quintana

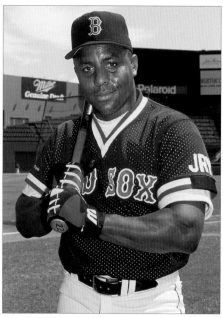

Billy Hatcher

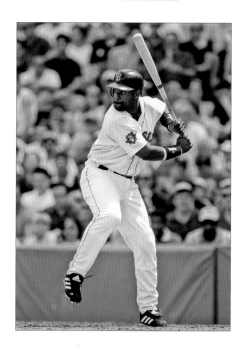

Carl Everett

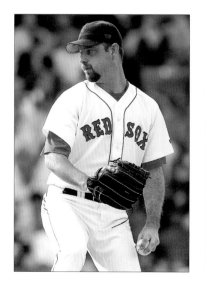

Alan Embree

Al Nipper

Adrian Gonzalez

Danny Darwin

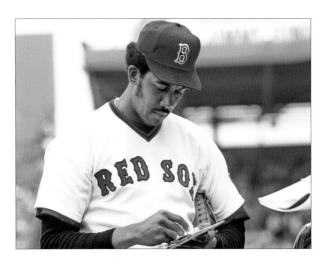

Fergie Jenkins

Dennis Lamp

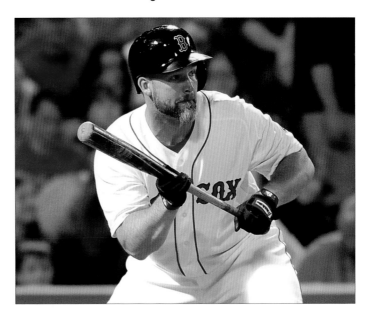

David Ross

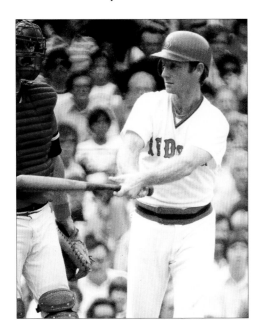

Denny Doyle

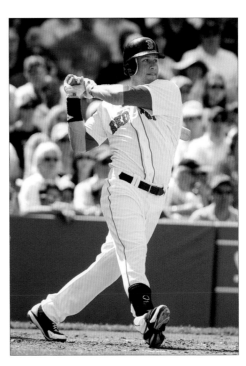

Daniel Nava

Jed Lowrie

Frank Tanana

Gary Allenson

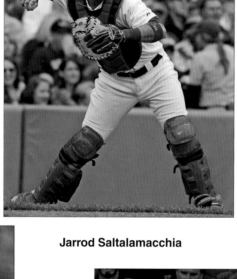

Jarrod Saltalamacchia

John Dopson

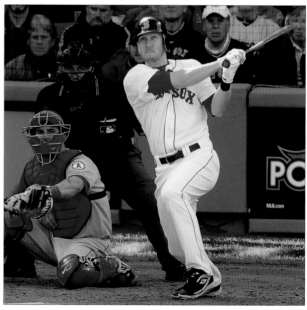

Jason Bay

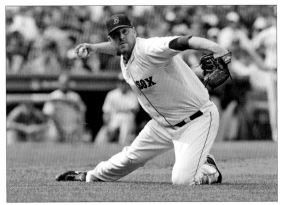

John Lackey

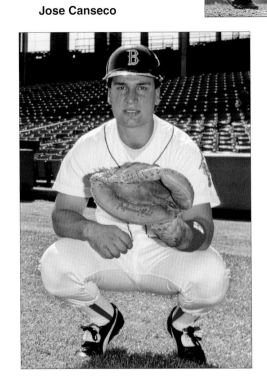

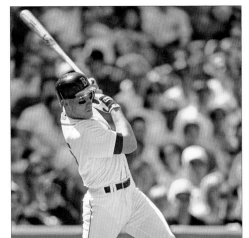

John Tudor

Jose Canseco

John Flaherty

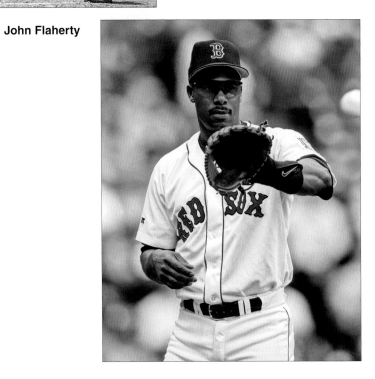

John Marzano

Jose Offerman

Marc Sullivan

Lee Smith

Julio Lugo

Lou Merloni

Kevin Romine

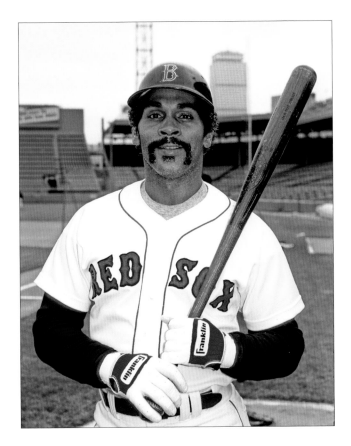

Mike Easler

Marco Scutaro

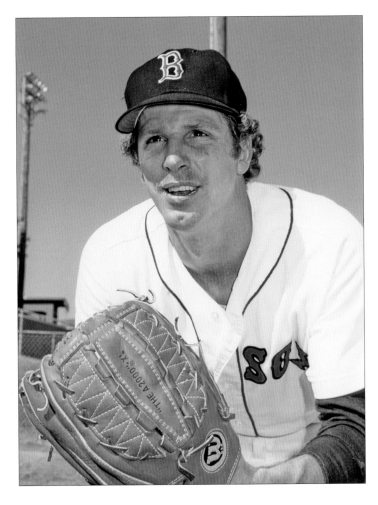

Mark Fidrych

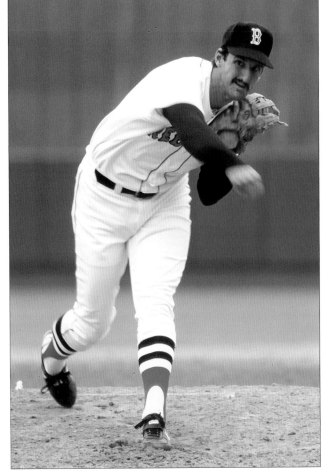

Mark Clear

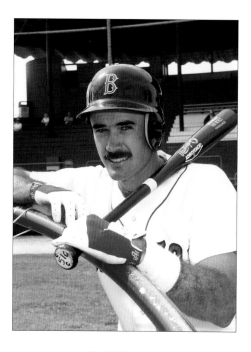

Reid Nichols

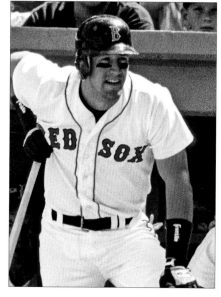

Phil Plantier

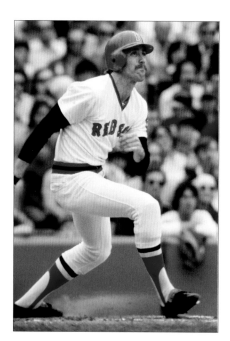

Rick Miller

Mike Smithson

Mike Stanley

Mike Macfarlane

Sam Horn

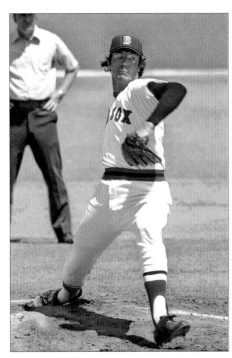

Spike Owen

Rick Wise

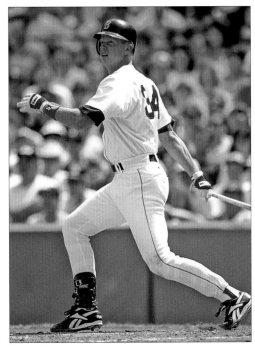

Shea Hillenbrand

Scott Cooper

Sammy Stewart

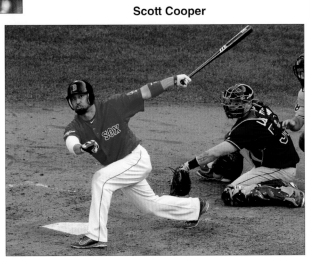

Shane Victorino

Tim Naehring

Tom Burgmeier

Todd Benzinger

Tony Clark

Tony Perez

VIctor Martinez

Troy O'Leary

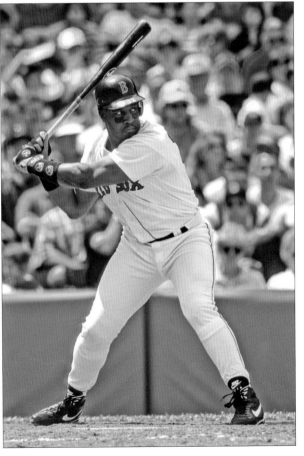

Wes Chamberlain

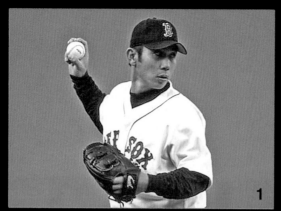

HIDEO NOMO **1**
KOJI UEHARA **2**
JUNICHI TAZAWA **3**
DAISUKE MATSUZAKA **4**
HIDEKI OKAJIMA **5**

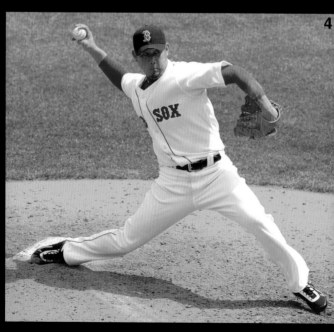

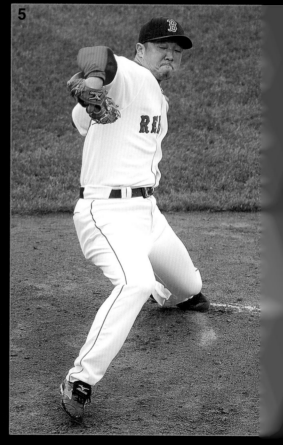

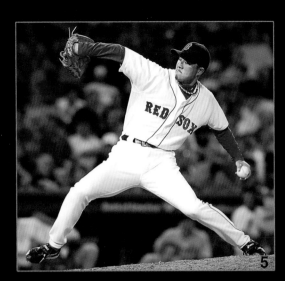

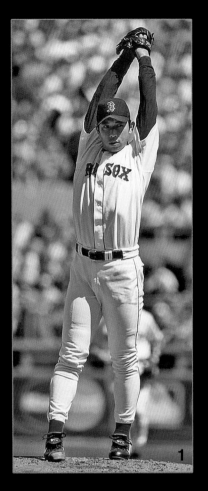

5

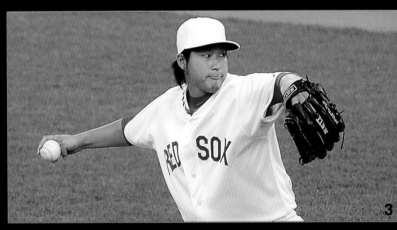

3

1

2

4

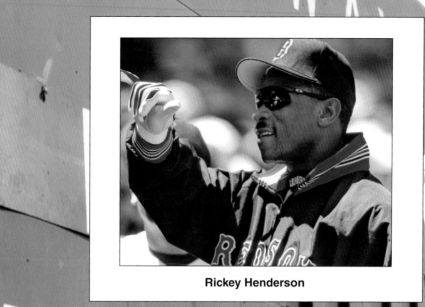

Rickey Henderson

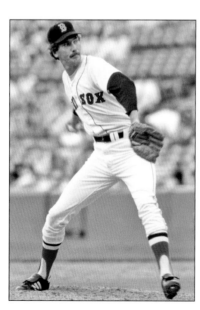

Jack Clark

Dick Drago

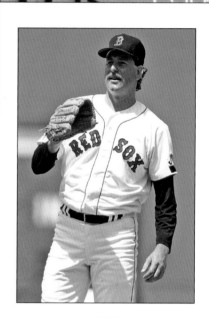

Frank Viola

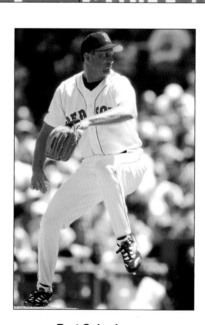

Bruce Kison

Bret Saberhagen

LAST HURRAH & MEMORIES

7

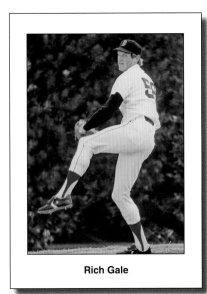

Rich Gale

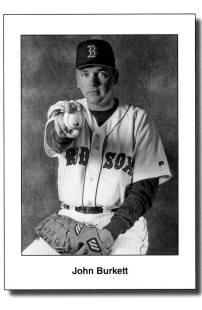

John Burkett

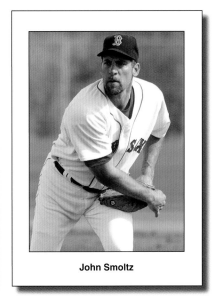

John Smoltz

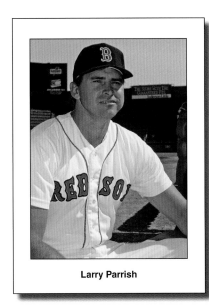

Larry Parrish

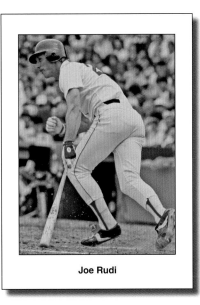

Joe Rudi

Scott Fletcher

Tom Seaver

Hall of Famer Tom Seaver had already captured his 300th career victory by the time he came to Boston to finish his career in 1986.

Back in 1985, when Carlton Fisk was catching Seaver with the White Sox, Seaver threw 147 pitches in a failed attempt at win No. 299, against the Tigers.

Asked to sum up the right-hander's effort in that game, Fisk said, "Gutsy."

"He didn't have great stuff but he worked the plate pretty well," Fisk said. "When you're pitching against the world champions, they're not gonna say, 'Well, Tom's pitching for 299 so let's just lay down and let him get it.' The next guys aren't gonna lay down and say, 'Let's let him get 300.' It doesn't work that way."

The forty-year-old Seaver beat the Red Sox with a complete game at Fenway in his next start, and then, August 4 at Yankee Stadium, in the city where it all began, on Phil Rizzuto Day (complete with Scooter getting knocked over by a real holy cow), Seaver again went all the way, beating the Yankees for No. 300. He became the 17th pitcher to reach 300.

Perhaps fittingly (for this book, anyway), former Red Sox outfielder Reid Nichols caught a fly ball off the bat of Don Baylor to end it.

"It was great," Nichols said that day. "I've gotten to be in on a lot of stuff . . . Yaz's retirement day, and now Seaver's 300th win."

Pitching coach Dave Duncan visited Seaver on the mound in both the eighth and ninth innings, but no change was made. Said Fisk: "He wasn't going. If he was going, I was gonna trip him.

"He's as strong as a horse. The last three games, he threw about 140 pitches [per game]."

Seaver, 5–7 for the Red Sox after coming over from the White Sox for Steve Lyons, was injured and couldn't pitch in the postseason. He finished with a 311–205 record and a 2.86 ERA.

David Cone

David Cone pitched a perfect game for the Yankees against the Montreal Expos on July 18, 1999, at Yankee Stadium.

Just over two years later, pitching for the Red Sox, Cone, who played only one season in Boston, was almost on the other end—as the opposing pitcher of what would have been the first perfect game in the history of Fenway Park.

Mike Mussina of the Yankees, on August 22, 2001, came as close as you can come to pulling it off, until Carl Everett broke it up with a two-out single on a 1–2 pitch.

"That was incredible," Cone said as he stood outside the YES Network booth prior to a 2017 game. "I was the last guy to throw a perfect game and he was trying to be the next guy. I had a shutout going into the ninth, so conceivably I could have blocked him. I gave up a run in the ninth inning that set him up for the bottom of the ninth, to throw a perfect game." Tino Martinez opened the top of the ninth with a single, and, after Jorge Posada flied out, Paul O'Neill reached on an error by second baseman Lou Merloni. Then Enrique Wilson doubled.

"And Carl Everett then broke up Mussina's bid, so close to the end. Oh-two with two strikes—you cannot get closer.

After that game, Cone said, "Part of me didn't want him to do it, because I was the last to do it. But part of me wanted him to do it."

Cone also pitched for the Mets, so he knew just about everything there was to know about playing in New York and Boston.

The difference?

Cone emphasized the "intimacy" and "scrutiny" of Fenway. "You hear them warming up in the bullpen because they're right on top of you. There's nothing like being a starting pitcher and you're warming as a reliever—they're as close as you and me right now. There's nothing quite like warming up at Fenway."

And he has a special feeling about his only season with the Red Sox, saying, "It was incredible. It really was.

"The year I was here I was 9–11, when 9-11 happened—it was the only game at Fenway where there were 'I Love New York' signs in the stands the first game after 9-11 here. So that was unique. The whole experience was a little bit surreal in that regard because of everything surrounding 9-11."

Paul Molitor

Though he hasn't forgotten his first visit to Fenway as a freshman in college, Hall of Famer and current Twins manager Paul Molitor couldn't quite remember his first game at Fenway as a major leaguer—so (during a 2017 Twins/ Red Sox game) we looked it up.

It was April 18, 1978, on which day Molitor went 1-for-5 for the Brewers, in the second game of a three-game series. He went 0-for-4 the next day as his team got swept—but Molitor wound up hitting .323 (146 of his 3,319 hits) in 106 games at Fenway, 12 homers, 60 RBIs, and 20 of his 504 career stolen bases.

"I remember the last day of one of the seasons [1987] where Roger [Clemens] was going for his 20th win. It was like 38 degrees and rainy and we knew we were going to play because Roger had to get his chance to win his 20th. I hit a home run here against Derek Lilliquist on the fourth of July at dusk and as the ball went over the Monster the fireworks started out there and I think it was the first time as a visiting player I ever got fireworks for hitting a home run.

"It's a unique place. Unique fans. It was a pleasure any time I had a chance to come here and play."

Asked about seeing the Green Monster for the first time, he said, "It felt like it was very intimidating, in terms of, as a hitter you were always aware of it.

"I was telling some of our guys yesterday, I said, 'When I learned to block out that wall is when I started to hit in Fenway Park.' There is so much room for hits out there in center and right—some guys were not good enough to force the wall to come into their offensive game. But for me, when I started to block [it] out is when I started to do well."

Jack Morris

Ask Jack Morris about his 8–10 career record at Fenway Park and he says, "It wasn't the park, it was the guys I had to face."

Morris won 254 games during his major league career. He was 19–16 lifetime against the Red Sox, but had his problems at Fenway. He says things evened out a bit later in his career, but it's clear he didn't have a wonderful time pitching in Boston.

Remember, Fenway can be an unfriendly place for a pitcher.

"I think . . . most of the losses I incurred were early in my career, back when Evans and Rice, even Yaz was here back in those early years," he said in the visiting broadcast booth when the Minnesota Twins visited in 2017. "They had some powerful players, really good players—couple guys in the Hall of Fame—and in my opinion Dwight Evans is another guy that should be in the Hall of Fame, Boggs in his early years."

And the old park?

"It's a very unique ball-park," Morris said. "Some guys really love it. I'm kind of from the school of thought that anything that's manmade can be replaced. I saw Tiger Stadium and Comiskey torn down because of age. This place kind of fits right in there. Then you have to ask yourself, 'Well where would they put it? Would it be in the same footprint and how would that be?'

"In a way I'm kind of glad that they haven't taken them ALL down, because I think there's still some charm and mystique and nostalgia."

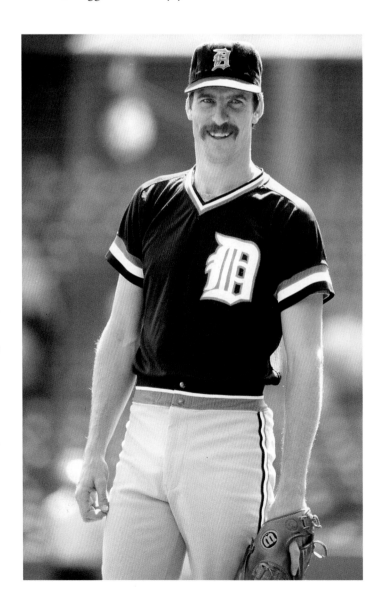

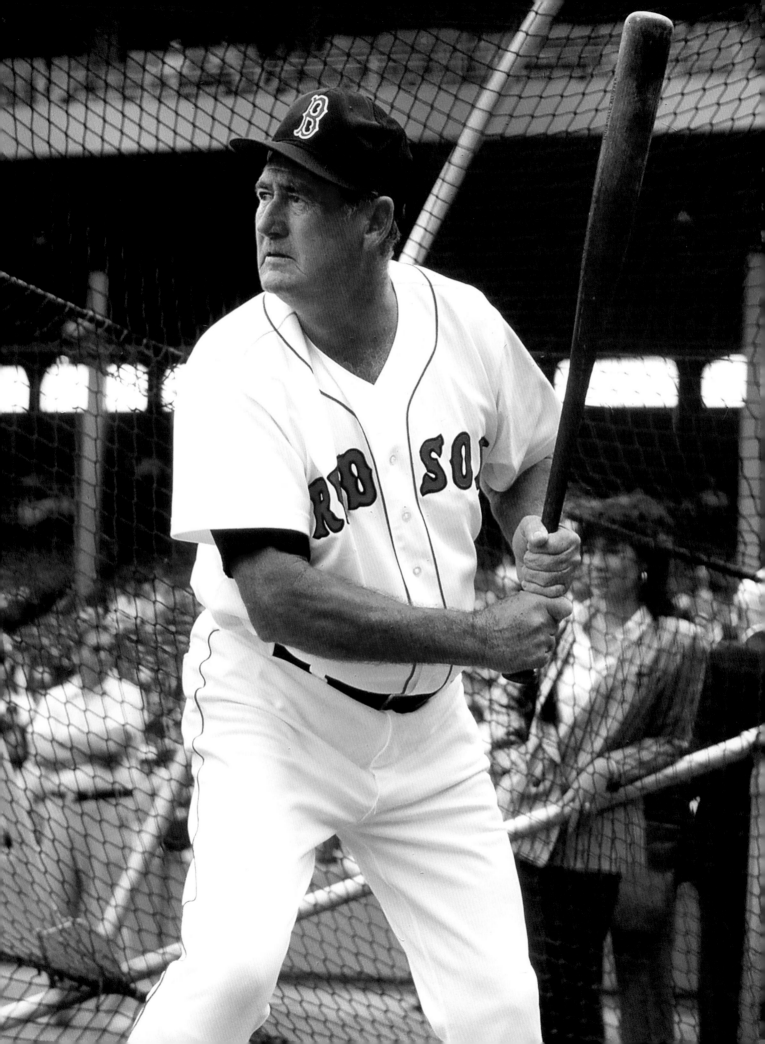

#9, ALUMNI, AND COMBOS

Ted Williams

Alumni and Combos

Johnny Pesky

Johnny Pesky did just about everything there was to do in the Red Sox organization.

And he did it with nothing but class.

He mentored young players. He was a friend to the media, even playing pepper with us during early batting practice on the road.

He always had a smile on in the clubhouse.

When we lost him, we lost a true giant in Boston sports.

Nomar Garciaparra paid tribute to Johnny after his passing in 2012. Speaking to Gethin Coolbaugh, then of *Bleacher Report*, Nomar made his feelings clear.

"It's a tough loss," he said. "It was hard for me when I heard the news of him passing away. For me, he meant so much to me. He taught me what it meant to be a Red Sox, what that uniform really meant."

Garciaparra batted .323 with 178 homers, 690 RBIs, and a .923 OPS in nine years with the Red Sox. He won back-to-back batting titles in 1999 and 2000, batting .357 and .372, respectively. Nomar led the league with 56 doubles in 2002 and 11 triples in '00. He also had three homers and 10 RBIs in one game, hitting two grand slams in that 1999 game.

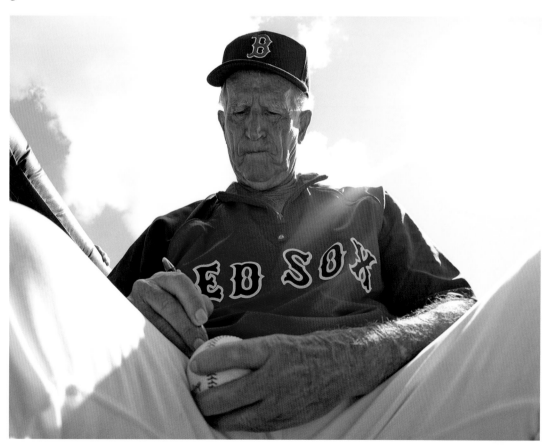

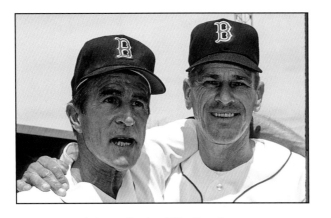
Johnny Pesky, Billy Goodman

Mel Parnell

Dick Radatz, Boo Ferriss

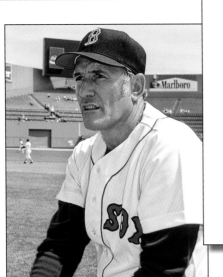
Jim Piersall

"Smokey" Joe Wood

Sox alumni team 1984

Earl Wilson, Bill Monbouquette

Jim Lonborg

Rico Petrocelli, Mike Timlin

Ted Williams, Dick Stuart

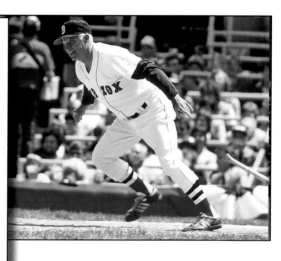

Bobby Doerr

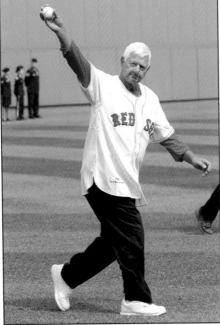

Carl Yastrzemski

Bill Buckner

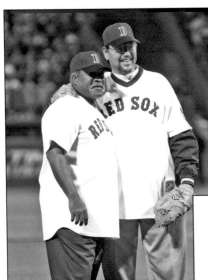

Luis Tiant, Carlton Fisk

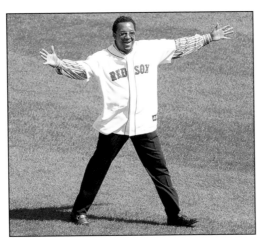

Pedro Martinez

Pumpsie Green

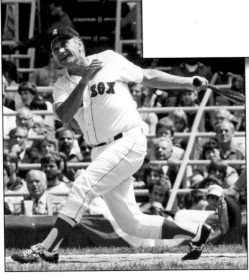

Frank Malzone

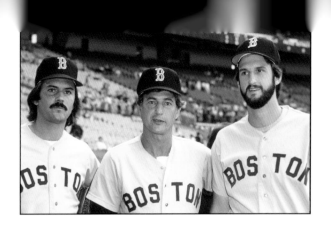

Dennis Eckersley, Yaz, Mark Clear

Gary Carter, Roger Clemens

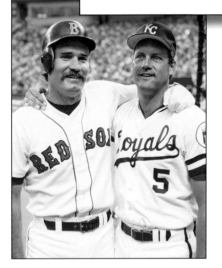

Wade Boggs, George Brett

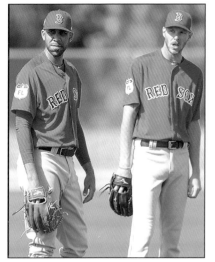

David Price, Chris Sale

Carlton Fisk, Rich Gedman

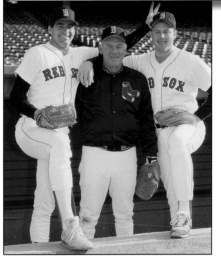

Bruce Hurst, Bill Fischer,
Roger Clemens

Dom and Joe DiMaggio

Fred Lynn, Dwight Evans

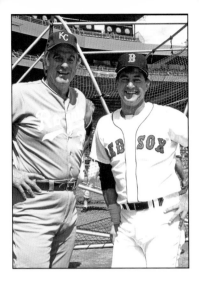

Gaylord Perry, Carl Yastrzemski

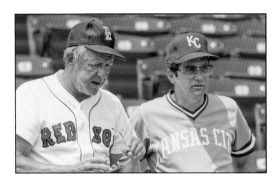

Ralph Houk, Dick Howser

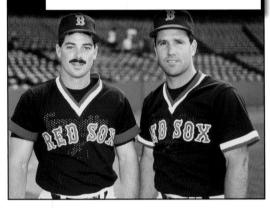

Jody Reed, Marty Barrett

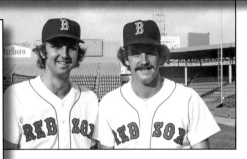

Glenn Hoffman, Dave Stapleton

David Ortiz, Tommy Harper

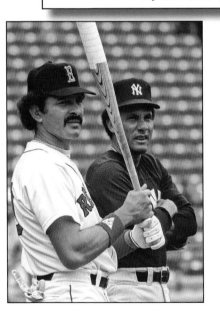

Tony Armas, Bert Campaneris

Jason Varitek, Derek Lowe

Rico Petrocelli, George Brett

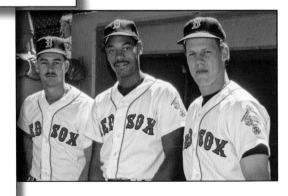

Mike Greenwell, Ellis Burks, Todd Benzinger

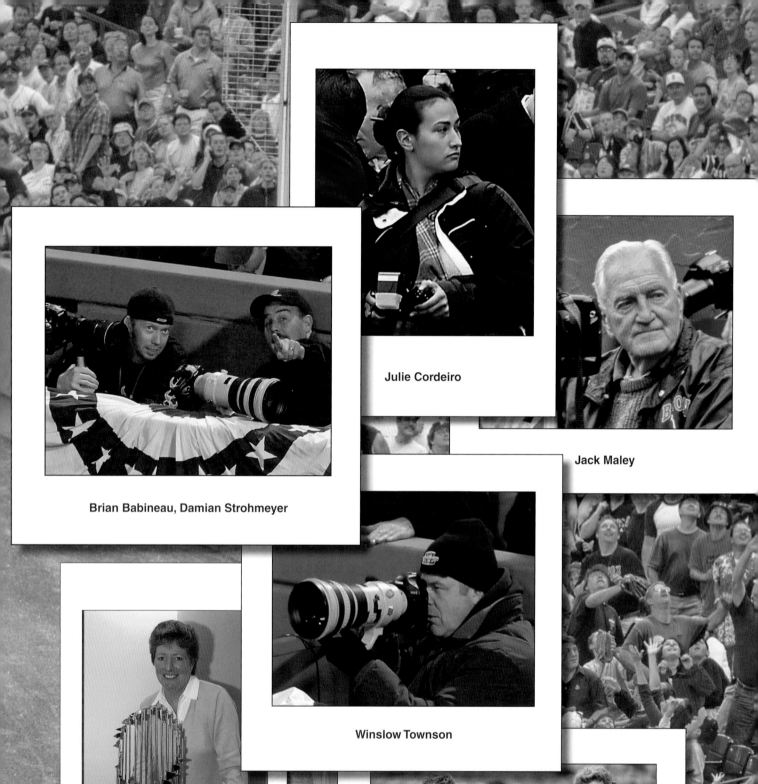

Julie Cordeiro

Jack Maley

Brian Babineau, Damian Strohmeyer

Winslow Townson

Debbie Matson
(Red Sox Publications)

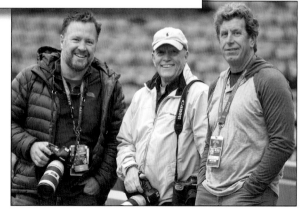

Matt West, Jim Davis, Charlie Krupa

COLLEAGUES, FRIENDS, AND SCRAPBOOK

Rick Dunfey, "Babs," Ann Gram

Tom Caron (NESN)

Red Sox photo crew 2013

Bob Tomaselli (NESN Video), "Babs"

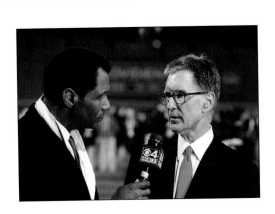

Steve Burton (WBZ), John Henry

"Babs," with daughter, Jamie, and wife, Anita

Brian, "Babs"

"Babs" was a contributor for *Baseball Digest* from 1976 to 1990

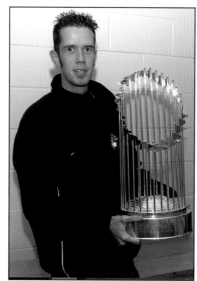

Keith Babineau

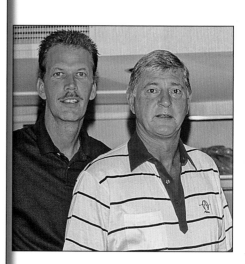

"Babs," Yaz

"Babs" taking swings

"Babs" was a Fleer Baseball staff photographer from 1979 to 1994